Abundantly More

Abundantly More

THE THEOLOGICAL PROMISE OF THE ARTS *in a* REDUCTIONIST WORLD

JEREMY S. BEGBIE

B
Baker Academic
a division of Baker Publishing Group
Grand Rapids, Michigan

© 2023 by Jeremy S. Begbie

Published by Baker Academic
a division of Baker Publishing Group
Grand Rapids, Michigan
www.bakeracademic.com

Printed in the United States of America

Library of Congress Cataloging-in-Publication Control Number: 2022057953
ISBN 978-1-5409-6543-1 (cloth)

Baker Publishing Group publications use paper produced from sustainable forestry practices and post-consumer waste whenever possible.

23 24 25 26 27 28 29 7 6 5 4 3 2 1

For Dan and Hillary

Contents

Acknowledgments

This book has occupied me on and off for about two years, during which I have been fortunate enough to have numerous conversations about its themes with an array of theologians, artists, theorists, writers, scientists, and philosophers. The influence of Rowan Williams will be especially evident at a number of points—it was his gentle and probing writing on the arts that provided the initial impetus for this venture. I am indebted to Christopher Oldfield of the Faraday Institute at the University of Cambridge for his illuminating grasp of the scientific, philosophical, and theological dimensions of reductionism. Brett Gray of Sidney Sussex College, Cambridge, and Andrew Torrance of the University of St. Andrews worked through the concentrated theological sections, providing a host of corrections and valuable comments. With her customary energy and forthrightness, Suzanne McDonald of Western Theological Seminary offered penetrating insight, and Richard Bauckham saved me from many an exegetical howler. A profound word of thanks goes to Bettina Varwig of the Faculty of Music at Cambridge for her kindness in reading the whole book, for bringing her extraordinary historical knowledge to bear, and for her enviable ability to attend to detail without ever losing sight of the big picture.

Numerous others have helped me along the way, among them Malcolm Guite, David Ford, Daniel Chua, Nicholas Wolterstorff, Alan Torrance, Allan Poole, and Jeremy and Debbie Whitton Spriggs. Jonathan Anderson, art historian, theologian, and postdoctoral associate at Duke Initiatives in Theology and the Arts, made numerous penetrating comments on a number of chapters. A wonderful cohort of first-rate doctoral students have contributed in various ways to the theological integrity of the text: Christina Carnes Ananias, Joe

Ananias, Will Brewbaker, Andrew Hendrixson, Nate Jones, He Li, Jon Mansen, Sarah Neff, Brett Stonecipher, Debbie Wong, and Nicholas White. My research assistants, Alice Soulieux-Evans and, more recently, Austin Stevenson, have gathered and collated numerous sources, as well as formatted a complex script for publication. Without their meticulously detailed reading, the text would be very much weaker. Sincere thanks also go to the ever-patient Bob Hosack at Baker Academic (this is the third project on which we have collaborated) and to his dedicated and skillful staff—especially Alex DeMarco for the multitude of helpful suggestions.

My colleague and friend Dan Train has been a tower of strength and has offered critically important comments on many parts of the text. And his wife, Hillary, has gone beyond the call of duty on countless occasions as my PA. To this remarkable couple the book is dedicated. As always, the deepest word of gratitude goes to my wife, Rachel, for her consistent, loyal, and heartwarming support.

Introduction

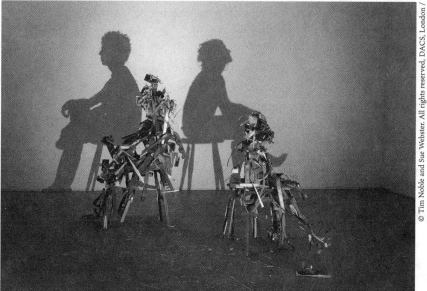

Fig. 0.1. Tim Noble and Sue Webster, *Wild Mood Swings*, 2009–10. Two wooden stepladders, discarded wood, light projector, dimensions variable. https://www.artworksforchange.org/portfolio/tim-noble-and-sue-webster/.

Figure 0.1 shows a remarkable sculpture by Tim Noble and Sue Webster. These London-based artists have long been fascinated by the relation between abstract and figurative forms. In this case, through meticulous arrangement and skillful projection, what at first looks like random pieces of art studio detritus is transformed into the silhouette of two figures (the artists themselves, as it happens).

What makes a human person? That is only one of the many questions this installation might provoke. Only the discarded clutter in the foreground is visibly solid. There is really nothing more than that—except the images on the wall that will disappear as soon as the light is switched off. And yet, part of us will want to say there is a good deal more here: for the silhouettes immediately evoke something far *more* solid and significant, and of far *more* value, than the shards and fragments on the floor—namely, human persons. And the appearances of these persons in no way diminish the concrete reality of the three-dimensional objects; indeed, the objects make the appearances possible.

Discerning this kind of "moreness" is the main preoccupation of this book—and not only the moreness of human beings but also that of the wider world we inhabit. Its opposite is a way of perceiving people and things that encourages us to think in terms of "*no more* than." "There is nothing else here but . . ." The name usually given to this outlook is *reductionism*. It is typically signaled by the presence of words such as "just," "only," "merely," "simply," "really," and (especially) "nothing more" or "no more than." To say "A reduces to B" is to say (or imply) that A is nothing over and above B, nothing but B. Hence the tag sometimes given to reductionism (associated with the physicist Donald MacKay): "nothing-buttery."[1] The universe is nothing but a machine, the brain nothing but a computer, the mind nothing but the firing of neurons.

Reductionism of this sort is typically associated with the natural sciences. But as a habit of mind in modern and late-modern culture, it is present far beyond domains directly influenced by science. It is embedded in a host of social and cultural practices, traditions and customs, symbols, and artifacts, affecting a wide variety of fields, including politics, health care, technology, economics, and cultural and social theory. So understood, reductionism is not a remote or obscure matter. It bears on some of the pivotal issues of life and death—not least, on what it means to be human.

We see it when the curriculum of a college is weighted almost exclusively toward STEM subjects (science, technology, engineering, and mathematics) on the grounds that it is primarily these that are "useful" to society. We see it in what Andrew Coyne calls the "triumph" of "literal-minded citizens," when in an effort to purge language of any socially harmful associations we screen out all humor and hyperbole, irony and suggestion and confine ourselves to the glum

1. MacKay, *Clockwork Image*, 42–44.

and barren world of the strictly literal.[2] We see it in hospitals when patients are treated as little more than mechanisms prone to dysfunction ("cases," "conditions"), but also when antimedical pressure groups treat ill people as no more than immaterial souls trapped in physical bodies. We see it when psychiatric care is limited to pharmaceutical management, but also when mental illness is regarded as having no physical determinants at all. We see it when all society's ills are traced to some form of systemic oppression of minorities, but also when all such oppression is explained entirely by the perverted will of supposedly autonomous individuals.

We see it in those who dismiss a Mozart symphony for its ineradicable attachment to White colonialism as well as in those who celebrate it for its supposed detachment from all things political and ideological. We see it when neuroscientists claim to have found "the key to understanding what art really is"[3] and when governments measure the value of the arts solely in terms of financial return.

In the halls of academic theology, we see it when biblical scholarship avoids all questions about the nature and character of God; when Christian ethics becomes wholly captive to a recent iteration of social theory; and when doctrinal theology becomes no more than erecting systems of ever-increasing abstraction.

Art's Theological Resistance

With all this in mind, in what follows I aim to advance two main theses. The first is that *the arts are capable of offering a distinctive kind of resistance to modernity's reductionist drives.*

Why do the arts matter? Clearly they *do* matter and have always mattered to human beings, even in the direst of circumstances. However desolate human life becomes, however destitute and poverty-stricken, however crushed by tyranny or subjugation, people still sing songs, scratch out images, compose verse, and spin stories. But why? More particularly, why might the arts matter in *this* time and *this* culture?

I am writing this during the third wave of a global pandemic, and the effects on many involved with the arts have been catastrophic. During the first wave of

2. Coyne, "Behold the Literal-Minded Citizens." Along the same lines, see Andrew Doyle's comments: "It's so much easier to think we've won an argument if we ignore context, nuance and the figurative nature of language" (Doyle, "Epidemic of Literal-Mindedness").

3. Ramachandran and Hirstein, "Science of Art," 17.

COVID-19, theaters closed, galleries teetered on the edge of bankruptcy, bands dispersed, orchestras collapsed, dance floors gathered dust, and town halls turned into haunted shells. Many had to think, perhaps as never before, about why any of this really matters. In the face of the vast human needs that cry out to us daily from every corner of the planet, how can we possibly justify caring about activities that, on the face of it, seem so trivial, so startlingly unnecessary, and, in many cases, so expensive?

From a wider historical perspective, major cultural changes have made the question especially pressing. The stunning ascendancy of the natural sciences in modernity and the extraordinary prestige they have come to hold in the cultural imagination have often left those who concern themselves with the arts very much on the defensive. Virtually everyone practices or enjoys the arts in some way. Millions are spent on artistic pursuits, and we are swamped with artistic media. Yet much discourse about the arts makes it sound as though they need to be ceaselessly justified, as if the arts by their very nature distract us from serious and weighty matters, as if they will forever be vastly overshadowed by those mighty, titanic twins, science and technology.

On the other hand, many will contend that the very success of science in enabling us to master the physical world has intensified our awareness of the things we cannot master, and that this has nudged many in the direction of the arts. The COVID-19 crisis may have reinforced our confidence in medical science through the production of vaccines, but it has also exposed our fragility and vulnerability to realities that are not easily managed and "fixed"—most obviously, our own mortality.[4] This has pressed some to ask whether the arts might speak to just these intuitions, to the unnerving sense of being out of control. Perhaps science's limitations are art's opportunity.

Whatever the pressures that lead us to ask why the arts matter, I have no intention of suggesting there is only one valid answer. We need only think of the confusing ambiguity of the concept of "the arts" and the bewildering diversity of artistic practices we find worldwide. Nor do I want to mount some kind of formal defense of all things artistic to ward off cynical detractors. However, I do want to highlight a feature of the arts' modi operandi that can be especially potent in contexts where reductionist sensibilities have taken hold—namely, the arts' capacity to draw upon and generate multiple and potentially inexhaustible levels of meaning, and in this way to offer a resistance movement of sorts, a

4. See Williams, "Confronting Our Own Mortality."

counterpressure to the dominant drives of modernity's reductive imagination, undercutting it at the deepest levels.[5] And the key image I shall be using to describe this dynamic is *uncontainability*.

The second main thesis of the book is that *this artistic pressure toward the uncontainable is potentially of considerable theological import*. It is highly resonant with the counter-reductionist dynamics of a trinitarian imagination of God's engagement with the world and of the uncontainably abundant life of God *ad intra*. And just because of this, it is crucially important for the way the arts are practiced in the life and witness of the church, as well as for the way we engage in the enterprise of Christian theology. It is no accident that when the Hebrew prophet Isaiah pleads with the exiles in Babylon to believe that God is not bowed down by the disastrous blunders of Israel, not restricted or curbed by their past—in other words, that God is not containable by the order of sin and death—he relies not on literal statements but on startling, metaphor-saturated poetry:

> Then the eyes of the blind shall be opened,
> and the ears of the deaf shall be opened;
> then the lame shall leap like a deer,
> and the tongue of the speechless sing for joy.
> For waters shall break forth in the wilderness
> and streams in the desert;
> the burning sand shall become a pool
> and the thirsty ground springs of water;
> the haunt of jackals shall become a swamp;
> the grass shall become reeds and rushes. (Isa. 35:5–7)

And later:

> Do not remember the former things
> or consider the things of old.
> I am about to do a new thing;
> now it springs forth; do you not perceive it? (Isa. 43:18–19)

5. As will become clear, this is not to be taken as supporting the oft-repeated trope that the arts do their most important work when they are in the mode of intentional "critique"—directly protesting, subverting, and undermining this or that outlook. My concern is not chiefly with the way artists might or might not set out to be critical of reductionism but with the implicit resistance to reductionist drives that results from their characteristic ways of operating.

Even more telling:

> Thus says the LORD:
> Heaven is my throne,
> and the earth is my footstool;
> *so what kind of house could you build for me,*
> what sort of place for me to rest? (Isa. 66:1, italics added)

I suggest that what leads the prophet to poetry is, at least in part, a realization that this is the kind of language that seems natural when trying to convince his hearers of the sovereign uncontainability of the living God of Israel.

I realize, of course, that to propose that the arts can offer a positive resistance to a reductive sensibility and that this carries theological ramifications is hardly new. In the late eighteenth and early nineteenth centuries, to take one example, the arts became crucial for Romantic writers and artists who wanted to counter the closed, cause-and-effect cosmology they associated with the physical sciences. Faced with a vision of the world that seemed to drain the universe of its wonder (and humans of their souls), and a society that often appeared to believe it no longer needed any metaphysical underwriting, the arts—especially music, literature, poetry, and painting—were lauded as portals to an incomparably broader and potentially "religious" vision of reality. And since the Romantics, one could point to wave after wave of artistic energy invested in opposing an imagination of the universe that is presumed to go with a "modern scientific worldview." One might think of Dickens's portrayal of the Gradgrinds in *Hard Times*, or of writers and artists such as John Ruskin, Gerard Manley Hopkins, Wassily Kandinsky, Antony Gormley, Dorothea Tanning, and Marilynne Robinson. Much of this opposition has been directed, implicitly or explicitly, against the ontologies associated with reductionism—deism, for example, or "naturalism," or, in some cases, outright atheism.

Thus I claim no originality for this book's double thesis. However, as far as I can tell, what follows is marked by a number of distinctives. One of these is that I am attempting to bring together things that are often held apart. In particular, there are three streams of thought and writing that to my mind have rather more to learn from each other than is often realized. The first is a series of sophisticated intellectual critiques of reductionism that have appeared over the last thirty years or so (several in response to the so-called New Atheism), some of which have come from philosophers at work in metaphysics, epistemology,

the philosophy of science, the philosophy of mind, and some from professional scientists—especially physicists, biologists, and neuroscientists. I do not regard myself as an expert in these fields, but I do attempt to give an indication of the main lines of the relevant contemporary discussions.

The second stream has a much longer history: philosophers, social scientists, and artists who have explored in depth how different art forms exercise their distinctive capacities in practice, and what, if anything, marks out "the arts" as unique ways of coming to terms with our lives in the world. A prominent concern in recent years has been to demonstrate the cognitive potential of the arts—that is, how they can be the means not only of emotional expression and embellishment but of *understanding* the world more deeply.

The third stream, of course, is the theological. Here I have attempted to prioritize sources of wisdom that, for whatever reason, are often marginalized in the current theology-and-the-arts arena, as well as in theological treatments of reductionism. The most important of these are the Christian Scriptures. To point to the need for tradition-sensitive biblical exegesis for an exercise such as ours will seem woefully archaic and "conservative" to some readers. But it strikes me as somewhat odd to find many theologians amid the arts (I include myself) being relatively neglectful of the church's principal and normative texts—in all their boundless luminosity as well as their stubborn awkwardness. Likewise, in the many fine Christian engagements with reductionism now available, it is fairly hard to find extensive wrestling with scriptural texts and biblically oriented doctrine. (It is ironic in the extreme that in biblical scholarship, reductionism of one sort or another has often stifled the very writings that arguably could most effectively release the reader from its grip.) Hence the two biblical "interruptions" from John's Gospel (chaps. 3 and 5) and the inclusion of detailed biblical exegesis in the most theologically concentrated chapters (7 and 8).[6]

Another distinctive of this book concerns the attention paid to music. I find that in much that goes under the "theology and the arts" banner, or "theological aesthetics," music tends to get short shrift, especially compared to literature and the visual arts. I have given music particular prominence not only because of its relative neglect in some quarters, or because it happens to be the art with which I am most familiar, but more importantly because it stands as something of a

6. My frequent use of John's Gospel is simply due to the way in which the trinitarian character of the New Testament's witness is especially evident there. For reasons of space, I will have to assume that its testimony is congruent with that of other New Testament texts; justifying this would take us far beyond the scope of this project.

paradigm case for my argument. Of all the arts, I believe it is the most irreducible, the most difficult to turn into a variety of something else, the hardest to paraphrase—indeed the hardest to speak about. But it is just this that probably more than anything else makes it so instructive theologically.

Two additional comments are in order here. First, as far as the expression "the arts" is concerned, mercifully we do not have to enter in any detail the tortuous debates surrounding its meaning. For our purposes it is enough to say that I am presuming a fairly wide reading of the term, attending as far as possible to the broad way it is most commonly used in current discourse. I shall take "the arts" to embrace, at the very least, the practices of (and activities associated with) painting, drawing, photography, video art, sculpture, music, literary fiction, poetry, drama, film, dance, and architecture. And, as will soon be obvious, I am working with an understanding substantially wider than the eighteenth-century concept of "fine art," with its focus on "works" intended for absorbed attention. I shall be assuming the priority and centrality of artistic *practices*—art as a field of action, from which works of art may or may not arise.

Second, the cultural setting with which I am most concerned is typically named Western "modernity." The term can refer to a cluster of norms and mindsets bound up with a set of distinctive social and cultural practices, but it can also be used in a secondary sense to identify a chronological phase or period (often understood as beginning with the Renaissance) in which these norms and mindsets are believed to have come to the fore—"the modern era." I will deploy the term in both these senses depending on the context. This is not, however, to claim that the reductive drives we identify as characterizing modernity are absent in other cultural movements or other periods in history— but that is a matter for another volume.

Outline

Clearly, to get our discussion off the ground, we need at least a working understanding of the "thought style" of the reductive imagination. So I begin in chapter 1 by sketching the outlines of "naturalistic reductionism," a form of reductionism that aims to take its cue from the physical sciences. From this I distill four "pressures" or drives that I believe characterize this thought style: a drive toward *ontological singularity*, a drive toward *exclusionary simplicity*, a drive toward favoring *one very particular epistemic stance* toward the world together with *one ideal discourse*, and a drive toward *control and mastery*. All

exhibit an aspiration toward "containment" of some form or another. They can be found far beyond the kind of reductionism that purports to take its bearings from the natural sciences. Indeed, in chapter 2, I examine how they have found their way into discourses surrounding the arts. A scriptural interruption follows (chap. 3), exploring an especially potent passage from John's Gospel that throws into relief the acute dissonance between the way its author imagines the world and the kind of constricted universe into which reductionist drives lead us.

Returning to the main argument, in chapter 4 I begin to sound some critical notes by highlighting the peculiarities that begin to surface when the four reductive ambitions I have identified are followed through. In particular, I note a marked tendency to adopt positions that are self-undermining—not only paradoxes, impasses, or aporias, but beliefs that are incoherent and self-refuting. With this goes a pronounced narrowness of vision, a highly restricted view of what is considered worthy of attention and explanation. I show this with respect to both naturalistic reductionism and the reductionism applied to the arts that we identify in chapter 2. A second interruption from John's Gospel follows in chapter 5.

I turn in chapter 6 to explore dynamics of making and engaging art that embody a counter-reductionist energy, a momentum of uncontainability. We are presented with metaphorical combinations of the incongruous, such that the familiar becomes unfamiliar and the realities being engaged become charged with multiple waves of significance that can never be fully specified. We are pushed toward the multiply allusive, the uncapturable.

This, I argue, is highly congruent with the dynamic of outgoing expansiveness that belongs to the heart of the Christian faith. In chapter 7, I explore this with regard to the uncontainability of God by the created world—the divine "moreness" evident in the history of Israel and the person of Jesus Christ. Divine uncontainability is not to be thought of as bare metaphysical infinity but as the uncontainability of God's love-in-action. I follow this through in chapter 8 by showing how the uncontainability of God's creative and saving economy can be viewed as the outworking of the unboundedness of God's own life *in se*. While strenuously avoiding the implication that God is under some compulsion to create, sustain, and redeem, I nonetheless contend that God's triune life is characterized by a love that by its very nature moves beyond determinate containment, and never aspires to contain (possess) the beloved. This is the love of the Father for the Son in the Spirit, returned in the Son's love for the Father: a

love that in and through the Spirit gives life to the other in a self-dispossessing *kenōsis* that, paradoxically, entails no loss or diminishment.

In chapter 9, I stand back and attend to the deep and striking resonances between our artistic and theological findings, and in particular, the strong ethos of uncontainability and unboundedness that characterizes both. I go on to show that by virtue of these resonances, the resistance to reductionism that is so characteristic of the arts carries considerable reverberations for the church's artistic life, as well as for the work of Christian theology. In short, the arts hold enormous theological promise in a culture that so often seems prone to becoming trapped in diminishing and dehumanizing patterns of life.

Chapter 10, "Open Feast," concludes the book with a short meditation on Caravaggio's unsurpassable *Supper at Emmaus*. I read this painting in light of the counter-reductionist pressures explored in the book, but, just as importantly, I attempt to let the painting "read" us in fresh ways, so that the familiar sounds of uncontainable grace might become unfamiliar, abundantly more than we can ask or imagine (Eph. 3:20).

Pressures
of Containment

1

Reductive Pressures

I think that sometimes, out of the corner of an eye, "at the moment which is not of action or inaction," one can glimpse the true scientific vision; austere, tragic, alienated, and very beautiful. A world that isn't *for* anything; a world that is just there.

Jerry Fodor[1]

This novel coronavirus is not influenced by blogs and opinions. The infection rate, morbidity and mortality cannot be spun. The good news is that science and facts have saved us in the past, and can once more.

Paul Klotman and Mary Klotman[2]

And if . . . on this earth there is nothing except this earth?

Czesław Miłosz[3]

Reductionism in modernity has been described in many and sundry ways. Very often it is spoken of as a commitment to a particular procedure, a way of going about an inquiry into the nature of things. It can also be understood as a commitment to a belief about reality, about the

1. Fodor, *In Critical Condition*, 169, italics original.
2. Klotman and Klotman, "Opinion: Science, Facts and Collaboration Can Save Us."
3. From "Meaning," in Miłosz, *New and Collected Poems*, 560.

way things actually are, whether that reality be human or non-human, physical or metaphysical. Without denying that it can take these two forms, and often simultaneously—we will encounter both in due course—I want to suggest that at another level it can be approached as a "thought style" (to pick up a phrase of Rita Felski's[4]) characterized by distinctive drives or ambitions enmeshed in a complex of social and cultural forces. The purpose of this chapter is to throw these drives—or "pressures," as I shall also call them—into relief.

Two points about context are worth keeping in mind throughout. First, there can be little doubt that contemporary reductionism is most commonly and preeminently associated with the growth and development of the natural sciences over the last few centuries, especially the so-called hard sciences of physics, chemistry, and biology. While reductionist ambitions can certainly be found very widely, their characteristic features are arguably most evident when the primary cues are being taken from the natural sciences. Hence this is where the bulk of our attention will be focused in this chapter.[5] Second, when modern reductionism has sought to take its main bearings from science, it has generally been heavily dependent on a particular narration of science's success. The narrative is essentially one of progressive advancement, of science's ever-increasing reach, its ever-more-extensive explanatory power, and its resultant ability to slay the numerous outdated and misguided beliefs of bygone eras. It is the story of an epoch having dawned in which the world can at last be illuminated and mapped as it *really is*. As with virtually every other intellectual discipline, Christian theology has found it impossible to ignore this potent story, and theologians have reacted in a variety of ways, ranging from outright hostility to drastic and wholesale revisions of their core beliefs.[6]

4. Felski, *Limits of Critique*, 2.

5. I am not suggesting that the origination of modern reductionism can be wholly traced to this scientific context. It is arguable, for example, that the development of the mathematical sciences has had a major part to play. In any case, mapping a genealogy of reductionism would take us far beyond what is manageable here.

6. The comments of Dan Edelstein on the Newtonian "scientific revolution" are worth quoting:
> The key French contribution to the genealogy of the Enlightenment was not epistemological but rather narratological: it simply happened that it was in France that the ramifications of the Scientific Revolution were interpreted as having introduced a philosophical age, defined by a particular *esprit*, and as having a particular impact on society. Given that this interpretation was unrelated to any epistemological change, we ought to stop searching for some intellectual revolution that made, in Paul Hazard's unfortunately catchy image, the French go to sleep one night thinking like Bossuet and wake up the next day thinking like Voltaire. (Edelstein, *Enlightenment*, 28–29)

I am grateful to Christopher Oldfield for this reference.

Naturalistic Reductionism

As I said at the outset, reductionism has often been understood as a commit-ment to a procedure, to a method of inquiry and discovery. *Methodological reductionism* refers to the belief that the behavior of entities of a certain kind can usefully be studied, and at least to some extent explained, by breaking them into their constituent parts—or, as it is sometimes put, that "higher-level" phe-nomena (e.g., biological organisms) can be elucidated by examining phenomena at a "lower" level (e.g., chemical reactions). This procedure is widely accepted among natural scientists as—potentially at least—immensely fruitful.[7] Method-ological reductionism is generally regarded as metaphysically and theologically benign, and it is not a major concern of this book.

Much more controversial is the belief that this procedure is always the *best* way to explain the behavior of entities, and—more strongly—that it is the *only* legitimate mode of investigating *all* phenomena. This is when methodological reductionism morphs into some version of *ontological reductionism*, where be-liefs about the constitution of reality are drawn into the picture.[8] Ontological reductionism takes various forms, and the one we shall be concentrating on here is *naturalistic reductionism* (NR)[9]—a commitment that does rather obvi-ously present major obstacles to Christian belief.

7. Arthur Peacocke writes, "Even before the dramatic successes of 'molecular biology' in recent decades . . . the progress of the natural sciences could already be attributed, in part, to their analyti-cal propensity to break down unintelligible, complex wholes into experimentally and theoretically more manageable lower levels of organization of component units for the purposes of exploration" (Peacocke, "Reductionism," 312). Compare the following from Tim Crane: "Reductive explana-tion may not be appropriate to all kinds of phenomena; but since any genuine explanation is an advance in our understanding, no-one can sensibly object to the very idea of reductive explana-tion" (Crane, "Reduced to Clear").

8. A distinction is often made between ontological and methodological naturalism. The former makes claims about what *is*, about the nature of reality. It insists that there *are* no su-pernatural agents or forces and that all is explicable in terms of the laws of physics. The latter is committed to the belief that the cosmos, as accessible to empirical enquiry, is to be explained with recourse to empirically accessible phenomena alone. In methodological naturalism, reli-gious or theological commitments can and should be set to one side in the practice of science. The methodological naturalist may have such commitments, but they are to be deemed ir-relevant to his or her conduct qua scientist. See Harrison, introduction to Harrison and Rob-erts, *Science without God?*, 2–6; Cunningham, *Darwin's Pious Idea*, 265–66. For an especially perceptive treatment of methodological naturalism, arguing that it is an incoherent position for the *Christian* scientist to adopt, see Torrance, "Should a Christian Adopt Methodological Naturalism?"

9. I intend this to be synonymous with Lynne Rudder Baker's "reductive naturalism." Baker, *Naturalism and the First-Person Perspective*, 6–10. For representatives of NR, see Rosenberg, *Re-duction and Mechanism*; Dennett, *Consciousness Explained*; Churchland, *Neurophilosophy at Work*.

We can focus on the naturalistic element of NR first. Naturalism has a history much more complex than is often thought,[10] and today the term can cover a diversity of opinions. (Indeed, it is probably better to think of it as a stance or mood than as a theory—or perhaps as a research program, a way of posing questions.)[11] But in contemporary usage, it is widely understood to involve at least two main elements. First, there is a rejection of any nonphysical entity or property, including, of course, God. (Hence the typically modern contrast between naturalism and supernaturalism.)[12] The complete stock of reality is said to be entirely exhausted by the entities and properties described by the natural sciences, especially physics. Second, naturalism is marked by a staunch confidence in the methods of these sciences—again, physics above all—as providing secure and reliable knowledge of reality.[13] This is of a piece with the notion of "leaving behind" that is so basic to the story of the advancement of science that many moderns have internalized: "We used to believe in the existence of ether, souls, spirits, demons, and God, but in the light of science we now know that such things have no reality outside our own thought and speech."

On this reading, the history of science, naturalism, and human progress all belong together. A crude but relatively widespread iteration of the story runs thus: naturalism appeared first with the ancient Greeks, was revived in the Middle Ages, and surged into prominence with the dazzling success of the natural sciences in the seventeenth century, leading in time to the wholesale elimination of the supernatural as an unnecessary and thoroughly misleading encumbrance.[14]

10. See the penetrating essays in Harrison and Roberts, *Science without God?*
11. Oldfield, "Who's Afraid of Naturalism?"
12. Goetz and Taliaferro, *Naturalism*, chap. 4. The natural-supernatural distinction is in fact far more polyvalent historically than is often realized. See the lucid discussion in Harrison, introduction to Harrison and Roberts, *Science without God?*, 6–10.
13. Of this second feature, Alvin Plantinga observes, "Naturalists pledge allegiance to science; they nail their banner to the mast of science; they wrap themselves in the mantle of science like a politician in the flag" (Plantinga, *Where the Conflict Really Lies*, 307).
14. This narrative is drastically flawed. For extensive discussion, see Harrison and Roberts, *Science without God?* Various terms have been interwoven with naturalism, and often confusingly. One of the most common is *materialism*—broadly, the view that there is only one "material" (i.e., matter). Daniel Dennett proclaims, "The prevailing wisdom, variously expressed and argued for, is *materialism*: there is only one sort of stuff, namely *matter*—the physical stuff of physics, chemistry, and physiology—and the mind is somehow nothing but a physical phenomenon. In short, the mind is the brain. According to materialists, we can (in principle!) account for every mental phenomenon using the same physical principles, laws and raw materials that suffice to explain radioactivity" (Dennett, *Consciousness Explained*, 33, italics original). The term *physicalism* has a complex history, but today is commonly taken to refer to the belief that the entities postulated

As far as the reductionist element of NR is concerned, it is held that all complex wholes and properties can be entirely reduced to—explained by—their constituent parts and the properties these parts bear. This usually means going all the way down to the lowest, microphysical level, as studied by physics. There is no "extra" reality needing explanation over and above these microphysical components and their properties.[15]

Emergence?

The question naturally arises: Does an account of, say, a camel, in terms of its constituent atoms alone, actually tell us all there is to know and all we might want to say about a camel? Surely not. A biological description of a camel will concentrate on things like the flow of blood through its veins, its breathing, the movement of its limbs, and so forth. A biologist will want to say that a camel has properties we do not ascribe to its molecules and atoms. And there are many other ways we might want to speak of a camel. We could point to its shape and appearance, or perhaps to the mood of a particularly tetchy camel we once rode on a trip to Egypt. We could say similar things of any complex whole: there seem to be properties that do not apply to the parts. A self-portrait by Rembrandt is more to us than brush marks on a canvas. We might speak of it as somber, displaying depth or beauty; these are things we would not say of the brush marks themselves. In the case of the written words you are now reading, they may be made up of millions of atoms of ink on the page, but that is irrelevant to your discerning the meaning of this sentence. I would not report the new dent in my car to the insurance adjuster by describing atomic particles; she will want to know what the dent looks like—how deep and wide it is.

With this in mind, many opponents of reductionism have come to employ the term *emergence*.[16] William Hasker explains it thus: "When elements of a certain sort are arranged in the right way, something new comes into being, something that was not there before. The new thing is not just a rearrangement

by physics are the only entities there are. Although *physicalism* is still often used interchangeably with *materialism*, many prefer the former term, given that physics has made it clear that what we call "matter" is nothing like as solid as we might have supposed.

15. Sometimes this reduction is taken to apply to theories, and sometimes to what David Chalmers describes as "facts"; but what is generally common to all forms of NR is the drive toward the microphysical level as engaged by physics (Baker, *Naturalism and the First-Person Perspective*, 7).

16. For discussion, see O'Connor and Wong, "Emergent Properties"; Pigliucci, "Between Holism and Reductionism," 261–67; Corradini and O'Connor, *Emergence in Science and Philosophy*; Crane, "Significance of Emergence."

of what was there before, but neither is it something dropped into the situation from the outside. It 'emerges,' comes into being, through the operation of the constituent elements, yet the new thing is something different and surprising; we would not have expected it before it appears."[17] So understood, two main types of emergence are often distinguished: weak and strong. The weak version, sometimes called *epistemological emergence*, holds that the emergent property of an object or system is new only at the level of knowledge or description. The point is that it is very hard to explain, predict, or describe an emergent property using only observations of its constituent parts. The wetness of water, for example, is difficult to explain, predict, or describe by inspecting the chemical structure of H_2O.

Strong emergence—the type we will assume in using the term from here on—is the claim that emergent properties are manifest in the behavior of the world itself. There are emergent properties of complex wholes that "cannot be reduced to any of the intrinsic causal capacities of their component parts, nor to any of the reducible relations between the parts, nor can the 'higher level' emergent properties be deducible, even in principle, from a mere inspection of their parts."[18] A commonly cited example of such an emergent property is consciousness. In the evolution of hominids, it is said, "Once the physical stuff of the brain and nervous system achieves the right state of functional complexity, new phenomena are produced, namely the phenomena of conscious awareness."[19]

Strong emergence entails that the higher-level properties of a system depend on the lower-level properties while remaining distinct from them. Thus many emergentists will claim that the properties of mind (such as intentionality, or "aboutness") depend on the properties of neurons but are nonetheless distinct from, and irreducible to, those properties. When I decide to buy a rowing machine, there is no way in which "deciding to buy a rowing machine" could be deduced by someone observing my neural networks. Moreover, for the emergentist, the emergent properties of complex systems can come to possess causal powers that are distinct from the causal powers of the properties of the systems' constituent parts: "Given the right configuration and functioning of the underlying elements, new forms of causality arise . . . that did not operate until the elements were in the correct configuration. Furthermore, the operation of

17. Hasker, "Emergence of Persons" 481.
18. Alexander, *Genes, Determinism and God*, 261.
19. Hasker, "Emergence of Persons," 482.

these powers cannot be inferred from the laws that govern the functioning of the elements apart from the special configuration in question."[20] On this account, conscious awareness—as a property of the brain, or some part of the brain, or the animal as a whole—is not reducible to the powers of its constituent elements but is considered to be causally efficacious in itself.

How do naturalistic reductionists respond to such claims? They are quite content to admit that this is how we typically speak. But they won't leave things there, for they claim that so-called emergent properties are entirely reducible to the properties of the parts of which the entities in question are composed, and that particular instantiations of a property in a concrete object are likewise reducible. Complex properties do not transcend, or operate over and above, the properties of their parts. They appear to be new only because of the limits of our language and cognitive faculties. In reality, an entity's lower-level properties wholly determine its higher-level properties, and its higher-level properties depend wholly on its lower-level properties. So, some will claim, what we call "mind" or "mentality" should not be regarded as some sort of substance complete with causal agency.[21] What we might deem to have causal power at a complex level are in fact the "epiphenomena" of a ground-level physical substrate, effects of the causative capacity of what is happening at the elementary particle level—the level studied by particle physics. Causation thus works from the bottom up, not from above to below.[22]

For daily practical purposes we will hardly ever apply a reductive method all the way down to the level of subatomic particles. It would be bizarre for engineers in a hangar to describe an Airbus A380 in terms of quarks. They will be expected to talk about cables, fuel tanks, turbines, hydraulic systems, and the like. But a naturalistic reductionist insists that in principle, should we ever want to, we could account for an aircraft and all its properties exhaustively in terms of such particles, and this would actually be the most accurate and truthful explanation of it we could ever provide. It is particles not only "all the way down" but "all the way up" too.

20. Hasker, "Emergence of Persons," 481–82.
21. So, for example, John Bickle calls for a reduction of psychological phenomena (including memory and attention) to the categories of molecular neuroscience (Bickle, *Philosophy and Neuroscience*). See also Churchland, *Neurophilosophy at Work*.
22. This is sometimes called *causal reductionism*. Another term employed in this context is *supervenience*. A poem entirely supervenes on the printed page; a dance entirely supervenes on the movement of the dancer's limbs; the property of solidity entirely supervenes on the constituent atoms of a block of wood.

We should note that most reductionists are prepared to ascribe a degree of concrete actuality to the phenomena being reduced. But some will want to intensify the reductive pressure and take things much further. For them, there is little point in speaking of a table as nothing more than an aggregate of particles; it is more accurate, ontologically speaking, to say that no single object is a table—that, in this sense, the object we call a table does not exist. According to this position, known as *eliminativism*, all that *really* exists are microphysical particles.

Further, in some versions of this position, it is urged that purported entities that cannot be shown to consist of microphysical parts ought not even to be spoken about.[23] Eliminativists will remind us that, for example, we no longer speak of demon possession but of psychiatric illness. Demons simply do not exist, and we should cease using language in ways that imply they do, as if they had causal agency. Indeed, it is probably best to stop employing the language of the demonic altogether. From this perspective some philosophers—admittedly very few—have elaborated fairly sophisticated theories to support eliminativist theories of consciousness, probably the best-known being espoused by the philosopher Daniel Dennett.[24] Proponents of such positions are fully aware that most of us speak of having a mind and of entertaining beliefs and desires, and they will normally concede that doing so can be pragmatically useful. But they insist that such talk must not be confused with philosophically accurate and strictly truthful description.

Mechanical and Impersonal

Various features of the physical world as NR conceives it (whether eliminativist or not) are worth highlighting here. In modernity, the metaphor most commonly employed to imagine the world and its processes along these lines has been that of a *machine*.[25] The image has a long history, but it emerged into particular prominence in early modernity, being commonly associated with Newtonian physics, and in due course with the Industrial Revolution.[26] Whether it is applied to the world as a whole, the human body, or the brain, the model

23. See Irvine and Sprevak, "Eliminativism about Consciousness."
24. Dennett, *Consciousness Explained*. For a recent version of the argument, see Frankish, *Illusionism*.
25. Glebkin, "Socio-cultural History of the Machine Metaphor." For an exceptionally clear account of the metaphor as applied to living things, see Vaage, "Living Machines."
26. See Dijksterhuis, *Mechanization of the World Picture*; Goatly, *Washing the Brain*.

of a mechanical system bound together by Newtonian laws of cause and effect is one of the modern age's most characteristic and potent visions, even if it has been significantly moderated by relativist and post-relativist physics. It crops up in many popular presentations of science and is especially pervasive in the context of synthetic biology (the creation of new components, devices, and systems from those found in nature—as in, say, genetic engineering).[27] René Descartes (1596–1650) famously imagined the human body (and all living organisms) in mechanical terms and the mind as a nonmaterial, thinking substance (*res cogitans*) indwelling the body and causally acting upon it.[28] Contemporary naturalists, dismissive of the idea of an immaterial substance, and having long since abandoned any notion of vitalism (belief in an independent, nonmaterial life force that supposedly distinguishes living from nonliving creatures), see no reason why *res cogitans* cannot be folded into *res extensa* (extended substance), why the mechanistic metaphor cannot be applied to the mind along with everything else.[29]

It is important to note here that the machine metaphor, when comprehensively applied, will readily encourage a drive to reduce all causality to efficient causes. In Aristotle's scheme, the *efficient cause* is that which brings something about—the carpenter who makes a table, for instance.[30] Aristotle also delineates three further kinds of causation. The *material cause* is *that out of which* something comes to be (the wood of a table), the *formal cause* is *that which* comes to be (the form of the table), and the *final cause* is *that for the sake of which* it comes to be (the purpose or end of the table). If the machine metaphor is allowed to dominate, then these latter three will tend to be bracketed out. Physical things knock into other physical things, bringing about changes in the state of those other things through efficient causation. We might think of one pool ball colliding with another. What are decisively ruled out are final causes, and thus purposive agency.

In this outlook, efficient causes are understood in wholly physical terms (there are no nonphysical causes, for the physical world is no more than matter in motion), and they comprehensively explain all that happens in the world.

27. Vaage, "Living Machines," 60–62.
28. Descartes, *Meditations on First Philosophy*, esp. 72–90. See also Steven Pinker: "We have understood the body as a wonderfully complex machine, an assembly of struts, ties, springs, pulleys, levers, joints, hinges, sockets, tanks, pipes, valves, sheaths, pumps, exchangers, and filters" (Pinker, *How the Mind Works*, 22).
29. See Boden, *Mind as Machine*.
30. Aristotle, *Physics* 2.3 and *Metaphysics* 5.2.

Everything that occurs is to be accounted for entirely in terms of its relation to a series of events that preceded it in a tight causal chain. Of course we might want to say that the pool ball moved only because it was struck by a player using a cue—clearly, a purposive act—but the reductionist replies that the player's decision is itself wholly explicable in terms of efficient causality: brain events, muscular contractions, and so forth. If there are no purposive agents in the world, then intra-worldly final causes are ruled out of order. Nor can we speak of an extra-worldly final cause—a purpose for the world as a whole—for that would be to invoke an extra-worldly agency, such as God. Of course, there are those who have employed the machine metaphor theologically, speaking of God as Maker of the world-machine, but the consistent naturalistic reductionist will dismiss the possibility of any such notion.

From all this it should be clear that NR presses one toward believing that the world of which we are part is impersonal through and through. If the key concepts and properties we associate with being a person—free will, mind, beliefs, and so forth—are held to be explicable entirely in terms of the categories we use to describe material realities as studied by physics, this would appear to be the only acceptable conclusion. First-person language—"I believe this," "I feel this"—has no place in the deliverances of the scientist. Authentic science acknowledges the reality only of objects and properties amenable to third-person physical analysis. First-person reports must be replaced by third-person designation. There are no first-person facts. So, on this account, if first-person experiences (such as consciousness of oneself *as* a self) are to be taken at all seriously, there must be some way of showing that they are reducible to physical entities and their properties and that third-person descriptions are capable, at least in principle, of fully accounting for them.[31]

Hierarchy and Reality

If the naturalistic reductionist's world leans heavily toward the mechanical, it also tends to be strongly hierarchical. It is no accident that we have already used the language of "higher-level" and "lower-level." Many supporters of NR hold

31. Dennett insists, "You've got to leave the first person out of your final theory. You won't have a theory of consciousness if you still have the first person in there, because that is what it was your job to explain" (quoted in Blackmore, *Conversations on Consciousness*, 87). See also Fred Dretske: "Subjectivity becomes part of the objective order. For materialists, this is how it should be" (Dretske, *Naturalizing the Mind*, 65). For the philosopher Jan Westerhoff, "Our self is comparable to an illusion—but without anybody there that experiences the illusion" (Westerhoff, "What Are You?," 37).

to a stratified ontology, a view of the physical world as multilevel, comprising a hierarchy of increasing complexity: "a series of levels of organization of matter in which each successive member of the series is a 'whole' constituted of 'parts' preceding it in the series."[32] We can imagine an ascending scale from a quark to a molecule, to a cell, to a multicellular organism, to a conscious being, to a self-conscious being, and so on up the scale.

As we have noted, for the strict naturalistic reductionist, the movement between these levels is strictly one-way: the higher levels are fully determined by and dependent on the lower. Entities at one level can be de-composed into the entities at the next level down, and so on. All the properties of an upper-level entity are present all the way down; all the functions of higher levels are realized in lower levels; all the laws pertaining to one level are wholly reducible to laws at the next level down, and so on. Explanation is strenuously oriented to the lowest level. And the same goes for causation, simply because there *are* no causal entities or properties at upper levels.

An obvious corollary of all this—one we have noted already—is that the further down we go, the lower on the hierarchy, the closer we get to the authentically *real*.[33] Tellingly, in March 2015, the front page of *New Scientist* carried the subheading "Forget the Higgs, Now we're searching for the root of reality."[34] "The underlying assumption of [the] reductionist programme," writes Michael Fuller, "is that *reality* is to be discovered by probing 'downwards' into things, by discovering, analysing, and understanding their constituent parts, and then by similarly analysing the parts themselves."[35] The gleeful pronouncement of Nobel Prize–winning biologist Sir Francis Crick has become an almost iconic encapsulation of this outlook: "'You,' your joys and your sorrows, your memories and your ambitions, your sense of personal identity and free will, are in fact no more than the behaviour of a vast assembly of nerve cells and their

32. Peacocke, "Reductionism," 318.
33. Whether (a) the belief that all wholes are no more than aggregates of particles, and (b) the belief that the whole does not exist (eliminativism) are really divergent positions is moot. Speaking of naturalistic reductionism, Lynne Rudder Baker observes, "What seems to be a difference in reality between aggregates of particles and people is only a difference in description. All that really exist, all that deserve a place in a complete description of reality, are microphysical particles and their properties. Such particles and microproperties exhaust the ontology" (Baker, *Naturalism and the First-Person Perspective*, 10).
34. *New Scientist* 225, no. 3011 (2015), front page. The reference is to the so-called Higgs boson.
35. Fuller, "Antireductionism and Theology," 433, italics added. Or, as Patrick McGivern and Alexander Rueger put it, "Moving up in the ordering does not add any ingredients to the world: all entities are already contained in the bottom layer, the level described by the most basic theories in physics" (McGivern and Rueger, "Hierarchies and Levels of Reality," 381).

associated molecules. . . . The scientific belief is that our mind—the behaviour of our brains—can be explained by the interactions of nerve cells (and other cells) and the molecules associated with them."[36]

Pressed to its extremes, then, NR will lead to conclusions that will naturally alarm those who have always believed in supposedly irreducible entities like "me"—and in properties of "me," such as joy, sorrow, and self-consciousness. As Alex Rosenberg puts it, there may have been a day when we were haunted by the "Big Questions"—about meaning, purpose, value, love, and so forth—but now "they all have simple answers, ones we can pretty well read off from science."[37] And for an eliminativist, we recall, not only can we explain these upper-level phenomena; we can now explain them *away*, in the manner we might explain away unicorns or the fairies at the bottom of the garden.

As we might expect, corresponding to a hierarchical vision of physical reality is a hierarchy of disciplines. This is in fact a relatively recent notion, but it has captured the imagination of a number of philosophers and scientists.[38] In a highly stripped-down form, one version might look like this:

humanities

social sciences (e.g., anthropology, sociology, social psychology)

ecology

biology (cellular and molecular)

chemistry

physics

According to most renderings of NR, theories developed in an "upper" science are seen as particular cases of the theories of the lowest level (physics), and nothing more. Implied in this—although by no means always spelled out explicitly—is that the ideal science, the über-science, is physics.[39] Naturalistic reductionism holds that, as Lynne Rudder Baker puts it, "there is only one ontological level, the level of physics, and that biology, sociology, and psychology have scientific legitimacy only if they are reducible to physics."[40] To be

36. Crick, *Astonishing Hypothesis*, 3, 7.

37. Rosenberg, "Disenchanted Naturalist's Guide to Reality."

38. For its best-known early formulation, see Oppenheim and Putnam, "Unity of Science."

39. As Massimo Pigliucci explains, this was indeed the hope of many at the onset of the twentieth century: "Chemistry had already for all effective purposes been reduced to physics . . . , and hopes were high that biology would soon follow suit" (Pigliucci, "Between Holism and Reductionism," 261).

40. Baker, *Naturalism and the First-Person Perspective*, 6.

sure, in practice reductionists will often treat physics, chemistry, and biology together as the base-level disciplines, and few biologists, for example, will press all their explanations down to the microphysical level.[41] But it is hard to see how any other discipline could ever attain the prestige that (particle) physics can command. Lewis Wolpert asks plaintively, "In a sense all science aspires to be like physics. . . . What hope is there for sociology acquiring a physics-like lustre?"[42] Connor Cunningham understandably describes this kind of physics-dazzled reductionism as "microphysical fundamentalism," summarizing it thus:

1. The hierarchy thesis: The universe is stratified into levels.

2. The fundamentality thesis: There is a bottom level, which is fundamental.

3. The primacy thesis: Entities on the fundamental level are primarily real and the rest are at best derivative, if they are real at all.[43]

Qualifications

I have attempted to sketch the basic lineaments and entailments of NR, as articulated in its philosophically elaborated accounts. However, some important qualifications are needed to avoid potential misunderstandings. First, within the naturalist fold a variety of philosophical views can be found, by no means all of which are reductive.[44] Naturalism can take on a much gentler and more generous character than the extreme examples cited above. By no means all naturalists are committed to the explanatory reduction of composite wholes to constituent particles. Stewart Goetz and Charles Taliaferro use the phrase "broad naturalism" to refer to more expansive outlooks in which we find, for example, a willingness to allow disciplines such as history, psychology, and sociology a place in accounting for the character of the physical world while nonetheless maintaining that all concrete objects are ultimately constituted by, or composed of, microphysical particles.[45]

41. As John Polkinghorne points out, "People of a strongly reductionist tendency, such as Francis Crick . . . and Richard Dawkins . . . , do not go below the level of their own discipline for explanatory purposes, but are content to frame their accounts in terms of molecules or genes, without pressing on to the quark level" (Polkinghorne, "Reductionism").

42. Wolpert, *Unnatural Nature of Science*, 121.

43. Cunningham, "Who's Afraid of Reductionism's Wolf?," 55.

44. Baker is exceptionally clear on this; see *Naturalism and the First-Person Perspective*, 10–17.

45. See Goetz and Taliaferro, *Naturalism*. Lynne Rudder Baker speaks of "optimistic" naturalists who resist the dehumanization of reality to which reductionism appears to lead us and who seek

Second, very few reputable natural scientists are supporters of NR as we are defining it. The majority would not subscribe to the kind of imperialism that holds that the procedures or findings of responsible science necessitate commitment to the all-embracing, universal applicability of NR's reductive method. And if pushed, many—probably most—would admit that naturalism is not presupposed by, or the result of, responsible scientific research. Naturalistic reductionism is probably best thought of as the consequence of an "imaginative overreach"; insofar as it has an ontology, it is one born of an excessive confidence in the explanatory power of some of the findings and characteristic procedures of modern science and an adherence to a highly questionable narration of the development of science in modernity.[46] In other words, more than from scientific activity itself, NR arises from a distinctive *imagination* of science—a particular vision of its supposed methods and capacities, linked to a very specific narrative and a cluster of symbols, images, and metaphors. And, I might add, if such a vision is to be challenged, as I believe it should be, the challenge will need to involve an appeal not merely to data or theory but to a *counter-imagination* of some sort. This, I will argue later, is where the arts can play a vital role, especially when they are attuned to a disciplined theological imagination.

Third, the belief that the scope of what is to be considered real is to be strictly limited to what can be described and explained by an ideal natural science (physics) is by no means as widespread among scientists or in society at large as is often thought. A huge set of contested issues arises here concerning the public perception of science, but suffice it to say that a large body of cultural commentary suggests the late-modern or postmodern condition is marked by a much more fluid sensibility (some speak of a "postsecular turn") in which cracks in the science-fixated ontology associated with outlooks such as NR are becoming ever more evident across a wide variety of activities and fields of study.[47] According to one stream of interpretation, although our culture may intellectually subscribe to naturalism, at the level of practical, collective imagination, "a manufactured hyper-real world of wishful fantasy is now a mundane part

to do justice to humanity's concern with the "big questions" and the values we hold dear (Baker, *Naturalism and the First-Person Perspective*, chap. 1).

46. "The main influence of science on modern man has not been, as is so often supposed, through the advancement of technology; it has come, rather, through the imaginative effects of science on our world view" (Polanyi and Prosch, *Meaning*, 104).

47. See, e.g., Hodkinson and Horstkotte, "Introducing the Postsecular"; Gorski et al., *Postsecular in Question*. The term *postsecular* implies, of course, the existence of a previous, widespread, and relatively uniform "secularity" of some sort—a matter that is itself contentious.

of the way we communicate, relax, and do business." Alongside the expanding sciences, "we like to watch movies, play computer games, and read books about enchanted worlds, gods, magical powers, and superhuman beings."[48]

Of course, the hard-core naturalist insists that the "magic" of fantasy literature and entertainment technologies is merely therapeutic, the product of the purely "inner" world of the constructive imagination, enabling us to cope with a world "out there" that science has shown to be barren of any meaning other than the meaning we give it.[49] Unlike in former eras, we no longer experience the natural world itself as alive with mystery and rumors of transcendence. Nevertheless, many still contend that the kind of heady hopes once invested in the natural sciences have waned considerably. Some philosophers argue that the very hope of a "grand unified theory" based on empirical science is inevitably incoherent because it assumes that the scientist is standing in a position outside the finite world, the very world that science wants to live wholly inside. In the Western academy there are signs that the exaltation of the "scientific method" as the ultimate measure of all truth-seeking inquiry is far less common than it used to be.[50] The reason why the works of fantasy writers like C. S. Lewis, J. R. R. Tolkien, and J. K. Rowling sell millions of copies, it is said, is that we *need* such myths, not merely to feed our "inner" lives but to engage the giant questions that are bound to arise about realities beyond our private worlds—questions of meaning, purpose, the coherence of the universe, and so forth.

All of this raises the obvious question: If the outlook of NR is less dominant than is often thought, why have we trawled through the material above? For three reasons. First, even though NR may be held by relatively few scientists, there is plenty to suggest that among nonscientists, as a hard-headed view of the physical world and an elevation of (a certain kind of) science as the supreme truth-deliverer, it is far from being marginal or obsolete.[51] Moreover, as I shall note in the next chapter, it has not been without influence in the world of the arts. Second, it is difficult to deny that NR articulates convictions that have played a sizable role in shaping modernity—socially, culturally, philosophically, and (not least) theologically—and it is with the possibilities of the arts in

48. Tyson, *Seven Brief Lessons on Magic*, 2, 2–3.

49. In other words, "enchantment" has moved out of the sphere of factual reality and into the sphere of the fabricating self (Tyson, *Seven Brief Lessons on Magic*, 29–41).

50. On postsecularity in the US academic world, see Jacobsen and Jacobsen, *American University in a Postsecular Age*; Schmalzbauer and Mahoney, *Resilience of Religion*; Marsden, *Soul of the American University Revisited*, esp. 365–89.

51. See Williams and Robinson, *Scientism*.

modernity (or at least in late modernity) that we are concerned here. Third, and most importantly, we have attended to NR insofar as it brings to the surface a "thought style" with characteristic pressures or drives that are arguably still very much alive, not only in the natural sciences but in many other fields—including, as we shall see, in discourses surrounding the arts. To be clear, the primary concern of this book is not with NR but with the kind of reductive pressures that animate it.

Reductionist Pressures

I want now to try to identify some of these pressures, with a view to seeing in the next chapter how they have found their way into artistic discourses. I want to single out four pressures, or drives, in particular, each of which can usefully be seen as being dominated by the logic of *containment*. They apply both to what the world is envisaged to be and to our engagement with it.

First, there is a pressure toward *ontological singularity*: an aspiration to identify one class of existing entities that can be considered fully and authentically real, to restrict reality to one bona fide type under which all ontological types can be subsumed. Further, if the "real" here is understood as being limited to what is amenable to the methods of the natural sciences (as with NR), the world is very likely to be seen as a self-contained system that needs nothing beyond it to explain its existence. Closely related to this sense of ontological singularity is another: singularity in the sense of undifferentiated oneness. There is a tendency, at least among some reductionists, to presume that "irreducible" implies "wholly undifferentiated."[52]

In the case of NR, the favored ontological type is, of course, the microphysical particle, and causation operates at this level alone. The exclusion of extra-worldly realities (such as God) is also integral to NR's vision; the world is a closed, self-explanatory system.

Second (and this is the negative side of the first pressure), there is a drive toward an *exclusionary simplicity* that contains and limits the scope of what needs accounting for. Hence the eagerness for simple explanations and the keenness to "tune out" what does not readily comport with a preestablished worldview.

52. Some have noted in both NR and in some emergentists a "widespread distinction [made] between 'basic' and 'emergent' features, instituted on the ground that emergent features are essentially *relational* whereas basic properties are *monadic*" (Bitbol, "Ontology, Matter and Emergence," 302, italics original).

In this connection, what is sometimes known as "Ockham's razor" (or the principle of parsimony) may well come to mind. The belief that the simplest account of a set of data has a higher probability of being true than a complex one has a long and distinguished pedigree, but it is especially associated with the figure of William of Ockham (1285–1347) and is traditionally expressed in the maxim *entia non sunt multiplicanda praeter necessitatem* (entities should not be multiplied beyond necessity). On the face of it, this seems sensible enough—indeed, fairly obvious. Why assume the existence of this or that entity when there seems to be no good reason to do so? As philosophers Paul Vincent Spade and Claude Panaccio note, "It is a sentiment that virtually *all* philosophers, medieval or otherwise, would accept; no one wants a needlessly bloated ontology." However, they continue: "The question, of course, is which entities are needed and which are not."[53] In other words, the effectiveness of this principle depends entirely on what one is willing to accept as an irreducible entity, on what it is that governs the "necessity" believed to constrain plurality.[54]

This is why I have used the word *exclusionary*. Modern or late-modern reductionism is characterized as much by what it disregards or denies as by what it acknowledges and affirms—sometimes more so. This is crucial to bear in mind in the chapters that follow: there is a manifest zeal to bracket out, peel away, and if necessary entirely dismiss phenomena and postulates that cannot be quickly accommodated in a premade ontological and epistemological frame.

This was well captured by James Baldwin in a famous radio interview from 1961 about what it means to be Black in America. His comments there on "Negro rage" are often quoted, but perhaps less well known is an observation that went with them: "It's a great temptation to simplify the issues under the illusion that if you simplify them enough, people will recognize them. I think this illusion is very dangerous because, in fact, it isn't the way it works. A complex thing can't

53. Spade and Panaccio, "William of Ockham," italics original.
54. Speaking of how easily the term *rationality* is replaced by *simplicity*, Michael Polanyi observes, "The term 'simplicity' functions . . . as a disguise for another meaning than its own. It is used for smuggling an essential quality into our appreciation of a scientific theory, which a mistaken conception of objectivity forbids us openly to acknowledge" (Polanyi, *Personal Knowledge*, 16). The sociologist Andrew Sayer astutely comments, "The ideal of parsimony is problematic where it is taken to trump the criterion of explanatory adequacy, so that inferior explanations are preferred on the grounds that they are simple and elegant, even though they fail to resolve problems explained by more complex accounts. Its only defensible use in substantive sciences is as a tie-breaker where two different substantive theories appear to have equal explanatory adequacy" (Sayer, "Reductionism in Social Science," 7).

be made simple. You simply have to try to deal with it in all its complexity and hope to get that complexity across."[55]

A current of impatience thus often runs through reductionism.[56] Indeed, we might think of reductionism as "simplicity in a hurry." In the case of NR, a haste toward exclusion means that numerous entities once thought to be substantially real, along with descriptions, explanations, and theories once considered cogent and valid, may need to be declared redundant. NR is thus inevitably intolerant of talk regarding extra-worldly realities such as God, and even of traditional accounts of phenomena such as mind, consciousness, will, and purposive agency.

Accordingly, third, there is a reductive pressure to *permit only one, very narrow epistemic stance toward the world*, typically characterized by disengagement, and to insist that reality can be articulated truthfully *only in terms of one very particular type of discourse.*

In the case of NR, this pressure commonly manifests as a passion to attain an "objective" perspective—the kind of dispassionate, context-free stance thought to be essential to the progress of physical science—and to exclude first-person experience and self-awareness when attempting to bring to light true states of affairs. The paradigmatic discourse regarded as legitimate in bringing reality to truthful articulation will be third-person, clear, logically coherent, and, as far as possible, singular in meaning. The gold standard will be the literal, declarative assertion in subject-predicate form. The multiple connotations of terms will be suppressed and nonliteral language eliminated as far as possible (especially tropes such as metaphors, whose semantic content exceeds their propositional content).

Fourth, with all three of these pressures we can discern what would appear to be a deeper drive—one widely discussed in relation to NR—namely, the pressure toward *control and mastery.*[57] It is probably this above all that gives reductionism its ethos of containment, and for that reason it is worth briefly pausing to explore it further.

55. "To Be in a Rage, Almost All the Time," 1A, NPR.

56. Undoubtedly, an important part of the background to reductionism's growth over the last seventy years or so is the perceived need for an account of the unity of the sciences in an era of increasing specialization. Reductive, or reductively inclined, strategies will prove highly attractive in this context. Andreas Hüttemann and Alan Love write of the way logical empiricists have seen reductionism as contributing to scientific progress: science's unity can be "underwritten by the progressive reduction of one theory to another (i.e., a form of reductionism). Successful reductions contribute to the goal of unification" (Hüttemann and Love, "Reduction," 462).

57. W. V. Quine (1908–2000) might be seen as paradigmatic in this respect. For an overview, see Hylton and Kemp, "Willard Van Orman Quine."

One of the most astute treatments of this drive in recent years—and before COVID-19 arrived to subvert many of our fantasies about being in control—can be found in the work of German sociologist Hartmut Rosa.[58] Drawing on an astonishing range of disciplines, Rosa is well known for explicating and critiquing some of the leading sociocultural currents of modernity, in particular "modernity's incessant desire to make the world engineerable, predictable, available, accessible, disposable."[59] Accordingly, the world is seen as a "point of aggression"—that is, "as a series of objects that we have to know, attain, conquer, master, exploit."[60] Rosa identifies four dimensions of this urge for control, all embedded in our institutional life: making the world more visible, more reachable or accessible, more manageable, and more useful. These result from complex social formations, involving a commitment to constant economic growth, technological acceleration, and cultural innovation, which together hold at bay the "threat" that the world presents to us. These are driven not so much by a lust for more as by a fear of scarcity, which we respond to by ceaselessly expanding our reach over things: "*Always act in such a way that your share of the world is increased.*"[61] In Rosa's eyes, modernity typically confuses reachability with controllability: having accessed something, we strive to master it.[62] Ironically, the result is that the world becomes ever more *un*controllable: it becomes mute, unreadable, hostile; it loses its *resonance* (a key term for Rosa)—seen dramatically in rampant ecological destruction. "Modernity has thus lost its ability to be *called*, to be *reached*."[63]

We shall have more to say about these terms—especially Rosa's understanding of resonance—at a later stage. For now, it is worth considering how reductionism is illuminated by this explanation of modernity's passion for control. Surely one of the main attractions of NR is that it offers to put us in a position from which we can *manage* material reality. Naturalistic reductionists are very much "in the know"; they can survey the landscape of the authentically real and see things as they truly are. And this in turn—at least in principle—opens up immense possibilities for exercising power over both nonhuman and human worlds. If we do indeed know what the physical world genuinely is and how its elements and processes actually work, then (depending on our social status, wealth, and

58. Rosa, *Resonance*; Rosa, *Uncontrollability of the World*.
59. Rosa, *Uncontrollability of the World*, viii.
60. Rosa, *Uncontrollability of the World*, 4.
61. Rosa, *Uncontrollability of the World*, 11, italics original.
62. Rosa, *Uncontrollability of the World*, 57.
63. Rosa, *Uncontrollability of the World*, 28, italics original.

technical skill) we are well placed to master it and harness it to our purposes. Our language and thought give us the means not only to image and describe but to encompass, grasp, and manipulate whatever we encounter, be that things or persons. And there is the additional attraction of being relieved of a whole range of potential obstacles that need no longer concern us—not only God but also much more down-to-earth, human phenomena. For example, if I am in a position of political authority and claim to know what human beings really are (say, in the last resort nothing but a buzzing collocation of subatomic particles), that could well provide me with an excuse to set aside, for example, the notion of human uniqueness or dignity.

I suggest that this same pressure toward control applies far beyond NR, even though it takes stronger and weaker forms. I hasten to add that my point here is not about the psychological motivations of any particular supporter of this or that reductionism, or of any specific person who seems caught up in one of the drives identified above. I am merely throwing into relief something relatively obvious: that issues of power, corporate as much as individual, can be deeply implicated in reductive ambitions. Certain forms of manipulation and exploitation naturally accrue to such drives, especially if they encourage us to imagine we have attained a mountaintop, context-free perspective on reality.

In this connection, the philosopher Nora Vaage's pointed comments on the use of the mechanistic metaphor in biology are apt: "An ontological and ethical danger arises from the conflation of organisms with machines." She continues: "The ideas of complete control, reduction and standardisation are part of what imbues [synthetic biology] with its power. Although this way of perceiving life can lead to important biotechnological innovations, the dominance of the machine conception can provide a hindrance both to further scientific understanding and to relational ways of thinking about living organisms."[64] Significantly, Vaage goes on speak of the arts. She believes they can offer "counter-points in a tech-noscientific discussion that is largely focused on utility, application and risk," and that in this way they can serve "to balance out *the ontology of controllable life*."[65] It is to the arts that we turn next.

64. Vaage, "Living Machines," 68.
65. Vaage, "Living Machines," 68, italics added.

2

The Arts under Pressure

The problem with . . . essentialising approaches [to music] is that they deny the
politics and contingency of the value of music, and they suggest that it is know-
able in some objectivist way.

Simon McKerrell[1]

Questions that children always ask—"Where do I come from?," "What is the
meaning of life?"—these questions have been given wrong answers by theology
for centuries. The right answers to these questions now come from evolutionary
science. That is my pitch, my educationist pitch, for evolution as the new classics.

Richard Dawkins[2]

If we would speak of things as they are, we must allow that all the art of rhetoric,
besides order and clearness; all the artificial and figurative application of words
eloquence hath invented, are for nothing else than to insinuate wrong ideas, move
the passions, and thereby mislead the judgment; and so indeed are perfect cheats.

John Locke[3]

The links between the kind of science-oriented reductionism I sketched
in the last chapter (NR) and reductionist currents in modern and late-
modern culture at large are immensely complex. It would be simplistic

1. McKerrell, "Social Constructionism in Music Studies," 425–26.
2. Quoted in Jahme, "Richard Dawkins Wants Evolutionary Science to Be 'the New Classics.'"
3. Locke, *Essay Concerning Human Understanding*, 3.10.34.508.

in the extreme to claim that all things reductionist have their origin in the natural sciences. Scientific inquiry is intertwined with a host of sociocultural factors in hugely diverse and intricate ways. In any case, whatever their genealogy, it is not hard to show that the four reductive drives I outlined are present and active in many spheres of culture beyond the strictly scientific. Our principal interest here, of course, is in the arts. Later I will try to show that artistic practices are typically marked by drives that work against those I have been sketching, and in ways that carry sizable implications for theology. But first we need to acknowledge the ways in which the arts themselves can, and have been, caught up in these reductive currents.

To turn briefly to just one art form, there are narrations of twentieth-century European and American painting—including some influential Christian accounts—that link some of its key movements to the deadening and secularizing effect of a reductionist mentality: the depthlessness and fragmentation of some forms of abstraction, for example, or the cynical and soulless portrayals of human figures, drained of life, reduced to mere flesh.[4] Or, to take another example, the output of some of the leading modernist painters, according to at least one line of interpretation, was marked by a quest for the pure and singular, an exclusionary simplicity designed to lay bare art's essential elements.[5]

Here, however, I am less concerned with how reductionist pressures are reflected or evoked by artists than with how they have appeared in modern and late-modern *discourses surrounding the arts*—from informal conversations to academic books and articles. Anything like a survey is out of the question here; I will instead highlight just four out of many examples, each of which displays in its own way the "containing" pressures of reductionist aspirations. It is worth bearing in mind that these modes of discourse are by no means all formally committed to the anti-metaphysical or anti-theological ambitions of the

4. The classic and highly influential Christian example is Rookmaaker, *Modern Art and the Death of a Culture*.

5. The art historian Michael Fried writes, "The practices of modernism in the arts are fundamentally practices of negation. . . . [T. J.] Clark's insistence that modernism proceeds by ever more extreme and dire acts of negation is simply another version of the idea that it has evolved by a process of radical reduction—by casting off, negating, one norm or convention after another in search of the bare minimum that can suffice" (Fried, "How Modernism Works," 217, 222). The art critic Clement Greenberg writes, "It has been in search of the absolute that the avant-garde has arrived at 'abstract' or 'nonobjective' art—and poetry, too. The avant-garde poet or artist tries in effect to imitate God by creating something valid solely on its own terms, in the way nature itself is valid. . . . Content is to be dissolved so completely into form that the work of art or literature cannot be reduced in whole or in part to anything not itself" (Greenberg, "Avant-Garde and Kitsch," 541).

naturalist, though it is probably fair to say that the first two have been especially allied to a suspicion or rejection of theological claims.

Evolutionary Reductionism

We begin with a brand of reductionism that does lean heavily on natural science, although chiefly on biology (not physics), and especially on the prevailing paradigm of contemporary evolutionary theory, known as neo-Darwinism—a synthesis of Charles Darwin's theory of natural selection and Gregor Mendel's genetics. Neo-Darwinism offers an account of how living organisms appear and change over time through replication, selection, and genetic mutation. Although it is at root a biological model, many are persuaded it can and should be deployed far more widely. For example, the burgeoning domain of "evolutionary psychology" seeks to apply it to humans' psychological and cultural life.[6] While some biologists belittle any such attempt, others see it as holding enormous promise, offering nothing less than a grand unified theory of human behavior.[7] One of its best-known enthusiasts and popularizers is Steven Pinker, renowned for his bracing directness: "The geneticist Theodosius Dobzhansky famously wrote that nothing in biology makes sense except in the light of evolution. We can add that nothing in culture makes sense except in the light of psychology. Evolution created psychology, and that is how it explains culture."[8]

Even better known among evolutionary reductionists (and no less direct) is Richard Dawkins, notorious for his highly charged and sustained hostility to religion. Dawkins's approach to culture is of a piece with his idiosyncratic take on the genetics of evolution. First published in 1976, his eminently readable *The Selfish Gene* popularized the notion that the main force behind the long history of the evolution of life is not the group, or the species, or the organism, but genes. These are *the* units of selection: replicators in their own right. Whereas humans are born and die, genes persist and endure. We are mere "vehicles" for the onward transmission of these incurably "selfish" microparticles. Dawkins advances a severely pared-down picture of *Homo sapiens* in vivid and compelling prose, laced with bons mots and a wealth of memorable metaphors. Human beings are at root "lumbering robots" driven by their self-serving genes;[9] living

6. See, e.g., Downes, "Evolutionary Psychology"; Tomlinson, *Culture and the Course of Human Evolution.*
7. See, e.g., the confidently titled book by Alex Mesoudi: *Cultural Evolution: How Darwinian Theory Can Explain Human Culture and Synthesize the Social Sciences.*
8. Pinker, *How the Mind Works*, 210.
9. Dawkins, *Selfish Gene*, 25.

organisms are "survival machines . . . blindly programmed to preserve [their] . . . genes";[10] the "individual organism [is] not fundamental to life [but] . . . a secondary, derived phenomenon."[11] What we have come to call love, kindness, and altruism are ultimately based in an underlying selfishness, an irrepressible urgrund of genetic self-interest.

All this is set within what Dawkins believes is the only cosmology compatible with neo-Darwinism: one that permits no extra-physical, and certainly no extra-worldly, reality. Evolution is a wholly blind process, without an extra-evolutionary intelligence. In the grand scheme of things (perhaps not the best phrase), human beings are accidental and irrelevant. Questions of ultimate purpose are beside the point since the universe is captive to "blind physical forces." The cosmos possesses "no purpose, no evil and no good, nothing but blind, pitiless indifference."[12] When it comes to accounting for culture, Dawkins presents what is in effect an extension of his genetic theory, proposing a specific "cultural replicator" analogous to the gene: the "meme."[13] A meme is a self-replicating "unit of transmission" residing in the brain—for example, a belief, preference, fetish, or fashion. Memes spread among the members of a population and give rise to cultural ideas and artifacts. Some memes are especially resilient, and by no means all of them are beneficial: religious belief is a prime example of an especially hardy and pernicious meme. The fact that a large number of people believe in God today is thanks to the capacity of the "God-meme" to replicate itself. (It is worth noting that Dawkins's brand of evolutionary reductionism is not broadly embraced by contemporary evolutionary biologists,[14] nor is the strong air of determinism that surrounds it.)[15]

10. Dawkins, *Selfish Gene*, xxix.

11. Dawkins, *Unweaving the Rainbow*, 308.

12. Dawkins, *River Out of Eden*, 133. Even so, and curiously, Dawkins claims that he is not a determinist, insisting that humans—only humans—are able to resist their genetic makeup: "We, alone on earth, can rebel against the tyranny of the selfish replicators" (Dawkins, *Selfish Gene*, 260). On *The Selfish Gene*, David Bentley Hart comments, "This is not, I think it is fair to say, an altogether logically consistent book, at least as regards human beings, inasmuch as it seems to argue simultaneously for and against a purely determinist account of human behavior" (Hart, *In the Aftermath*, 187). Hart suggests that what Dawkins should have said is that some genes are "fortunate," "privileged," or "graced," for "a gene can no more be selfish than a teacup" (Hart, *Experience of God*, 263).

13. Dawkins, *Extended Phenotype*, 165–70.

14. For summary and discussion, see Cunningham, *Darwin's Pious Idea*, 47–78. Even Dawkins concedes he is offering only one way of reading the evidence: "I am trying to show the reader a way of seeing biological facts. . . . I doubt that there is any experiment that could be done to prove my claim" (Dawkins, *Extended Phenotype*, 2).

15. On genetics and determinism, see the lucid study by Denis Alexander, *Genes, Determinism and God*.

Evolutionary accounts of the arts are not hard to come by.[16] Surveying the theories, one is struck by their sheer diversity and the lack of consensus among scholars who propound them. To state the obvious, the evidence is fragmentary and ambiguous, making a high degree of speculation almost inevitable, and it is not always clear what is being studied under the umbrella of "the arts." By no means are all of these accounts as severely reductionist as Dawkins's, although the default cosmology tends to be heavily naturalist. Most theorists in this stream assume that the arts are *adaptive*—that they have given humans specific selective advantages, improving their chances of survival. Among the most-often-proposed adaptations are those pertaining to habitat selection, mate choice, problem-solving, storytelling, the chance to play and imagine alternate realities, the generation of physical pleasure, and the relief of anxiety. Some theorists stress advantages to a group, such as social cohesion and communal cooperation.[17] A few see the arts and our aesthetic sense as *exaptations*—that is, as features that now enhance evolutionary fitness but did not originally do so.[18] The most commonly cited example of exaptation is the way in which bird feathers, believed to have originated as mechanisms for thermal regulation (adaptation), seem eventually to have been co-opted for a different function— namely, flying (exaptation).

The degree to which all such theories could be called "reductionist" varies considerably. But even given the variety of the literature, it is relatively easy to

16. Probably the best known are Ellen Dissanayake's *What Is Art For?* and Denis Dutton's *Art Instinct.* In this connection, mention should be made of the relatively new discipline of "neuro-aesthetics," which aims to use neuropyschology to illuminate the production and perception of art and beauty. See, e.g., Ramachandran and Hirstein, "Science of Art"; Chatterjee, *Aesthetic Brain.* For assessment and criticism, see Ball, "Neuroaesthetics Is Killing Your Soul"; Noë, *Strange Tools,* esp. chap. 10.

17. Lumsden and Wilson, *Genes, Mind, and Culture*; Rosenberg, *Sociobiology and the Preemption of Social Science.*

18. "The . . . evidence suggests that the arts did not evolve as adaptations, but rather arose as a non-beneficial by-product of certain long standing psycho-sensory biases, which were duly co-opted by the arts in the context of ritual as a result of cultural evolution" (Hodgson and Verpooten, "Evolutionary Significance of the Arts," 83). It is worth adding that some believe certain art forms have never served any adaptive function. Over twenty years ago, Steven Pinker famously contended that music did not originate to enhance any survival prospects; it is merely a by-product, an off-shoot of adaptive mechanisms that evolved for other reasons. "As far as biological cause and effect are concerned, music is useless." He mused, further, "I suspect that music is auditory cheesecake, an exquisite confection crafted to tickle the sensitive spots of at least six of our mental faculties" (Pinker, *How the Mind Works,* 528, 534). Needless to say, this account has been met with disdain by music lovers, not to mention a host of evolutionary theorists of music. For a very fine summary and evaluation of evolutionary theories of music, see Davies, "Evolution"; on Pinker in particular, see p. 692.

discern traces of the four reductive drives we have delineated in the previous chapter, even if they may not all be pursued to the same extent. As far as the drive toward *ontological singularity* is concerned—the reduction of reality to one type or kind—here it is the biological that emerges as key: it is from this vantage point that we are being encouraged to describe and (wholly?) explain the arts. And this very naturally goes with the assumption that causation always operates from the bottom up (as with NR). Human culture (as with the physical world at large) is driven by basic particles—which in this case means *biologically significant* particles (Dawkins's gene-like "meme" would be a prime example). In his lucid study of reductionist evolutionary theories of culture, Jean Lachapelle explains that, in this outlook, "*higher-level cultural phenomena can in principle be explained in terms of lower-level entities and mechanisms*. Presumably, if they have not been explained in these terms yet, it is simply that our knowledge of, inter alia, the brain (e.g., evolved mental mechanisms) and developmental genetics is incomplete; but the argument goes, as science progresses and improves its understanding of these fields, higher-level phenomena should turn out to be mere outcomes of more basic processes."[19]

Exclusionary simplicity, the hasty and ruthless rejection of all phenomena that do not readily fit a preconceived explanatory mold, is probably most apparent in the insistence—often stridently expressed, and supposedly on the basis of science itself—that the evolutionary process is blind and directionless, rendering the notion of an extra-worldly divine intelligence guiding, or at work in, the process both implausible and unnecessary. Speaking of a variety of attempts to account for the arts under "the bio-cultural umbrella," Christina Bieber Lake comments that what they all seem to share is "an aggressive metaphysical naturalism."[20] Of course, this will not make a huge difference to the plausibility or otherwise of bio-cultural accounts of the arts *as such*. But when these are combined with a rigorous exclusionary logic, more troubling questions arise.

A case in point is the exclusion, in at least some evolutionary theories of art, of the relevance of a first-person perspective. Lake brings this to the fore in her critique of some prominent strands in literary theory.[21] Edward Warburton discerns similar traits in otherwise laudable contemporary philosophical attempts to recover a sense of the importance of embodiment: "[Such attempts] often assume that experiences of dance, like other human behaviours and mental

19. Lachapelle, "Cultural Evolution," 332, italics added.
20. Lake, *Beyond the Story*, 68.
21. Lake, *Beyond the Story*, 58–63.

events, are entailed or instantiated by either physical processes in the brain-body or cultural processes in society. In principle, these assumptions must be correct, since dance can be explained by events in the physical or social world. But materialist accounts often go one step further by *assuming experiences can be redefined as nothing but these causes, and therefore must be understood solely in terms of them.*"[22] What is overlooked here, Warburton goes on to note, is any acknowledgment of what dancers themselves say about what it feels like to perform—the conscious experience of dancing itself: "To know what dancing is or feels like, one must ask dancers what they experience or experience dance oneself. . . . Questions about material underpinnings of experience will never reveal the entire story."[23]

With regard to the favored *epistemic stance*, as with NR, this is assumed to be the disengaged objectivity associated with the "hard" sciences, even when biology is the principal focus of interest. We also note that one kind of *discourse* is held to be supremely appropriate for speaking truthfully about human culture, including the arts. Further, the theories we have observed are reductionist inasmuch as they suppose that one type of biological explanation must be sought for any cultural activity: evolutionary adaptation (or exaptation). Indeed, for some, pinpointing the adaptive or exaptative origination of a behavior is believed to provide an entirely sufficient explanation.

As far as *control and mastery* are concerned, we hardly need point to the enormous amount that has been written about attempts to harness biological-evolutionary science for dehumanizing ends, but I am not aware of this taking a strong hold among those who write of the arts from an evolutionary perspective.

None of what I have said here is intended to imply that evolutionary accounts of the arts have nothing to offer, that they are devoid of value, or that all such accounts are aggressively reductive. At this stage I am merely concerned with pointing up reductive currents as they appear in the existing literature, currents we shall return to in chapter 4.

Sociocultural Reductionism

In many ways, our second form of reductionism as applied to the arts stands at the opposite pole to evolutionary reductionism. Here we find a deep suspicion of linking culture to anything that might suggest transcultural "universals"

22. Warburton, "Of Meanings and Movements," 68, italics added.
23. Warburton, "Of Meanings and Movements," 68.

(especially those pertaining to a "human nature") and a pointed distrust of what is seen as the sweeping confidence of natural scientists. Nonetheless, reductionist pressures are by no means absent; they simply take a different form.

At the risk of gross generalization, for many centuries in the premodern West, among those who reflected seriously on what we now call "the arts," it would have been taken for granted (a) that there was something akin to an identifiable human "nature" to which the arts were in some way related, and (b) that art-making was to a large extent grounded in, and responsible to, an order possessed by the physical world at large, an order in which humans as bodily creatures were embedded, and the significance of which preexisted the appearance and constructive power of human beings. The metaphysics supporting these convictions could vary widely, but the convictions themselves, strengthened by Christian theological frameworks of various kinds, were rarely challenged.

With the move out of the late medieval and Renaissance eras, however, they came to be widely questioned; and, in the West at least, they have been the subject of debate ever since. In our own times, and from the second half of the twentieth century in particular, many art theorists came to contest the notion that the arts can or should be regarded as underwritten by stable and enduring essences, forms, or universals, whether human or cosmological (or, indeed, divine). With the growth of various forms of "constructivism," the socially and culturally embedded character of the arts came to be stressed with a new intensity. People act in some ways and not others "due to certain 'social constructs': ideas, beliefs, norms, identities or some other interpretive filter through which [they] perceive the world."[24]

With this goes a profound mistrust of the discourse of "nature" and the "natural." "Human nature" is a concept vigorously interrogated in feminist, queer, and anti-racist spaces; "inner nature," understood as something constitutive of persons and impervious to outside influence, is challenged by what is known about the shaping power of social and cultural forces; "second nature" is spurned in light of, among other things, postcolonial theory, exposing the crushing effects of the imposition of cultural norms on "the other"; and "physical/biological nature" is rendered deeply suspect in view of, for example, gender identity theory, with its stress on the social constructedness of the categories we use to distinguish biological phenomena.

24. Parsons, "Constructivism and Interpetive Theory," 75.

To a significant extent, this manifold mistrust is fueled by a distinctively modern (broadly Kantian) epistemology. Against the suggestion that we passively receive data through our senses, the constructivist will highlight the formative contribution of the mind in all our cognitive commerce with the world: we actively shape what we receive through the senses and can never get "behind" this shaping activity to attain an unmediated knowledge of the world as it is in itself. On this account, there is every reason to suppose this mediation operates on the social as well as the individual level. We cannot extricate ourselves from our social time and place in order to secure some asocial, indubitable knowledge of reality. Knowledge and reality are mutually constitutive. This holds as much for scientific inquiry as for anything else—a crucial point, bearing in mind science's repeated tendency to vaunt its empirical methods as theory-free, as simply depicting "the way things are." Along with this we will find an emphasis on the contingency of all truth claims—you may speak of "truth" where you are, but the truth always looks different from over *here*.

Language is inevitably enfolded into the same pattern: our speech and writing do not simply name, designate, or dispassionately describe an antecedent world; they form and sustain—indeed, many would claim, *constitute*—that world. As Plato's *Euthydemus* put it, saying is a "making and doing."[25] And with this heavy accent on the formative power of language there usually comes a strong political thrust: to be situated in a society and culture means to be enmeshed in various agendas of power, and those fortunate enough to have a substantial degree of power will typically diminish, suppress, or simply ignore those who have little of it, a move especially insidious when it is done under the guise of "impartiality."

Needless to say, this cluster of convictions and predilections can appear in many combinations and can be pressed much further by some than others. But they will be very familiar to anyone who has worked, for example, in a humanities department in a secular university in North America over the last twenty years or so.

What happens when the arts are brought under this outlook? The very fact that they involve *making* at their heart will readily resonate with a temper that stresses the formative, constructive dimensions of human life. Renaissance paintings are obviously (often blatantly) products of their time and place. Shakespeare's plays are clearly enmeshed in the turbulent political ambitions of the Elizabethan and Jacobean monarchies. Contemporary hip-hop makes no

25. Plato, *Euthydemus*, in *Plato: Complete Works*, 284c (p. 721).

attempt to hide its interwovenness with the values, fears, passions, and agendas of marginalized African Americans. Many will understandably conclude that art must not be interpreted or understood in anything *other* than sociocultural terms.

Music is especially instructive here, for it has proved to be fertile ground for reductionist sensibilities along sociocultural lines. It has become de rigueur in virtually all academic musical-theoretical circles to stress the social and cultural situatedness of musical practices and discourse. This is especially so since the so-called performative turn of the early 1990s,[26] and the recent exponential availability of non-Western or "world" music, together with the expansion of ethnomusicology. We are repeatedly reminded that music never escapes the dynamics of socially shaped interests. The fixation of Western art music on the "work"—supposedly untethered to peoples, times, and places—is symptomatic of a desire to occupy a neutral aesthetic zone, typically privileging White and socially privileged males. "Music" is, at root, not a thing but a practice—"musicking"[27]—a set of activities carried out by flesh-and-blood human beings. It is to be understood not in terms of supposedly free-floating works but in terms of the concrete, corporate, embodied practices of singing and playing, hearing and listening—practices that are woven into profoundly disparate and distinctive cultures. Ethnomusicologists typically gravitate toward the "partial" rather than the "universal," the particular and the local rather than the supposedly transcultural. What is more, we can no longer think that music-making and music-hearing simply reflect or mirror prior beliefs or image a world "out there" (did we ever?); rather, through music *we make* our lives significant. Music offers sites for the production of meaning. Needless to say, the growth of popular music studies in the academy has put all these matters much more firmly on the scholarly agenda, challenging the way in which theoretical methods associated with Western art music are applied to, say, country music or calypso.[28]

Where things take on a particularly reductive edge is when we are told that music should not *in any way* be considered or interpreted as being grounded in realities that transcend the constructive interests of a particular social or cultural group: music is sociocultural "all the way down." Yes, of course it involves phenomena in the extra-human physical world (say, vibrating strings), but the makeup of that world is irrelevant to discussing meaning, significance,

26. See Cook, *Beyond the Score.*
27. Small, *Musicking.*
28. For a lively discussion, see Born, "For a Relational Musicology."

and value. These are wholly human constructs that need to be tackled from the perspective of the interests of social groupings, not by appealing to supposedly transcultural fixities. In this atmosphere, natural scientists may well find themselves under a good deal of suspicion. Writing of social constructivism in music studies, with an almost palpable irritation, Simon McKerrell bemoans "a growth in the mass media of essentialising, often hegemonic discourses that offer deterministic analyses of topics such as the musical characteristics of a particular genre or canon, the 'qualities' that determine a 'hit' record across time, or (my particular bug bear) neurodeterministic accounts of how music 'means.'"[29] Evolutionary theory tends to get similar treatment. Pushing us to seek a basis for musical behaviors in biological factors unaffected by social and cultural difference, it inevitably risks foisting one cultural frame upon another, something all the more pernicious when it masquerades as "objectivity." A classic case is the attempt to argue that modern Western European music is superior because of its demonstrable rooting in unchangeable features of vibrating matter (the overtone series, for example). Another would be the effort to explain the widespread use of certain rhythmic patterns in the world's musics by appealing to universal features of human physiology. Such schemes may be presented as innocent descriptions of "the way things are," but they are likely to be complicit at some level in systems of oppressive power.

To switch to another art form, English literature, Rita Felski, although hardly ever speaking of "reductionism," has recently written of what she sees as the unhealthy dominance in literary studies (and in the humanities more widely) of what she calls "critique."[30] This is a mood or sensibility affecting a variety of hermeneutical strategies (including ideology critique, post-structuralist critique, and Foucauldian historicism) according to which scholars regard their prime role as exposing the worst—unmasking, uncovering, laying bare whatever is dehumanizing. She points to "a spirit of skeptical questioning or outright condemnation, an emphasis on [art's] precarious position vis-à-vis overbearing and oppressive social forces, the claim to be engaged in some kind of radical and/or political work, and the assumption that whatever is *not* critical must therefore be *uncritical*."[31] She notes also "the relentless grip . . . of what we could

29. McKerrell, "Social Constructionism in Music Studies," 426. He expands his point: "The problem with . . . essentialising approaches is that they deny the politics and contingency of the value of music, and they suggest that it is knowable in some objectivist way" (pp. 425–26).
30. Felski, *Limits of Critique.*
31. Felski, *Limits of Critique,* 2, italics original.

call antinormative normativity: skepticism as dogma."[32] This sort of critique has spawned, among other things, the prevailing "metalanguage" of literary studies and generally regards itself as the only hermeneutical show in town, "the be-all and end-all of interpretation."[33] "For many scholars in the humanities, it is not one good thing but the only imaginable thing."[34]

I am, of course, being highly selective in those I have cited. My aim has been merely to throw into relief some of the ways in which strong sociocultural reductionist impulses are evident in discourses associated with the arts. They do, however, seem to be prominent and influential, and it is certainly not hard to discern our four reductive pressures. The concentrated drive to *ontological singularity*—the "really real"—here of course finds its favored territory in the social and cultural. It is the tools of sociocultural analysis that enable us to predict, prescribe, and explain—to penetrate to the fundamental forces and effects of a poem, film, or song. One cause, or one type of cause, is pursued above all others. Intriguingly, on the ontological hierarchy we spoke about in chapter 1, this is an "upward" reduction, in contrast to the "downward" reduction stipulated by NR. The lower levels must now be reduced to the upper, the social and cultural. But the pressure toward understanding everything in terms of one favored level is still very much the same.

The pressure toward *exclusionary simplicity* is hard to miss. The simplicity that comes with concentrating so severely on social and cultural dimensions means excluding—or at the least holding under intense suspicion—the belief that the nonhuman world at large has any significance independent of our involvement with it. Even if we might want to believe it has, we have no reliable access to that significance, so for all intents and purposes the belief is redundant. The fact that by far the majority of artists in human history have seen themselves to be—in part at least—responsible to an order not of their own making might be of historical interest, but it cannot be relevant to an intellectually viable theory of artistic making today.

One might also note (at least in some versions of this outlook) a marked lack of interest in the good of which humans are capable; it seems far more important to unveil the oppressive, hegemonic, and manipulative than to celebrate the worthy, the liberating. The tilt toward determinism that we met in evolutionary reductionism crops up here also. Little is said about the exceptional, the

32. Felski, *Limits of Critique*, 9.
33. Felski, *Limits of Critique*, 9.
34. Felski, *Limits of Critique*, 8.

beguiling singularities of a text or image, about the way artists so often chafe against their context, about the way so much art seems able to speak far beyond its time and place.

On the face of it, the *epistemic stance* valorized here appears to be the opposite of that assumed by hard-line "scientific" reductionism; and in many ways it is. It stresses not the independently existing, extra-human world but the constructive powers of humans. The disciplines believed to be especially alert to these powers are prized above all others. Hence the heavy investment in social studies, in philosophy (understood as a socially embedded, culturally formed practice), and in "material culture" studies. Scant attention will be paid to biology, chemistry, or physics. We are not to be dazzled by the prestige of the natural sciences, as if they offered some kind of entrée into a supracultural or transcultural realm of "nature" or the "natural." On the other hand, perhaps a more useful way of interpreting the constructionist stance is to see it not as the negation of the stance assumed by the "scientific" model but as springing from the same root. Both outlooks presume an epistemology of distance or disengagement in which direct human involvement in the business of knowing is seen as inherently problematic, in which knowledge is described in terms that are abstracted from the daily business of indwelling and navigating the material world as embodied agents. As far as the favored truth-bearing discourse is concerned, this is of course the language associated with analysis at the sociocultural level.

With respect to *control and mastery*, although sociocultural reductionism will tend to associate such ideas with the most heinous crimes of science and technology, it too offers an overview of things that is arguably no less prone to encouraging hegemony and domination.

Linguistic Reductionism

Our third reductionism is one we have bumped into already, and it has had a key part to play in shaping discourse about the arts over the last few hundred years. It can take a number of forms, but two broad types may be distinguished here: (a) the belief that language is truth-bearing to the extent that it conforms to a particular linguistic paradigm, and (b) the belief that truthful representation, and thus understanding, is possible only through language. Undoubtedly, both types (especially the first) are bound up with the kind of exaltation of the natural sciences that lies behind much of what we have been tracing so far.

As for the first type, the ideal of truth-bearing language typically depends on holding that the meaning of a word is that to which it refers and that language is temporally and ontologically dependent on thought—*thought* being understood as the mental processes of an individual: "There are 'things' [self-defining referents, such as physical items, ideas, truths, spiritual entities] to which we first *refer* by pure thought and second *express* . . . by attaching terms to these mental acts of referring."[35] The relation of thought to "thing" will be understood in terms of direct correlation. Language can thus be considered truthful just to the extent that it displays a one-to-one correspondence with ready-made things, and it is this correspondence that gives us the capacity to identify, stabilize, and engage with such things. The highest form of this language is the literal, declarative statement or assertion, with a clear subject-predicate structure.[36]

In his recent book *The Language Animal*, Charles Taylor discusses this paradigm—or something very close to it—at considerable length.[37] He sees it as especially characteristic of mainstream analytical philosophy and discerns it, often in a less sophisticated form, in a number of illustrious sixteenth- and seventeenth-century philosophers.[38] Key here is that "words are introduced to designate features [of the world] which have already in one way or another come to our attention."[39] Language's primary purpose is "the encoding of our thoughts, or information,"[40] such that we are able to designate entities that are otherwise fully available to us. There can also be the additional stipulation that "all acceptable sentences must be derivable from propositions of physical science,"[41] and these, of course, must be devoid of the connotations of human

35. Torrance, *Persons in Communion*, 326, italics original. We should note that Torrance goes on to *oppose* this view.

36. I am deliberately not using the word *proposition* here. I am assuming a logical distinction between a proposition and an assertion, although the distinction is admittedly a fine one. I am taking *assertion* to be a claim that something is the case, whereas a *proposition* is a statement offered for consideration (i.e., a proposal). In many cases, the distinction will depend on the context of the linguistic act: what is intended as a proposition may well be heard as an assertion.

We should also note that on the model of reference we are considering here, whether terms are believed to refer to "external" objects or "internal" thoughts and feelings, the essential structure of the paradigm is the same.

37. Taylor, *Language Animal*, chap. 4.

38. Taylor speaks of "HLC" theories, named after Hobbes, Locke, and Condillac (Taylor, *Language Animal*, chap. 4). The extent to which he fairly represents these figures is a matter I will have to leave to one side.

39. Taylor, *Language Animal*, 133.

40. Taylor, *Language Animal*, 84.

41. Taylor, *Language Animal*, 131.

purposes or ends. A legitimate description of any state of affairs must be dispassionate—in third-person form, not dependent on any first-person perspective.

Needless to say, this kind of paradigm is often supposed by those who hold to the kind of "scientific" reductionism (NR) we met in the last chapter. Especially important for our purposes is the implication that the "figuring" dimension of language (seen in the use of, say, metaphor) can add nothing to the truth-bearing capacities of language; indeed it will probably impede them.[42] The linguistic norm, in other words, is the literal: above all, the purportedly disembodied, dispassionate, rule-based, and context-independent assertion. Only this can deliver what John Locke called "dry truth and real knowledge."[43] Indeed, the acquisition of knowledge, secure and reliable reasoning, along with truthful communication with others (whether of the everyday, informal kind or the more formal communication involved in science) *depends* on avoiding language that fails to align with this norm.

Similar assumptions will often be applied to the art forms of poetry, story, fiction, and fantasy literature—and here we meet a well-known form of reductionism in the arts. Insofar as these literary forms are to be regarded as mediating knowledge and understanding , we should be able to render that knowledge and understanding adequately in literal, assertoric prose. In reality, it is quite hard to find anyone explicitly arguing that, for example, all poetry can be paraphrased adequately in literal prose. Critical commentary is rarely regarded as a *substitute* for a poem (at least for a poem regarded as serious or substantial). The point about paraphrasability is usually expressed informally rather than formally, and in practice rather than theory. Even so, the reductive assumption typically remains: the strictly poetic devices in a poem (e.g., meter, rhyme, assonance) do not and cannot add anything to our knowledge and understanding. Indeed, as with metaphors, they are more likely to impede them. A further problem is that, insofar as poetry uses metaphor, hyperbole, imagery, irony, and so on, it is likely to be multiply allusive and multivalent, opening up a range of possible meanings and thereby compromising "dry truth and real knowledge."

42. Taylor, *Language Animal*, chap. 5.
43. Locke, *Essay Concerning Human Understanding*, 3.10.34.508. Although Locke concedes that "since wit and fancy find easier entertainment than dry truth and real knowledge, figurative speeches and allusions in language will hardly be admitted as an imperfection of it," he still contends that "if we would speak of things as they are, we must allow that all the art of rhetoric, besides order and clearness; all the artificial and figurative applications of words eloquence hath invented, are for nothing else than to insinuate wrong ideas, move the passions, and thereby mislead the judgement; and so indeed are perfect cheats" (3.10.34.508).

I recall encountering a version of this reductionism very early on in my seminary training, in the context of classes on preaching (and I went on to practice this reductive strategy on numerous occasions myself). I was told by many of my peers that when faced with, say, a parable of Jesus, or with a richly metaphorical passage in one of the Hebrew prophets, the preacher ought to make every effort to encapsulate or capture its "meaning" in solid prose, and in due course organize that prose under key assertions, or "points." ("What Jesus is saying here is, first, that") Illustrations, metaphors, and images should give way as quickly as possible to prose, organized around a sequence of compressed statements (ideally alliterated). No one cautioned us that this might alter or even damage the theological content. On the contrary, it seemed that *only* such language would ensure that the "message" or "takeaway" of the passage would be rendered clearly (a crucial concern of those who recommend this approach), effectively (in a way that would be memorable, repeatable), and in a way that would be life-changing.

This type of linguistic reductionism is often accompanied by a second: the belief that truthful representation, and thus understanding, is possible only through language. We will say more about the thorny subject of representation later, but at this stage we need only remark on the obvious—that if assertive language is exalted in the way we have described, then art forms that do not directly employ language at all are bound to be seen as suspect from the start. Visual art is instantly in trouble (presuming its content is nonverbal, and setting aside any title or accompanying text). Music is in the worst position of all, for unlike, say, painting, music does not have even a rudimentary ability to designate or pick out things for our attention.[44] It cannot "represent" things in this way, let alone assert anything in subject-predicate form. It cannot even "say" something as basic as "there is a tree over there." So if a piece of music is to be accorded respectability as a vehicle of knowledge and understanding, we will need to be able to show *either* that its meaning can be securely identified and expressed in the form of assertions (a virtually impossible task), *or*—a subtler strategy—that in at least some respects it operates in ways comparable to the dynamics of a certain model of representative language. This latter option has a long and persistent history. A good example is the way in which some eighteenth-century European musicians and theorists were intent on showing that music, even though it might not make assertions, still depends on

44. I am thinking here of music without associated texts such as titles or lyrics.

correspondences between particular note-patterns and extra-musical entities of various sorts.[45]

As far as the four reductive drives are concerned, it is the first and third that are especially prominent here: a strong impulse toward *ontological singularity*, in a way that takes its cue from the natural sciences, and extolling a "scientific" *epistemic stance* that exalts *one kind of discourse* over all others. With regard to the fourth—the drive to *control and mastery*—we might note that language (above all, the literal, declarative assertion) has often been regarded as critical for keeping the arts under control (especially the nonverbal arts), for moderating or directing their emotional energy, and restraining their tendency to multiple allusiveness. This practice can be seen at many points in modernity, not least in the Protestant Reformations, where even though a full-blown account of "scientific" language may not have come into being, a renewed commitment to Scripture and preaching often gave rise to an intense suspicion of non-verbal communicative media, music being the prime example.

Instrumental Reductionism

The desire to tether, harness, or bend the arts to particular practical ends, especially to enact and enforce power in social relations, is pervasive in human culture. But in modernity, with the explosion of technology and associated casts of mind, the instrumental impulse has taken on quite distinctive forms in discourse surrounding the arts. Impossible to ignore in this connection is the sociologist Max Weber (1864–1920), who famously spoke of a process of "rationalization" marking the modern West. The term is used in different ways, but of special interest here is what Weber called "formal rationality": the calculation of means and ends such that a rational action in any given situation is preeminently the action that is most efficient.[46] One fixes on an end and goes all out to secure it in the most efficient way possible. Weber believed this calculating, goal-oriented, and technocratic spirit was pervasive in a wide range of political, economic, and technical arrangements and was responsible in large part for the fragmentation, dissociation, and estrangement of modern society.

45. For discussion, see Bartel, *Musica Poetica*; Grant, *Peculiar Attunements*.
46. Weber, *Economy and Society*, 172. He also uses the term to refer to the way bureaucracies organize human behavior across space and time and to speak of the "disenchantment" (*Entzauberung*) of the world, the typically modern process of voiding the world of magical and spiritual forces. See Kim, "Max Weber."

As far as the arts are concerned, this context and outlook has doubtless encouraged a binary that often crops up in current discussions between *instrumental* and *intrinsic* worth: between what a piece of art (or our engagement with art) can *do*, on the one hand, and the *inherent* merits of the art (or our engagement with it), on the other.[47] The instrumentalist will be on the lookout for the "uses" or "functions" of art while the intrinsicist wants to speak of valuing the arts "for their own sake." A 2016 report on arts and culture policy from the Arts and Humanities Research Council in the UK observed that "the intrinsic-instrumental dichotomy has become entrenched in discourses about policy."[48] It can also be found in modern philosophy of art—and, indeed, in much Christian art-talk.

Instrumental reductionism, therefore, is the reduction of one side of this binary (intrinsic worth) to the other (instrumental worth). However, we need to be more precise than this, for the kind of instrumentalism most often perceived as reductive depends on an "instrumental rationality,"[49] the kind of rationality at work when an action is performed *with the intention of causing an event to take place*. I water the plants in a garden in order that the plants will grow. What gives an act value in this case is not whether or not it accords with this or that principle (principles of watering) but how well or efficiently it achieves a particular effect (the growth of the plants).[50]

Applied to the arts, we probably see the instrumental mindset at work most often when it comes to justifying the value of the arts. To return to the UK report on arts and culture quoted above, it is claimed there that "despite the big strides made by cultural organisations in the last decade or so, in making their case for investment, there has remained a sense that we are lacking robust methodologies for demonstrating the value of the arts and culture, and for showing exactly how public funding of them contributes to wider social and economic goals."[51] An instrumental response to such a challenge will assume that—from the artist's side—an artist's labor is of value to the extent that her work is guided

47. I should stress that in this section I am talking about a way in which the arts are often informally *perceived*. Reductive instrumentalism of this sort is rarely set out as a *program* either for artists or for those who engage the arts.

48. Crossick and Kaszynska, *Understanding the Value of Arts and Culture*, 15.

49. In this whole section, I am heavily indebted to Nicholas Wolterstorff's discussion of what he calls "causal instrumental rationality" in Wolterstorff, *Art Re-thought*, chaps. 3–7.

50. This aligns with the mechanical model of efficient causality we discussed above. See under "Mechanical and Impersonal" in chap. 1.

51. Thompson, foreword to Crossick and Kaszynska, *Understanding the Value of Arts and Culture*, 4.

by the intention to bring about positive effects in others. (Think of a sculptor making a wooden figurine of an animal *in order to* educate her granddaughter. That end shapes the decisions she makes when carving it.) From the side of those who encounter the art, it will be assumed that the value or worthwhile-ness of art for the viewer, listener, or reader depends on how well it generates certain effects. (Did the figurine successfully instruct the granddaughter about the animal?) In short, the *prime measure* of value in any artistic practice—for some, the sole measure—is the extent to which a causal effect is aimed for or realized. And the sooner the desired effect can be achieved, the better. There will be a stress on immediate ends, efficient utility, the shortest route from artist to effect.

I expect bells will be ringing here for any parent who has wondered about spending money on music lessons for their children. It is hardly going to improve employment prospects. So what is the benefit? Will it ramp up their IQs? Will it make them easier to live with at home? Bells might also be ringing for any who have tried to raise funds for the arts in their local community. Whether proposing a show for a small town, an arts curriculum for a high school, or a concert on the church premises, we will be pressed to name the extra-artistic gain, the "takeaway" or "impact"—be it financial (will it reap a profit? will it contribute to the local economy?), moral (will it heighten our ethical awareness? will it prompt virtuous action?), intellectual (will it boost students' interpersonal skills?), or even redemptive (will it help resocialize offenders?). On a wider front, when there are so many mouths to feed, illnesses to treat, injustices to right, we may well ask ourselves, How can we possibly justify spending sub-stantial amounts on the arts at all?

Paradoxically, this form of instrumentalism is often used to counter another: the reduction of the arts to mere amusement. The notion of the "arts as dessert,"[52] as a "highminded but harmless pastime"[53] is surely part of why many struggle to take art seriously in a hard-nosed world of material means and ends. This is, no doubt, why many are eager to demonstrate the "seriousness" of the arts. Leo Tolstoy, in *What Is Art?* (1897), urged that we recover a sense of art as crucial for the flourishing of humankind. Art enables the communication of "feeling" from artist to audience, and in this way it can elevate the life of a society: "The evolution of feelings takes place by means of art, replacing lower feelings, less

52. Bérubé, "Utility of the Arts and Humanities," 25.
53. Diffey, "Aesthetic Instrumentalism," 340.

kind and less needed for the good of humanity, by kinder feelings, more needed
for that good. This is the purpose of art."[54] Moreover—and this links with what
I said about language in the previous section—frequently lurking in the back-
ground here is a felt need to defend the arts against those who assume that only
language, particularly that of the "hard" sciences, can be meaningful or truthful.
If we cannot reduce the art in question to a respectable assertion, then we will
need to show other ways in which it can benefit us.

Those at work in the arts and humanities in colleges and universities will
likely be familiar with the attitude here. A recent academic commentator laments
that "in a material sense the Arts and Humanities are not going to contrib-
ute significantly to what will be, over the next century, the true 'growth' areas
of higher education in the USA and UK: business, science and technology."[55]
Joanne Banks, former director of the Center for Humanistic Medicine at the
Pennsylvania State University College of Medicine, writes of the subdiscipline
of literature and medicine: "If we can show that literature works in the context
of such a basic, life-enhancing as well as life-threatening endeavor as medi-
cine, then we can ameliorate our otherwise self-centered desire to bask in the
philosophical and aesthetic pleasures of superb texts."[56]

What do we see of the four reductive pressures in this instrumental reduc-
tionism? The drive to *ontological singularity* is evident in the intense focus on
efficient causality as the key dynamic. *Exclusionary simplicity* is seen especially
in the narrowing of value according to the criterion of the efficient achievement
of an end. Moreover, one type of end will habitually be privileged, very often
to the exclusion of others: that of financial gain. Ends that exceed the economic
ends so frequently paraded as paramount in our culture for human flourishing
will tend to be marginalized or ignored.[57] There is also an implied narrowing
of the artistic medium to a mere tool—a channel for messages or a vehicle for
feelings—such that we set aside the distinctive contribution of the medium itself.
The favored *epistemic stance* and the *discourse* considered to be truth-yielding
will inevitably follow patterns similar to those we have already noted in this
chapter. And it hardly needs pointing out that an ethos of *control and mastery*
pervades this kind of instrumental rationality: the artist makes art with a view

54. Tolstoy, *What Is Art?*, 123–24.
55. Bérubé, "Utility of the Arts and Humanities," 23. The words "in a material sense" are
significant here.
56. Banks, "Life as a Literary Laboratory," 98.
57. Relevant here, not least on the theological front, is Kathryn Tanner's *Christianity and the
New Spirit of Capitalism*.

to bringing about predetermined and measurable effects, and her art is judged according to the efficiency and success of that venture.

Perhaps the "containing" reductionist pressures we have sketched here are simply common sense for large sectors of the population. For many, this is just the way things are and perhaps have always been. But these drives are by no means inevitable. A brief immersion in a world energized by very different passions might prompt us to think otherwise.

3

A Scriptural Interruption

Seeing and Not Seeing (John 9:1–34)

In the shadow of the temple, a rabbi from Nazareth spots a beggar, blind from birth. The disciples of this wandering teacher want to know whose sin caused the beggar's affliction: his own or his parents'? The rabbi merely tells them that in this man the works of God will be revealed. After cryptic words about light overcoming darkness, he spits on the ground and mixes mud from the dust. Spreading it on the man's sightless eyes, he tells him to wash in the pool. Through the shimmering waters of Siloam, light breaks into the beggar's lifelong prison of darkness for the first time. Bewildered onlookers struggle to take in what has happened. Outraged by this violation of the Sabbath, the Pharisees interrogate the newly sighted derelict. "One thing I do know," he says, "though I was blind, now I see." Condemned and driven away, the beggar encounters the rabbi a second time. After yet more questioning, he finds himself worshiping the man who gave him eyes to see, while the Pharisees find themselves derided as guilty and blind.

Such is the fifth of the seven great "signs" of John's Gospel. Virtually everything about this passage seems foreign to the narrowing and flattening impulses of the reductive imagination. The light "which enlightens everyone" (John 1:9) makes possible a perception of the world that cannot be contained by the categories we typically use to make sense of things, not only because the categories are inadequate but because they have become twisted and distorted.

Indeed, this Gospel as a whole—its themes and its literary forms as well as its subject matter—repeatedly curbs any inclination toward speedy conclusions. The evangelist seems to be pressing his hearers toward a vision of a world that always exceeds what we can glean on the surface. As Richard Bauckham puts it, "It is a text that constantly creates the impression that more is going on than immediately meets the eye."[1] Through a variety of devices—including irony, symbolism, allusion, and double entendre—John invites us to read the events, characters, and symbols of his Gospel in a multilevel, multidimensional way. Indeed, a hasty drive to simplicity is probably a sign of what his text constantly warns us against: a kind of life that perversely wants to close itself off from the living God.

Levels and Layers

The blind man receives physical sight, but soon begins to realize that something more—abundantly more—is going on. He is being given another kind of sight: the ability to see who his healer is, a gift that turns out to be life-renovating. One level is never enough in this Gospel. As every rookie preacher finds out, John's Gospel can be vexing. Just when we think we have a fix on one easily summarizable point, others rush in. In this story, the identity of Jesus is disclosed layer by layer as the narrative unfolds: "the man called Jesus" (9:11) is "a prophet" (v. 17) . . . and "from God" (v. 33) . . . and "the Son of Man" (v. 35) . . . and "Lord" (v. 38).

The portrayal of sin also expands through the narrative. Initially, sin is an unnamed transgression supposedly committed by "this man or his parents" (v. 2); later, a matter of disobeying of the law (v. 16); and by the end of the chapter, a refusal to acknowledge who Jesus is (vv. 39–41). There is no sense that any of these levels is less real than the others, or that any category of sin is being negated, subsumed, or explained away.[2]

The same applies to the materiality of the story. Never is the nonmaterial or "spiritual" set against the material or historical, as if the physicality of the beggar's healing were of no consequence, or as if the story's historicity could be forgotten once we grasp the theological truth it conveys. The Fourth Gospel refuses to leave concrete events behind in this way. Notice the mention of the

1. Bauckham, *Gospel of Glory*, 132.
2. It can of course be argued that some levels are more theologically important and significant than others, but that is a different matter.

spit and dust that gets mixed and spread onto the man's blind eyes, and the direct cleansing power of water in the Pool of Siloam. Physical elements and historical events are fully real and integral to what God is bringing about in and through Jesus.

Knowing and Seeing

What kind of model of knowing do we find here? At first blush, it seems narrow in the extreme, highly exclusive. And in at least one sense it is. Insofar as John has an "epistemology," it is one that is audaciously Christ-focused.[3] Salvation depends on this singularity, and it is just this that eludes the Pharisees. Authentic knowledge of God is disclosed and anchored in Jesus, and the Spirit is the "epistemic agent" who "unlocks the truth that is present in Jesus's teaching so that it can be accepted as saving knowledge of the divine."[4] And yet this very singularity turns out to be extraordinarily multifaceted in nature, certainly a far cry from the narrowness of the epistemology presumed in reductionist schemes that turn on a model of the distanced knower. If there is a detachment being recommended here, it is detachment from fixed false perceptions. Knowing is intertwined with love and trust, and this includes a willingness to be re-formed by whatever (or whomever) is known. Knowing seems to involve the whole person: it is no accident that cognitive, relational, volitional, and bodily dimensions are all manifest in the beggar's healing.

Self-involvement, then, appears to be intrinsic to this kind of knowledge. But in the Pharisees, Jesus meets a type of knower whose involvement has become radically compromised: the fallen self that thinks it *already* knows, and already knows *how* to know. Far from presuming that humans possess an innate, unaided, and intact capacity to see God's truth with clarity and relate to God accordingly, John portrays the blind man's sight entirely as a gift: the man was blind from birth, nothing is said of his faith (unlike in the parallel stories in the other three Gospels), and Jesus seems to act wholly on his own volition rather than in response to a request. Indeed, it is just this that has made some see the healed beggar as the model disciple.[5] Faith in Jesus, it seems, is not an

3. Bennema, "Christ, the Spirit and the Knowledge of God," 129.
4. Bennema, "Christ, the Spirit and the Knowledge of God," 129.
5. Lincoln, *Gospel according to Saint John*, 280. John Chrysostom puts it beautifully:
 For if the blind man, the beggar, who had not even seen Him, straightway showed such boldness even before he was encouraged by Christ, standing opposed to a whole people, murderous, possessed, and raving, who desired by means of his voice to condemn Christ,

immanent possibility waiting to be self-activated but something that needs to be given "from above" (John 3:7). Not even a reliable awareness of one's own sin is presumed in John 9; on the contrary, the Pharisees are oblivious to their own blindness.[6]

Indeed, the narrative turns more than anything else on the contrast between what we might call "generated" and "degenerated" perception: between the blind man's progressive awakening to the light and the Pharisees' steady descent into deeper darkness. The beggar, initially ignorant of who Jesus is (9:12), goes on to confess Jesus as "a prophet" (v. 17), later as "from God" (v. 33), and eventually as "Son of Man" and "Lord," worthy of worship (vv. 35–38). And there is no suggestion that the later terms negate or diminish the earlier ones.[7] The man born blind is gradually granted the power to "judge with right judgment" (John 7:24), to perceive *who* this rabbi is and what is taking place through him—and this comes from outside his own resources.

But just as all this is going on, its opposite is being played out. Some of the Pharisees doubt Jesus is from God (John 9:16). They suspect the miracle never happened (v. 18), question the method of healing (v. 26), fail to understand what it might mean about Jesus (v. 29), and eventually drive the newly sighted man away (v. 34). Jesus himself clinches the double movement: "I came into this world for judgment, so that those who do not see may see and those who do see may become blind" (v. 39).

The Literal and the Literary

John is clearly not burdened with the assumption that only one type of language is valid when the truth needs to be shared. The Fourth Gospel deploys multiple

if he neither yielded nor gave back, but most boldly stopped their mouths, and chose rather to be cast out than to betray the truth; how much more ought we, who have lived so long in the faith, who have seen ten thousand marvels wrought by faith, who have received greater benefits than he, have recovered the sight of the eyes within, have beheld the ineffable Mysteries, and have been called to such honor, how ought we, I say, to exhibit all boldness of speech towards those who attempt to accuse, and who say anything against the Christians, and to stop their mouths, and not to acquiesce without an effort. (John Chrysostom, "Homily 58 on the Gospel of John")

6. "The distinction is not between those who are blind and those who see; it is between those who know they are blind and those who claim that they see" (Newbigin, *Light Has Come*, 119).

7. A parallel instance of this process can be found in John 1, where we are given four uses of the word "follow," progressively stronger in their theological content (1:37, 38, 40, 43). Bryan Born comments, "These multiple allusions do not negate the lower level of meaning but rather they extend and elevate that meaning" (Born, "Literary Features in the Gospel of John," 4–5).

language forms. Its theology trades in deliberate ambiguity, multivalent figures, allusive symbolism. Our text is a case in point—the key terms are *light, blindness/sight, day/night, sin, sinner, Sabbath, Messiah, Son of Man, Lord, judgment.* These are not deployed according to a simple calculus of one-to-one naming. The "Son of Man," for instance, as in the Synoptic Gospels, is an indirect form of self-reference, but it can also carry connotations of final vindication and exaltation, being Israel's representative, being "descended from heaven," judgment (a major theme of John 9), and exaltation through debasement (being "lifted up" on the cross).[8]

Irony is also pervasive in John. As we have seen, this narrative turns more than anything else on the counterpoint between those whose perception is *degenerated* (the Pharisees) and one (the healed beggar) whose perception is *generated* by Jesus. Ironically, the self-appointed defenders of the law are the very ones who are in fact working against it; the ones convinced they can see are in fact blind. It is the guardians of light who plunge into deeper darkness, living under the illusion of sight, while a blind nobody comes to see things as they really are. This is the haunting irony announced in John's prologue: "He came to what was his own, and his own people did not accept him" (1:11).

Another way the semantic layers unfold is through a rich interpretation of the Hebrew Scriptures, especially their key symbols. The law is one such. Jesus is here accused of breaking the Sabbath, which to the Jewish leaders confirms him as a sinner and "not from God" (9:16). Here they are determining their Jewish identity according to their own reading of the Mosaic law: "We are disciples of Moses. . . . God has spoken to Moses" (vv. 28–29). But this, we learn, is to read the law flatly, as a set of prescriptions and prohibitions of one kind, cut off from God's deep, long-term, and life-giving purposes. As Richard Hays observes, we find in John "a number of references to the law . . . that suggest a positive function for the law's prescriptive role in mandating just and merciful practices in the community."[9] What Hays says of Jesus's encounter with the Jews in John 7 applies here also: "John is portraying Jesus as the true Messianic king who *sees beyond surface appearances* to the real substance of the law and who therefore judges with righteousness in a way that brings healing to the poor and down-trodden."[10] It is not that the surfaces are irrelevant or disregarded, only that their significance will be missed if they are not read along with their

8. Hays, *Echoes of Scripture in the Gospels,* 332–35.
9. Hays, *Echoes of Scripture in the Gospels,* 297.
10. Hays, *Echoes of Scripture in the Gospels,* 298, italics added.

theological undercurrents. Again, we need to avoid the reductive assumption that what lies on the surface is of no account, that only the truth "underneath" really matters.

Critical here is that the law, appropriately read, points ahead to Jesus. In Judaism, light is strongly associated with law; here Jesus is *the* light by which the law is to be understood. So, in healing the blind man, Jesus does not actually break the law of the Sabbath at all, because *his* Sabbath works are *God's*, performed with divine authority and carrying the power to bring life.[11] To be sure, God spoke to Moses, as the Pharisees insist. But now God speaks to Jesus—that is, to one who himself speaks God's words (John 3:34; 7:16; 12:49–50) and who, in fact, *is* God's Word (1:1).[12] Again an irony is thrust into the open: those who oppose Jesus out of zeal for the law show their failure to understand it.

This "reading backward" of central Old Testament symbols in the light of Christ is highly characteristic of John. The temple, the liturgical feasts, and the Passover lamb become "figural signifiers for Jesus and the life that he offers,"[13] which is to say, with an alertness to the theological depth given to them by Christ. "[John's] symbolically transformative hermeneutic is possible for one compelling reason: Jesus is the incarnation of the *Logos* who was present before creation, through whom all things were made. . . . For John, reading Scripture in this figural/symbolic fashion is nothing other than a way of uncovering the preincarnational traces of the Word that has now been gloriously and fully revealed to the world in Jesus."[14]

It is clear, then, that the counter-reductionism of the Fourth Gospel is kept in play by, among other things, techniques that we would naturally associate with the arts of poetry, fiction, and drama—metaphor, irony, symbolism, multiple allusion, intertextual resonances, and so forth. These are not simply rhetorical tricks of the trade. Rather, John seems to *require* them in order to unfold a theological worldview that by its nature refuses to construe God's world, and God's relation to it, in monodimensional terms. Hays widens the point beyond this particular Gospel: "To read Scripture well we must bid farewell to plodding literalism and rationalism in order to embrace *a complex poetic sensibility*."[15]

11. Thompson, *John: A Commentary*, 211.
12. Lincoln, *Gospel according to Saint John*, 285.
13. Hays, *Echoes of Scripture in the Gospels*, 354.
14. Hays, *Echoes of Scripture in the Gospels*, 355.
15. Hays, *Echoes of Scripture in the Gospels*, 360, italics added.

Causal Chains

We recall the inclination in naturalistic reductionism to read the physical world as a closed causal system.[16] It would obviously be wildly anachronistic to imagine that Jesus's opponents (the "Jews") were reductionists of this sort. Belief in a self-sufficient universe would have been quite foreign to them. Certainly, the Pharisees are skeptical about this miracle, but this has much more to do with Jesus breaking the Sabbath and the unprecedented nature of the healing of a congenitally blind man than with any kind of naturalistic worldview.[17] And the Pharisees' keenness to find a down-to-earth "explanation" is not due to a refusal to believe in the possibility of God's action in the world but to a reluctance to admit that this would-be Messiah could be doing God's works in their midst.

Nonetheless, it is striking how patterns of thought emerge in this story that prefigure some of the moves we find in modern naturalism, especially with regard to causation. Take, for example, the disciples' question: "Rabbi, who sinned, this man or his parents, that he was born blind?" (John 9:2; see also v. 34). This assumes a direct causal link between sin and suffering in line with a strong current in Jewish and ancient belief according to which the righteous will flourish and the wicked get their deserts: "I have been young and now am old, yet I have not seen the righteous forsaken or their children begging bread" (Ps. 37:25). Here is a blind man begging for bread; that means he or his parents must have sinned. The causal chain must hold. And the suggestion here is not only that this is how the world works but that even God is in some way bound to a similar logic of direct cause and effect.

Without denying the reality of divine judgment or divine action in the world, Jesus diverts his disciples' attention from such tight schemes: "Neither this man nor his parents sinned; he was born blind so that God's works might be revealed in him" (John 9:3). In other words, Jesus is pressing them to focus on the good that God will bring out of this suffering. In Lesslie Newbigin's words, "The only thing which can 'make sense' of a dark world is the coming of light, and the light does not come from below but from above, not from the past but from the future."[18] We can hardly forget that the Hebrew Scriptures (especially the book of Job) have already questioned the kind of logic that attempts to

16. We saw this also in the case of sociocultural, evolutionary, and instrumental reductionism (see above, chap. 2).

17. "Never since the world began has it been heard that anyone opened the eyes of a person born blind" (John 9:32).

18. Newbigin, *Light Has Come*, 120.

"make sense" of evil and suffering by tracing lines of unbroken causation from the past.

Control and Mastery

Finally, it is hard not to notice the profound drive toward control and mastery laid bare in this mini-drama. The miracle occurs in a world ruled by fear. The blind man's parents "fear the authorities, and the 'authorities' fear for their authority."[19] The Pharisees are understandably fearful about a situation outside their direct influence, beyond what they can contain and manage, raising a series of dilemmas that their interrogations cannot resolve and their theology cannot explain. They are the ones convinced that they have the overview, that they have grasped how things really are with God and the world—enshrined in the law of Moses. And, like all guardians of an established order, they fight to preserve their privileged position. Hence the intensity of their questioning of the blind man and his parents.

Contrast the willingness of the blind man to admit his ignorance—"I do not know"—and to let the implications of his healing steadily dawn on him. Contrast too Jesus's own apparent freedom from the need to fix things or sort out the controversy quickly; he is not even present for the main debate between his opponents and the blind man. Irony of ironies: he is in supreme control, but not as one who needs to dominate—only as one who is himself liberated and lives to liberate others.

19. Newbigin, *Light Has Come*, 122.

4

Reductionism's Peculiarities

Physics cannot tell us why Biology exists.

Mariam Thalos[1]

It is quite reasonable for work within a field to take on a variety of explanatory forms, some of these "thick" and some of these "thin" and for these at the same time to preserve legitimate independent explanatory roles.

Catherine Driscoll[2]

After her first daughter was born, a friend of mine . . . told me, "I found I loved her more than evolution required."

David Brooks[3]

If our small minds, for some convenience, divide this glass of wine, this universe, into parts—physics, biology, geology, astronomy, psychology, and so on—remember that nature does not know it! So let us put it all back together, not forgetting ultimately what it is for. Let it give us one more final pleasure; drink it and forget it all!

Richard Feynman[4]

1. Thalos, *Without Hierarchy*, 26.
2. Driscoll, "Cultural Evolution and the Social Sciences," 7.
3. Brooks, *Second Mountain*, 42.
4. Feynman, *Feynman Lectures on Physics*, chap. 3, part 7.

The brief interruption from John 9 brings to the fore an acute contrast, perhaps even dissonance, between the world as imagined there and the world as imagined under the dominance of reductionist drives. In itself this does not, of course, prove anything, and the hard-line reductionist who has rejected the possibility of God will likely regard the biblical text as merely a relic from a bygone age. But we might at least be prompted by the contrast to ask some pointed questions about how far reductionist drives of the sort we have been examining can be viably sustained.

A good way of bringing these questions to the surface is to return to the brand of reductionism we examined in chapter 1—naturalistic reductionism (NR). To recap: NR names the belief that there are no extra-physical properties or entities (which, of course, excludes God); that it is the natural sciences—physics above all—that provide secure and reliable knowledge of the complete inventory of reality; and that all complex wholes and properties can be entirely reduced to (explained by) their constituent parts. Naturalistic reductionism has been met with a formidable array of scientific and philosophical criticism from numerous quarters, ranging from the respectful and probing to the mocking and dismissive.[5] There is no need to rehearse the well-established critiques here, though we shall be drawing on a few of them in what follows. Rather, in the first part of this chapter I want to expose the *peculiarities* or oddities that arise if the ambitions of NR are followed through—not only the strange intellectual positions we are forced to adopt but also the curious consequences of NR for the everyday business of living in the world as embodied and social creatures. Even on a generous reading, we are quickly led toward what would appear to be radically counterintuitive and impractical conclusions, and in the process we are expected to disregard widely held, basic intuitions about the world and our experience of it. Similar things can be said of the attempts to apply reductive pressures to the arts (examined in chap. 2), and this will be our concern in the second part of this chapter.

There are two kinds of peculiarity I want to highlight in particular. First is the tendency toward positions that are *self-undermining*—not only paradoxes, impasses, or aporias but also stances that are incoherent and self-refuting. Second, bound up with this is a pronounced *narrowness of vision*, a highly restricted

5. Among the most compelling in my view are Cunningham, *Darwin's Pious Idea*; Cunningham, "Who's Afraid of Reductionism's Wolf?," 51–79; Midgley, *Are You an Illusion?*; Tallis, *Reflections of a Metaphysical Flâneur*; Baker, *Naturalism and the First-Person Perspective*.

view of what needs accounting for. (This lines up especially with what we have called reductionism's "exclusionary simplicity.") The problem is not simply that widely recognized features and dimensions of the physical world are ignored but that even when these are acknowledged there is a failure to offer a reading of them that resonates convincingly with sizable tracts of our everyday experience.

Exposing these peculiarities is not on its own sufficient to refute this or that reductionism, but it might well indicate that there is something seriously awry about the pressures propelling the reductive imagination. This will pave the way for our later reflections on the arts. The arts do not challenge reductionism by presenting new empirical evidence or a fresh set of philosophical arguments; rather, they habitually resist the energy and direction of its characteristic drives. In this way, they can serve to jolt us out of the belief that a reductive thought style is obligatory for a truthful and fruitful encounter with the world we inhabit—and this, I contend, is something of considerable theological import.

Naturalistic Reductionism Revisited

Stratification, Basements, and Top Stories

We can begin by returning to the stratified model of reality outlined in chapter 1. As we saw, for the adherents of NR, all complex wholes can be explained and described adequately in terms of their constituent parts. In this view, it is fallacious to hold that there are composite wholes at the "upper" levels that possess properties beyond those of the "lowest" level particles of which they are constituted, or that such upper-level properties possess causal power. Needless to say, any kind of nonphysical substance with causal power will also be disallowed. The simple particle level at which physics operates is the "really real," and causation operates at that level alone.

As a tool for highlighting the ways in which different phenomena invite different kinds of explanation and understanding, a multilevel model of this sort can undoubtedly be illuminating. But caution is needed. Let us examine the assumption, widespread among naturalistic reductionists, that there is an identifiable lowest level of the physical world. The hierarchical vision of the unity of science famously propounded by Paul Oppenheim and Hilary Putnam in the 1950s depends on postulating just such a fundamental tier: the level of elementary particles.[6] There are ancient historical precedents for such a view.

6. Oppenheim and Putnam, "Unity of Science," 9–10.

Greek and Roman natural philosophers such as Democritus, Epicurus, and Lucretius were committed to the notion that everything in the universe, from the largest stars down to the smallest creatures, consists of atoms (Gk. *atomos*, "uncuttable") bouncing off each other, flying apart, and recomposing.[7]

For many contemporary reductionists, these "uncuttables" are precisely those studied by particle physics. But if we take an ontological elevator and head down to the supposed basement, we find that things are much less solid than this suggests. What we habitually call "matter" appears to be far from stuff-like.[8] On scientific grounds, Jonathan Schaffer has argued for a theory of "infinite descent," contending that there is no cogent reason to believe that

1. there will be a complete microphysics,

2. the complete microphysics will postulate particles, and

3. these particles are the mereological atoms.[9]

In challenging the kind of comprehensive microphysics he has in his sights, Schaffer believes he has history on his side: "The history of science is a history of finding ever-deeper structure. We have gone from 'the elements' to 'the atoms' . . . to the subatomic electrons, protons, and neutrons, to the zoo of 'elementary particles,' to thinking that the hadrons are built out of quarks, and now we are sometimes promised that these entities are really strings, while some hypothesize that the quarks are built out of protons (in order to explain why quarks come in families). Should one not expect the future to be like the past?"[10] In other words, the low-level phenomena in the hierarchy seem to be no more "solid" than the emergent phenomena higher up the ladder. Philosopher of science Michel Bitbol comments: "If the message of quantum physics

7. Berryman, "Ancient Atomism."

8. Tim Crane and D. H. Mellor tell the story:

In its seventeenth-century form of mechanism, . . . materialism was a metaphysical doctrine: it attempted to limit physics a priori by requiring matter to be solid, inert, impenetrable and conserved, and to interact deterministically and only on contact. But as it has subsequently developed, physics has shown this conception of matter to be wrong in almost every respect: the 'matter' of modern physics is not all solid, or inert, or impenetrable, or conserved; and it interacts indeterministically and arguably sometimes at a distance. Faced with these discoveries, materialism's modern descendants have understandably lost their metaphysical nerve. (Crane and Mellor, "There Is No Question of Physicalism," 186)

9. Schaffer, "Is There a Fundamental Level?," 502. "Mereological" here means pertaining to parts that make up a whole.

10. Schaffer, "Is There a Fundamental Level?," 503.

is taken seriously, the critique of reification concerns not only the high-level properties but also the low-level properties; not only the emerging properties, but also the properties of the so-called basic constituents of the world. The reductionist eventually loses the game, because her so-called 'reduction basis' is as firm as quicksand, and because it proves quite easy in this case to put the emergent behaviour on exactly the same footing as the so-called 'elementary' entities and laws."[11]

Someone may understandably object that this kind of argument merely reveals the limitations and provisionality of physics as it stands today. *In principle*, given enough white coats and lab hours, all will be shown to be reducible to identifiable, wholly irreducible particles. But this of course prompts the question: Where does *this* "principle" come from? It does not seem to be an axiom that follows from or is required by physics.

Similar challenges confront us if we take the elevator upward. Does the hierarchy have a top story? Consider emergence again. At least some emergentists, we recall, want to offer a third way beyond NR, on the one hand, and belief in nonmaterial causal powers, on the other. They point to what appear to be irreducible, novel phenomena of various degrees of complexity emerging in the history of the physical world. The advantages of emergentism over NR are considerable. Emergentism challenges the assumption that lower-level explanations always yield the fullest or most comprehensive explanation of things.[12] It recognizes that different levels of reality require different kinds of explanation, and that this means giving each level a certain ontological dignity.[13] It allows "upper-level" entities to have causal powers. But care is needed, for it seems that even emergentists can be prone to assuming the strong ontological superiority of one particular level and, with this, supposing that the physical world will always adhere to some kind of strictly ordered hierarchy of inferiority and superiority. The relevant arguments are complex and too intricate to consider in detail here, but suffice it to say that on empirical grounds, there is no reason to presume a tidy system in which some ontologically superior level causes and determines all else, and there is ample evidence for both top-down *and*

11. Bitbol, "Ontology, Matter and Emergence," 302.

12. "What is truly significant about emergent phenomena is that we supposedly *cannot* appeal to microstructures in explaining or predicting these phenomena even though they are constituted by them" (Friskics-Warren, *I'll Take You There*, 92, italics original).

13. "Embryology is about embryos. It is not designed, like physics, to deal with every kind of physical matter. So it uses forms that suit its particular topic. And so does every other special branch of science" (Midgley, *What Is Philosophy For?*, 94).

bottom-up causation. "At times the macro is in charge, while at other times the micro is."[14] Bitbol comments, "In modern cosmology, . . . the observable features of the 'elementary' particles are just as much determined by global features of the universe than the other way around."[15]

With particular developments in modern physics in mind, Bitbol asks, "What if the so-called 'substrate properties' happen to be just as much configurational as the high level features?"[16] This would mean that there is no fundamental structural disparity between the components (and properties) of different levels. The multilevel hierarchical picture could well be inverted: we need not allow the connotation of the term *base* (i.e., being the foundation) to push us into imagining that microparticles are somehow more real or significant than macro entities. Why should we presume that smaller things are more significant than larger things? We might just as well situate more complex entities at a lower level than simpler ones. All of this makes one wonder whether we need to be wary of reifying the multilevel model into a metaphysical structure, however useful it may be for certain purposes.

If I have interpreted these findings correctly, NR presents us with a striking example of the second of our two types of peculiarity: a narrowness of vision and a corresponding narrowness of explanatory power. Though it purportedly takes its cues from natural science, NR cannot account convincingly for at least some phenomena acknowledged by science's practitioners.

Mechanisms and Consciousness

To expose another of NR's peculiarities, we can return to one of its most prominent metaphors: the machine. This image draws attention to the way in which the physical world operates in an orderly fashion according to laws and regularities, and to the way its parts are interrelated and work together toward

14. Cunningham, "Who's Afraid of Reductionism's Wolf?," 52. Expanding on this, Cunningham writes, "The example of the reduction of macroscopic thermodynamics to classical statistical mechanics is a telling demonstration of the impossibility of reducing macro to micro, or *vice versa*" (p. 60).

15. Bitbol, "Ontology, Matter and Emergence," 302.

16. Bitbol, "Ontology, Matter and Emergence," 303. Physics seems to be demonstrating, Bitbol continues, that "there is no essential difference between the alleged 'basic' level and the emergent levels. Every level of organization which falls within the domain of study of physics is thoroughly relational. And no level can claim for itself the privilege of being *for sure* the ultimate one; ultimate *and* monadic" (303, italics original). The ontology opened up here is therefore one in which "the overall process of which we partake by our actions and cognitive relations has no fundamental level on which everything else rests. It has *no absolute fundamental level* and *no absolute emergent level* either, but it has co-emergent order" (303, italics added).

certain ends, small-scale and large-scale. And yet its drawbacks are consider-able. The notion of the universe as a fundamentally closed system ruled entirely by the Newtonian laws of cause and effect, in which every event follows another in a wholly predictable manner, has been widely questioned by physicists. The weaknesses of the metaphor are revealed with particular clarity when it comes to the issue of causation. For the strict naturalistic reductionist, we recall, all causes are to be reduced to physical efficient causes: one bit of matter collides with, and produces an effect in, another. Final causes—ends and purposes—do not need to be invoked (and should not be) in accounts of why things happen in the way they do. This obviously rules out any divine purposive agency. But just as seriously, it puts the status of human agency into question.[17]

Here we are pushed toward conclusions that are as counterintuitive as they are far-reaching, and that exclude phenomena that would seem to cry out for some kind of alternative description and explanation. Take, for example, the vexed matter of mind and consciousness, and the associated concepts of will, belief, and intention.[18] We have already alluded to attempts to regard such phe-nomena as lacking reality—for the eliminativist, as wholly lacking existence—on the grounds that reports of consciousness take the form of first-person utter-ances about mental states ("I believe," "I feel," "I remember"), which, unlike the brain states that accompany them, cannot be objects of empirical study. The physical sciences—the disciplines that inform us about what is (and is not) real—trade in third-person language alone. The problems with this become sharpest if we consider the "intentionality" or "aboutness" of consciousness. Consciousness is directed, oriented toward the objects of thought, belief, desire, and so forth. Yet intentionality cannot be observed as such by the empirical scientist for the simple reason that intentionality is not a physical entity or a relation to be observed but an operation of the mind.

The incoherences spawn rapidly. For example, it is hard to make sense of what is entailed in having a belief. Beliefs are oriented toward states of affairs in such a way that they can be judged true or false, correct or incorrect. A brain

17. Thomas Pfau, summarizing a current of thought in Hobbes, Locke, Mandeville, and Hume, writes, "Reductionist accounts tend to beg the question of action and agency on a large scale, quite simply because from the outset they can only accept as 'proof' something that must be non-human, a-semantic, a-rational, and ultimately unintelligible; reductionism begins by posit-ing (without arguing the point) that all causation is mechanical, rather than something imagined, reasoned, chosen, and enacted" (Pfau, *Minding the Modern*, 20).

18. For an astute discussion of these issues, especially in relation to eighteenth-century phi-losophy, see Pfau, *Minding the Modern*, chap. 11.

(considered simply as a physical organ) cannot be true or false, correct or incorrect. Indeed, a brain considered solely as a machine cannot be right or wrong—nor can a brain event. How can I claim that my belief is true and at the same time hold that my beliefs are no more than brain events?[19] This difficulty applies especially to the scientist. If all that exists is the totality of physical facts, there can be no intentional facts (beliefs, desires, thoughts, preferences, and so forth) and no intentional agents—agents whose beliefs can be true or false. This would seem to cut against what most scientists think of themselves as doing in their day jobs. If there can be no intentional agents, there can be no spoken or written statements that can tell the truth, and this destabilizes any attempt to articulate a theory of mind that is being proposed as *true.*[20]

I am fully aware that proponents of extreme reductive strategies are cognizant of these weaknesses, and many have marshaled arguments to meet them. I am also aware that whatever position one adopts, numerous problems surrounding the philosophy of mind permit no straightforward solution. Consciousness is an immensely complex phenomenon. Nonetheless, our main contention does, I believe, stand: when applied to matters of mind and consciousness, reductionist drives do seem to direct us relatively quickly to positions that will be widely regarded as incoherent, and to involve narrowly focused perspectives with severely attenuated explanatory power. The words of Marilynne Robinson seem especially apt in this context: "Assuming that there is indeed a modern malaise, one contributing factor might be the exclusion of the felt life of the

19. "The successors of modern nominalism share at least one aim: viz., to expunge the idea of human interiority and introspection altogether by driving a wedge between the phenomenological *event* of a thought (deemed inaccessible and thus irrelevant to empirical inquiry), and its *content*—judged real and pertinent only insofar as it can be objectively captured either as an ordinary-language proposition, a statistically observable behavioral pattern, or a measurable neural event" (Pfau, *Minding the Modern*, 329, italics original).

20. Especially relevant to this discussion is the work of the philosopher Lynne Rudder Baker on what she calls a "robust first-person perspective" (Baker, *Naturalism and the First-Person Perspective*). Her arguments are dense and involved, but the basic thrust is always clear. By a "robust first-person perspective," Baker means the capacity, unique to humans, "to think of oneself, conceived in the first person, as the object of one's thought," the ability to identify an "I" whose perspective is distinct from (though similar to) the perspective of the "you." This is manifest "with every thought, utterance, or action that exhibits self-consciousness" (p. xx). The word "robust" distinguishes this form of first-person perspective from the "rudimentary" form found in nonhumans (pp. 30–31). Baker describes this first-person perspective as a *disposition* that can neither be reduced to something non-perspectival or non-first-personal by science nor be eliminated by scientific inquiry. Knowledge of the underlying mechanism of this perspective would not explain (or explain away) the phenomenon itself. Moreover, this robust first-person perspective has causal powers, and an individual with such a perspective is in this way acting as an irreducible agent: a person.

mind from the accounts of reality proposed by the oddly authoritative and deeply influential parascientific literature that has long associated itself with intellectual progress, and the exclusion of felt life from the varieties of thought and art that reflect the influence of these accounts."[21]

Objectivity and Language

Related peculiarities appear when we probe the notion of "objectivity" that is so integral to NR's vision. We have noted that the paradigmatic epistemic stance demanded by NR requires the radical exclusion of the "I."[22] As far as scientific discovery is concerned, a first-person perspective is an intrusion into a place where it does not belong, and can only serve to hinder fruitful exploration. Reliable knowledge can be secured only insofar as the knower's first-person experience—stances, interests, beliefs, attitudes, bodily awareness—is ruthlessly excised from the process of inquiry.

There is, of course, something vital to be heeded here: the potentially distorting effects of one's interests and agendas. The scientist aspires to find theories that can be universally held, formulations of truth that are not tied to this or that particular person, society, or culture. But the notion that authentic knowledge can best be attained by eradicating all elements of personal commitment and self-involvement on the part of the knower, according to an ideal of disengaged "objectivity"—despite its deep and persistent hold in the intellectual history of modernity—has been challenged on multiple fronts.[23] It is—yet again—self-undermining, since holding this epistemology in the first place depends on first-person consciousness, will, purpose, embodiment, and social commitments. And it seems unable to account for how flesh-and-blood scientists actually go about their work. As Connor Cunningham nicely puts it, "Science is itself the opposite of what it produces. For it may well be the great vivisectionist—it may well turn nature into a corpse, . . . but it does so from a position that is otherwise than dead. For science is *itself* a moment of life."[24]

Related points can be made about language. NR privileges a distinctive kind of descriptive and explanatory discourse when it comes to matters of truth—a third-person language of precision, clarity, and logical coherence, with (as

21. Robinson, *Absence of Mind*, 35.
22. See under "Mechanical and Impersonal" in chap. 1.
23. The literature is vast. Perhaps the most perceptive and penetrating writer in this regard is the scientist Michael Polanyi (1886–1964). See, e.g., Polanyi, *Personal Knowledge*; Polanyi, *Tacit Dimension*.
24. Cunningham, *Darwin's Pious Idea*, 312, italics added.

far as possible) singular, easily identifiable meanings attached to the spoken or written words employed. Figurative language—which is typically multiply suggestive, allusive, and (in many cases) first-person—must be set to one side. We will have much to say about this in a later chapter, but for the moment it is simply worth underlining the remarkable narrowness of this prescription. For example, it excludes language that practicing scientists are generally prepared to regard as legitimate (the crucial role of metaphor in natural science has long been recognized), and it is quite unable to accommodate vast swaths of language we would normally regard as capable of providing reliable access to concrete states of affairs beyond the language-user (metaphor, allegory, simile, etc.).

Control and Mastery

I alluded at the end of chapter 1 to the way NR inevitably gestures toward a stance or disposition of "management" vis-à-vis the physical world—and, indeed, other humans. It is committed to an all-encompassing ontology, an account of the constitution of all that is and ever could be, which puts us in a singularly advantageous position when it comes to arranging things as we would like them to be. A double oddity emerges here. In the first place, such an account can be properly given only from a position outside the totality of reality, a location not actually possible to attain as long as we are creatures of space and time. That is to say, NR is committed to the exclusion of any nonfinite reality, and yet it relies for its coherence on taking up a stance that would seem to transcend finitude.[25] The second oddity is that NR is recommended in the name of science, yet it is not required by science (it neither follows from nor needs to be presupposed by it) and potentially undermines what is arguably one of the keys to science's immense success: its concern with finite, empirically identifiable, physical contingencies. It is beyond the scientist's capacity qua scientist to pronounce "from above" about the character of reality as a whole, or to make judgments about whether entities other than those accessible to its methods actually exist—and this is to science's advantage, not its detriment.

In summary, in this section I have tried to point to a double set of peculiarities presented by NR: it seems especially vulnerable to inconsistencies, amounting

25. "Naturalism is a picture of the whole of reality that cannot, according to its own intrinsic premises, address the being of the whole; it is a metaphysics of the rejection of metaphysics, a transcendental certainty of the impossibility of transcendental truth" (Hart, *Experience of God*, 77).

at times to positions that are plainly self-undermining and incoherent, and it betrays a narrowness of outlook that excludes or quickly dismisses phenomena that it cannot readily account for within its own parameters but that none-theless seem to cry out for attention and some kind of explanation. We may understandably question whether its leading pressures, directed as they are to particular ideals, are symptomatic of a deep-rooted malaise, one that can be countered only by abandoning some of the imaginative positions and moves that NR takes for granted.

Reductionism in the Arts Revisited

As we might expect, when reductive pressures are applied to the arts we also find no shortage of peculiarities. Indeed, we are oriented in some very strange directions, in some cases toward bizarre end points. In chapter 2 we outlined four types of reductionism that commonly appear in discourses surrounding the arts. We can now take up each in turn and point out some of the oddities that emerge when their leading assumptions are examined and their aspirations followed through. Again, there seems to be a proneness to incoherence and a strangely restricted vision of what calls out for attention and explanation.

Evolutionary Reductionism

With regard to evolutionary reductionism, we saw that its major thrust is toward finding a neo-Darwinian account of artistic activity, understood in terms of the physical battle for survival, whether through adaptation or exaptation. In its stronger forms this means finding a theory that *wholly* accounts for both the origin and the continuation of this or that artistic practice.

The most obvious sign that something is off-kilter here is the widespread reli-ance among evolutionary theorists on a strict naturalism that rigorously excludes any conception of intention or purpose. As many have pointed out, as long as one works with this exclusion, there is surprisingly little reason to have a robust confidence that the theory of evolution *itself* is true. For a consistent naturalist, the forces of the physical world are blind, directionless, and purposeless. If they do happen to point to any goal or end, that is purely by accident. But if that is the case, the chances of a human mind appearing that is capable of entertain-ing true beliefs are minute, to say the least.[26] And of course "true beliefs," in an

26. Hart, *Experience of God*, 154.

evolutionary naturalist's account, would have to include belief in evolution.[27] Evolution in Darwinian terms is concerned with advantage and survival, and the question of survival is logically distinct from the question of truth.[28] That a belief aids survival does not of itself tell us anything about its truth.[29]

Also prominent in naturalist evolutionary theories of the arts is the belief that causation can operate only from the bottom up—the base level in this case being the biological. But we have already seen that this restriction on causality is not self-evident. Indeed, there seems to be no strong reason to rule out the possibility that culture can affect biology.[30] A lucid critique of evolutionary reductionism by Jean Lachapelle develops the point well. Natural selection may have brought about culture, he writes, "but in doing so it brought about a system which enjoys a certain causal autonomy, a 'life of its own.'"[31] Lachapelle contends that "*there need not be one physical basis* underlying a given cultural phenomenon, however 'universal' it may be. There is a vast number of physical ways through which . . . cultural phenomena . . . can be realized, and variations at the level of cultural evolution need not be strictly correlated with a given set of variations at the physical level."[32] He continues, "There seems to be little

27. This is something that famously seems to have troubled Darwin himself: "With me the horrid doubt always arises whether the convictions of man's mind, which has been developed from the mind of the lowest animals, are of any value or at all trustworthy" (quoted in Plantinga, *Where the Conflict Really Lies*, 316).

28. Patricia Churchland, a naturalist, is often quoted in this connection: "The principle chore of the nervous system is to get the body parts where they should be in order that the organism may survive. . . . Improvements in sensorimotor control confer an evolutionary advantage: a fancier style of representing is advantageous *so long as it is geared to the organism's way of life and enhances the organism's chances of survival*. Truth, whatever that is, definitely takes the hindmost" (Churchland, "Epistemology in the Age of Neuroscience," 549, italics original).

29. As Jerry Fodor puts it, "Evolution [in Darwinian terms] doesn't care whether most of our beliefs are true" (Fodor, *In Critical Condition*, 201). Daniel Dennett's riposte to this is to insist that "the capacity to believe would have no survival value unless it was a capacity to believe truths" (Dennett, *Brainstorms*, 17). But that is far from self-evident. In principle, it would seem possible to entertain beliefs that help us survive without them necessarily being true. Moreover, if naturalistic reductionists are correct when they claim that only since Darwin have we begun to understand the true nature and origins of humanity, then "most of our beliefs have been false for millennia" (Cunningham, *Darwin's Pious Idea*, 214). It was with these considerations in mind that the Reformed philosopher Alvin Plantinga elaborated what has become a justly famous rejoinder to antitheological naturalism (Plantinga, *Where the Conflict Really Lies*, chap. 10). David Bentley Hart speaks of "the delightful paradox" that "if naturalism is true as a picture of reality, it is necessarily false as a philosophical precept; for no one's belief in the truth of naturalism could correspond to reality except through a shocking coincidence (or, better, a miracle)" (Hart, *Experience of God*, 18).

30. See Causadias, Telzer, and Lee, "Culture and Biology Interplay"; Lachapelle, "Cultural Evolution," 345–48.

31. Lachapelle, "Cultural Evolution," 349.

32. Lachapelle, "Cultural Evolution," 341, italics added.

grounds for thinking that lower-level accounts are necessarily more explana-
tory than higher-level ones."[33] Lachapelle advocates an "explanatory pluralism"
that allows for downward *and* upward causation: "Explanatory pluralism is
the view that explanations in terms of both processes are not only possible but
equally justified—none having the privilege to always outweigh the other."[34]
Hence, "different evolutionary phenomena, resulting from different processes
and thus having different causes, require different types of explanations."[35] With
all this in mind—and considering the enormous variety of roles the arts play in
human life, the diversity of practices they involve, and the leading part human
intentions play in artistic creativity—to explain all artistic activity in terms of
biological drives and needs alone (perhaps bolstered by an appeal to chemical
and physical factors) seems drastically narrow.[36]

Further, one of the most notable features of this discourse is the swing toward
some variety of determinism in order to sustain its claims. As Rowan Williams
puts it, "One of the greatest misunderstandings of popular modernity is the notion
that when we have, like good Darwinians, identified the function of various de-
velopments in various life-forms, we have thereby demonstrated their necessity;
when the truth is that we have not begun to answer the question, 'Why precisely
this?' or 'Was this the only possible resolution to an evolutionary conundrum?'"[37]
As far as the arts are concerned, the more we are attracted to a machinelike ontol-
ogy of necessity, the harder it is to make sense of a huge amount that comes under
the umbrella of "the arts." Alva Noë comments, "The trouble . . . with evolution-
ary theories of art is that they tend to be empty. They don't tell us why we make
art or why art is valuable to us."[38] Indeed, there is a great deal of artistic activity

33. Lachapelle, "Cultural Evolution," 341.
34. Lachapelle, "Cultural Evolution," 350.
35. Lachapelle, "Cultural Evolution," 351. The case for downward causation in the relatively
new field of "biological physics" is well presented by Tom McLeish in "Strong Emergence and
Downward Causation in Biological Physics."
36. "Art is simply too complicated to be explained as a mere fulfilment of instincts" (Milliner,
"Art and the Apophatic Horizon").
37. Williams, *Grace and Necessity*, 156. The vaulting aspirations some invest in the power of
genetics to deliver comprehensive accounts of human behavior are by no means universally shared
by contemporary biologists. Simon Conway Morris, Professor Emeritus of Paleobiology at the
University of Cambridge, even goes as far as to say that "claims for the primacy of the gene have
distorted the whole of biology" (Morris, *Life's Solution*, 238). It is worth noting that Dawkins's and
Dennett's theories of the "meme" (the cultural counterpart of the gene) have met with sustained
skepticism and even derision from many within the biological science community.
38. Noë, *Strange Tools*, 61. This, say some, is the key problem with "neuroaesthetics" (see
above, chap. 2, note 16). Bevil Conway and Alexander Rehding note that "rational reductionist
approaches to the neural basis for beauty run a . . . risk of pushing the round block of beauty into

that seems to have no particular evolutionary advantage—elaborating variations on a musical theme, photographing flowers, dancing *The Rite of Spring*. If it is claimed that these *must* be instances of exaptation, spin-offs of the evolutionary story, and that we *must* assume they have an origin in adaptation, we are bound to ask the obvious question of both: Why? The essayist and critic Louis Menand mischievously comments, "One suspects that enjoying Wagner, singing Wagner, anything to do with Wagner, is in gross excess of the requirements of natural selection. To say that music is the product of a gene for 'art-making,' naturally selected to impress potential mates . . . , is to say absolutely nothing about what makes any particular piece of music significant to human beings. No doubt Wagner wished to impress potential mates; who does not? It is a long way from there to 'Parsifal.'"[39] Along similar lines, after summarizing a recent attempt to explain art through appeal to adaptive selection, Noë remarks that "what such a view cannot explain is why art has values that *go beyond* those it may have in common with other sexual displays of the art mentioned."[40]

This is not to say that evolutionary science is bereft of wisdom when it comes to understanding the arts. Far from it. It is only to highlight that an overconfidence in evolutionary theory, especially the kind of confidence wedded by default to a naturalistic and deterministic ontology, lands us in puzzling positions that are hard to sustain coherently, and with a markedly blinkered view of what actually appears to need some explanation.

Sociocultural Reductionism

As we saw in chapter 2, in sociocultural reductionism we find a resolute focus on the constructive activity of specific social groups and on the social dynamics of power interests. In its strongest forms, this limits meaning to the human sphere alone (the world's significance is entirely exhausted by the meanings we ascribe to it), and to a highly constrained view of the human person (as shaped primarily, perhaps even exclusively, by particular social and cultural forces).

It would be foolish in the extreme to pretend we can in some way extricate our understanding of the arts from the contingencies of social and cultural life.

the square hole of science and may well distil out the very thing one wants to understand" (Conway and Rehding, "Neuroaesthetics and the Trouble with Beauty," 4). In Noë's words, "The problem is not that neuroaesthetics takes aim at our target and misses, but that it fails even to bring the target into focus" (Noë, *Strange Tools*, 96). See also his extended critique in *Strange Tools*, chap. 10.

39. Menand, "What Comes Naturally."

40. Noë, *Strange Tools*, 62, italics added.

Ideological, post-structuralist, and postcolonial critique, to take just three examples, have exposed the often-pernicious currents at work in celebrations of "great art," "timeless beauty," and the like. But constructivist fervor has a habit of swallowing up all interpretative options, and in ways that lead to some decidedly curious conclusions. Take, for example, the epistemic stance assumed in extreme versions of sociocultural reductionism, where the knower seems to be positioned at the opposite pole from the supposedly "objective" scientific inquirer. Here it is not human agency but the reality and status of extra-human phenomena that come into question—it seems there is nothing quite so real as our (socially formed and constructive) selves.[41] In an eminently lucid and thorough study of this ethos, the philosopher Sally Haslanger notes the ease with which comments about the causal role of social factors can tumble into highly dubious claims: for instance, when "P is socially caused" is taken to imply "P is less (or defectively) real." Further, she writes that

> in addition to the claims that race, gender, and sexuality are socially constructed, it is also claimed, for example, that "the subject," "identity," "knowledge," "truth," "nature," and "reality" are each socially constructed. On occasion it is possible to find the claim that "everything" is socially constructed or that it is socially constructed "all the way down." But once we come to the claim that *everything* is socially constructed, it appears a short step to the conclusion that there is no reality independent of our practices or of our language and that "truth" and "reality" are only fictions employed by the dominant to mask their power.[42]

She later observes that although we inevitably access the world via conceptual and linguistic media, this does not of itself say anything about the success of that access, or about the independent integrity of whatever is in view:

> Does it follow from the fact that our epistemic relation to the world is mediated (by language, by concepts, by our sensory system, etc.) that we cannot refer to things independent of us? Certainly not. Intermediaries do not necessarily block access: when I speak to my sister on the phone, our contact is mediated by a complicated phone system, but I still manage to speak *to her*. And intermediaries sometimes improve access: there are many things in the world I cannot see without my glasses, and there are many things I cannot recognize without my concepts.[43]

41. See the survey by Ron Mallon, "Naturalistic Approaches to Social Construction."
42. Haslanger, *Resisting Reality*, 83–84, italics original.
43. Haslanger, *Resisting Reality*, 154, italics original. Haslanger makes a useful distinction between *causal* and *constitutive* construction: "Something is causally constructed iff [if and only if]

Here Haslanger is doing what any philosopher of a broadly "realist" persuasion would do: challenging the slippage from the claim that all our knowledge, language, theorizing, and concepts (including the concept of truth) are socioculturally conditioned to the claim that they are socioculturally imprisoned (*contained*, we might say).[44] Indeed, it is hard to miss the heavy aura of determinism that seems to haunt this form of reductionism (though determinism will rarely be endorsed openly).

It is perhaps ironic that although constructivists fiercely oppose the reductionism that pictures human beings as prisoners of their microparticles, the impression often given is that in their case the determinism has simply shifted from the microphysical to the sociocultural level. Now it is physical and biological conditions that come under suspicion as causal factors in socialization and enculturation. And this brings its own oddities, the most obvious being that it is remarkably hard to live from day to day believing we are *entirely* controlled by social and cultural forces. Apart from anything else, it is difficult to offer a convincing account from this perspective of how genuine cultural *change* might be possible.

All this is of considerable relevance to the arts. A sociocultural reductionist will struggle to account for many of the things humans typically value about the arts, some of which appear (at least to *some* extent) to overcome (and even rise above) particular social and cultural determinants: originality and novelty, for example, or the arts' ability to speak across cultural divides or stop us in our tracks. Rita Felski puts this with characteristic punch when she speaks of the way hermeneutics can easily turn into "hermeneutering";[45] she comments that "over the last few decades, the rhetoric of 'social construction' has been weaponized to weaken the status of artworks, to downgrade them to a shadow of their former selves. . . . [But] the fabrication of things does not have to be played out *against* [human ties to artworks]—to diminish or undercut them—but

social factors play a causal role in bringing it into existence or, to some substantial extent, in its being the way it is. . . . Something is constitutively constructed iff in defining it we must make reference to social factors" (Haslanger, *Resisting Reality*, 87). Andrew Sayer notes that "the reductionist character of strong social constructionism is evident in the popularity of the hyperbolic metaphors of *construction* and *constitution*, as in the claim that the subject is 'constituted in discourse'" (Sayer, "Reductionism in Social Science," 13, italics original).

44. As Anthony O'Hear puts it, "Something which belongs, and necessarily belongs, to the way in which certain sentient beings perceive some physical reality, surely has for that very reason a perfectly good title to be thought of as part of what the world is really like" (O'Hear, *Element of Fire*, 9).

45. Felski, *Hooked*, 12.

can also be played out *with* them. . . . That ties to artworks must be made does not weaken their value; that we help create the work does not mean it cannot surprise us."[46]

Certainly, we need to be alert to the hazards that go with talk of "essentials," "universals," "nature," the "natural." But anxieties about such dangers can be drastically overplayed. Even putting aside questions of *extra*-worldly universals, awkward issues are bound to arise. Take, for example, the matter of physical and biological constraints. Why should we presume a priori that nothing can have any significance or value independent of its cultural significance? Why should the artist construe matter as mere "stuff," randomly ordered clusters of particles waiting to be formed by us into meaningful wholes? Why can we not account for a sculpture in ways that take account *both* of its sociocultural formation *and* of the ways it draws on distinctive features of its medium (stone, clay, bronze)? Why should we assume that the integrity of the materials an artist engages—pigment, paint, gold leaf, a vibrating string—cannot be regarded as comprising both patterns *and* particles, and, moreover, patterns that are unavoidably part of the process of sociocultural meaning-making? What the wood of a violin can and cannot do is part of what makes Tchaikovsky's violin concerto the piece that it is. This fact stands at the heart of the concept of material causation, which we discussed earlier. Similar things could be said of our biological constitution as culture- or art-makers. Noting that some insist "our natural environment has been thoroughly transformed by earlier human action, and thus is already cultural, rather than belonging to some extra-cultural realm," sociologist Andrew Sayer responds, "Although this is undoubtedly the case, these transformations and the environments and artefacts they produce are enabled and constrained by the properties of the physical and biological processes involved, and do not break their laws. While they are cultural in the sense that, insofar as the transformations are registered by people, they are culturally construed, informed and guided, they are nevertheless not reducible to their cultural significance but are dependent on physical powers which could and have existed independently of cultural interpretations."[47]

The case of music seems especially pertinent here. In chapter 2 we noted the way many theorists are understandably wary of attempts to "essentialize" music, of naive appeals to "nature" (appeals that so often carry destructive

46. Felski, *Hooked*, 6, italics original.
47. Sayer, "Reductionism in Social Science," 11.

Western European assumptions about race and gender).[48] But pendulum-swing reactions can be just as disingenuous and just as naive as the positions being opposed. For example, the unqualified pronouncement that there are *no* musical universals is surely no less simplistic than the confident claims to have decisively identified them, and the same goes for the stronger assertion that there *cannot* be universals of any sort (an obviously self-undermining position). As it happens, outside the confines of late Western modernity the belief that music can engage and develop dynamic patterns of activity engrained in the physical world, and that this is one of its most fruitful capacities, has been remarkably pervasive. This might prod us to wonder whether the current hyper-*suspicion* surrounding the notion of musical universals is more in thrall to Western hegemony than attempts to address the issue as a matter of serious concern.

Leaving aside the knotty question of how to define *universal*, one can at least point to substantial evidence indicating that all human societies engage in musical behaviors of some sort and that in these behaviors, certain sound structures (discrete pitches, octave equivalence, phrase structures, musical scales, etc.) and certain actions associated with sound patterns (the functions and roles of music, bodily movement, etc.) are remarkably widespread. Moreover, there is good reason to suppose that these are in many cases related not only to the constitution of the extra-human physical materials that music involves (air vibrations, animal skin, wood, and so forth) but also to our biological predispositions.[49] The obvious question that surfaces here is: Why should we be *so* keen to believe otherwise?[50]

48. See under "Sociocultural Reductionism" in chap. 2.

49. Surveying the relevant material, Donald Hodges of the University of North Carolina concludes, "On balance, evidence supports the notion that biological and cultural aspects combine and interact to create whatever may be universal in music" (Hodges, "Music through the Lens of Cultural Neuroscience," 31).

50. The literature on these themes is vast. But for concise treatments, see Trehub, Becker, and Morley, "Cross-Cultural Perspectives on Music." Iain Morley summarizes a mass of research in this way:

> It would appear that musical behaviours amongst all humans involve the encoding of sounds into pitches (usually between three and seven) which are unequally separated across the scale, including the perfect fifth, favouring consonance and harmony over dissonance, and organizing sequences of sounds so that they have a deliberate temporal relationship to each other. It is clear that although the cultural manifestations of these behaviours are very varied, frequently incorporating other features too, the variation builds upon a limited number of core common elements, which are derived from underlying biological predispositions. The ways in which these elements and their relations are used varies from culture to culture but the mechanisms required to make use of them, and to process that use, are universal,

It is worth noting that there is now a significant cohort of philosophers of music who have resisted the somewhat obsessive concentration on cultural formation that we find in some contemporary philosophy of music. They invite us to see music as a way in which we are enabled to inhabit our physical environment as physical creatures more deeply and fruitfully, and thus to attain a new form of "being-at-home" in the world.[51] We might also mention the so-called "ontological turn" in sound studies, a relatively recent development that has sharply challenged what is seen as a sociocultural fixation among music theorists.[52] Its proponents want to reclaim a sense of the "prior" integrity of sound—prior, that is, to humans, both temporally and ontologically. One of the best known, Christoph Cox, propounds "the notion of sound as an immemorial material flow to which human expressions contribute but that *precedes* and *exceeds* those expressions."[53] Simply put, there was sound before humans did anything with it. Whatever questions we may have about this movement,[54] what is striking from our perspective is the urge to recover at least some sense of a "givenness" to sonic order, pushing against the idea that "the material real offers no ontological resistance, that it can be carved into whatever shape suits a subject, culture, or language."[55]

To move from music to literature, we can return to Rita Felski, an author who never flinches from laying bare the peculiarities of reductive excess.[56] As we

varying only in their application relative to the conventions of the culture. (Morley, *Prehistory of Music*, 7)

51. See, e.g., Johnson, "Music Language Indwelling."

52. See, e.g., Goodman, *Sonic Warfare*; Cox, *Sonic Flux*; Hainge, *Noise Matters*. This current of thought is often associated with a so-called "new materialism" in the humanities and social sciences. "The general consensus seems to be that new materialism embraces a non-anthropocentric realism grounded in a shift from epistemology to ontology and the recognition of matter's intrinsic activity" (Gamble, Hanan, and Nail, "What Is New Materialism?," 118).

53. Cox, *Sonic Flux*, 2, italics added.

54. The metaphysics of a primordial flux that grounds some presentations of this outlook, drawing on Leibniz and Deleuze, among others, is to my mind far from convincing. For a critique, see Kane, "Sound Studies without Auditory Culture." For a spirited defense of the ontological turn against its critics, see Cox, "Sonic Realism and Auditory Culture."

55. Cox, "Sonic Realism and Auditory Culture," 236. Cox and others are aware that "sonic realism" of this kind will invite fierce critique. It will be claimed, for example, "that the turn to ontology amounts to an occlusion of the social and the political; and that new realism and the ontological turn—in general and in sound studies—implicitly naturalize and universalize a historically and culturally specific subject position, that of the white, European man" (Cox, "Sonic Realism and Auditory Culture," 235). In response, Cox insists that ontology per se cannot be spirited away simply because a certain approach to it (Western European) has been exploited to deleterious effect, and in any case, he argues, the new interest in the ontology of sound cannot be aligned neatly or exclusively with Whiteness or with any particular construction of masculinity (Cox, "Sonic Realism and Auditory Culture," 235).

56. Felski, *Limits of Critique*; Felski, *Hooked*.

noted in chapter 2, she draws attention to the dominant tone of "critique" in her field, with its ardor to expose the negative and excavate the hidden dangers of texts. The problem with this, she thinks, is not so much its validity as its bloated ambition. Her study *The Limits of Critique* is in large part an anti-reductionist plea, as evidenced by the metaphors that crop up on virtually every page. She wants to make "the case for a less hemmed-in and less rigidly constricted model of meaning that gives texts room to breathe"[57] and to "free up literary studies to embrace a wider range of affective styles and modes of argument."[58] She asks, "What if critique were limited, not limitless; if it were finite and fallible; if we conceded that it does some things well and other things poorly or not at all?"[59] As Felski sees it, "Literary scholars are confusing a part of thought with the whole of thought, and . . . in doing so we are scanting a range of intellectual and expressive possibilities."[60]

Especially pointed is Felski's treatment of the matter of context. She queries what she views as a curious assumption among some literary scholars that context is akin to a "historical container in which individual texts are encased and held fast"[61] and a no-less-curious reluctance to admit that a piece of literature might trigger fruitful resonances beyond and outside its original cultural setting. To recognize that artworks are embedded in contexts need not diminish their distinctive potency: "Works of art cannot help being social, sociable, connected, worldly, immanent—and yet they can *also* be felt, without contradiction, to be incandescent, extraordinary, sublime, utterly special. Their singularity and their sociability are interconnected, not opposed."[62] Perhaps most striking is Felski's concern not to lose sight of why anyone might want to read literature at all. Doubtless, she says, some forms of our speech are inspired by "self-delusion or misperception; others may bully or browbeat, or exclude. Yet they can also forge new attachments and solidarities, renounce or reaffirm past histories, offer fresh angles of vision or reaffirm crucial but long-forgotten insights."[63]

Might it be possible to combine a sense of the "critical" with an awareness that the text can deliver far more than can be gleaned by adopting a critical stance

57. Felski, *Limits of Critique*, 161.
58. Felski, *Limits of Critique*, 3.
59. Felski, *Limits of Critique*, 8.
60. Felski, *Limits of Critique*, 5.
61. Felski, *Limits of Critique*, 155.
62. Felski, *Limits of Critique*, 11, italics added.
63. Felski, *Limits of Critique*, 79.

alone? Felski quotes Michel Chaouli of the Department of Germanic Studies at Indiana University, who marvels at "the lengths to which we [scholars] go to keep at bay the force of artworks, the same artworks whose ability to snap us out of our torpor drew us into them in the first place."[64] In another place, she comments, "Any talk of loving literature seems jejune to most English professors, guaranteed to trigger a pained recoil or a moue of distaste."[65] Felski thus calls for a "post-critical" mode of interpretation, "one that is willing to recognize the potential of literature and art to create new imaginations rather than just to denounce mystifying illusions. The language of attachment, passion, and inspiration is no longer taboo."[66]

This reminds me of an incident that occurred during a course I once taught in the music department of a distinguished university. The module was designed for those pursuing a career in music, and most of the students had two years of academic musicology under their belts. I was struck by the almost squirming embarrassment of a student as he confessed to the class that he was actually excited and moved by the piece of music we were analyzing. I reminded him that it was probably something like this—certainly not his ability to unmask or decode a score—that put him on the vocational path he was now following.

It is worth adding that Felski frames her post-critical interpretation in a way that directly challenges reductionist drives: we do not want to "endorse a view of aesthetic experience as transcendent and timeless; but neither do [we] seek to demystify it by translating [it] into the categories of another domain— economics, politics, psychoanalysis—that is held to be *more fundamental or more real.*"[67]

In sum, the sociocultural reductionist's drive for a one-size-fits-all account of the arts appears to be prone to the same kind of peculiarities that we observed emerging from NR. It too tends to adopt self-defeating positions and to work with a constricted vision that discounts or explains away phenomena that deserve far greater attention—indeed, perhaps a different kind of attention. Some comments of Stanley Cavell's on Wittgenstein are worth quoting here: "For Wittgenstein, philosophy comes to grief not in denying what we all know to be true, but *in its efforts to escape those human forms of life which alone provide the coherence of our expression.* He wishes an acknowledgement of human limitation

64. Quoted in Felski, *Limits of Critique*, 191.
65. Felski, *Hooked*, 30.
66. Felski, *Limits of Critique*, 187.
67. Felski, *Hooked*, xi, italics added.

which does not leave us chafed by our own skin, by a sense of powerlessness to penetrate beyond the human conditions of knowledge."[68]

Linguistic Reductionism

As far as reductive assumptions about language are concerned, we spoke of two in particular that seem to have found their way into discourse surrounding the arts: first, that language can be truth-bearing only insofar as it conforms to the paradigm of the kind of declarative statement supposedly favored by the natural sciences; and second, that truthful representation is possible only through language.[69]

With regard to the first: the exclusion of all but the literal, declarative statement from the halls of truth has been widely challenged among language theorists. And understandably so, for it is not hard to see how odd it is. In particular, the notion that understanding and explanation will be advanced *just to the extent that* we rid our language of figurative devices makes little sense. As Gordon Graham observes, "Simple attempts to understand and explain are replete with metaphor, simile, analogy, synecdoche, and so on. Take the common expressions 'I *see* what you mean,' 'I *follow* your argument' or 'I *get* your point.' These are all metaphors. . . . If we try to expunge such expressions from factual conversation, what could we put in their place? And without a replacement, we should not have unembroidered speech, but silence."[70] And as Graham comments (in line with numerous others), the discourse of science finds it exceedingly hard to avoid metaphor: "Electricity *flows* in a *current*, magnetic *forces* arrange themselves in *fields*."[71] Indeed, it would seem that metaphorical language can play a key role not only in the dissemination of scientific ideas but in scientific inquiry itself.[72] This should make us wary of assuming that, for example, the figurative devices of a poem add nothing to our knowledge and understanding of the world beyond the mental and emotional states of the poet. We shall treat these matters more fully in chapter 6.[73]

With regard to the second assumption—that truthful representation is possible only through language—clearly much depends on how we construe the

68. Cavell, *Must We Mean What We Say?*, 61, italics added.
69. See under "Linguistic Reductionism" in chap. 2.
70. Graham, *Philosophy of the Arts*, 133, italics original.
71. Graham, *Philosophy of the Arts*, 133, italics original.
72. The matter is ably dealt with in a careful and balanced article by Susan Haack, "Art of Scientific Metaphors."
73. See under "Discovery and Understanding through Metaphor," "Bodily Indwelling," and "Inexhaustible Allusivity."

term *representation*. It is one heavily scarred by perennial debate, if not fatally wounded. But I am inclined to think it is worth preserving, at least in the broad sense outlined by Rowan Williams in *The Edge of Words*.[74] In his account, representation is not to be thought of as the reproduction or duplication of a set of data whose ideal would be point-for-point verisimilitude, but rather as what happens when something (A) is presented again (*re*-presented), rendered in a different form or mode (B)—a re-presentation that depends on there being patterns in A (not merely isolated features but configurations of relations between its elements) that are to some degree capable of being rendered in and through B. The aim of representation is not to produce a substitute for the original but to enable something of the form of life and vital presence of the original to be made apparent to the perceiver: representation is "performing or enacting a form of being in a new mode."[75] Accordingly—and this point is crucial—the representation itself need not be seen as something that by necessity *gets in the way* of perception, an intrusion or interference that always clouds or distorts; rather, it is potentially that *through which* an object can declare itself more fully, come more powerfully to light, become more extensively present to us. Here some reflections of the literary critic and theorist Quentin Kraft are apposite, as he seeks a way beyond what he regards as a bogus choice—between, on the one hand, the view of language as window-like, as utterly transparent to its referents, and, on the other hand, the poststructuralist construal of language as a screen that cannot help but obfuscate. Kraft settles on the term "mediation," describing it as

> something that goes in the middle; it is a medium, a means, something that intervenes between consciousness and an object. In that sense, it separates and makes a difference by maintaining a middle distance. But it also connects; it is what makes interaction possible; indeed it is an *interaction* and not a thing. Thus, as used here, mediation is more verb than noun, not anything just statically situated between a person and the world, not a screen, but instead an activity or interaction going on in the space between, as often an attempt to do something as an attempt to know something. . . . What is meant here by "mediation" is presence, not the mythical pure presence but the actual adulterated presence, the only kind ever available to us. And by "presence" is meant the whole range of possible interactions between a consciousness and the world.[76]

74. Williams, *Edge of Words*, 186–97.
75. Williams, *Edge of Words*, 195.
76. Kraft, "Toward a Critical Re-renewal," 60, italics original.

This is very close to what Williams seems to be getting at—truthfulness without verisimilitude[77]—and it is obvious that language can serve as a vehicle of truthful representation in this sense. The descriptive cataloging or picking out of features in what is perceived in the form of a literal statement is undoubtedly one form of representation. But there are many others, including those that do not directly involve language. The account of representation Williams is advocating can readily accommodate these wider uses. Images have the capacity to represent, not just in the narrow sense of "corresponding to" (as with diagrams, maps, floor plans) but in the sense of "bringing to our awareness" some dimension of reality-as-encountered, of the world as we interact with it. Similar things can be said of music and dance: something in the configurations of realities external to the sounds of music and the rhythmic motions of dance find fresh expression, a "presencing," in these artistic modes. In these cases, the language of "truth" and "truthfulness" may need to be supplemented with terms such as *aptness, appropriateness, fittingness*—there is something that is being faithfully mediated, enacted, "re-lived" through art. But there is no need to abandon the notion of representation wholesale to convey this. The only reason we might do so is if we have already fallen into the trap of assuming that language—and a particular type of language at that—is humanity's sole and paradigmatic mode of sense-making. Words from art historian T. J. Clark are worth pondering:

> It matters enormously that from the beginning there existed, alongside the scribal and priestly world of writing, other rival systems of representation, opening onto quite different modes of being-in-the-world—other temporalities, other kinds of concreteness and immediacy, other promises of order, other balancings of body and mind. "Depiction" may be the one that holds me captive; but of course music, and dance, and the shaping of stone or clay, and the patterning and reshaping of the body's surface (or indeed the very form of its face and musculature) are just as fundamental *counter-languages* at the species' disposal.[78]

Much more will need to be said about language later, but we have seen enough to suggest that linguistic reductionism (at least the variety I have described) generates peculiarities broadly parallel to those spawned by other reductive strategies: it seems to veer toward cutting the ground from under its own feet,

77. Williams, *Edge of Words*, 149.
78. Clark, "Interview with T. J. Clark." By "counter-languages," Clark seems to have in mind languages that challenge demeaning social hierarchies.

and it operates with a kind of tunnel vision that refuses to acknowledge the ways in which both linguistic and nonlinguistic media are commonly employed.

Instrumental Reductionism

What of instrumental rationality when taken into the arts? In chapter 2, I concentrated on the instrumental reduction of *value*: when artistic worth is to be measured primarily (perhaps exclusively) according to immediate utility, often with one very specific and narrow end in view.[79] There is probably little point in belaboring the objections to this form of reductionism, since it has come under much heavy fire in the last two hundred years. Some of the most illustrious names of the past have sought to expose its peculiarly blinkered outlook.

It is in this context that the concept of "disinterested contemplation"—or perhaps better, "absorbed attention"[80]—came to the fore in the eighteenth and early nineteenth centuries, standing as a bulwark against the means-ends thinking associated with modern technology and industrialization. When I attend to an object in a disinterested way, I refuse to consider it as a tool to achieve any end external to the act of attending to it. In viewing a painting or listening to a song, any concern for utility, practical use, how it may serve interests apart from attending to the work itself (such as morals, goals, ideals) must be strictly set aside. Disinterestedness was key to Kant's aesthetics,[81] and it came to be strongly allied to the category of "fine arts," to the establishment of spaces in which this attitude could be developed (museums, art galleries, concert halls), and to institutions of "high art." The nineteenth-century lauding of wordless instrumental music ("absolute music") belonged to the same sensibility.[82] This elevation of the notion of disinterestedness, in whatever form, was at the very least a *cri de coeur* against the narrowing down of the criteria of artistic value to direct utility. It was also a way of resisting the notion of art as a mere conduit for the transmission of separable and verbally articulable truths. Art must be allowed to do its own kind of work in its own kinds of ways.

Important as these concerns might be, however, unless we are clear about where the heart of the problem lies with reductive instrumentalism, enthusiasm

79. I am leaving to one side the almost universal commitment to naturalism in these accounts, since I have said much about this already.

80. See the illuminating discussion of the concept in Wolterstorff, *Art Re-thought*, esp. 1–13 and chap. 4.

81. For discussion, see Burnham, *Introduction to Kant's Critique of Judgement*, 50–55.

82. See Bonds, *Absolute Music*; Dahlhaus, *Idea of Absolute Music*.

for disinterestedness can easily slide into yet another form of reductionism, one that is just as peculiar. To explain: when it comes to evaluating the worth of this or that art, what needs resisting, I submit, is the wholesale dominance of thinking in terms of the kind of instrumentality we discussed in chapter 2.[83] Nicholas Wolterstorff's fine discussion in *Art Re-thought* is especially helpful at this point.[84] The idea that an artist's labor is of value just to the extent that it is guided by the intention to bring about effects in those who will encounter it—or, from the other side, that the value of a piece of art for a viewer, listener, or reader must be judged according to how far it generates certain effects—is indeed a notion that is severely reductionist and peculiarly restrictive. There is a paring down of causality to efficient causation. There is a failure to come to terms with the particular integrity of art-making, and with what makes us regard a piece of art as distinctive, different from other artifacts.

The narrowness of this outlook is particularly clear when we bear in mind that a vast amount of the art that our culture values cannot be accounted for along these lines, especially the kind made for, and enjoyed through, absorbed attention—as with a wordless Beethoven symphony. The process that goes into making art has by no means always been guided by the intention to bring about effects in those who encounter it; nor are pieces of art always valued according to their success in bringing about this or that effect. Typically, the art we gaze at in a museum we attend to "for its own sake"—that is, we value the act of attending because of the delight or pleasure experienced *in* that act (aesthetic gratification) or because the art has qualities that are good in themselves (form, beauty, balance, and so forth).

All that being said, it is easy to overplay this kind of argument and imagine that *all* art worthy of the name can and should be treated as falling outside networks of causation and instrumentality altogether, as if all talk of "use," "function," or "end" will necessarily pollute art's essential purity. This is just as reductionist, just as narrow and exclusive, and just as odd as the attitude it opposes. Much highly valued art is not created for absorbed attention. A well-crafted hymn is an obvious example. Another is J. S. Bach's *St. Matthew Passion*, which was composed for a vespers service in 1727 with the clear aim of bringing out an effect—the transformation of the believer.[85]

83. See under "Instrumental Reductionism" in chap. 2.
84. Wolterstorff, *Art Re-thought*, chap. 7.
85. Wolterstorff's sustained criticism of what he calls the "grand narrative" of modern art history comes into play here: the story that art "came into its own" with the advent of "fine art" in

By way of clarification, two observations are worth making here.[86] First, there are different ways of producing or engaging something disinterestedly, and we should not be bewitched by simple models of one-to-one efficient causality into thinking there is only one. It is quite possible to engage art—and to make it—outside the instrumental framework I have described (i.e., disinterestedly) *and* outside the framework of absorbed attention. Think of singing a hymn in worship. I sing the hymn in order to worship God, with that purpose in view. But I am not singing in order to bring about an effect, the way I might kick a ball in order to score a goal. The act of singing does not cause worship; it *counts as* worship.[87] The singing *is* worship in action, not a cause of it. At the same time, I am not engaging the hymn as I might a wordless Beethoven symphony, as an object of absorbed attention.

To come at the same point from the art-making side, when someone dances in the privacy of her sitting room "just for the fun of it," that act is free from means-ends rationality. The elation experienced is not a causal consequence of dancing external to the act of dancing but a way of describing the dancing; it is elation *in* the dancing. Yet it is clearly not done with a view to absorbed attention.

Second, it is also quite possible to make something *both* for absorbed attention *and* in order to bring about an effect. A local artist recently produced a tapestry for a hallway near my office. She intended it to be viewed with absorbed attention, but she also made it in order to earn a check, to augment her meager income. Similarly, an art student might view a painting with absorbed attention *and* do so in order to bring about the effect of passing her art history exam.

All of this is to say that if we are to oppose instrumental reductionism when speaking of the value of the arts, we need to recognize two things: (a) Art can be made with a huge variety of purposes in view (of which absorbed attention is but one), and it can be engaged in a huge variety of ways (of which absorbed attention is but one). I have found that when someone tells me that the arts are "useless," what they typically mean is that they are biologically unnecessary for

eighteenth-century Europe when absorbed attention could at last be acclaimed as *the* definitive way to engage all art worthy of the name (Wolterstorff, *Art Re-thought*, chap. 7). Wolterstorff engages some of the key writings on this theme, including Shiner, *Invention of Art*; Kristeller, "Modern System of the Arts (2)"; Abrams, "From Addison to Kant." Wolterstorff also questions the way this tradition typically construes authentic art as affording a quasi-religious escape from social and cultural determinants (Wolterstorff, *Art Re-thought*, chap. 5).

86. Again, I am drawing here on Wolterstorff's admirably lucid arguments in *Art Re-thought*.

87. Wolterstorff, *Art Re-thought*, 68–70. Relevant here is the distinction in dependency relations between causation and constitution. When he uses the term "counts as," Wolterstorff is clearly speaking of the latter.

physical survival, or perhaps that they are ineffective in combating threats to survival.[88] But if we have a wider and richer view of human flourishing, the arts are anything but useless and can serve all sorts of ends, often simultaneously. (b) Art can be created to serve a purpose (as when I compose a hymn for worship) without being made to cause an effect, and it can be engaged without the intention of bringing about an effect (as when I sing a hymn in worship). The belief that once we allow art to be part of purposes and aims we have somehow betrayed it, despoiled its virtue, and succumbed to the stifling worldview of a closed instrumentality is simply misplaced. As social and cultural practices, the arts are inextricably embedded in purposeful actions, and this is not something to shun—it belongs to what they are.

This suggests that the simple exclusionary binaries we often hear in this context—"instrumental vs. intrinsic," "useful vs. useless," "for its own sake vs. for a purpose"—are best dropped. Indeed, the pressure they impose on us to opt for one side or the other is *itself* reductionist. The reality is much more interesting.[89]

At any rate, it should be clear that instrumental reductionism (as I have described it) is no less peculiar than the other kinds of reductionism spoken about in this chapter, and especially with respect to the second type of peculiarity I have highlighted: a narrowness of vision. It fails to take account of huge swaths of activity that we would typically describe as making and engaging art, and it has become overly focused on efficient causality.

◆ ◆ ◆ ◆

None of what I have said in this chapter amounts to a watertight refutation of this or that reductionism; and in any case, that has not been my goal. I have been reflecting on the oddities that reductive pressures quickly spawn as they press their agendas forward—in particular, incoherent and self-refuting positions and the exclusion of so much that would seem to call us toward far broader horizons of interpretation. It seems appropriate at this stage to see whether another biblical interruption might help to open some of them out.

88. As Michael Bérubé puts it, "No infusion of Jane Austen will send stomach cancer into remission, and no IV drip of Martin Amis's latest will combat renal failure" (Bérubé, "Utility of the Arts and Humanities," 25).

89. The UK report discussed in chap. 2, *Understanding the Value of Arts and Culture*, comments on the need "to break down the divide between the intrinsic and the instrumental camps, to transcend the debate about things to be valued 'for their own sake,' or else understood only in terms of the narrow economic or other material benefits that they provide" (Thompson, foreword to Crossick and Kaszynska, *Understanding the Value of Arts and Culture*, 5).

5

A Scriptural Interruption

Living Water and Overflow (John 4:1–15)

J esus makes his way from Judea to Galilee. Passing through Samaria, he comes to the city of Sychar. His followers leave him to go shopping. Tired and thirsty in the midday heat, he rests by a well. This is no ordinary well, it turns out, but one that Jacob used centuries ago. A local woman arrives to draw water. Recognizing Jesus as a Jew, she is bemused—and even more so when this Jewish man asks her, a Samaritan woman, for a drink and starts to chat with her. Yet more mystifying than this double breach of etiquette is the stranger's offer of better, "living" water, without so much as a bucket to hand it over. Does he really believe he can outdo Jacob, the patriarchal ancestor and namesake of Israel who watered his cattle and family at this very spot? Jesus responds with oblique and cryptic sayings about an endlessly refreshing water that never runs out.

Such a skeletal summary of John 4:1–15 gives little sense of the enormous metaphorical energy of the passage.[1] Like a peal of bells, not only is each metaphor allowed to sound with its own multiple overtones, but each resonates with the others, setting off further overtones to create a fullness of meaning that would be impossible to encompass in a simple statement or concept. Truth-telling for this author seems to depend on just such multiple evocation. And this could hardly be more appropriate, given the centrality of the theme of overflow

1. On metaphor in John's Gospel, see van den Heever, "Theological Metaphorics"; Malina, *Gospel of John in Sociolinguistic Perspective*; Koester, *Symbolism in the Fourth Gospel*.

in these verses, a surplus springing from God's lavish abundance. Abundance belongs to both the character and the content of this passage, and indeed, to the Fourth Gospel as a whole.

Living Water, Thirst, and Betrothal

The most prominent metaphor here is that of living water—running water, the sort that bubbles up from a spring, in contrast to the still, brackish water at the bottom of a well. Moses strikes a rock to provide flowing water for the Israelites (Exod. 17:1–5); the psalmist longs for God as the deer longs for "flowing streams" (Ps. 42:1). Zechariah looks to a day when living water will pour from a renewed Jerusalem (Zech. 14:8), and Ezekiel to a time when a life-giving stream will flow from a new temple into the desert (Ezek. 47:1–12). In Sirach, God's Wisdom is described as water to drink, and those who drink it as thirsting for more (Sir. 15:3; 24:21). Through Jeremiah, God declares,

> My people have committed two evils:
> they have forsaken me,
> the fountain of living water,
> and dug out cisterns for themselves,
> cracked cisterns
> that can hold no water. (Jer. 2:13)

If water was a commonplace metaphor for God's life-giving Spirit in Old Testament and later Jewish thought, its focus in John's Gospel is quite specifically on the Spirit given by and through Jesus to others, the Spirit the Father gives "without measure" (John 3:34), surging to eternal life in all who believe in Jesus, and potentially reaching all peoples of the world, including the alienated Samaritans. Later, Jesus will issue a startling invitation: "Let anyone who is thirsty come to me, and let the one who believes in me drink. As the scripture has said, 'Out of the believer's heart shall flow rivers of living water'" (John 7:37–38). A familiar metaphor of God's Spirit as water has been taken up and refreshed through its direct association with Jesus.

Along with living water, we find the metaphor of thirst used for yearning, longing for God. Linda King writes, "As the primal sensations of hunger and thirst are common to all people, and the use of hunger and thirst as metaphors for need, lack, and desire has endured across the millennia from Hebrew scripture to romantic poetry to popular music, the bodily basis for the underlying image

schemas remains powerful, capable of evoking intense emotional responses in the mind-bodies of all human beings."[2] Here in John 4, a well-worn metaphor is again rewritten in relation to Jesus himself: Jesus is the quencher of humanity's deepest thirst. But there is a further jolt. *Jesus himself* wants a drink. Augustine comments, "Jesus [was] weak, wearied with His journey. His journey is the flesh assumed for us. . . . As He deigned to come to us in such manner, that He appeared in the form of a servant by the flesh assumed, that same assumption of flesh is His journey. Thus, 'wearied with His journey,' what else is it but wearied in the flesh? Jesus was weak in the flesh: but do not become weak; but in His weakness be strong, because what is 'the weakness of God is stronger than men.'"[3]

Intertwined with living water and thirst is the image of betrothal. The passage draws on a familiar narrative of the time. A potential bridegroom journeys to a foreign country, finds a woman at a well, and asks for (or is offered) water. The woman dashes back home to tell her family what has happened, whereupon the man is invited to her father's home and betrothal is arranged.[4] Jacob had met his future wife, Rachel, at a well when the sun was high (Gen. 29:1–13). And we recall that the relation between God and Israel was often spoken of through the imagery of betrothal and marriage.[5] "The woman by requesting the gift of living water is becoming . . . a bride for a bridegroom."[6] This is a "betrothal consummated through the divine life mediated by the Spirit,"[7] satisfying an eternal thirst for the living God.

The unnerving twist is that the bride is now represented by a Samaritan woman—a semi-gentile, not a law-abiding Israelite; she has become the representative of the world beyond the Jews. The reader is thus invited to reimagine not only God's covenant commitment to Israel but also God's intentions for Israel and, through Israel, for the wider world. Augustine thus speaks of the woman as a "type" of the church:

> It is pertinent to the image of the reality, that this woman who bore the type of the Church, comes of strangers [i.e., Samaritans]: for the Church was to come of the Gentiles, an alien from the race of the Jews. In that woman, then, let us hear

2. King, "Full of Life," 130n23.
3. Augustine, *Tractates on the Gospel of John* 15.7.
4. See Lincoln, *Gospel according to Saint John,* 170. See also Gen. 24:1–67; 29:1–14; Exod. 2:15–21.
5. See, e.g., Isa. 54:1, 5–6; 62:4–5; Jer. 2:2–3, 32.
6. Carmichael, "Marriage and the Samaritan Woman," 338.
7. Lincoln, *Gospel according to Saint John,* 174. Calum Carmichael notes, "Commentators show a remarkable reluctance to enquire into the significance of the male-female aspect of the Samaritan incident" (Carmichael, "Marriage and the Samaritan Woman," 335).

ourselves, and in her acknowledge ourselves, and in her give thanks to God for ourselves. For she was the figure, not the reality; for she both first showed forth the figure and became the reality. For she believed on Him who, of her, set the figure before us. "She comes, then, to draw water." Had simply come to draw water, as people are wont to do, be they men or women.[8]

Earthed

Commentators often point out the pervasive theme of misunderstanding in John's Gospel: the way in which those who meet Jesus, especially the Jewish authorities, repeatedly get the wrong end of the stick.[9] This story gives us a prime example: the Samaritan woman clearly misconstrues the words of her Jewish interlocutor. A conventional reading of this story tells us that the misunderstanding arose because the woman was thinking literally and Jesus metaphorically, the woman concretely and Jesus abstractly, reminding us that "although metaphorical language has the possibility to enlighten, it does not always achieve enlightenment."[10] But are things quite so clear-cut? To begin with, we need to be careful not to identify the distinction between literal and metaphorical as that between concrete and abstract. One can speak metaphorically of concrete things (as when I talk of a large old house as a "pile"). Later in this narrative, Jesus tells his disciples, "My food is to do the will of him who sent me and to complete his work" (John 4:34). The focus here (at least in part) is concrete—doing the will of the Father entails visible, embodied actions—but "food" is clearly being used metaphorically. But just as important, in our passage there appears to be no dichotomy between literal and metaphorical, concrete and abstract (not to mention between material and nonmaterial). In fact, the conversation seems to shift back and forth within each pair. There is no sense that one side must be sacrificed for the other. So, for instance, King observes that it is not clear "when,

8. Augustine, *Tractates on the Gospel of John* 15.10.

9. Culpepper, *Anatomy of the Fourth Gospel*, 152–65. Quite *why* John includes so many accounts of misunderstandings is a matter of debate. Some see it as his way of addressing church-synagogue tensions; some even regard it as a blanket condemnation of Judaism. More convincing, to my mind, is to read John in conjunction with the Synoptic Gospels: "Even though each canonical gospel preserves distinctive emphases on the theme of misunderstanding, all of them agree on such major points as that none of the disciples really understood the passion predictions until after the events to which they pointed, that the disciples experienced a radical improvement of their understanding of a broad sweep of messianic and eschatological issues after the resurrection—and that all of the evangelists recognized this change and avoided anachronism in regard to the degree of the disciples' understanding" (Carson, "Understanding Misunderstandings in the Fourth Gospel," 89).

10. Malina, *Gospel of John in Sociolinguistic Perspective*, 86.

and for whom . . . the subject of the conversation change[s] from H_2O to Holy Spirit, from thirst-quenching water to soul-satisfying salvation in the presence of the Messiah."[11] Jesus's theologically rich metaphorical language draws on and depends on physical, embodied experience. It "can fuse the physical experience, emotional response, social or historical contexts and references, and express language into an instantaneous new understanding."[12] It is not as if the bodily need for physical water is being downplayed in order to sharpen the theological focus of the passage. Similarly, when Jesus later speaks of worship being neither on Mount Gerizim nor in Jerusalem (John 4:21), the physical setting of worship is not being dismissed as irrelevant, as if the materiality of bodies in space was of no consequence.[13] Granted, the woman's need cannot be reduced to the need for water, but that does nothing to undermine the importance and goodness of such basic necessities.

Along the same lines, there is no need to suppose that John's use of metaphor assumes a split between theology and history. There has been a repeated tendency among scholars of this Gospel to presume that John's rich theological symbolism, just because it is symbolism, renders the historicity of its narrated events irrelevant—as if having a primarily theological interest precluded a concern with concrete happenings in space and time. As Richard Bauckham writes, "The literal meaning—the meaning on the level of the events narrated in their chronological placement within a developing narrative—has its own integrity that is not manipulated or disrupted by other levels of meaning."[14]

Uncontainability

As I shall stress in the next chapter, metaphors by their very nature present us with an acute case of irreducibility. Attempts to flatten them into statements typically defuse their distinctive power; their multiple allusivity is key to making them such powerful vehicles of truth-telling. The fact that John's Gospel relies so heavily on pregnant and resonant metaphors is highly significant, given that uncontainable abundance plays such a major role in the story it tells. King has

11. King, "Full of Life," 260.
12. King, "Full of Life," 260.
13. "Both in the world of the story and the mind-bodies of readers, the container schema compresses the concepts of water jar and well, thirst and lack, cool, running water and overflowing Holy Spirit into a comprehensible blend of global insight that is immediate, emotional, physical, and does not yield to conventional parsing" (King, "Full of Life," 134).
14. Bauckham, *Gospel of Glory*, 132; see also 135, 142.

made a fascinating study of metaphors of fullness, abundance, wholeness, and completion in John's Gospel. Drawing on the pioneering work of George Lakoff and Mark Johnson,[15] she argues that these metaphors are united by the "image schema," or template, of FULL/EMPTY, which in turn depends on the template of CONTAINER. Together, they create "an understanding of that which Jesus brings as abundant, overflowing, limitless, and satisfying: the knowledge of God, God's love and God's purpose for creation now, including the experience of health and healing, and wholeness that will be established in full in the age to come."[16]

In our passage, containers of one sort or another are highly conspicuous, and they are all theologically significant: Jacob's well, with its sustenance-giving connotations; the woman's water jar (empty and needing to be filled); the woman herself (lacking water); the fountain of living water (an eternal wellspring for others). It is the Spirit, of course, who is portrayed as the Filler par excellence, and the connotations of inexhaustibility are unmistakable: the well of the Spirit will never run dry, and the woman will never thirst again. (Jacob's well may have been legendary for its abundance, but no one would have thought of it as inexhaustible.) But just as important as inexhaustibility are the connotations of surplus, excess, and overflow—of *uncontainability*. This living water/Spirit is "without measure" (John 3:34); it cannot be calibrated, stored, or held by any finite vessel: "The living water, taken in, goes beyond slaking thirst: it overspills the one who drinks and becomes in the receiver a spring gushing into eternal life. The schema of CONTAINER moves from the concept of contingent, hard-earned daily sustenance to secure and splashing abundance, eternally renewed as God's gift."[17]

A delightful detail adds to the sense of overflow: when the woman returns to the city, breathless with excitement, she leaves her water jar behind (John 4:28). What has happened to her—and in her—cannot be held or held back, let alone managed or controlled. "She has exchanged the bounded finitude of her water jar for the infinite gift of God, the ever-flowing, divinely supplied spring available not just for Samaritans at Jacob's well but for whoever drinks of the living water of Jesus, whom God has sent."[18]

This theme of uncontainability is ubiquitous in John's Gospel. We see it in the surfeit of wine at the Cana wedding feast (2:1–11), in the twelve baskets of

15. Lakoff and Johnson, *Metaphors We Live By*.
16. King, "Full of Life," 87.
17. King, "Full of Life," 131–32.
18. King, "Full of Life," 132.

surplus food gathered up after a vast crowd had been "satisfied" (6:1–14), in the promise of living water at the Festival of Booths (7:37–39), and in the powerful images of abundant life (10:10) and abundant fruit (15:1–17). This signals not only "spatial" uncontainability, the immensity of God's life in relation to the created world, but temporal uncontainability, the impossibility of this abundant life being captured in the present, within the world as it now is. The "eternal life" the woman is offered through the water of the Spirit, whatever else it is, is the life of the future as celebrated by the prophets, the new life of the messianic age to come, when this world will be flooded with God's Spirit.[19] All this suggests an eschatological vision of new creation, in which the ultimate future is not a return to some *status quo ante*, nor merely some kind of proportionate answer to sin and evil, but an excessive re-making, a re-creation that never reaches final closure, let alone any *en*closure of the divine.

Like the one from John 9, then, this passage from John 4 dramatically interrupts and resists the containing and constricting pressures of a reductive imagination—the flattening of reality to one level or uniform type, the urge to narrow down what needs accounting for, the keenness to regard true knowledge as available only to those standing at a distance from reality and true language as only of one narrow type, and the eagerness to constrain and commandeer. Not least, this passage urges us to imagine God as active in this world as One who cannot be controlled or mastered—indeed, as One who cannot be contained.

19. Isa. 12:3; Ezek. 47:1–12; Zech. 14:1–21.

Counterpressures

6

Art's Generativity

Just know the Earth is just a rock without the voices of art.

Kendrick Lamar[1]

[Cézanne] doesn't paint a copy of an apple or a tree, he paints its reality, the whole that it is, the whole that is lost to us as we walk past it, eat it, chop it down. It's through the artist . . . that we can rediscover the intensity of the physical world. But not only the physical world. . . . The earth is not flat, and neither is reality. Reality is continuous, multiple, simultaneous, complex, abundant, and partly invisible.

Jeanette Winterson[2]

You put two things together that have not been put together before. And the world is changed.

Julian Barnes[3]

L et us retrace our steps. In chapter 1, I offered a compressed account of naturalistic reductionism (NR) and discerned four major aspirations or "pressures" driving it: (1) toward *ontological singularity*—identifying and recognizing only one ontological type or level; (2) toward an *exclusionary simplicity*—restricting as far as possible the range of what is worthy of

1. Lamar, "Prayer."
2. Winterson, "What Is Art For?," 185.
3. Barnes, *Levels of Life*, 3.

attention; (3) toward acknowledging only one very specific *epistemic stance* as truth-bearing (typically that marked by distance or detachment), and, with this, only one type of *language* as legitimate for bringing reality to truthful articulation; and (4) toward *control and mastery*.

These pressures are by no means limited to NR. In chapter 2 we saw something of how all four are manifest in contemporary discourses surrounding the arts. In chapter 4, I highlighted the peculiarities generated by these drives when they are allowed to get the upper hand. Along with a tendency toward incoherence and self-defeat, we are left with outlooks marked by a very limited explanatory range. This suggests that the heady confidence that often seems to go with these reductive pressures is in some way misplaced. The scriptural interruptions of chapters 3 and 5 opened up a strikingly different imagination of the world—different not just in that they assume the reality of God but in that they bear witness to a God who generates events that press in the opposite direction to all reductionisms, to an expansive vitality that spills over limits and bounds. Before I say more about this, however, I want to return to the world of the arts and suggest that here we can find ways of engaging the world and each other that are highly resonant with this alternate, counter-reductionist imagination.

As I said in the introduction, the notion that the arts are in some manner inherently *counter*-reductionist and *as such* have the capacity to open up religious or theological perspectives is hardly novel. Indeed, it has animated much in the story of the "fine arts" of Western modernity (especially when NR or one of its antecedents is being opposed). In fact, it has frequently been held that the supreme value of the arts lies in their capacity to counteract modernity's reductionist ambitions, not least when those ambitions threaten to strip the world of any meaning beyond its own bare existence. Various studies suggest that many with little avowed interest in formal religion will naturally link their experience of the arts to the "spiritual" or the "transcendent."[4] When the world is seen in barren and colorless naturalistic terms—"A Nature shorn of the divine"[5]—the arts seem to be able to recover something of the religious intuitions of a previous age: a sense of awe and wonder, perhaps; of ambiguity and mystery; of forces that elude the grasp of scientific rationality.

The following, from a recent article titled "Spirituality and the Visual Arts," would likely speak for many:

4. See, e.g., Callaway, *Scoring Transcendence*; Cowan, *Sacred Space*; Friskics-Warren, *I'll Take You There*; Graham, "Enchantment and Transcendence"; Johnston, *God's Wider Presence*.

5. Friedrich Schiller, *The Gods of Greece*, as quoted in Taylor, *Secular Age*, 317.

For all the benefits of rational choice and effective means, modernity deprives the world of transcendent significance. It is a desire for a re-enchanted experience of spirituality that leads people toward the arts as a resource. For many, this search for re-enchantment involves a desire for beauty. . . . One can also think of the thematic elements of several popular film series. If the movies can be seen perhaps as one avenue of the visual arts for popular audiences, then surely the success of such series as *The Lord of the Rings, The Chronicles of Narnia, Star Wars, Harry Potter*, dramas featuring images of transcendental nature such as *Life of Pi, Wild, The Revenant*, and the many adaptations of superhero stories, many of which contain themes which seem to suggest that people desire a larger sense of life, where conflicts between good and evil are rooted in more than just personal preferences and aspirations but are of cosmic consequence.[6]

Doubtless such a yearning for "re-enchantment"[7] owes a considerable debt, directly or indirectly, to the Romantic movement of the late eighteenth and early nineteenth centuries, with its reaction against a perceived mechanical rationalism in society and culture at large. Drawing on the work of Earl Wasserman, the philosopher Charles Taylor presents Romanticism as a turning point for the arts, one offering a "middle space" between full-blooded religious commitment, on the one hand, and a godless, self-contained cosmological worldview, on the other.[8] This links up with what Taylor calls the "cross-pressure" that besets the modern self: the self is pulled by "the solicitations of the spiritual," on the one hand, and by stark unbelief, on the other. In premodern metaphysics, what we now call the arts were understood to be resonant with a divinely created, hierarchically ordered, multilevel cosmos—one possessing an interconnectedness in which humans were believed to be integrally embedded. By the Romantic era, says Taylor, this unified cosmology had faded, the aesthetic "unhooked from the ordered cosmos and/or the divine,"[9] and the notion of an infinitely creative human self came to the fore. So "where formerly poetic language could rely on certain publicly available orders of meaning, it now has to consist in a language of articulated sensibility."[10] The aesthetic does not need to specify what it is "about" in the world of identifiable objects. Artists thus search for a "subtler language" (Shelley) than formal doctrine, for symbols that can give

6. McCullough, "Spirituality and the Visual Arts," 374.
7. On art and re-enchantment, see Graham, *Re-enchantment of the World*; Wijnia, *Beyond the Return of Religion*.
8. Taylor, *Secular Age*, 360. See also Wasserman, *Subtler Language*.
9. Taylor, *Secular Age*, 360.
10. Taylor, *Secular Age*, 353.

voice to "deep truths in the nature of things" mediated preeminently through an exploration of the depths of the self. Of the present day, Taylor writes, "It is largely thanks to the language of art that our relation to nature can so often remain in [a] middle realm, [a] free and neutral space, between religious commitment and materialism."[11]

Some will feel uneasy about such grand and sweeping claims; doubtless they would need to be nuanced and qualified historically. But, taken along with what would seem to be obvious frictions and perhaps even antagonisms between the arts and reductive outlooks, Taylor's reflections do at least push us to ask what it might be about the artistic imagination that resists the pressures of reductionism and gestures toward theological terrain.

I want to explore just one avenue here, what I take to be one of the most significant counter-reductionist capacities of the arts, and one that seems to link up strongly with our leading and theologically potent theme of the uncontained and uncontainable: the arts' capacity to draw on and generate potentially inexhaustible dimensions of meaning. I will argue that this gathering and germination of meanings very often takes place through a process of "defamiliarization," in which the familiar is made unfamiliar in such a way as to yield a profounder apprehension of whatever reality is at hand, including an apprehension of that reality's uncontainable significance. And I shall suggest that this process, whatever else it is, is typically metaphorical in nature: we are enabled to perceive an idea, object, event, or domain through an "unexpected other."[12]

Two qualifications are in order. First, I am not proposing anything akin to a grand "philosophy of the arts" (another way in which reductionism could get a sizeable grip). There is no pretense here to providing a master key that will unlock every stubborn door in the philosophy of art. Apart from anything else, the very concept of "the arts" is far too complex to advance anything of that kind. Rather, I am identifying and exploring just one especially pervasive feature of the ways in which much of what we have come to call "art" is made and experienced, with an eye to what this might intimate theologically as we encounter and struggle with the reductive pressures of our time. I invite others to develop and qualify these embryonic reflections more fully.

Second, I have no interest in shoring up a theory of the "autonomy" of the arts that sees all ties they may have with other realms of cultural activity as

11. Taylor, *Secular Age*, 360.
12. Williams, *Edge of Words*, 133.

detrimental to their integrity. Rita Felski's comments in her recent book, *Hooked: Art and Attachment*, are especially pertinent on this issue: "How can the aesthetic force of novels, films, or paintings be given its due if it is defined as subordinate to something else? . . . Art possesses its own form of reality that is not derived from, or dependent on, a more fundamental level of existence."[13] And yet, Felski urges, this should never be used to justify ascribing some kind of hard-edged self-sufficiency to art, for "a mode of being is not synonymous with a *domain* of being. A mode, in contrast to a domain, has no clear edges, borders, or walls; differing modes—aesthetic, religious, economic, legal, political—overlap and interact at numerous points. To question single-order causalities . . . is not to deny connectedness."[14] She goes on to note that "the task is to account for distinctiveness without overlooking connectedness, to trace actual ties without presuming inevitable foundations."[15]

In other words, a piece of art is multiply related—linked with innumerable ties to objects, memories, ideologies, and passions. It arises from and is taken up into manifold purposive actions. And the same goes for art's making and reception. Nevertheless, none of this precludes art having its own distinctive modes of being and operating, nor does it preclude these modes from playing a key part in the nonartistic activities into which art is drawn. I am here exploring one of these modes, and I am contending not only that it is irreducible to other modes but that it is *itself* counter-reductionist in force.

Making Strange

In his *Biographia Literaria* of 1815, S. T. Coleridge—an arch-opponent of all things reductionist[16]—penned some of his most oft-quoted words:

> To carry on the feelings of childhood into the powers of manhood; to combine the child's sense of wonder and novelty with the appearances which every day for

13. Felski, *Hooked*, 20. In the background here is Bruno Latour's concept of "modes of existence." See Latour and Porter, *Inquiry into Modes of Existence*. Needless to say, this would need to be carefully qualified if we are to allow the possibility of an ever-present and active, infinite mode of "existence": the reality of God. Theologically speaking, Felski's comments apply to modes of being within the created order.

14. Felski, *Hooked*, 20, italics original.

15. Felski, *Hooked*, 21.

16. Above all, Coleridge opposed instrumental reductionism. According to Thomas Pfau, "The true catastrophe of modernity," for Coleridge, lay "in its unconditionally espousing a means/end model of rationality as the sole way of being in the world" (Pfau, *Minding the Modern*, 461).

perhaps forty years had rendered familiar; . . . this is the character and privilege of genius, and one of the marks which distinguish genius from talents. And therefore it is the prime merit of genius and its most equivocal mode of manifestation, *so to represent familiar objects* as to awaken in the minds of others a kindred feeling concerning them and that *freshness of sensation* which is the constant accompaniment of mental, no less than of bodily, convalescence.[17]

Later in the same work, writing of his collaboration with William Wordsworth that led to *Lyrical Ballads*, Coleridge explains,

In this idea originated the plan of the 'Lyrical Ballads'; in which it was agreed, that my endeavours should be directed to persons and characters supernatural, or at least romantic, yet so as to transfer from our inward nature a human interest and a semblance of truth sufficient to procure for these shadows of imagination that willing suspension of disbelief for the moment, which constitutes poetic faith. Mr. Wordsworth on the other hand was to propose to himself as his object, to give *the charm of novelty to things of every day*, and to excite a *feeling analogous to the supernatural*, by *awakening the mind's attention from the lethargy of custom, and directing it to the loveliness and the wonders of the world before us; an inexhaustible treasure*, but for which in consequence of *the film of familiarity* and selfish solicitude we have eyes, yet see not, ears that hear not, and hearts that neither feel nor understand.[18]

Here Coleridge gives vivid expression to something many have alighted upon when speaking of the power of poetry: the familiar is made unfamiliar, and our eyes and ears opened to an unlimited plenitude of meaning in such a way as to generate a sense "analogous to the supernatural." Although the concept is ancient, the term *defamiliarization* is especially associated in modern times with the Russian literary critic Victor Shklovsky (1893–1984), whose short essay "Art, as Device" (first published in its full version in 1919) has proved to be seminal. Shklovsky's main expertise was in literature, but his treatment of "making strange" (остранение, *ostranenie*) has been taken up by a host of artistic disciplines and movements (including Dada, epic

17. Coleridge, *Biographia Literaria*, 62, italics added.
18. Coleridge, *Biographia Literaria*, 208, italics added. The Polish Nobel laureate Czesław Miłosz writes, "When a thing is truly seen, seen intensely, it remains with us forever and astonishes us, even though it would appear there is nothing astonishing about it" (quoted in Wolfe, *Bearing the Mystery*, 55). For a recent and engaging discussion of this quality of attention, see Cording, *Finding the World's Fullness*, 21–30.

theatre, film studies, science fiction, and "culture jamming," as well as biblical studies).[19]

As Shklovsky expounds it, defamiliarization involves pushing habitualized everyday language out of shape. He bemoans the way our speaking and writing easily becomes superficial through being enslaved to habit and routine. We settle for off-the-shelf vocabulary, stock phrases and expressions. This kind of "automatization" desensitizes us to the world we encounter: things are perceived merely as "there," present yet invisible to us. The following describes the process well and echoes much of what we have said in previous chapters:

> Regarding economy as a law and goal of creation might be right for a particular linguistic case, namely, "practical" language, but ignorance of the differences between the laws of practical and poetic language led to the idea of economy being applied to the latter. . . . Routine actions become automatic. All our skills retreat into the unconscious-automatic domain; you will agree with this if you remember the feeling you had when holding a quill in your hand for the first time or speaking a foreign language for the first time and compare it to the feeling you have when doing it for the ten thousandth time. . . . Algebraizing, *automatizing a thing, we save the greatest amount of perceptual effort.*[20]

There is, then, a kind of linguistic entropy that sets in when our language demands less and less from our capacities of perception and understanding. As it becomes ever more efficient it becomes less and less capable. Shklovsky believes that the literary artist needs to counteract just this automatization, undermining Coleridge's "lethargy of custom" with its "film of familiarity," so that what we perceive gains a freshness, a new substance and depth. Literature of worth slows us down, enables us to see things as if for the first time—indeed, to re-see them. In a famous passage, Shklovsky proposes that "this thing we call art exists in order to restore the sensation of life, in order to make us feel things, in order *to make a stone stony.* The goal of art is to create the sensation of seeing, and not merely recognizing, things; the device of art is the 'estrangement' of things and the complication of the form, which increases the duration and complexity of perception, as the process of perception is, in art, an end in itself and must be prolonged."[21]

19. See Kessler, "Ostranenie, Innovation, and Media History." For other helpful discussions, see Stacy, *Defamiliarization in Language and Literature*; Gunn, "Making Art Strange"; Crawford, "Viktor Shklovskij"; Chernavin and Yampolskaya, "'Estrangement' in Aesthetics and Beyond."

20. Shklovsky, "Art, as Device," 161, 162, italics added.

21. Shklovsky, "Art, as Device," 162, italics added.

How does this defamiliarizing and reapprehension come about? How does literary art make the "stone stony"? Shklovsky points us to literature's characteristic forms and techniques. He speaks at length of Tolstoy, whose "method of estrangement consists in not calling a thing or event by its name but describing it as if seen for the first time, as if happening for the first time. While doing so, he also avoids calling parts of this thing by their usual appellations; instead, he names corresponding parts of other things."[22] Shklovsky also cites other devices, such as poetic imagery: "The goal of an image is not to bring its meaning nearer to our understanding but to create a special way of experiencing an object, to make one not 'recognize' but 'see' it."[23] In this way, recognition becomes re-cognition, refreshed cognition. Shklovsky also has in mind the techniques especially characteristic of the medium. Poetic rhythm, for example, distorts prosaic rhythm, makes it strange: Shklovsky offers a "definition of poetry" as "decelerated, distorted speech. . . . Prose is ordinary speech: economical, easy, correct."[24] And just as words atrophy through habitual use, so also do procedures such as rhyme, meter, and assonance. They too need to be made fresh.

Shklovsky was a leading proponent of what came to be known as Russian Formalism, a movement in literary studies peaking in the early 1920s. Iconoclastic and polemical, the Formalists had little interest in artistic subject matter or the subjectivity and creativity of the artist. As one critic explains, "Uncontrolled by, and irreducible to, ethics, religion, or politics, [literature] was now shaped not by individual imagination and authorial will but by a repertoire of devices, motifs, and rules, the exploration of which stimulated the formalists' interest in rhyme, rhythm, sound patterns and repetition, plot structure, and narrative frames."[25] So it comes as no surprise that, for Shklovsky, the function of poetic imagery is to make the content of a poem not *more* immediately recognizable but *less* so. Thus the Formalists stood sharply against the emerging Marxist-Leninist ideology of their day, in which communication of ideals largely displaced interest in the workings of art itself: "The fate of formalism in the Soviet Union after 1930 was marked by wholesale rejection; formalism became a label of condemnation widely applied to stigmatize any interest in the

22. Shklovsky, "Art, as Device," 163.
23. Shklovsky, "Art, as Device," 167. Shklovsky uses erotic imagery liberally—for example, quoting Knut Hamsun's novel *Hunger*: "Two white marvels showed through her chemise" (quoted in Shklovsky, "Art, as Device," 168).
24. Shklovsky, "Art, as Device," 172.
25. Tihanov, "Russian Formalism," 1239.

formal aspects of [literature] and art, as opposed to the 'healthy' preoccupation with 'content' (ideas)."[26]

In sum, at the heart of literary art for Shklovsky lies a process whereby practical, everyday language is rendered unfamiliar through an array of literary procedures, the result being that our customary, routine perception of things is unsettled and made more adequate to the reality at hand. This way of construing literature has been expressed and reworked by many others. The philosopher Alva Noë, for example, writes, "Design stops and art begins when we lose the possibility of taking the background of our familiar technologies for granted, when we no longer take for granted what is, in fact, a precondition of the very natural-seeming intelligibility of such things as doorknobs and pictures. Art starts when things get strange."[27] Defamiliarization is also one of Rowan Williams's trademark leitmotifs, eloquently expressed in his Gifford Lectures, where he writes of realistic fiction obliging us "to see what we thought we knew as if for the first time" (citing Tolstoy). He also references Dickens's use of two narrative voices in *Bleak House* and Dostoyevsky's "polyphony" of voices.[28] Without naming Shklovsky, Williams concludes, "The common point is the *making strange*: the 'excess' either of overdetermined actions or of undetermined ones, the 'excess' of an invocation of fate or an invocation of random liberty."[29]

Explorations in Metaphor

Let us now dig a little deeper into what this "making strange" might involve. Shklovsky writes, "The poet uses images—tropes and similes; he calls for, let us say, a red flower or applies a new epithet to an old word or, like Baudelaire, he says that the carrion raised its legs as a woman does for shameful caresses. In

26. Tihanov, "Russian Formalism," 1241.
27. Noë, *Strange Tools*, 100.
28. Williams, *Edge of Words*, 136–37.
29. Williams, *Edge of Words*, 138, italics original. See also p. 144, where Williams notes of *Ridley Walker* that "the sometimes apparently wild 'connections' invoked by the constant word-play defamiliarize history." It is worth noting here that familiarity is not to be denigrated as such: familiar perceptions may be profound and truthful. I am drawing attention here to a kind of familiarity that through lazy habit becomes set in its ways, immune to challenge or enrichment, and thus shallow. The positive use of familiarity—as when we experience something familiar "ringing true"—is very close, perhaps equivalent, to what I mean by *resonance* in chapter 9. Thus the arts at their best will often *refamiliarize* the world for us, so that what is already perceived as eloquently disclosive can now be perceived as more so. I am grateful to Jonathan Anderson for this observation and clarification.

this way the poet achieves a semantic shift: he takes a concept out of its former semantic setting and transfers it (metaphorically) to another setting and we feel the novelty of the object in its new setting."[30] Shklovsky is speaking of the transfer that lies at the heart of linguistic metaphors, and though he did not to my knowledge develop a theory of metaphor as such, he seems to believe that this particular mode of transfer belongs to the core of defamiliarization.

A plethora of writers has argued that metaphor is at work far beyond verbal language, and not only in other arts but in cognition, communication, and culture at large. Indeed, according to some, it is basic to all human thought and action, to the very way we understand and negotiate the world as embodied creatures.[31] Whatever one's final judgment on that, it is worth exploring the ways in which metaphorical processes are present in, and perhaps especially characteristic of, not only the verbal and literary arts but the arts more widely.

We can begin by making some observations about metaphor as a linguistic device or speech act. Here the scholarship is vast and daunting, but we can at least pinpoint some features of spoken and written metaphors that are especially salient for our purposes—features that are (mercifully) widely acknowledged as basic. At the very least, metaphor involves "figuring" one object, event, or domain "through another,"[32] or, perhaps better, apprehending something "through an *unexpected* other."[33] If I say "my relationship with him turned acrid," I am speaking of a relationship (the *focus*) in terms of an unpleasant taste or smell (the *frame*).[34] There is an interaction between phenomena associated with a source domain (smell) and with a target domain (relationship) such that features or structural relations of the former are made available to, mapped onto, the latter. When Jesus refers to Herod as "that fox" (Luke 13:32), we are made to perceive the king through the source domain of foxes. What gives a metaphor its peculiar edge or energy is the incongruity between frame and focus, source and target: a relationship is not a taste or smell; Herod is not a furry, four-legged animal. There is something initially surprising, perhaps even startling or shocking, about a metaphor. A "categorical transgression"[35] has occurred. But

30. From *O teorii prozy*, quoted in Stacy, *Defamiliarization in Language and Literature*, 41.
31. Lakoff and Johnson, *Metaphors We Live By*.
32. Taylor, *Language Animal*, 139.
33. Williams, *Edge of Words*, 133, italics added.
34. Here I use Max Black's terms *focus* and *frame* as equivalent to the more common terms, associated with I. A. Richards, *tenor* and *vehicle*. See Black, "Metaphor"; Richards, *Philosophy of Rhetoric*.
35. Ricœur, *Rule of Metaphor*, 80.

because this incongruity is accompanied by some recognizable affinity between the two domains, the outcome is not intractable confusion. We can figure it out and appreciate the metaphor as an intelligible whole.[36]

I have suggested elsewhere that, mutatis mutandis, a great deal of what comes under the canopy of "the arts" entails just this sort of generative combination of the disparate.[37] This can take a huge variety of forms. We can see it when a poet employs an atypical juxtaposition of images, or when a novelist places a character in surprising surroundings, or when a visual artist invites us to see others in terms of unexpected objects. An example of the last of these is Ai Weiwei's portrayal of the Chinese people in *Sunflower Seeds* (2010), with its millions of porcelain sunflower seeds (suggesting mass production, the anonymity of the individual, and so forth).

In addition, there are the incongruities generated by those factors that enable us to recognize something *as* art, that signal to us that we are not dealing with a "straightforward," everyday presentation of objects and events but with a particular kind of re-presentation. In poetic verse, there will likely be incongruity between, on the one hand, the presence of poetic devices such as feet, meter, stanzas, rhyme, consonance, assonance, and alliteration—which together give a poem its distinctive character *as* verse—and, on the other hand, the forms of language we habitually employ in everyday speech. We do not, after all, ordinarily speak in poetry. In conventional dramatic performance, there is often a mismatch between the plot as presented in discrete segments and the kind of presentation we would recognize as reportage of the "real world" in "real time" (we don't jump on the stage to rescue the hero about to be murdered). In figurative landscape painting, there is a discrepancy between the framed two-dimensional canvas and the three-dimensional site being portrayed. These artificial devices subliminally announce to us that we are dealing with art, that we are not engaging the familiar in familiar ways. They defamiliarize. Of course, we may well be presented with recognizable objects and events from our world (trees, people, houses), but simply by being presented in this different, incongruous way, they are, to some extent, defamiliarized: they demand fresh attention. Furthermore (and this was especially

36. This kind of incongruity-with-affinity is of course also crucial to other figurative linguistic devices, such as irony and paradox.

37. Begbie, *Voicing Creation's Praise*, 233–55. The literature on art and metaphor is by now fairly extensive; see, e.g., Forceville, "Metaphor in Pictures and Multimodal Representations"; Hausman, *Metaphor and Art*; Dixon, "Artistic Metaphor"; Rough, "Metaphor in the Art of Vincent van Gogh."

important for Shklovsky), in much modernist Western art, conventional artistic techniques are deliberately disrupted and distorted (as in, say, avant-garde dance and theater). This does not affect our main point, but it reminds us that we are dealing with a distinctive form of "re-presentation": figuring one thing through an unexpected other.[38]

Along with the disturbance or shock value, there is nonetheless something *appropriate* about the conjunction involved in a metaphor, something readily intelligible about the link one is making. The incongruity will be anchored in a perceived affinity or likeness of some sort. Only in this way can the art make sense. Without the affinity, we would not be able to figure one thing through an unexpected other; without the incongruity, we would not bother doing so.[39] The art thus not only makes sense of something, it makes *fresh* sense of something: the familiar is made unfamiliar.

To be sure, I have used examples of art where the relation between the art and its subject matter is relatively obvious and readily perceptible (a figurative landscape bears a resemblance to its subject). But the relation need not be of this kind in order for the metaphorical dynamic to be present; all that is needed is that there be some recognizable, perceptible relation (or relations) between the artwork and the extra-artistic phenomena, and that there be incongruity between the extra-artistic phenomena as normally perceived and the way they are being re-presented in and through the artistic medium.

Discovery and Understanding

We can expand on this by considering some further parallels between metaphors deployed as figures of speech and pieces of art as we engage them. To begin with, it is widely acknowledged that metaphors can be vehicles of *discovery*, granting epistemic access to realities beyond the speaker or writer in ways that enlarge, enrich, modify, perhaps even correct our understanding of

38. I am using the word *unexpected* here to mean "incongruous" or "strikingly different." I realize that we would probably not describe the theatrical trappings of a play as "unexpected," but my principal point is about the mismatch between these trappings and the objects and events that form the content of the drama.

39. Speaking of the combination of music and language in, say, a song, Julian Johnson writes, "It's the gap between music and language that becomes a question for the philosophy of music, not the similarity. But the similarity ensures that this gap is not characterised by non-relation; instead, it makes for a highly-charged space, which sparks across the tension between like and not-like, between the assumption of linguistic manners and the myriad ways in which they are displaced, deformed, undercut, or ignored" (Johnson, "Between Sound and Structure").

those realities. Jesus intended his hearers to learn something about Herod by calling him a fox; he was not merely giving his language extra punch or simply emoting (though he was likely doing these things too). Once we understand a metaphor, after all, we can judge it to be successful, appropriate, fitting, unfair, unjust, and so forth.

This presents a challenge to those who, in the interests of ensuring truthful representation, go out of their way to eschew metaphor and give pride of place to the literal, descriptive assertion, the designation of preexisting ideas or objects. Although the need for such language in many contexts is beyond doubt (it has vastly extended our knowledge and grasp of the world), what needs questioning is the assumption that language is truthful *just to the extent* that it approximates to such expressions. As we saw in chapter 2, this outlook has been commonly allied to a denigration of metaphor (and of all nonliteral, figurative language) as inherently deviant, perhaps even deceptive (Locke's "perfect cheats"[40]): metaphors may be rhetorical, ornamental, aesthetically pleasing, or emotively beneficial—but they can have no cognitive truth-bearing capacity *as* metaphor. However, when Winston Churchill declared in 1946 that "an iron curtain has descended across the Continent,"[41] he was doing more than rhetorically embellishing his oratory, more than registering his own inner emotional state; he was making possible a fresh apprehension of concrete political affairs, and one that significantly altered the West's view of the Soviet bloc at the time.

We should bear in mind that this kind of apprehension is made possible not *despite* a metaphor's peculiar concurrences and strange couplings but precisely *through* and *because of* them. It is in this way that metaphor unsettles and stimulates the imagination, defamiliarizes the habitual, reveals semantic connections between things (connections of which we might otherwise never have been aware)—including connections that can be apprehended *only* metaphorically.[42] As Janet Martin Soskice notes, "The interesting thing about metaphor, or at least about some metaphors, is that they are used *not to re-describe but to disclose*

40. See chap. 2 epigraphs. Locke, *Essay Concerning Human Understanding*, 3.10.34.508.
41. "'Iron Curtain' Speech," The National Archives.
42. "By fusing features into patterns, the metaphor affords epistemic access to characteristics and regularities we might otherwise overlook" (Elgin, "Art in the Advancement of Understanding," 5). On the use of metaphors in the natural sciences, see Haack, "Art of Scientific Metaphors"; Colburn and Shute, "Metaphor in Computer Science." As Laura Otis puts it in a perceptive article on metaphor in nineteenth-century telecommunications, "Metaphors do not 'express' scientists' ideas; they *are* the ideas" (Otis, "Metaphoric Circuit," 127, italics original).

for the first time.[43] Indeed, this is one of their most fascinating and paradoxical features: metaphors are very obviously constructed, and yet at the same time can be strikingly revelatory. The fact that they are artifacts, bringing things together that were hitherto apart, does not disqualify them from being media of discovery and understanding.[44]

All this may seem counterintuitive to some, so conditioned are we to thinking of the arts as quintessentially constructive (and thus "subjective") and of the sciences as descriptive (and "objective"). But enough has been said by now, I hope, to render that kind of dichotomy unsupportable. Thus Charles Taylor contends that the arts are concerned with "portrayal," a presentation of meanings that is not straightforward description but nonetheless goes far beyond the expressive projection of the self.[45] It is hard to deny that one reason the arts are so highly valued across vastly diverse cultures is that they can—to put it rather abstractly—uniquely engage particular states of affairs external to the artists and to their art, states of affairs not limited to the conditions of human interiority, in such a way that our perception and grasp of those states of affairs can be enlarged, enhanced, and perhaps even amended.

What I am pressing toward here is what some have called "aesthetic cognitivism,"[46] an outlook I began to develop in a theological context in an earlier book.[47] Aesthetic cognitivism names a cluster of views, but common to most is

43. Soskice, *Metaphor and Religious Language*, 89, italics added.
44. Catherine Elgin rightly remarks,
Metaphor enables us to identify previously unmarked classes, and to state previously inarticulable truths. It equips us to recognize new likenesses and differences, patterns and discrepancies both within and across domains. It enables us to draw on cognitive resources we have developed elsewhere to advance our understanding of a given realm. It provides resources for asking questions and exploring hypotheses that could neither have been framed nor motivated without the partition of the domain that the metaphor supplies. When these resources and abilities constitute or contribute to cognitive progress, metaphor advances cognition. (Elgin, "Art in the Advancement of Understanding," 6)
45. Taylor, *Language Animal*, 247–49 and chap. 6 passim.
46. Graham, *Philosophy of the Arts*, chap. 3. I am indebted in what follows to Graham's lucid arguments in this book. On aesthetic cognitivism (properly speaking, a cluster of theories and positions), see also Baumberger, "Art and Understanding"; Gaut, "Art and Knowledge"; Elgin, "Art in the Advancement of Understanding"; Gibson, "Cognitivism and the Arts."
47. Begbie, *Voicing Creation's Praise*, 205–58. In making his case for cognitive aestheticism, Christoph Baumberger is one of a number of scholars who distinguish between knowledge and understanding. *Understanding* he takes as the central category of epistemology, and his interest is especially in understanding as "cognitive success or achievement." *Knowledge* he understands in a much narrower sense: unlike understanding, knowledge needs to be couched in terms of justified (or reliably generated) true statements or beliefs. He believes art can contribute to *understanding*, and insofar as it does contribute to knowledge, this function is often minimal and usually relatively

the belief that the arts offer far more than entertainment, delight, or emotional release (important as these may be): they can further our understanding, and such understanding ranges far beyond the trivial. The point is expressed *in nuce* by Nelson Goodman: "The arts must be taken no less seriously than the sciences as modes of discovery, creation, and enlargement of knowledge in the broadest sense of advancement of the understanding."[48] As I suggested in the previous section, very often key to this process is the way in which arts defamiliarize the familiar, pressing us to apprehend something in terms of an unexpected other.

Of course, if *understanding* is taken to mean the collation and assimilation of data and their articulation in statements, then we do not normally regard this as a characteristic feature or prime value of the arts. We do not generally think of the art gallery as the first place to go in order to add to our stock of historical data (though with a painting, as with an historical novel, we may well pick up such data along the way), nor do we tend to value highly the kind of art in which the dissemination of information appears to be the primary interest. But an aesthetic cognitivist maintains that this is not the kind of understanding that distinguishes the arts, for here the understanding we gain is inseparable from the process of encountering the art (in contrast to the truth of a scientific theorem, for example, which can often be articulated in a number of equally valid ways).[49] The arts' distinctive ways of operating are intrinsic to the cognitive process, not mere dispensable coating: it is *as encountered* that artworks have the capacity to contribute to the advancement of understanding.

I spoke earlier of the tendency of preachers to assume that their task is to expose a kernel of propositional meaning beneath the literary husk of a biblical text.[50] Sarah Ruden has recently reminded us that ancient biblical languages "were not like modern globalized ones, serving mainly to convey information in explicit and interchangeable forms—but with a dimension called 'style' for artistic uses on the side. Instead, the original Bible was, like all of ancient rhetoric

insignificant (Baumberger, "Art and Understanding," 2–9). I prefer to take *knowledge* in a much wider sense (see, e.g., under "Bodily Indwelling," later in this chapter).

48. Goodman, *Ways of Worldmaking*, 102.

49. On these points, see Graham, *Philosophy of the Arts*, chap. 3. Michael Polanyi and Harry Prosch write, "Works of science, engineering, and the arts are *all* achieved by the imagination. However, once a scientist has made a discovery or an engineer has produced a new mechanism, the possession of these things by others requires little effort of the imagination. *This is not the case with the arts.* . . . [We have] to achieve an imaginative vision in order to 'use' a work of art, that is, to understand and enjoy it aesthetically" (Polanyi and Prosch, *Meaning*, 85, italics original).

50. See under "Linguistic Reductionism" in chap. 2.

and poetry, primarily a set of live performances, and *what* they meant was tightly bound up in *the way* they meant it."[51] In other words, the literary tropes of Scripture, as performed, are the media *in* as well as *through* which the theological vision is conveyed and understood.[52]

What, then, might this advance in understanding through the arts look like? Christoph Baumberger outlines some of the forms it takes.[53] The arts can give us resources to categorize and classify objects (Charles Dickens coined the word "doormat" in *Great Expectations*[54]); they can offer perspectives on objects (a novelist "groups together a set of qualities, and, if a character has depth and plausibility, as do Emma Woodhouse and Emma Bovary, then one can learn to see real people in terms of the characters, and so discover more about the former"[55]); they can push us to ask questions that open up the density of moral dilemmas (as in many of Dostoyevsky's novels). They can "provide us with knowledge of how it is (or was or would be) like to have certain experiences or emotions, or to be in a certain situation."[56] The poetry of Shane McCrae contains many examples of this. Raised as a mixed-race child by his White-supremacist grandparents in Texas, McCrae's verse pulls the reader into the warped entanglements of racist America.[57] Further, Baumberger notes that the arts may offer penetrating thought experiments—for example, Orwell's *1984* and the 2021 Adam McKay film *Don't Look Up.*

Baumberger rightly stresses that by no means all art is fictional (although it is common for reductionists to assume that it is). Art can directly engage actually existing or previously existing concrete realities. "Biographies and documentary films with artistic aspirations refer to real people and places. . . . Many portraits and landscapes denote real persons and scenes and impart beliefs about them by representing them as having certain properties."[58]

51. Ruden, *Face of Water*, xxi, italics original.

52. The art historian T. J. Clark comments in an interview, "My main quarrel with the discipline of art history is very simple, very commonsensical. It seems to me not to take seriously enough the difference between visual and verbal representation. It does not truly confront the investment of the human species in non-linguistic forms of thought. It exists, as a discipline, too completely and comfortably in a textual universe—it is happiest when it finds a piece of language to 'correspond' to an image, or indeed to generate (to determine) it" (Clark, "Interview with T. J. Clark").

53. Baumberger, "Art and Understanding," 9–18.

54. I owe this example to Daniel Train.

55. Gaut, *Art, Emotion and Ethics*, 143.

56. Baumberger, "Art and Understanding," 13.

57. See, e.g., McCrae, *In the Language of My Captor.*

58. Baumberger, "Art and Understanding," 19.

None of this should be taken as suggesting that the advancement of discovery and understanding is always a conscious reason for producing or engaging art, or that this is the only value the arts can have. Nor is it to deny that much art may well have little to offer by way of promoting discovery and understanding. It is simply to affirm a possibility, but a critically important one at that.

Metaphorical Discovery and Understanding through the Arts

How does this process of enhanced understanding through the arts link up with the dynamics of metaphor? We can attend to a few examples to glean something of what is entailed.[59]

The German-born artist Käthe Kollwitz (1867–1945) is perhaps best known for her heart-wrenching exposure of the conditions of the working poor who flooded into German cities in search of factory employment in the late nineteenth century. While living in Berlin in 1900, she produced one of her most searing etchings, *The Downtrodden* (fig. 6.1).[60] A mother holds her child, pale and sickly (asleep, or maybe lifeless). The father, in silent desperation, cannot even bear to look. He holds out a rope noose. The angelic light of the innocent child is set next to the hopelessness of the noose. The child leans from right to left, in contrast to the conventional Western left-to-right movement of reading a text, thus making her look less settled than she would otherwise. With her eyes fixed on the rope, the mother tenderly cradles the child, her posture perhaps suggesting giving birth. No door or window is portrayed. The background is entirely dark.

These are disturbing, defamiliarizing devices that, along with the etching's two-dimensionality (portraying a three-dimensional scene), turn our attention

59. A number of writers have explored the metaphorical dynamics of visual art at length. Charles Forceville, for example, has offered an extended account of "pictorial metaphor," concentrating on the interplay of elements within pieces of visual art, including cinema (Forceville, "Metaphor in Pictures and Multimodal Representations"). He speaks of *contextual metaphors*, in which objects are placed in unusual contexts; *hybrid metaphors*, in which normally distinct entities are merged into single gestalts; *pictorial similes*, in which dissimilar objects are made to look similar; and *integrated metaphors*, in which "a phenomenon experienced as a unified object or gestalt is represented in its entirety in such a manner that it resembles another object or gestalt" (Forceville, "Metaphor in Pictures and Multimodal Representations," 464–69).

60. For the following observations, I am especially grateful to Stephanie Gehring for her dissertation on Käthe Kollwitz and Simone Weil (Gehring, "Attention to Suffering," chap. 2). In an illuminating way, Jennifer Craft relates this etching to the exposure of injustice to be found in the prophet Amos (Craft, "Needy in the Gate"). I am also especially indebted in what follows to insightful conversations with Jonathan Anderson.

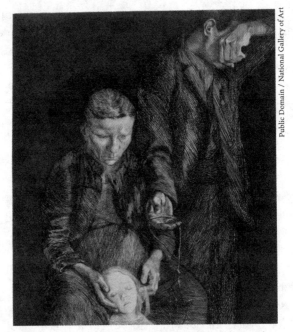

Public Domain / National Gallery of Art

Fig. 6.1. Käthe Kollwitz, *The Downtrodden*, 1900. Etching and aquatint on paper, 12⅛ × 9¾ in.

in a particular, emotionally charged way to the subject in hand. Nothing is asserted, and even though the picture is historically rooted, we are presented with something that far exceeds historical reportage. We discover something of what it is to *be* in the midst of the gray, numbing prison of poverty. Indeed, we are granted a particular understanding of poverty that would be hard if not impossible to achieve by any other means.

In this image, metaphorical energy is generated through visual means. Rather more complex are what Charles Forceville calls "multimodal metaphors," in which "target, source, and/or mappable features are represented or suggested by at least two different sign systems (one of which may be language) or modes of perception."[61] Examples include the combination of text and music in a song, or of speech and image in a film—where we are met with at least two media or sensory modes. Forceville speaks of a scene from *American Psycho* (2000) in which the central character and his colleagues brag to each other about their

61. Forceville, "Metaphor in Pictures and Multimodal Representations," 463. I have written at length about the combination of music and language in Begbie, *Music, Modernity, and God*, chaps. 7–8.

business cards.[62] As the cards are presented, an added swooshing sound under-
lines the movement. One character presents his card with an outstretched arm,
suggesting the drawing of a knife. Distinctive imaging techniques (camera angles
and movement); montage; sounds (swooshing, silence); and scripted lines—all
these are combined. The affordances of the source domain (knifing someone)
are mapped onto the target (exchanging business cards). In this way a rather
dull piece of etiquette is defamiliarized through metaphorical juxtaposition, and
given bodily enacted and emotionally charged significance, opening out to us
the life-and-death competitiveness of the characters.[63]

Music might appear to present an insuperable challenge to foregrounding the
metaphoricity of the arts in this way. For, as we have already observed,[64] it does
not employ terms that readily designate extra-musical objects: ideas, events,
states of affairs. And music's resulting relation to extra-musical realities will thus
be of a very different sort than designative reference. Of course, music is occa-
sionally used to ape extra-musical phenomena (birdsong, for example), but in
such cases, the music normally makes perfectly good sense without the hearer
needing to have those particular phenomena in mind. In short, unlike language,
music does not have a literal, descriptive mode from which a metaphorical
sense (employing "source" and "target") may be convincingly distinguished.[65]

How, then, might music operate metaphorically as a vehicle of disclosure
and discovery? We might point to the way internal components of music com-
bine in metaphor-like ways (irregular meter, incompatible keys, antitheses of
contrasting phrases), but this alone will not get us very far when it comes to
making sense of music's links with the extra-musical.

Admittedly, a large can of worms opens up here (more like a crate), and we
will have to limit ourselves to making two broad points. First, in my judgment,

62. Forceville, "Metaphor in Pictures and Multimodal Representations," 471–72.
63. Another telling use of multimodal metaphor can be found in computer interfaces. "The
desktop metaphor, with its documents, folders, and wastebasket, structures our thinking and be-
havior concerning digital data, as does surfing, hacking, and firewalling" (Forceville, "Metaphor
in Pictures and Multimodal Representations," 476).
64. See under "Linguistic Reductionism" in chap. 2.
65. Speaking of Chopin's *Fantasie-Impromptu*, Charles Taylor writes, "A human possibility
is disclosed here, but nothing at all is asserted" (Taylor, *Language Animal*, 236). The conductor
and pianist Daniel Barenboim caught something of this in a tribute to his friend Edward Said:
"Edward saw in music not just a combination of sounds, but he understood the fact that every
musical masterpiece is, as it were, a conception of the world. And the difficulty lies in the fact that
this conception of the world cannot be described in words—because were it possible to describe
it in words, the music would be unnecessary. But he recognized that *the fact that it is indescribable
doesn't mean it has no meaning*" (Barenboim and Said, *Parallels and Paradoxes*, x, italics added).

the most convincing accounts of music as a metaphorical means of disclosure appeal to the way music draws on and resonates with features of our embodied experience. Music, that is, depends on mapping features or structural relations from the domain of bodily experience onto the "unexpected" domain of musical sound. Especially significant in this respect are bodily movements and dispositions that are strongly charged emotionally, such as vocalization, gait, bearing, and carriage. Bodily behaviors characteristic of certain emotional states are represented in another (incongruous) mode: the structured and stylized forms of musical sounds in time. (Our emotional life is rarely, if ever, so ordered.) This makes possible a heightened emotional involvement with the extra-musical reality or realities being engaged.[66] Also relevant here is a substantial body of literature now supporting so-called cognitive theories of emotion—according to which emotions are not simply mindless, irrational reactions, surges of internal affect, but profoundly important, bodily rooted means of being oriented appropriately to concrete realities beyond ourselves.[67]

So in a funeral service, for example, music may play an important part in the process of coming to terms with the loss of someone close to us. Such music often draws on bodily behaviors associated with sorrow—a slow walking pace, the limited pitch range of a grieving voice—giving them particular expression in the characteristic idioms of music (phrases, rhythmic patterns). These affinities and the incongruity of the musical form together enable a fresh and heightened emotional participation in the event of grieving. Indeed, through the music we may well discover more deeply what it is we lament, and why.[68] We might also point here to abundant evidence showing that music, due to its links with bodily expression, can engender remarkably strong interpersonal emotional empathy.[69]

66. See Spitzer, *History of Emotion in Western Music*, 969–71; Davies, *Musical Meaning and Expression*, 221–40. This does not mean that music is "about" our emotional life, in the sense of directing our attention to it, in the way that the metaphor "Juliet is the sun" directs our attention to Juliet, and even less in the way that the statement "Juliet is a woman" does so. Just because musical sounds do not employ designative terms, our awareness of an object of attention will depend to a very large degree on other factors that form the context in which the music takes place (words, text, images, memories, and so on). The meanings we ascribe to music generally depend far more on contextual variables than the meanings we ascribe to language.

67. For an overview, see Reisenzein, "Cognitive Theory of Emotion."

68. The psychologist Anjan Chatterjee writes, "The tension and release, conflict and resolution, excitement and calm, motion and stasis, joy and sorrow, expectation and fulfilment that we hear in music can prompt us to reflect on and thereby better understand our own emotional life" (Chatterjee, "What Does Aesthetic Cognitivism Really Mean, Anyway?").

69. See King and Waddington, *Music and Empathy*.

Second, the bodily experience on which music draws is inextricably bound up with a wider context: that of the physical world at large. This is what many ancient theories of music's powers grasped so vividly—and many non-Western understandings of music still do. The centuries-old belief that music taps into and re-forms the dynamic sonic order of the universe, however naively expressed, speaks to a profound and important intuition of music's resonance with the material world that we inhabit as bodily creatures. We have already spoken of this in connection with the issue of "universals."[70] To be sure, music hardly ever attempts simply to replicate that order. We *make* music; it does not drop down from the sky. And music rarely if ever seeks to designate or refer to that order, or to assert something about it. But music does *engage* with it—with the vibrations of wood, the harmonics of vocal cords, the oscillations of air—and in so doing draws us into a bodily participation in that order, however much we might shape, form, re-shape, and re-form it in the process. In this sense, cannot music be a vehicle of discovery as well as of expression and invention?[71]

Bodily Indwelling

Thinking of music in this way brings to our attention a crucial and widely acknowledged feature of metaphors: they depend for their intelligibility on *our pre-reflective, pre-conceptual bodily involvement with the world*. And the same, I propose, typically characterizes the processes of making and encountering art.

Beginning with metaphors: they bring to expression something integral to our navigation of this world—the ability to map one kind of experience onto another, an ability that at the deepest level arises from and is shaped by sensorimotor processes of the body, as well as by our social and cultural experience. As Iain McGilchrist puts it, "Any one thing can be understood only in terms of another thing, and ultimately that must come down to a something that is experienced, outside the system of signs (i.e. by the body)."[72] Especially relevant here is the influential work of George Lakoff and Mark Johnson,[73] according to whom metaphor is to be regarded not fundamentally as a linguistic phenomenon but as a means through which we organize our experiences at a

70. See under "Sociocultural Reductionism" in chap. 4.

71. On this in relation to the music of J. S. Bach, see Begbie, *Music, Modernity, and God*, 43–50.

72. McGilchrist, *Master and His Emissary*, 118. In other words, it is not as if the metaphorical needs literal translation in order to be intelligible; if anything, the literal needs the metaphorical. (I hasten to add that this does not mean all language is metaphorical!)

73. Lakoff and Johnson, *Metaphors We Live By*.

fundamental level, a practice that is ineluctably grounded in the body. Metaphor, they claim, arises from "sensorimotor schemata," primitive "image schemas" or mental patterns that mediate and structure the planning and performance of our bodily movements—*templates* might be a better word than *schemata*.[74] An example would be CONTAINER (especially important in John's Gospel, as we saw in chapter 5)—a field or space "in" which or "outside" which things can be situated—a template that derives from our experience as bounded, bodily creatures. Metaphors arise from the creative application of these templates. So, for example, when arguing a point, we might say that we "keep on track," "stay on course," "get stuck"—all expressions that depend on viewing the business of pursuing an argument through the bodily derived metaphor "LIFE IS A JOURNEY." These conceptual metaphors make it possible for us to structure entire domains of thought and language, and, crucially, to figure one domain through another.

We are thus speaking of a process that draws on what Charles Taylor calls a "penumbra of meanings," one that is "rooted in our bodily know-how, which enables us to make our way in and around our immediate surroundings, and deal with the objects that show up in it."[75] A child learns her way around the world not by developing quasi-scientific descriptions of things but by discovering the properties of things that resonate with her engagement with them: my granddaughter finds out one day that the TV remote control can be chewed, that the kitchen shelf can be climbed. Such "human meanings" are always present, says Taylor, even in the most formal use of language, because of a "know-how" rooted in our bodies.[76]

For many, this will call to mind the phenomenological tradition in philosophy. For Edmund Husserl (1859–1938) and those in his wake, all perception takes place within a "world-horizon," an infinite horizon of meaning-formation (*Sinnbildung*).[77] Maurice Merleau-Ponty (1908–61), perhaps the most com-

74. As suggested by Charles Taylor (Taylor, *Language Animal*, 150–64). Trevor Hart speaks of these templates as "*abstractions of* recurrent embodied patterns of motion, and not *abstractions from* the physicality and temporality of our embodied existence. They constitute ways in which we experience the world as meaningful rather than concepts in terms of which we subsequently reflect upon it" (Hart, "Creative Imagination and Moral Identity," 5, italics original).

75. Taylor, *Language Animal*, 148.

76. Taylor, *Language Animal*, 149.

77. For a fascinating comparison of Shklovsky with Husserl, see Chernavin and Yampolskaya, "'Estrangement' in Aesthetics and Beyond." They write that "the key messages of Russian Formalism and phenomenology are quite similar, although expressed using different language: the heart of aesthetical experience is the constitution of a new meaning as a meaning-in-formation driven

monly cited thinker in this stream, spoke of "motor intentionality," a form of un-reflective bodily activity that is nonetheless "intentional," *about* something.[78] But probably the most lucid presentation of this outlook comes from the Hungarian-British scientist Michael Polanyi (1886–1964), whose intellectual interests and skills reached far beyond his own professional expertise. Polanyi proposed a basic distinction between what he called "focal" and "subsidiary" awareness. When I hammer a nail into a block of wood, I am focally aware of driving in the nail, but I am subsidiarily aware of the feelings in my hand and palm as I hold the nail and hammer. I rely on these feelings in order to perform the task, but I am not aware of them focally. All knowing, Polanyi contends (and he is using *knowing* in a way broadly equivalent to our sense of *understanding*, dis-cussed above), proceeds according to this pattern: subsidiary awareness, rooted ultimately in bodily experience, is drawn on and integrated to a focal goal. We rely on the subsidiaries and attend to the goal. If we focus our attention on the subsidiaries (e.g., if we attend to the font size of printed words rather than what they communicate), the semantic relationship collapses. Consequently, the sub-sidiaries by their very nature are never fully specifiable in words or concepts. We can of course identify factors relevant to our knowledge of X, but as and when we do so, we are no longer knowing X. The upshot is that *"we know more than we can tell."*[79] All knowing and all meaningful language use, according to Polanyi, depend on this inarticulate "tacit dimension" (Taylor's "penumbra of meanings") that accompanies our bodily engagements with the world—*including* the most formal or directly descriptive, denotative, and precise assertions we could ever employ.[80]

As far as the arts are concerned, they not only depend on this pretheoretical, tacit, bodily dimension of our involvement with the world, and in particular on the capacity—rooted in this tacit dimension—that undergirds all our under-standing: the ability to figure one domain through another, to map one kind of experience onto another. They draw upon it with a peculiar intensity, giving it concentrated expression through the "strange" (often exceptionally strange) metaphorical combinations they specialize in generating and making available to our perception.

by our affective involvement with a work of art" (Chernavin and Yampolskaya, "'Estrangement' in Aesthetics and Beyond," 105).

78. Merleau-Ponty, *Phenomenology of Perception*, chap. 3.

79. Polanyi, *Tacit Dimension*, 4, italics original.

80. Polanyi, *Tacit Dimension*; see also Polanyi, *Personal Knowledge*.

Inexhaustible Allusivity

I will expand on these points at a later stage. For the moment, we need to consider a major consequence of approaching the arts from this metaphorical perspective, and we can do so through a poem at once entertaining and instructive, "Naming of Parts":

> Today we have naming of parts. Yesterday,
> We had daily cleaning. And tomorrow morning,
> We shall have what to do after firing. But to-day,
> Today we have naming of parts. Japonica
> Glistens like coral in all of the neighbouring gardens,
> And today we have naming of parts.
>
> This is the lower sling swivel. And this
> Is the upper sling swivel, whose use you will see,
> When you are given your slings. And this is the pilinge swivel,
> Which in your case you have not got. The branches
> Hold in the gardens their silent, eloquent gestures,
> Which in our case we have not got.
>
> This is the safety-catch, which is always released
> With an easy flick of the thumb. And please do not let me
> See anyone using his finger. You can do it quite easy
> If you have any strength in your thumb. The blossoms
> Are fragile and motionless, never letting anyone see
> Any of them using their finger.
>
> And this you can see is the bolt. The purpose of this
> Is to open the breech, as you see. We can slide it
> Rapidly backwards and forwards: we call this
> Easing the spring. And rapidly backwards and forwards
> The early bees are assaulting and fumbling the flowers:
> They call it easing the Spring.
>
> They call it easing the Spring: it is perfectly easy
> If you have any strength in your thumb: like the bolt,
> And the breech, and the cocking-piece, and the point of balance,
> Which in our case we have not got; and the almond-blossom
> Silent in all of the gardens and the bees going backwards and forwards,
> For today we have naming of parts.[81]

81. Reed, "Naming of Parts," in *Henry Reed: Collected Poems*, 49. Used by permission.

In the summer of 1941, the poet Henry Reed (1914–86) underwent basic training in the Royal Army Ordnance Corps. He recalls the training instructor identifying each part of a Lee-Enfield rifle with impersonal precision. In his poetic memory of the occasion, the new recruit dreams of plants and flowers in neighboring gardens, in particular the flowering almond (*Prunus japonica*). The poem's gentle irony turns on the apposition of the mechanical with the natural; the direct, "naming," pragmatic language of the instructor with the sensuous, affective words of the daydreaming trainee; the cold, colorless, and lifeless with the warm and colorful blooming of life. In fact, the soldier's naming is piecemeal and arbitrary; essential components are omitted; nothing is said about the purpose of the parts (except that the bolt opens the breach), nothing about loading or firing. It is merely naming: naming of parts. Reductionism at its starkest and chilliest, we might say. This dead and monochromatic labeling contrasts with the multiply allusive, suggestive vocabulary Reed uses of the garden's "eloquent gestures." The juxtaposition is ameliorated when the sterile labels are themselves taken up and made allusive as they are applied to the garden, most tellingly in the last stanza, with a delicious play on "spring/ Spring" enabling what one commentator calls a "final expanded perception."[82]

It is this kind of generative allusivity that we need to ponder here, and the "expanded perception" it makes possible. William Empson writes of the "pregnancy" of metaphors, their connotative fertility.[83] Because they draw so intimately and intensively on our bodily indwelling of the world—an indwelling that is prearticulate, and whose part in the creation of meaning we cannot fully spell out—metaphors can generate an array of significance that can never be exhaustively enumerated or specified. Good metaphors are inexhaustibly evocative. It is as if we are being tacitly told, *There is always more here for you to find*.

This is emphatically not to claim that metaphors are infinitely ambiguous or malleable, wholly indeterminate—still less that they are necessarily vague. It is to say that their significance can never be comprehensively articulated. However much we might try to list all the things that the metaphor "Juliet is the sun" might connote about Juliet (beauty, radiance, etc.), we would never get to the end of it. Recall all the metaphors and allusions in our two Johannine interruptions; it is no accident that Richard Bauckham speaks of the Fourth Gospel's "cornucopia of meanings."[84] This of course pushes against the kind of

82. Hyndman, "Point of Balance," 571.
83. Empson, *Structure of Complex Words*, 16–17.
84. Bauckham, *Gospel of Glory*, 132.

reductionism that imagines we can turn metaphors into nonmetaphorical state-ments without loss of content or revelatory power. "She is a ball of fire" must convey to us more than, say, "she is energetic"; otherwise "ball of fire" would be synonymous with "energetic." Explaining a metaphor is like explaining a joke; the metaphor dies.

The upshot is that some things can be accessed *only* metaphorically. As Charles Taylor observes, even to say that metaphors reveal "aspects of things not noticed before" too easily suggests "that 'aspects of things' are lying around, ready to be noticed, and metaphors trigger the noticing"—and that, by implication, after identifying these aspects the metaphor can be dropped.[85] The perception of the truth of a metaphor is inseparable from entering the metaphor and letting it do its own kind of work. The "harmonics" disclosed in an effective metaphor cannot be disclosed in any other way. It is thus virtually impossible to reduce a metaphor to a literal assertion—not, as is often thought, because it is "only subjective," or because it is approximate rather than precise, but because of the integral relation between engaging the metaphor and the insight or understanding it generates.

Of course, it might well be objected that if we are not able to provide *some* sort of paraphrase of a metaphor, we are tacitly admitting that the metaphor is meaningless. Stanley Cavell puts the point well:

> Now suppose I am asked what someone means who says, "Juliet is the sun." . . .
> I may say something like: Romeo means that Juliet is the warmth of his world;
> that his day begins with her; that only in her nourishment can he grow. And his
> declaration suggests that the moon, which other lovers use as an emblem of their
> love, is merely her reflected light, and dead in comparison; and so on. In a word,
> I paraphrase it. Moreover, if I could not provide an explanation of this form, that
> is a very good reason, a perfect reason, for supposing that I do not know what it
> means. Metaphors *are* paraphrasable.[86]

Perhaps it could be said that a good paraphrase of a metaphor extends and opens up its allusivity, making it more generative.[87] But the main point for our

85. Taylor, *Language Animal*, 142. Iain McGilchrist makes the point well: "Our sense of the commonality of the two ideas, perceptions or entities [in a metaphor] does not lie in a *post hoc* derivation of something abstracted from each of them, which is found on subsequent compari-son to be similar, or even one and the same thing; but rather on a single concrete, synaesthetic experience more fundamental than either, and *from* which they in turn are derived" (McGilchrist, *Master and His Emissary*, 117, italics original).

86. Cavell, *Must We Mean What We Say?*, 73, italics added.

87. I am grateful to Jonathan Anderson for putting it in this way to me.

purposes here is that paraphrase, however justified in certain contexts, cannot *substitute* for the metaphor or *compete* with it. If it could, we would have a good case for abandoning the metaphor altogether.

And likewise for the wider world of the arts. It is virtually a truism to say that art cannot be "translated" into nonartistic terms without a loss of force and revelatory capacity. Hence the proverbial composer who simply played his piece again when someone asked, "What does it mean?" Benjamin Piekut speaks of the work of the music critic as tracing out the "promiscuous associations that spill across conventional parsings of the world."[88] And that could be applied far beyond music. It is not surprising to find the artistic world alive with such promiscuity, resisting the containment of paraphrase. A good example in this respect is the art of rap, especially in what some would see as its heyday in the late 1980s. As Michael Viega explains, "The dialogue within rap music is multi-layered, with double and triple entendre, musical and lyrical references to other artists across genres, a meta-dialogue on culture, politics, and society."[89] It is also replete with wordplay, assonance, enjambment, and rhyming techniques; and for the novice, the sheer speed and intensity of its allusivity can be overwhelming. Of course, rap in hip-hop culture is normally tightly held to a beat, but this does little to curb what often amounts to an almost wanton generation of meaning.

It was over forty years ago that the Reformed Christian philosopher Calvin Seerveld proposed "allusivity" as a way of describing the core of the "aesthetic mode."[90] Very few followed him on this at the time, but his intuition was surely correct. Hillary Brand and Adrienne Chaplin memorably contrast one of Van Gogh's famous paintings of a pair of worn-down shoes—with its intimations of trudging in soil, a hard day's work, and so on—with the sketch of a shoe we might find on the side of a shoebox.[91] The latter efficiently answers to an immediate need; once the shoes are found on the shelf, the picture is superfluous. Van Gogh's portrayal (which has stimulated a substantial current of philosophical reflection[92]) is richly suggestive and continues to be generative of further meanings with each viewing. We are never finished with it.

88. Piekut, "Actor-Networks in Music History," 192.

89. Viega, "Exploring the Discourse," 140.

90. "Peculiar to art is a parable character, a metaphorical intensity, an elusive play in its artifactual presentation of meanings apprehended" (Seerveld, *Rainbows for the Fallen World*, 27).

91. Brand and Chaplin, *Art and Soul*, 123.

92. Most famously (and controversially) by Martin Heidegger: "The Origin of the Work of Art" in *Poetry, Language, Thought*, 16–86. For a detailed discussion of Heidegger's interpretation of van Gogh, see the relevant section in Thomson, "Heidegger's Aesthetics."

For a recent example of this kind of allusivity in a related art form, we might turn to an artist such as Chicago-based photographer Dawoud Bey (b. 1953).[93] In his project "Night Coming Tenderly, Black" (2018), in effect he asks us to join the Underground Railroad, a secret network of routes and houses used by escaping slaves in the United States during the early to mid-nineteenth century. The most telling incongruity is that between the brightness of many of the subjects and the darkness or half-light that frames all twenty-five large-format photographs. As Brian Allen notes, "Whatever the mood, they demand that the viewer—the surrogate for the fleeing slave—puzzle out a way through the inky atmosphere and unfamiliar terrain."[94] A recent commentator writes, "Shot in daylight and printed dark to suggest the poetry of midnight, these nocturnes give us lucent swamps surrounded by feathered grey branches, open fields and groves. With a stroke of allusive magic, Bey conjures black fugitives moving invisibly through a black terrain to the shores of Lake Erie. There, chunky waves meet the horizon where freedom hovers, swathed in suggestive shadow."[95]

It is unlikely that reading a scholarly history of the Underground Railroad would ever be a substitute for going to such a show (even though the photos clearly concern historical events). In the same way, a scholarly biography of Henry V is very different from reading or seeing the Shakespeare play.[96] The latter, through its dramatic ploys, its multiple figuring of one thing through an unexpected other, pushes us to draw intensively on a wide range of tacit awareness, generating a multiple allusivity in a manner that both illuminates and involves us with its subject matter in ways not possible through prose history alone. When we do use prose to speak of poetry—in literary criticism, for example—we will likely say something like "Well, the poet is saying X and Y and Z, *and so on.*" The "and so on" here is crucial; it signals the "more" we know but can never fully tell.[97]

The contrast between the kind of perceptual excess provoked by artists and much of our habitual perception might well bring to mind Jean-Luc Marion's much-cited notion of "saturated phenomena"—phenomena that exceed the limiting horizons of concepts and language.[98] A recent commentator on Marion explains it thus:

93. For a good "way in" to Bey's work, see Charlton, "Dawoud Bey."
94. Allen, "Dawoud Bey Brings Viewers on an Evocative Journey."
95. Budwick, "Dawoud Bey at the Whitney."
96. Graham, *Philosophy of the Arts*, 56.
97. See Cavell, *Must We Mean What We Say?*, 73.
98. See Marion, "Saturated Phenomenon."

The colors red, yellow, and green in the experience of a traffic light, which only conveys information, versus the experience of those colors in Rothko's painting N. 212, the sound of a voice over a loudspeaker at an airport versus the experience of listening to the aria of a famous diva at the opera, the smell of gas versus the fragrance of a perfume, the taste of a poison versus the flavors of a good wine, the attempt at orientation in a dark room through the handling of objects to find a light switch versus the loving touch of the other's flesh. In the former cases, Marion claims, we can constitute the phenomenon through intentionality, understand it fully, indeed experience it primarily in terms of the information it conveys (e.g., a change of gates, the danger of a gas explosion). The later phenomena, however, defy all such simple description or constitution, but that makes them no less phenomena: they are still given to intuition; indeed, their rich intuition is one of their primary characteristics.[99]

In this light, then, it is not surprising if many who reflect on the arts show such a fierce resistance to any attempt to turn them into a version of something else. It is not just that a piece of art, or the production and enjoyment of art, has distinctive features and qualities of its own, but that basic to this very distinctiveness is something that works against any such reductive move. Coleridge declared that "untranslatableness in words of the same language without injury to the meaning" is "the infallible test of a blameless style."[100] Meaning comes to light as art is encountered, not as something that can be distilled and articulated as a "takeaway." Art yields its fruits *as* it is made, *as* it is engaged, *as* it is circulated in a community; otherwise it is mere packaging.

In this vein, Robert Alter reflects on the place of the poetic in biblical literature. He writes that "poetry, working through a system of complex linkages of sound, image, word, rhythm, syntax, theme, idea, is an instrument for conveying densely patterned meanings, and sometimes contradictory meanings, that are not readily conveyable through other kinds of discourse."[101] It was with this irreducibility in mind that Cleanth Brooks famously wrote in 1947 of the "heresy of paraphrase."[102] As a proponent of what came to be known as the New Criticism (one of whose main tenets was the non-paraphrasability of poetry), Brooks spurned the notion of a separable "content" that could be abstracted from the "form" of a poem:

99. Gschwandtner, "Turn to Excess," 451.
100. Coleridge, *Biographia Literaria*, 320.
101. Alter, *Art of Biblical Poetry*, 113.
102. Brooks, *Well Wrought Urn*, chap. 11.

The conventional terms [*form* and *content*] are much worse than inadequate: they are positively misleading in their implication that the poem constitutes a "statement" of some sort, the statement being true or false, and expressed more or less clearly or eloquently or beautifully; for it is from this formula that most of the common heresies about poetry derive. The formula begins by introducing a dualism which thenceforward is rarely overcome. . . . Where it is not overcome, it leaves the critic lodged upon one or the other of the horns of a dilemma: the critic is forced to judge the poem by its political or scientific or philosophical truth; or, he is forced to judge the poem by its form as conceived externally and detached from human experience.[103]

He continues,

We can very properly use paraphrases as pointers and as short-hand references provided that we know what we are doing. But it is highly important that we know what we are doing and that we see plainly that the paraphrase is not the real core of meaning which constitutes the essence of the poem.[104]

This probably needs qualifying. What Brooks says is certainly true of much poetry, but some poems lend themselves much more readily to paraphrase than others.[105] Nonetheless, he is surely correct in holding that the devices distinctive of poetry that mark it out as "detached" are themselves cognitively significant, not mere coating.[106] Thus it is vital, Cavell insists, that we not treat paraphrase and poem as if they "*operate, as it were, on the same level, are the same kind of thing*,"[107] and then relegate a poem to the status of a second-class assertion. The truth of a poem is opened up to us through an irreducibly integrative mode of experience.

Music, I suggest, is especially pertinent in this connection, given its very obvious resistance to being summarized in words and concepts. It is, in a sense, purely metaphorical—it has no "literal" sense. *And yet*, on any account it is profoundly "meaningful"; we don't hear it as a random, senseless conglomeration of sounds. Perhaps more than any other art, therefore, it can evoke a kind of meaningfulness that we are never finished with, one that always outperforms us, that we are never fully able to capture or grasp.

103. Brooks, *Well Wrought Urn*, 196.
104. Brooks, *Well Wrought Urn*, 196–97.
105. Cavell, *Must We Mean What We Say?*, 69–77.
106. Significantly, Stefán Snævarr has offered a rejuvenation of Cleanth Brooks's theory, enlisting Polanyi's work. See Snævarr, "Heresy of Paraphrase Revisited."
107. Cavell, *Must We Mean What We Say?*, 71, italics added.

Perhaps the best way to close this section is with a simple testimony of the painter Andrew Hendrixson, now a doctoral student in theology, who speaks of a project he titled *Not Yet Fallen*: "I spent months working with youth being held in a juvenile detention center in the Rust Belt. We talked about form in visual art and how form can have metaphorical resonance that might help them tell their often horrific stories in ways that exceed the capacity of prosaic language. We also worked together on writing their biographies, but from the future looking backward. In this way I sought to help them imagine newness for their future lives."[108]

◆ ◆ ◆ ◆

I have tried in this chapter to convey something of the way in which art making and our engagement with the arts involves metaphorical combinations of the unlike, generating an incongruity that is nonetheless anchored in an underlying affinity. These metaphorical acts draw intensively on the "tacit dimension" of our bodily experience of the world, resulting in an "expanded" perception and understanding of whatever it is we engage (objects, events, themes, ideas, persons). We sense multiple waves of significance that can never be fully specified. The upshot is that, whereas reductionism seems imbued with an ethos of containment, this artistic world of expanded and expansive understanding bears a dynamic of uncontainability. There appears to be a pressure in the production and reception of art that resists the drive to narrow down and hedge in. This would go at least some of the way toward explaining what we began to see in the second part of chapter 4: that artistic practices seem especially resistant to the various attempts to make them conform to reductionist agendas.

Indeed, we can discern an opposition to all four of our reductionist drives. The drive toward *ontological singularity* that gives credence to only one type of reality will receive little encouragement from an activity that makes things (works of art) that are irreducibly *other*—that is to say, entities that may very obviously engage with a reality beyond the art or artist but in a way that re-presents, re-realizes a dimension of that reality in an irreducibly distinct and different mode. Pieces of art thus have a life and integrity of their own, a way of being that cannot be subsumed into another mode without loss of power and content. (Recall Cavell's comment about the danger of thinking that a poem

108. Andrew Hendrixson, from a private conversation.

and its paraphrase *"operate . . . on the same level, are the same kind of thing."*[109])
Art seems to carry an especially strong antipathy to being treated as, or turned
into a subset of, something else. And, moreover, much of what we call art
seems adept at pressing us to perceive the world as an arena of particulars, and
particular modes of being that are just that: irreducibly particular even while
intrinsically related. (Indeed, artworks themselves normally depend for much
of their power on their own internal differentiation, their unity-in-multiplicity.)
At the same time, despite the concern for particularity, the artist will certainly
resist NR's eagerness to drill down to the component parts of things and declare
those to be more real, more basic than composite wholes. The artist, after all,
is in the business not of taking wholes apart but of making wholes *from* parts.

The pressure toward *exclusionary simplicity*, with its zeal to remove from the
field of our attention and inquiry anything that does not meet preset criteria
governing "the real," is met in the arts with a pressure that would appear intent
on widening our perception, broadening the scope of possibilities. Works of art
commonly press toward the proliferation of meanings, expanding rather than
narrowing the range of what we might consider worthy of notice. We are made
to sense what otherwise we might have merely passed by.

The drive toward one narrow *epistemic stance* (the "objectivism" presumed
to belong to the natural sciences, perhaps, or the "subjectivism" that goes with
extreme constructivism) and one *form of language* (such as literal, declarative
assertions) is clearly undercut by what has been outlined above. The arts enlarge
the range of what we are prepared to call "knowledge" and "understanding,"
serving to manifest with particular potency the profounder levels of participa-
tory knowing—the boundless, bodily grounded "penumbra of meanings" on
which all knowledge and understanding depend. Furthermore, an encounter
with literary art of any depth will likely call into question the restriction of
truth-bearing language to one narrow type.

With regard to the impetus toward *control and mastery*, although artists are
by no means immune to the urge to dominate and over-manage (and the same
goes for all who engage the arts), there seems to be a modus operandi close to
the heart of the production and engagement with art that is strikingly opposed
to the grasping, managing, and possessing ethos that characterizes what Nora
Vaage calls "the ontology of a controllable life."[110] The pressure toward allusive-
ness, the recognition that there is "always more," that we can never contain

109. Cavell, *Must We Mean What We Say?*, 71, italics added.
110. Vaage, "Living Machines," 68.

what we encounter—all these point to the capacity of the arts to dispossess us of the comforting fiction that we can gain some kind of total control, that we can secure a "fix" on things.

In large part, it seems that the arts "make sense" not by closing down possible relations but by opening them up; and this demands of the artist (and of the reader, listener, or viewer) a certain letting go of schemes, programs, and highly determinate ends. In particular, there needs to be a loosening of the instrumental rationality of means and ends that we considered in chapters 2 and 4. It is not that the artist can or should escape the world of doing things for a purpose—making a sculpture for this square, a hymn for this church. But if the process is wholly and completely ruled by the intention to cause a particular effect, then the ethos of control will not be far away, and the art is likely to be stunted as a result.

7

God's Uncontainable Pressure

In truth, we might catch up the whole of the Christian faith in this little word *more*. . . . God is the Name of this "more."

Katherine Sonderegger[1]

We can never fully know God if we think of him as an object of capture, to be fenced in by the enclosure of our own ideas. We know him better after our minds have let him go.

Thomas Merton[2]

The mystery of the incarnation of the Logos holds the power of all the hidden *logoi* and figures of Scripture as well as the knowledge of visible and intelligible creatures. Whoever knows the mystery of the cross and the tomb knows the *logoi* of these creatures. And whoever has been initiated in the ineffable power of the resurrection knows the purpose (*logos*) for which God originally made all things.

Maximus the Confessor[3]

1. Sonderegger, *Systematic Theology*, 1:456.
2. Merton, *No Man Is an Island*, 239.
3. Maximus the Confessor, *Chapters on Theologia and Oikonomia* 1.66, quoted in Paul Blowers, *Drama of the Divine Economy*, 245.

W here does this leave us? Not with the conclusion that the arts can equip us with a watertight demonstration of the falsity of reductionism. Art does not defy reductive sensibilities by advancing philosophical propositions or arguments. Rather, as I have tried to show, the processes of making and engaging art can pull us into a distinctive dynamic of discovery and understanding, one that by its very nature runs counter to the containing, controlling drives that propel the reductive imagination. Artistic practices re-situate us in relation to other persons and the wider physical world such that we can begin to experience them as abundant, exceeding what is immediately and obviously perceptible or "manageable." At best, we are jolted out of assuming without question that the flat, uniform, and constricting visions of reality that often surround us are the only ones available.

The question to ask now is: Could there be an imagination of the world and of our lives in it that is wide, rich, and supple enough to accommodate and advance this artistic counterpressure? Asking this does not necessarily lead us into theological territory—there are plenty of anti-reductionist art lovers who disavow all theological belief. But it is at least worth asking how our findings might resonate with theological commitments. What I will attempt to show in this chapter and the next is that just as reductionism is dominated by pressures of containment—narrowing down, closing off, constricting—the Christian faith takes its energy from an opposite pressure, one that refuses bounded containment, that is intrinsically uncontainable by this world: a pressure that has its source in a living, abundant God. We have already had a sense of this in our two Johannine "interruptions" (chaps. 3 and 5), but now we need to explore the theme more extensively, first with respect to God's relation to the created world—God's uncontainability by creation (this chapter)—and then with regard to God's triune life *in se*—God's own uncontainable "ex-pressive" life (chap. 8). This will pave the way for a penultimate chapter that brings into the open the multiple resonances between our theological and artistic findings and their ramifications for the arts in the life and witness of the church, including its theology.

To begin with, we need to note a couple of pitfalls. If we spend any time in a theological bookstore, it will not be long before we find vigorous ripostes to reductionism, and especially to the naturalistic reductionism (NR) that we examined in chapter 1. This is hardly surprising, given NR's commitment to the exclusion of the possibility of God. Many of these critiques are written by practicing scientists, some by philosophers and theologians. They are often

brilliantly executed, and I have gained much from them myself. However, surveying them makes it clear that some sizable traps lie in wait for the Christian anti-reductionist, and since this chapter's focus is specifically theological, it is worth highlighting at the outset two of the most common.

The first pitfall is that in rejecting a picture of the world as a closed system of natural processes and making room for what is sometimes called, rather loosely, the "supernatural," we treat God as a metaphysical "add-on" (or "add-in") to the finite world—as another object or agency among objects and agencies, a supplementary factor in the scheme of things. In fact, imagining God in this way is a pointed example of *theological* reductionism: in effect, it assigns God to the level of a creature. So—to pick up on an earlier discussion—although there may well be good theological reasons for adopting some version of the multilayered model of reality we spoke about in chapter 1, we should be careful not to try to baptize it by simply adding one more level—a "God layer" at the top (or bottom) of the scale. Mainstream Christian tradition has held that God is not a member of any type or class (*Deus not est in genere*),[4] not an "instance" or "case" of something already known in the contingent world (and certainly not an instance of "divinity").[5] God is other than the world, and in this sense transcendent, but transcendent in a manner that transcends all creaturely types of transcendence.[6] As transcendent, God is present to, upholds, and carries forward the entire contingent order with *all* its levels.[7]

The second pitfall—which often goes with the first—is to operate with a controlling metaphysics or theological ontology only minimally invested in the christological and trinitarian distinctives of Christian faith. This can take myriad forms: it might be a broadly conceived theism that rules the conceptual field, perhaps a form of deism, or a philosophically nuanced "perfect being" doctrine of God. For understandable apologetic reasons (perhaps to engage

4. Aquinas, *Summa theologiae* I.3.5.

5. Nicholas of Cusa (1401–64) famously spoke of God as "not other" (*non aliud*), intending not a dismissal of the ontological difference between God and world but an affirmation that God is not *an* other, merely another object alongside a string of "others." See Hopkins, *Nicholas of Cusa on God as Not-Other*. For further discussion of this general point, see, e.g., Placher, *Domestication of Transcendence*; Carlson, "Postmetaphysical Theology"; Shortt, *God Is No Thing*.

6. Hence the phrase *totaliter aliter*, used of God, is probably best rendered not as "wholly other" but as "wholly other*wise*" (McFarland, "Gift of the *Non Aliud*," 45–46).

7. That this crucial insight is often forgotten by proponents of "creationism" and "intelligent design" (who are doubtless motivated by well-intentioned apologetic interests) should give us pause for thought. For an extended and lively discussion of this issue, see Cunningham, *Darwin's Pious Idea*.

sensitively with those of little or no faith, or with those belonging to a non-Christian religious tradition), these and other schemes are sometimes employed as provisional frameworks, with the full intention of incorporating the particularities of Christian faith in due course. But whatever strategy is adopted in this or that practical situation, acute problems arise when it is assumed that such particularities can be treated as icing on a precooked metaphysical cake, as supplemental additions to philosophical agendas adopted in advance. In my judgment, if Christian theology is to meet at any depth the reductive pressures we have been speaking about in the preceding chapters, rather more attention will need to be given to the concrete and distinguishing specifics of Christian faith than is often the case—especially to the transforming disruption of crucifixion and resurrection—and such attention is bound to carry ramifications that are, to say the least, metaphysically unsettling.

Uncontainable God

With these pitfalls in mind, we turn to our main theme: God's uncontainability by the created world. We touched on this in our reading of John 4. The "living water" Jesus promises to the Samaritan woman will gush up to eternal life (John 4:14). This is God's Spirit, described earlier as "without measure" (John 3:34), uncontainable by any finite vessel. We also noted that the theme of surplus or overflow recurs at many points in this Gospel. But these texts by no means cover the range of references and allusions to divine uncontainability in Scripture, nor the multiple implications that range can carry.

Mount Horeb

A good place to begin exploring this territory is the encounter between Moses and God on Mount Horeb, recounted in Exodus 3, one of Scripture's most dramatic (and dramatically important) narratives. Moses is tending his father-in-law's sheep, and an angel appears in flames of fire from within a burning bush. Curious about why the bush is not consumed, Moses finds himself pulled into a dialogue involving a life-changing theophany. Moses is told he is to be sent to Pharoah to lead God's people out of Egypt.

> But Moses said to God, "If I come to the Israelites and say to them, 'The God of your ancestors has sent me to you,' and they ask me, 'What is his name?' what shall I say to them?" God said to Moses, "I AM WHO I AM." He said further, "Thus

you shall say to the Israelites, 'I AM has sent me to you.'" God also said to Moses, "Thus you shall say to the Israelites, 'The LORD, the God of your ancestors, the God of Abraham, the God of Isaac, and the God of Jacob, has sent me to you':

> This is my name forever,
> and this my title for all generations." (Exod. 3:13–15)

Whatever else the much-debated self-designation "I AM WHO I AM" (Heb. 'ehyeh 'asher 'ehyeh, Exod. 3:14a) is intended to convey, it is hard to miss the profound aura of divine uncontainability it evokes, an aura evident at many places in the passage as a whole. At least four aspects of this uncontainability can be distinguished.

To begin with the most general and obvious, we are here presented with an encounter between the infinite and the finite. To claim that God is uncontainable is to claim that *God cannot be circumscribed by the finitude of this world*. Solomon prays at the dedication of his temple, "But will God indeed dwell on the earth? Even heaven and the highest heaven cannot contain you, much less this house that I have built!" (1 Kings 8:27; see also 2 Chron. 2:6; 6:18). God cannot be encompassed or confined by any object or event in the world of space and time, nor by the space-time continuum as a whole. To be more precise, we are here speaking of God's *infinity*—in relation to time, God's *eternity*; in relation to space, God's *immensity*.

The second aspect of uncontainability is implied by the first: God exceeds all human systems of representation, and this of course includes human *thought and language*. God's uncontainability here takes on the sense of *incomprehensibility* (i.e., exceeding our cognitive grasp) and of *ineffability* (i.e., exceeding the limitations of our speech).[8] God is always overtaking our ideas and utterances. There is always more to God than we could ever think or say, always more than *could* be thought or said.

At Mount Horeb, Moses learns that the knowledge gained in his encounter with God is anything but grasping or enclosing. Walter Moberly, in a lucid analysis of this text, interprets the burning bush and the declaration "I AM WHO I AM" as together "archetypal expressions of mystery."[9] A "mystery," for Moberly,

8. Here I am using *incomprehensibility* not in its strong sense (i.e., completely beyond understanding) but in the sense of "ungraspable in its completeness by our minds." Likewise, *ineffability* is being understood to mean not "wholly unspeakable" but "ungraspable in its totality by speech."

9. Moberly, *God of the Old Testament*, 78.

is a reality that outstrips our epistemological grasp ("The more you know, the more you know you don't know").[10] A mystery is intrinsically incapable of being circumscribed by thought (and, by implication, by language). "The symbolic resonances of this bush are as open and unlimited and resistant to being pinned down as are the implications of God as 'I AM WHO I AM.'"[11] Along similar lines, Andrea Saner comments that 'ehyeh 'asher 'ehyeh "suggests something about the nature of God, yet the nature of God is . . . withheld; [I AM WHO I AM,] in its indeterminacy and first-person form, is ascribed to God who can only be identified through self-reference and who cannot be fully described in words."[12] The title of Saner's book is telling: "Too Much to Grasp."

A third dimension of divine uncontainability can be seen when we consider the context of Moses's encounter. God's people are enslaved by a ruthlessly unjust regime, and God is promising liberation. God speaks into a corrupted world as the one who is uncontainable not only by the world's finitude but also by *its fallenness*. Any theological account of God's infinity in Scripture will need to come to terms with its moral as well as its metaphysical overtones, with humanity's perverse desire to exceed its creaturely, finite limits and reach for a godlike status. Against this background, divine uncontainability assumes the connotations of ultimate moral resistance: whatever tactics God employs to engage the complexities of human opposition, God can never be ruled or overcome by sin and evil.

A fourth aspect of uncontainability evident in this text concerns God's freedom in relation to others: *God is uncontainable by any other agency*—never dominated by or in thrall to the will of another. In Exodus 3, instead of "I AM WHO I AM," many translators and commentators prefer to render the ambiguous Hebrew as "I will be who I will be." The future tense is appropriate, it is said, not only because Moses is being told what God is going to do (send Moses and liberate Israel) but because the phrase seems to pick up an idiom that elsewhere in the Old Testament can carry a future connotation, with additional overtones of sovereign, unconstrained choice. On this reading, the meaning turns out to be something like "I will be whoever I choose to be."[13] In other words, "God is utterly self-determining. . . . He can say who he is and who he will be only by reference to himself. . . . God is who he chooses

10. Moberly, *God of the Old Testament*, 79. Moberly is here quoting Terence Fretheim.
11. Moberly, *God of the Old Testament*, 79.
12. Saner, "Too Much to Grasp," 229.
13. I am indebted here to the discussion in Bauckham, *Who Is God?*, 39–45.

to be."[14] This is surely part of why God does not at first provide Moses with a name: the cultural setting was one in which gods were regularly named, and knowing the name of a god would naturally encourage devotees to think they had some kind of control over the deity. Even when God's name *is* eventually given (YHWH, "LORD," in Exod. 3:15), there is no hint that God is thereby relinquishing the freedom to be who God will be, no sense that the LORD can become a tribal god "owned" by the Israelites, a tamable god at their disposal. On the contrary, the implication is that although they can *address* God, they cannot *control* God.[15]

Of course, it might well be said that included within God's freedom is the freedom to respond to the actions of God's creatures, and that God may freely will to be temporarily conditioned by another. There are numerous instances of this in Scripture, the most central being the Son of God's free submission to the powers of evil at the crucifixion. Our point here, however, is that God is never under the ultimate directive of a will outside God. There can never be a situation in which any reality other than God could *own* God, in which God would relinquish God's freedom to *be* God.

We note here that this aspect of uncontainability overlaps with the second (the uncontainability of God by thought and language), and with the third (the uncontainability of God by the world's fallenness). In Exodus 3, knowing God's name—and, by implication, being able to speak to and of God—does not give Moses or the Israelites any kind of leverage over or claim on God. As Jonathan Platter points out, when Moses asks for a name he is acutely conscious of his own weakness; he is "asking God for a name of *power*, by which he will perform the role to which God is calling him . . . , a name of power in which he and Israel can trust."[16] He is met with a partial evasion of his request, undercutting any temptation to believe that God is at his beck and call. Saner puts the point well:

> God cannot be known as an "item in the universe," but only as a subject who meets Moses in Midian and the reader in the text, pronouncing his own name. . . . In response to Moses' concerns about his own weakness, YHWH reveals himself as the one who is able to carry out the task. YHWH's self-disclosure as subject in verse 14 is precisely in opposition to Moses' self-concern, because

14. Bauckham, *Who Is God?*, 42.
15. Bauckham, *Who Is God?*, 44.
16. Platter, "Divine Simplicity and Scripture," 301, italics original. On this, see Sonderegger, *Systematic Theology*, 1:210–23.

it draws Moses' attention away from himself and into God's "I." Knowledge of YHWH will require Moses' ongoing attention, because God does not describe himself according to a definition or by means of an object that can be mastered.[17]

The bush that never gets consumed takes on a striking relevance in this context. As Moberly points out, the divine words "I will be who I will be" and the bush that burns without being destroyed mutually interpret each other. Even a regular fire "by its very nature . . . cannot be grasped or readily controlled by humans. It is thus an appropriate symbol for a God who is beyond human control or manipulation."[18] But in the case of a fire that needs no fuel at all, one that is entirely self-generating and self-sustaining, the connotations of uncontainability are dramatically heightened.[19]

Back to the Pitfalls

There are, however, crucial dimensions to divine uncontainability in this passage that we have not yet brought into the open. This is where heeding the two pitfalls we noted above becomes especially important. The first, we recall, was to treat God and the world as if they were of the same ontological type, and thus to trap God in a logic of sameness—God becomes in effect "another thing" in the universe. Applied to divine infinity (and uncontainability in this sense), this almost inevitably leads us into one of two cul-de-sacs.

On the one hand, divine infinity is thought of in quantitative terms as a boundless extension of the conditions of time and space as we experience them. God's eternity is conceived as akin to our time but without end ("on-and-onness"), and God's immensity as akin to our space but without limit (like a room without walls or a sea without shores). The problems hardly need to be pointed out. Our conceptions of these dimensions are simply inappropriate if applied directly to God; we cannot univocally ascribe properties to God that properly belong to the finite world.

On the other hand, we might be tempted to imagine God's immensity or eternity in wholly negative terms—entirely in terms of properties the finite world

17. Saner, *"Too Much to Grasp,"* 125.
18. Moberly, *God of the Old Testament*, 56.
19. Relevant also is the strand in the prophetic tradition that fervently resists the idolatrous localization of religion, any notion that God can be tamed by physical enclosure: "Do not trust in these deceptive words: 'This is the temple of the LORD, the temple of the LORD, the temple of the LORD'" (Jer. 7:4). Israel is being urged to acknowledge "the entirely gratuitous character of [God's] universal presence as the Most High" (Webster, *Confessing God*, 99).

does *not* possess. Infinity then becomes the antithesis of created time and space, "an inverted image of the finite."[20] Significantly, moves in this direction are not that hard to find among those who want to account for the sense of "transcendence" many report when encountering the arts. The arts, we are reminded, can engender a profound awareness of an "Other" or "Beyond," a sense that there is "more than" this world, perhaps even infinitely more. This excess is notoriously hard to think about, let alone to articulate in words. So, it is said, if we want to address and articulate this sense of the Other in the arts while honoring the Other's infinite uncontainability, we will need to draw primarily (perhaps even solely) on the retractive discourse of incomprehensibility, ineffability, and so forth. This kind of strategy (here rather crudely summarized) has undeniable strengths. But insofar as this Other or Beyond is presumed to be God, it is by no means always clear how we are to prevent God-talk from disappearing into a vortex of exclusion, nor, indeed, how we are to escape the charge that we are merely projecting categories (albeit by negation) onto the divine from the finite world. As numerous theologians have shown (especially those pursuing some version of "post-metaphysical" theology), the risk of projection from this world's finitude onto God is just as strong if we attempt to construe God's infinity through negating the finite as it is by amplifying the finite, however humble and reverential the former may seem to be on the surface.[21]

In this connection, it is easy to miss a prominent theme in Exodus 3—that of God's *incomparability*. Platter observes that Moses's request for a name is driven by an awareness that his own power and status are feeble compared to Pharoah's. "God's response, including the giving of the name in Exodus 3:14, shifts away from the quantitative comparison by promising God's own presence to Moses. This suggests that there is something radically different about God that distinguishes him from the kind of continuum [of power] on which Moses and Pharaoh are separately placed."[22] In other words, God is revealed as exercising a power that is qualitatively (not merely quantitatively) different from what we see in both Moses and Pharaoh. "If God unsettles the quantitative power continuum internal to the creaturely plane of being, then God's incomparability can be understood non-quantitatively. *God is not a member*

20. Webster, *Confessing God*, 92.

21. On the way in which certain streams of "negative theology" can too easily lead toward an undifferentiated and amoral sublime, see Begbie, *Redeeming Transcendence in the Arts*, chap. 2. It is worth heeding Walter Lowe's comment: "The qualifier 'infinite' does not assure exemption from the hegemony of 'the Same'" (Lowe, "Postmodern Theology," 618).

22. Platter, "Divine Simplicity and Scripture," 301.

of a quantitative series, hence God's being cannot be described or defined in quantitative terms (except perhaps metaphorically)."[23] All this suggests that talk of God's uncontainability by the finite—although of course employing a term borrowed from the spatiotemporal world—needs to be diverted from all such quantitative schemes, and that we should, rather, allow the LORD of Exodus 3 to demonstrate the LORD's own kind of uncontainability.

This relates to the second pitfall I spotlighted: working with an ontology drained of the theological distinctives of the Hebrew Bible and the New Testament. Many treatments of Exodus 3 fail to set it in its immediate narrative and theological context, not to mention in its canonical setting. Indeed, just because of this it has proved to be a key text for some of the fiercest critics of monotheism. This God, we are told, is clearly a power-mad autocrat, an utterly self-sufficient, solitary potentate who stifles our maturity, encourages cringing subservience, and will almost inevitably underwrite the oppression of the weak and dispossessed. So Gordon Kaufman tells us that "God is identified here as the great 'I AM,' the ego-agent par excellence, sheer unrestricted agential power. Given this model, it is not surprising that God has often been conceived of as an all-powerful tyrant, a terrifying arbitrary force before whom women and men can only bow in awe and fear."[24]

But is this the kind of monotheism disclosed in Exodus 3? If we widen our textual view and allow some of the covenantal markers of Israel's faith to come more fully into view—markers that, Christians hold, ultimately converge on Jesus Christ—things begin to look decidedly different.

Uncontainable Faithfulness

We note that even before the issue of a name arises, God self-identifies as "the God of your father, the God of Abraham, the God of Isaac, and the God of Jacob" (Exod. 3:6; reiterated at 3:15) and assures Moses, "I will be *with you*" (3:12). In Katherine Sonderegger's words, "The Lord calls Moses to himself and gives him first a rehearsal of the great patriarchal promise: I am the God of the covenant, the God of the ancient promise. . . . I am with you, the Lord says, the one who sees the suffering of Israel in Egypt. I am the God of Deliverance; that is what

23. Platter, "Divine Simplicity and Scripture," 301, italics added.
24. Kaufman, "Reconstructing the Concept of God," 104. For Janet Soskice, Jacques Lacan's psychoanalytic take on Exod. 3 belongs essentially to the same circle of ideas: "Moses at the burning bush, according to Lacan, meets the Symbolic father who is literally capable of laying down the law—of saying 'I AM WHO AM'" (Soskice, "Gift of the Name," 67).

'with you' means."[25] The God of Israel's ancestors has not forgotten them or
cast them aside. God has heard the plea of the enslaved and now promises to
release them from bondage, with Moses leading the way (Exod. 3:7–10). This
suggests that divine uncontainability is closely linked to God's active presence
to and for God's people—to God's faithfulness in the past, present, and future.[26]
In Richard Bauckham's words, "The One who cannot be *constrained*, even by
Israel's cries for help, *commits himself* to a course of action for Israel's sake. . . .
God declares himself to be the God who himself has chosen, in his grace and
love, to be Israel's God, dedicated to Israel's good."[27] Thus Terence Fretheim
can paraphrase "I AM WHO I AM" as "I will be God for you."[28]

On this reading, then, it is God's "steadfast love and faithfulness" (Exod. 34:6)
that resists containment, God's covenant commitment to intimacy with Israel
and to her freedom and flourishing. In the subsequent narrative, despite the
austerity of the scene there is no suggestion of wholesale divine inscrutability,
or of a deity of crushing, impersonal force. God's uncontainability is not that of
a naked will calling for unquestioning submission: "There is no sense of God's
swatting aside Moses' objections ('Don't argue. Just get on with it'); rather the
narrative conveys a sense of space in which genuine interacting with God, a
real to-and-fro, is possible. The clear implication is that God does not want
to coerce Moses, instead meeting his anxieties with appropriate responses."[29]

The same pattern—linking divine uncontainability with covenant love—
appears repeatedly in Scripture. Earlier, I cited Solomon at the temple's dedi-
cation: "But will God indeed dwell on the earth? Even heaven and the highest
heaven cannot contain you, much less this house that I have built!" (1 Kings
8:27). It is no accident that this is preceded by a narration of Israel's covenant

25. Sonderegger, *Systematic Theology*, 1:214.
26. "In the divine self-designation to Moses in Exodus 3, God is placed as the God of Israel's
history. Moses is to know that what he meets is the God of Israel's past (of Abraham, Isaac and
Jacob), of its present (who sees its suffering) and of its future (the God who will lead them from
slavery to the promised land)" (Soskice, "Gift of the Name," 71).
27. Bauckham, *Who Is God?*, 43, italics original. Unfortunately, the extraction of Exod. 3:14
from its narrative context has led to it being used to justify theological schemes with a high degree
of metaphysical abstraction, many of them only loosely related to the redeeming character and
purposes of the God of Israel. Having said that, care is needed not to assume that this passage is
resolutely "nonmetaphysical"—i.e., that metaphysical concerns are wholly foreign to its purpose.
28. Fretheim, *Exodus*, 63.
29. Moberly, *God of the Old Testament*, 60. Sonderegger comments, "In this passage . . . we
encounter a Divine Naming that shows us, now in positive relief, how the traditional notions of
Omnipotence—the God who does what he wills—and the modernist account—the God who is
Absolute Cause—should be set aside, recast, and corrected in a proper doctrine of Divine Power"
(Sonderegger, *Systematic Theology*, 1:210).

history (8:14–21). Similarly, in Isaiah 40–55 the prophet's protest against idols includes the famous divine declaration: "As the heavens are higher than the earth, so are my ways higher than your ways and my thoughts than your thoughts" (Isa. 55:9). But this is a declaration not of arbitrary independence but of freedom to be the God and Savior of Israel (as exemplified in the story of the exodus, a narrative repeatedly alluded to in this section of Isaiah). Compare Stephen's speech to the Sanhedrin in Acts 7 (which directly cites Exod. 3): "The Most High does not dwell in houses made with human hands" (Acts 7:48). These words follow a lengthy summary of Israel's redemptive story stretching back to Abraham (vv. 2–47).

Even from these passages alone it is clear that when we are speaking of the uncontainability of the God of Israel, we are speaking of the unbounded pressure of covenantal goodness, other-directed faithfulness. We can expand on this by using the four senses of uncontainability we outlined above. To claim that God cannot be circumscribed by the finitude of this world is not a statement about spatiotemporal metaphysics in the abstract but an affirmation of the limitlessness of Israel's LORD, of God's loving immediacy to God's people and to the world God has made. To pick up John Webster's fine phrase, this is God's "boundless capacity for nearness."[30] God's infinity is the eternity and immensity of divine faithfulness. God is sovereignly free, certainly, but for the sake of a "creative and saving presence to all limited creaturely reality."[31] Likewise, the notion of God's uncontainability by thought and language needs to be set in the light of the incomprehensibility and ineffability of the LORD's steadfast love. To assert that God is uncontainable by the world's fallenness and corruption is to speak of more than the divine capacity to defeat opposition; it is, more centrally, to affirm God's resolve not to let God's gracious purposes for creation come to nothing. And the claim that God is uncontainable by the will of another is not an announcement of divine self-sufficiency in the abstract but of the LORD's singular determination to be *this* God—God-for-God's-people and God-for-God's-world.[32]

30. Webster, *Confessing God*, 95.

31. Webster, *Confessing God*, 92. Thus God's immensity cannot be understood apart from God's omnipresence: which is to say, apart from the active, creative, and saving presence of God to the entire contingent order to which God is committed (Webster, *Confessing God*, 93–94, 98–103). We would do well to heed Aquinas: "God is in all things; not, indeed, as part of their essence, nor as an accident, but as an agent is present to that upon which it works [*sed sicut agens adest ei, in quod agit*]" (Aquinas, *Summa theologiae* I.8.1).

32. I am therefore sympathetic to those in the Reformed tradition who use the phrase *covenant ontology* to bring out these dimensions of the God-world relation. God's commitment to the

Christologically Formed Uncontainability

The Christian church sees all these strands climactically and definitively played out and sealed in the self-disclosure of "I am" in the incarnate Son, Jesus Christ. Indeed, the Exodus 3 encounter is echoed and alluded to a number of times in the New Testament.[33] Here again we need to set aside abstraction and allow the rationale of God's covenant love for Israel to unfold—indeed, allow the Christ-event from conception to ascension to take center stage in opening up that very rationale. In Christ's life we discover preeminently what it is for divine love to be uncircumscribable by the world's finitude. In the faithfulness that takes Jesus to the cross and raises him from the dead, we find the ultimate measure of what cannot be thought or spoken. In his cruciform victory over evil, confirmed on Easter Day, we encounter power-for-the-good-of-the-other. And here, in one utterly "possessed" by his Father's love, we see God being who God will be.

Uncontainable Faithfulness . . . in Christ

It would take many books to explore all the ways in which divine uncontainability is climactically and paradigmatically enacted in the incarnate, risen, and ascended life of Christ. I confine myself to comments in four main areas, corresponding to the four senses of uncontainability sketched above.

Immensity Cloistered?

The first and broadest sense concerned the world's finitude: *the momentum of God's love-in-action cannot be circumscribed by the finitude of this world.* Applied

world is consistent with, corresponds to, the covenant enacted in Christ and prefigured in God's commitment to Israel. See, e.g., Horton, *Covenant and Salvation*.

33. Most notably, Jesus's "I am" sayings in John's Gospel ("I am the bread of life," in 6:35, etc.) are resonant with Exod. 3:14. "The analogy of form is both straightforward and interpretively suggestive" (Moberly, *God of the Old Testament*, 83). One might point in particular to the "I am" sayings of Jesus that have no predicate, including the one found in the story of the woman at the well. The NRSVue renders John 4:26, "I am he, the one who is speaking to you." But in the Greek (*egō eimi, ho lalōn soi*), there is no objective pronoun "he," and "the one who is speaking to you" is not a predicate that completes a statement but, rather, an appositive that supplies another designation for "I am"—which means, effectively, "I am" is "the one who is speaking to you." And perhaps most memorable are the astonishing words in Jesus's discourse to the Jewish leaders: "Before Abraham was, I am [*egō eimi*]" (John 8:58; see also v. 24). The Septuagint renders Exod. 3:14 as "*egō eimi ho ōn*." However, care is needed here, since most commentators understand the principal background to these texts as lying in Deutero-Isaiah (e.g., Isa. 41:4; 43:10, 25; 45:18–19), and perhaps in Deut. 32:39. For discussion, see Lincoln, *Gospel according to Saint John*, 178, 276; Thompson, *John: A Commentary*, 156–60.

to the person of Christ, this seems immediately to present us with an insuper-
able difficulty in that the very truth of the incarnation would appear to entail
the very containment we are denying. In Jesus of Nazareth, God appears as
a visible, tangible human within space and time. If this is indeed God making
"his dwelling" with us (John 1:14 NIV, an allusion to the Old Testament tab-
ernacle), if in Jesus "the *whole fullness* of deity *dwells* bodily" (Col. 2:9, italics
added), are we not committed to saying that here God *has* been circumscribed
by space and time, that the uncontainable *has* been held within finite bounds
and *is* therefore in principle containable? Following the Council of Chalcedon
(451 CE), the church catholic confesses Jesus Christ as the eternal Son who is
possessed of a fully human nature (a finite body, soul, and mind—spatially and
temporally located), and it claims that the very possibility of salvation of humans
qua humans depends on this spatiotemporal embodiment. What is this if not,
as John Donne had it, "Immensity cloistered" in Mary's womb?[34]

Complexities and debates crowd in at this point, but a few basic comments
can be made to show that a traditional doctrine of the incarnation requires
no lessening of the Jewish doctrine of God's uncontainability, that the same
basic logic of love we have spoken about above is at work here also—indeed,
supremely at work. We can take space and time in turn.

With respect to *space*: it is of course impossible when wrestling with the
metaphysics of Christology to avoid spatial terminology. In Jesus of Nazareth,
we are dealing not only with a physically located, three-dimensional human
being but also with the copresence of human and divine, and this will require
employing terms of distinction, difference, and relation, all of which are spatially
implicated (indeed, *copresence* is another such term). However, philosophies
of space are many and various, and we need to be acutely aware of the poten-
tial problems in conceiving the incarnation using language borrowed without
qualification from our perception of space as finite creatures. We are hardly the
first to be saying this. Basil of Caesarea (330–79) insisted that Mary's womb

34. Donne, "Annunciation," in *Collected Poems of John Donne*, 244. See also John Milton:
"That glorious Form, that Light unsufferable,
 And that far-beaming blaze of Majesty,
Wherewith he wont at Heav'n's high council-table,
 To sit the midst of Trinal Unity,
 He laid aside, and here with us to be,
 Forsook the courts of everlasting day,
 And chose with us a darksome house of mortal clay."
 (Milton, "On the Morning of Christ's Nativity,"
 in *John Milton: The English Poems*, 3)

is not so much a constraint as a "workshop of the economy,"[35] a "site" in which God's purposes for the cosmos at large are being worked out. Ephrem the Syrian (306–73) vividly portrays the conviction that as the divine Son grew in Mary's belly, he was also upholding the universe:

> Thus although all of him was dwelling in the womb,
> his hidden will was supervising all . . .
>
> For while the power dwelt in the womb,
> it was forming babes in the womb.
> His power embraced the one who embraced him,
> for if his power were curtailed all would collapse.
> Indeed, the power that contained all creation,
> while he was in the womb, did not desert all.[36]

And in another place:

> He dwelt in the vast wombs of all creation.
> They were too small to contain the greatness of the First-born.
> How indeed did that small womb of Mary suffice for him?
>
> Of all the wombs that contained him, one womb sufficed:
> [the womb] of the great one who begot him.[37]

In the twentieth century, employing a range of (especially patristic) sources, the Scottish theologian Thomas F. Torrance (1913–2007) drew attention to the many unnecessary theological aporias the church creates for herself by relying on what he called "receptacle" or container-like notions of space and time.[38] Torrance argued that when space is conceived as a finite receptacle "in" which both God and humans operate, it is hard not to imagine the eternal Son's incarnation as some form of "re-location" from a divine place to a created place, perhaps even to the extent of thinking of the Son as entirely confined to

35. Quoted in Blowers, *Drama of the Divine Economy*, 248.
36. Quoted in Blowers, *Drama of the Divine Economy*, 248.
37. Quoted in Blowers, *Drama of the Divine Economy*, 249. Here we cannot enter into an extended discussion of the key notion of God as "uncircumscribable" (Gk. *aperigraptos*) in the iconoclastic debates of the eighth and ninth centuries. For a fine treatment, see Tollefsen, *St. Theodore the Studite's Defence of the Icons*, 60–97.
38. Torrance, *Space, Time and Incarnation*, 71. For exceptionally clear discussions of Torrance on these matters, see Molnar, *Incarnation and Resurrection*, 90–96; Molnar, *Thomas F. Torrance*, 124–35.

the new place (leaving some kind of vacancy in the Trinity?). Crudely put, the Son is either "up there" with the Father or "down here" with us—he cannot be in both "places" at the same time. Likewise, the Son cannot occupy the same earthly place as a human being without either the Son or his human nature (or both) being compromised.

This is of course a prime example of succumbing to the first of our two pitfalls: thinking of God and humanity (or God and the world) as two instances of the same ontological *genus*, quasi-finite objects occupying a kind of super-space in which they both reside. In this model, God cannot be in two places at the same time ("up there" *and* "down here"), and God and humanity cannot be in the same space at the same time (since that would compromise the integrity of one or the other, or both). Whatever we might say about the details of Torrance's patristic exegesis, his broad thesis is highly illuminating when it comes to interpreting some of the church's historic christological wrangles. For example, in Reformation and post-Reformation theology, the Lutheran objection to the Calvinists' insistence that the eternal Son is *both* in heaven upholding the universe *and* living on earth as Jesus of Nazareth—namely, that this implies that part of the Son (the so-called "Calvinist extra," *extra Calvinisticum*) is still "outside" Jesus of Nazareth—appears to depend on just this kind of receptacle vision of space that Torrance highlights.[39] The same could be said of those forms of "kenotic" Christology that invest heavily in the terminology of retraction, "setting aside," or "self-limitation" when speaking of the Son's incarnation.[40] Notwithstanding the concern to do justice to Christ's full humanity, questions about the integrity of the divine nature are bound to be raised, as well as questions about the inclination to set divine and human off against each other. Related problems arise with respect to divine *presence*. As long as we are thinking along the lines of physical containment, we will likely be pressed to reduce God's presence in the world to some variant of creaturely physical presence—for example, to the ability to be in many places simultaneously. Space, however, is a created reality, and God's

39. See Calvin's own reflections in *Institutes of the Christian Religion*, 2.13.4. When the Calvinist tradition insisted in the context of Christology that *finitum non capax infiniti* (the finite cannot comprehend/contain the infinite), this "did not erode the finitude and particularity of [Christ's] humanity, nor did it suggest that God *could not* assume finite or local form: only that such finite, local form as actually instantiated in the person of the mediator did not restrict or jeopardize the immensity of God (*infinitum capax finiti*), nor did it violate the reality of the humanness enacted. . . . The burden was that divinity and humanity were not to be differentiated in abstraction, but only as they were in fact found, in the concrete person of the union: there, each nature retained that which was essential to it" (Davidson, "Christ," 462, italics original).

40. Torrance, *Space, Time and Incarnation*, 15, 46.

relation to created space is thus not akin to the relation of one physical object to another (very large) one; it is, rather, the relation to created space of one who is infinitely and generatively present to all spatial coordinates (even if God is present with special revelatory intensity to some particular spatial coordinates).[41] Similar impasses emerge if we conceive of God encompassing the world according to the model of an infinite receptacle containing a finite reality: it becomes almost impossible to do justice to the incarnation, for how can a container be both a container and one of the objects contained within it? How could we avoid positing some form of uncrossable dichotomy between God and world?[42]

It is with these tangles in mind that Torrance urges us to move away from models of space as a pre-given vessel "in" which entities may or may not be located, a frame extrinsic to particulars (the "room" things take up), and thus away from spatializing the God-world relation according to patterns borrowed without qualification from physical space as we experience it. With a strong gesture to post-Einsteinian physics, he proposes that we think of space relationally—that is, as a dimension of concrete particulars (distinct objects, events, and agencies) related to each other intrinsically. These relations can take on different forms depending on the nature of the object, event, or agency in question. If we are to use spatial language theologically, therefore, we will need to attend carefully to the "space" *of whatever reality is being considered.*

Applied to the incarnation, then, we might say something along the following lines. The veracity of the gospel—the claim that, in Christ, God has decisively reconciled humans to God—hinges on Christ being fully human, subject to the conditions of bodily life where people and things are related to one another in a way appropriate to the spatiality of the created world. But the gospel also hinges on the Son being at every point the eternal Son of the Father, sharing the Father's being and life, living as the one through whom all creation is upheld and held together. That is to say, the incarnate Son inhabits *both* the "space" of the triune God (primordially) *and* the space of this world.[43] God's immensity—

41. I owe this way of putting the matter to Brett Gray.

42. Torrance, *Space, Time and Incarnation*, 63–64.

43. Stéphane Mosès's study of Rosenzweig's philosophy includes this striking passage: *Revelation is this movement through which God entrusts his own being to the experience man has of him.* It is this movement through which God brings himself toward man that Rosenzweig calls love. . . . As in the Song of Songs, human love is here the paradigm that serves as model for the description of a relation whose departure point is not accessible to experience. In fact, Revelation constitutes itself as experience only within human subjectivity, even though the nature itself of this experience requires the coming out of itself of this subjectivity. . . . This is the paradox of Revelation according to Rosenzweig; Revelation is

God's uncontainability by created space—therefore has nothing to do with the impossibility of fitting God's enormity into a finite container. It has everything to do with the pressure of divine love—with God's desire to relate creatively and savingly to the entirety of the world *as spatial*, and yet without that spatiality being compromised in any way. That, so the church maintains, is just what has happened supremely in the incarnation. As John Webster puts it, "Immensity and embodiment . . . are not competing and mutually contradictory accounts of the identity of the Son of God. Incarnation is not confinement, but the free relation of the Word to his creation—the Word who as creator and incarnate reconciler is *deus immensus*."[44]

What underwrites this kind of pattern, it should be stressed, is not the necessity of a metaphysics constructed prior to or independently of the drama of salvation but the dynamic ontology of love that is shown to propel that drama. The "space" of the triune God is, after all, the site of love-in-action, and the integrity of the world's created spatiality needs to be maintained precisely because God is lovingly committed to it *as such*. (Needless to say, the language of "*un*contained/*un*containable" needs to be subject to the same kind of vigilance we have been speaking about here.)

With respect to *time*, parallel comments are in order. To return to Torrance: he argues that receptacle models of time no less than those of space can seriously mislead us, especially when time is falsely construed as in some way existing "prior to" and independently of things and events. God's loving engagement with time in the incarnation is not to be thought of as God—who would otherwise inhabit a super-time that encompasses both God and world—deciding to become (change into?) a creature "within" created time. To say that God transcends time is not to say that God transcends time *in a temporal way* (just as to say that God transcends space is not to say that God transcends space *in a spatial way*). We would do better to imagine the incarnate Son fully engaging with created time in a concrete history, in an earthly life that is temporal through and through (for God's love for this world entails God redeeming the world *as* temporal), and yet also living as the eternal Word, the Father's Son in God's own "time" (for it is only out of this relation in the Spirit that the world can be healed). God's eternity, therefore, has nothing to do with a resistance

an event of personal experience, but the latter, by definition, is not capable of containing it. (Mosès, *System and Revelation*, 102–3, quoted in Levenson, *Love of God*, 190, italics original) I am grateful to Andrew Torrance for directing me to this quotation.

44. Webster, *Confessing God*, 96.

on the part of God to being involved with time; it has everything to do with the pressure of a free divine love that wills to relate creatively and savingly to the entire created world *as temporal,* and yet without that temporality being diminished in any way. This—so mainstream Christian tradition affirms—is what has taken place in the incarnation.

Beyond Words

The second sense of God's uncontainability we delineated was that God cannot be encompassed by thought and language. With regard to language, the verse at the very end of John's Gospel seems especially apt: "There are also many other things that Jesus did; if every one of them were written down, I suppose that the world itself could not contain the books that would be written" (John 21:25). John gives voice to the ungraspability of the "grace upon grace" believers have received from God's "fullness" (John 1:16), its sheer "evermoreness." Something of the same can be sensed in the doxological outbursts in Paul's letters. "Thanks be to God for his indescribable gift!" (2 Cor. 9:15), the apostle writes after a lengthy section on financial giving. "Indescribable" (*anekdiēgētō*) here carries the sense of uncircumscribable, "unwraparoundable,"[45] and Paul's wonder is clearly not simply that of a finite mortal before an infinite God but that of a self-described chief of sinners (1 Tim. 1:15) before an unfathomably gracious Giver. Nonetheless, this acute awareness of inexpressibility does not, of course, reduce John or Paul to permanent silence. Doubtless they were both often dumbstruck, but there is no hint in their writings that the inadequacy of language means it should be jettisoned as speedily as possible.

On the contrary, basic to the Jewish Scriptures and tradition is the belief that the human capacity for speech has been directly enfolded into the dynamic of God's reconciling action. And it is chiefly from this perspective, I suggest, that the "shortfall" of human God-talk is to be recognized. If, to pick up David Jones's phrase, God "has placed himself within the order of signs,"[46] language can hardly be shunned as inherently an obstacle to God's self-revealing action. Ancient Israel bears witness to a God who has taken up human language to serve God's covenant; and Christians confess that in Jesus the Messiah that same God becomes the speaking Israelite, the one whose words of grace and judgment are integral to bringing God's covenant to a head. The Word becomes

45. Murray Harris suggests (among other possible translations) "not able to be described exhaustively" (Harris, *Second Epistle to the Corinthians,* 660).
46. Jones, *Epoch and Artist,* 179.

a word-user, directly engaging the finitude and fragility of speech.[47] To return to the woman at the well in John 4: human language is very clearly the primary medium through which the Samaritan discovers the uncontainability of divine grace. She expects no conversation; many Jews will not say a word to her, and doubtless she herself intends to say nothing. But through this Jew's searching words and her own (unexpected) spoken responses, she begins to discover an upwelling and inexhaustible source of love and life.

God-talk, in other words, though it can never enclose or encapsulate the divine, is believed in Jewish and Christian thought to have been assumed into God's purposes and cannot therefore be regarded as something to be shed at the earliest opportunity. That God transcends language does not mean God is opposed to it, per se, or negatively related to it.

In a recent and important article, Timothy Troutner offers perspectives on language that amplify the point tellingly.[48] Troutner's prime concern is with eschatology, specifically with the issue of whether there will be language in the eschaton. He shows that this apparently abstruse question raises fundamental questions about language in the purposes of God. He offers a sustained critique of "eschatologies of silence," schemes that claim or imply that language will be suppressed or perhaps even wholly abandoned in the world to come.[49] According to such outlooks, the paradigmatic eschatological experience is one that is wholly transparent to God, unmediated by speech of any kind. Language is thus typically seen as a temporary remedy for the lack of intimacy with God occasioned by the fall. Indeed, some of these eschatologies invoke the notion of an ideal prelapsarian, primordial "supra-language" in which no gap separates sign and reality.

Behind all such schemes, Troutner argues, is a tendency to set language against a negative background: to suppose that language as we know it today would not have appeared had the fall not occurred. Its inadequacy—its falling short of reality, supremely the reality of God—is regarded first and foremost

47. "That Jesus once spoke is more fundamental for the understanding of the Logos [in John's Gospel] than is the history of Greek philosophy, or the story of the westward progress of oriental mysticism, more fundamental even than the first chapter of Genesis or the eighth chapter of Proverbs" (Hoskyns, Fourth Gospel, 130). Compare the following from Mike Higton: "The redemptive transformation of human beings in which God is manifested is their incorporation into Christ by the Spirit, on the way to the Father—and to recognise it as such will make a transformative difference to the account one might give of God-language, its limits, and what it can nevertheless accomplish" (Higton, "Apophaticism Transformed," 516).

48. Troutner, "Beyond Silence."

49. He cites Paul Griffiths and Denys Turner as representative advocates of this approach.

as a mark of sin. Language may be given a positive role—"the transmission of information, description of content, or communication more generally"—but according to Troutner, "this 'positivity' is remedial and provisional, the rectification of negative states of affairs (ignorance, distance, absence): language is 'parasitic' on that negativity."[50]

Troutner contrasts these perspectives with "eschatologies of praise," drawing on Jean-Louis Chrétien and David Bentley Hart, among others, in which language's central and highest form is doxology: the praise of God. The "heavenly liturgy" of the book of Revelation bears witness to the eschaton's "constitutively linguistic and doxological character."[51] This is where Troutner is particularly pertinent for our purposes. He writes of the "maximal logic of praise."[52] That the language of praise falls short of its addressee (God) should not be taken as a cue to discard it but rather to allow it to be "maxed out," stretched to its limits. "*One does not cease to praise because one's voice is inadequate. Rather, one only praises, and praises forever, that which one knows one's praises can never equal, even in infinite, eschatological, time. . . . Divine excess does not discourage language and speech, but rather welcomes them, nay even demands them.*"[53] My only addition to this would be the observation that divine excess is the excess of love, the love that has appropriated speech in the world's reconciliation, and that it is in the human life of Jesus above all that we find speech glorifying God.

Troutner backs up his case by challenging the assumption that language never belonged to God's fundamental intentions for humanity. Against the tendency to index language to the negativity of sin, he urges that it be regarded as intrinsic to our intended, finite creaturehood: "To be perfected, creatures do not have to be stripped of their finitude. The eschatological correlate of the doctrine of creation is hope for the transfiguration, not abolition, of finitude."[54] The eschaton will doubtless be marked by the cessation of corrupt speech, death-dealing talk, the language of violence, hatred, and division—but not of language as such. To

50. Troutner, "Beyond Silence," 926.
51. Troutner, "Beyond Silence," 921.
52. Troutner, "Beyond Silence," 921–22.
53. Troutner, "Beyond Silence," 921–22, italics added. As Jean-Louis Chrétien imagines it, the hymn of praise is possible "if it is exceeded twice over by the disproportionate magnitude both of that which is its task to bear in its speech, the vast and various world, and of the one to whom it addresses that speech in antiphonal response, the God who is always greater. This is the breathing of the song: the fact that there is always more air than our lungs can contain" (Chrétien, *Ark of Speech*, 108).
54. Troutner, "Beyond Silence," 922.

affirm the presence of language in the world to come is to take seriously the materiality of the body and of the sign, the physicality of all human communication. "If our tongues and voices are constitutive of our humanity, they and the material signs they enunciate must participate in the last things."[55]

Part of what Troutner is resisting is a model of language as a kind of screen, an obstacle or impediment standing between us and reality-in-itself, with the latter regarded as intrinsically inaccessible. On this model, language by its nature estranges us from the world. Much more in keeping not only with biblical perspectives but with a considerable corpus of philosophical reflection on language is a construal of language as belonging to our bodily "indwelling" of a world whose concrete reality, before anything else, calls forth an attitude of trust, of acknowledgment. In this context, however prone to error it may be, language can be seen as available primarily to *enable* access to reality. This is nicely captured by Rita Felski: "Language is more like an interface than a firewall, an array of devices that connect us to other things."[56]

It is hardly surprising that many contemporary theologians are especially prone to set language primarily within the gravitational force of sin, because so much critical theory has made them acutely aware of the ease with which God-talk has been used to try to gain some kind of hold on God, and thereby to manipulate and subjugate others in God's name ("Thus says the Lord . . ."). Given the torrents of religious abuse that have flowed from this pathology, many insist that any account of God-talk must *start* with the recognition of Christianity's shameful complicity in systems of oppression, concealment, delusion, and domination and with an honest acknowledgment of its frequent co-option by self-serving political drives and agendas. The sentiment behind this demand is more than understandable. And yet at some point we will be pushed to admit that the speech that registers these dangers is by no means immune to the same dangers itself. This should make us wonder if we might do better to recover a sense of language as a primordially intended good, and as something that, in the light of Christ, need not be irredeemably trapped in the deformations of human sin—indeed, as something that through him can begin to be re-formed as it becomes part of a life of praise.

None of this in any way obviates the need for apophatic reserve—for heeding the dangers of over-saying, learning the discipline of unsaying, attending to the intervals "between" words, and to the crucial roles of silence. The postmodern

55. Troutner, "Beyond Silence," 923.
56. Felski, *Hooked*, 70.

"linguistic turn" has brought all these to the fore, and quite properly so. But much depends on the context in which these stipulations are set. If we are open to the possibility that language has in some manner been appropriated directly into God's reconciling initiative, we would do well to avoid prescribing protocols of ineffability in advance of attending to what this "prior speech" might mediate and imply.[57] Further, the purpose of stressing God's ineffability will not be so much to render us dumb—despite the myriad times when silence is appropriate—as to keep us wonder-fully aware that there is always more that can be said of divine goodness, an abundance that language can never hope to capture. God's love-in-action can never be out-spoken.[58]

What holds for God-talk in this regard will apply mutatis mutandis to "God-thought," to the networks of ideas and concepts intertwined with our speech and writing. As with ineffability, God's incomprehensibility is in danger of being undermined altogether if it is defined (negatively) in advance of God's own self-attestation, and apart from God in Christ getting to grips with the human capacity to think and know. The inadequacy of God-thought is not primarily a consequence of the fall (though speech will always be susceptible to the distortions of sin) but a sign of our (good) creatureliness, and as such should make us doubly aware of the sheer inexhaustibility of the faithfulness of God. Along these lines, Hans Urs von Balthasar argues that incomprehensibility is

> not a mere deficiency in knowledge, but the positive manner in which God determines the knowledge of faith: this is the overwhelming inconceivability of the fact that God has loved us so much that he surrendered his only Son for us, the fact that the God of plenitude has poured himself out, not only into creation, but emptied himself into the modalities of an existence determined by sin, corrupted by death and alienated from God. This is the concealment that appears in his self-revelation; this is the ungraspability of God, which becomes graspable because it *is* grasped.[59]

57. In rather more direct terms: "The better a man learns to pray, the more deeply he finds that all his stammering is only an answer to God's speaking to him; this in turn implies that any understanding between God and man must be on the basis of God's language" (von Balthasar, *Prayer*, 4).

58. "For Christian theology, critique serves confession and genealogy serves Christian proclamation. Confessional speech directs critical speech, . . . showing that no critique can 'go all the way down' such as to uproot the creaturely basis that testifies to there being something *there*" (Tran, "Lovely Things," italics original). Speaking of Augustine in this context, Tran comments that the Latin saint's "tethered critique discovers not a bottomless pit of fault—though Augustine, the original master of suspicion, gives us plenty of fault—but God as the rough ground of the Christian confessional life" (Tran, "Lovely Things").

59. Von Balthasar, *Glory of the Lord*, 1:461, italics original.

In the same vein, he writes,

> "Incomprehensibility" does not mean a negative determination of what one does not know, but rather a positive and almost "seen" and understood property of him whom one knows. The more a great work of art is known and grasped, the more concretely we are dazzled by its "ungraspable" genius.[60]

Exceeding Goodness

We turn, third, to *God's uncontainability by the world's fallenness*. In the New Testament, never is the uncontainable pressure of God's goodness-in-action more evident or more clearly on display than when all that threatens to constrain God's purposes for God's beloved creation is climactically overcome and a new creation inaugurated—that is, in the three days from Good Friday to Easter. What happens in the Triduum is imbued with a sense of excess, of being "more than" we could ever expect. Of the profusion of reflections this provokes, I limit myself to four.

Here more than anywhere else God *exceeds the forces of evil that oppose God and threaten the world's integrity*. "The light shines in the darkness, and the darkness has not overcome it" (John 1:5 NIV).[61] Just the opposite. As John 16:33 affirms, in Christ God has overcome "the world" (i.e., all that is opposed to God). Here we are up against the *Christus Victor* motif, the note of decisive triumph that surrounds the New Testament's declaration of Christ as crucified and risen. Of course, it cannot be forgotten that the resurrection is the raising of a crucified Messiah, not the cancellation of Good Friday but—among other things—its decisive confirmation. God voluntarily submits to the downward spiraling of sin and death; in this way the principalities and powers are disarmed (Col. 2:15), the chains that hold the world in their grip are snapped. Easter Day is not a negation of the way of the cross but the vindication of the love that finds its acme at Golgotha.

Also, it is supremely in the Easter Triduum that God *exceeds the fallen world's immanent possibilities*. Christian theology has always insisted that the dying and rising of Jesus together constitute an achievement whose origin and impetus lie wholly beyond the capacities of human beings and beyond the capacities of the physical world at large. This death is not one that we could ever undergo.

60. Von Balthasar, *Glory of the Lord*, 1:186.
61. It is worth noting that the root verb behind "overcome" may mean "to defeat," but it can also mean "to grasp with the mind." John is likely playing on the ambiguity.

It is only God the Son who can reach into and beyond the extremities of the world's darkness. The Son's resurrection is likewise emphatically a divine act, and one in which God's power to outstrip creation's immanent powers reaches its most concentrated expression. From this the New Testament's witness to "new creation" takes its major cue: a stupendously novel act of the Creator, the nearest analogy we have to creation out of nothing.

Recall Isaiah voicing God's declaration: "I am about to do a new thing" (Isa. 43:19). Isaiah, the prophet of new creation par excellence, clearly does not believe that God's "new thing" (in this case, the rescue of the exiles from Babylon) depends on some kind of intact and active capacity sitting inside fallen humans, still less that new creation has been inserted from the start into the fabric of this world. The language evokes an unprecedented and intrinsically "unnecessary" happening, one that finite creatures can neither bring about nor fully account for in creaturely terms.

The same de novo sense of irruption, of newness from beyond—a newness that *needs* to come from beyond—runs through countless New Testament passages. For example, the virginal conception of Jesus is presented (especially in Luke) as an event that cannot be thought of as proceeding seamlessly out of Israel's prior history. The new birth that Jesus invokes in his conversation with Nicodemus in John 3 does not originate in an act of the fallen human will but in a radically fresh initiative of the Spirit: one is "born, not of blood or of the will of the flesh or of the will of man, but of God" (John 1:13; words that could also be applied to Jesus himself). The examples could be multiplied, all the way through to Revelation 21, where the End is envisaged not as the end point of something preprogrammed into the nature of things but as God's doing, the final performance of renewal— the event of Easter, we might say, extended to the cosmos as a whole.

Further, the outcome of the three-day Easter drama *qualitatively exceeds all that precedes it*. The divine excess of love-in-action undermines the logic of neat equivalence or "balance" that would meet evil with a proportional good. The victory won and confirmed in cross and resurrection is not a return to a *status quo ante*. It outperforms all that it "answers"; it is, we might say, an aesthetic joke, a subversion of anticipated symmetries, a comedy taken to the nth degree.

Thus when the prophet Isaiah declares to the exiles in Babylon that God will bring to birth a new world order, he portrays it as a new exodus that radically surpasses the first,[62] outrunning it, resulting in a world in which previously

62. E.g., Isa. 40:3–5; 41:18; 52:12; 55:12–13.

unimaginable realities break forth (hence Isaiah's stretched, excessive speech). Hyperbole tumbles into absurdity: running and not growing weary (Isa. 40:31), hundred-year-olds finding themselves young, a wolf feeding with a lamb, a lion eating straw like an ox (65:20, 25). Indeed, the ultimate promise is described in terms of a renewed creation (65:17–25).

And this superfluity pervades the ministry of Jesus. In our two Scriptural interruptions above, we have already noted it suffusing the account of Jesus in the Fourth Gospel. We might also cite the father's over-the-top welcome for his rebellious son in Jesus's famous parable in Luke 15:11–32; the startling, almost offensive liberality of a slighted vineyard owner in the story of Matthew 20:1–16; the surfeit of fish Simon Peter catches in Luke 5:1–11 ("so many fish that their nets were beginning to burst"); and the feeding of the multitude in Mark 6:31–44 ("and they took up twelve baskets full of broken pieces and of the fish"). And we could well add Paul's refrain of "much more," as in "For if the many died through the one man's trespass, *much more* surely have the grace of God and the gift in the grace of the one man, Jesus Christ, abounded for the many" (Rom. 5:15; see also v. 17).

It is in Jesus's resurrection that this pattern of excessive renewal is displayed in its most concentrated and decisive form. Scanning the Gospel accounts of the disciples' first encounters with the risen Christ, it is hard not to be struck by a pervasive two-sidedness. On the one hand, the risen Jesus belongs to this spatiotemporal physical world—this newly alive person was not less physical, less embodied than a person waking up from sleep. He was recognizable, ate food, spoke, and invited his followers to become his new community. On the other hand, he was not at first recognized; he appeared and disappeared; he was not to be grasped. He seems to have been imbued with a mode of life that is "more than" the bodily dimensions of this world can accommodate. Language struggles and cracks to describe one who is both material and particular but who, at the same time, exceeds the confines of material particularity.[63]

These accounts thus echo in their own way the rooted-yet-uncontainable character of the incarnation itself, especially the first two aspects of uncontainability outlined above (the excess of infinite to finite and the inadequacy of thought and language). We see a similar pattern in Paul's First Letter to the Corinthians, where against the background of his Jewish theology of the "two ages" the apostle strains to convey something of the metaphysical logic of the

63. Markus Bockmuehl puts it tersely: "The New Testament writers affirm of the resurrection of Jesus both (1) that it is an event in historical time and space, and (2) that it cannot be straightforwardly understood as an event in historical time and space" (Bockmuehl, "Resurrection," 109).

future resurrection of believers (1 Cor. 15:35–49). His language, extended and distended by the enormity of his subject, points to a future renewal that clearly surpasses resuscitation, but without leaving the physicality of the body behind. In the age to come, believers will be given a "spiritual body" (*sōma pneumatikon*, 1 Cor. 15:44)—not a nonmaterial body but a Spirit-animated body, whose prototype is the body of the risen Jesus. This future body contrasts with the "soulish body" (*sōma psychikon*, 1 Cor. 15:44) that we have now, which, although created good, has become subject to sin, decay, and death. The new body, although free from these things, will not be less substantial but more so—alive and excessively vigorous. It will be *hyper*physical, we might say: a body in which materiality has been "transfigured" or "transformed,"[64] expanded, granted a new dignity. This is not a reversion to life as it now is (as with the raising of Lazarus) but an elevation to a qualitatively different kind of vitality, one that will not run down and slip back into the pull of decay and death ("they shall run and not be weary," Isa. 40:31). All this Paul sets in a creational context with numerous echoes of Genesis. Along with human resurrection, Paul has in mind the loving commitment of the Creator God of Israel to the transformation of all that God has brought into being—new creation in the widest possible sense.[65]

It is worth adding that Paul describes the future resurrection body with a word often translated as "imperishable" or "incorruptible" (1 Cor. 15:42, 50, 52–54). In his commentary on 1 Corinthians, Anthony Thiselton argues that this fails to bring out the force of the original Greek word, *aphtharsia*. He translates this key term as "decay's reversal."[66] The true eschatological reversal of running down—the degeneration, emptiness, and fruitlessness of our current bodies—is not simply "running on" (survival) but something like "running up": "*a dynamic process of ethical, aesthetic, and psychosocial flourishing, purpose, and abundance.*"[67]

64. Thiselton, *Corinthians*, 1292. Compare Phil. 3:21. For exemplary discussions of the resurrection body in Paul, see Thiselton, *Corinthians*, 1169–315, esp. 1276–1306; Wright, *Resurrection of the Son of God*, 313–61.

65. In Paul's Second Letter to the Corinthians, his declaration that "if anyone is in Christ, new creation!" (2 Cor. 5:17, my trans.) may refer chiefly to human renewal, but it assumes a cosmological setting (Hays, *Moral Vision of the New Testament*, 20). Similarly, when Paul's chief interest is the renewal of the created world at large, humanity's part in that renewal is implied. Speaking of Rom. 8, T. Ryan Jackson writes, "Paul's movement from creation to new creation in Rom 1–8 takes the position that creation itself is affected by human sin and Rom 8 makes clear that, for Paul, the redemption of humanity was part of the redemption of creation. . . . Paul sees the redemption of the body as fundamental to the renewal of the creation as a whole" (Jackson, *New Creation in Paul's Letters*, 180–81).

66. Thiselton, *Corinthians*, 1272, 1296–97.

67. Thiselton, *Corinthians*, 1296, italics original.

This is certainly a mind-bending thought. But it makes sense in the context of Paul's overall argument, especially if we take seriously the New Testament's testimony to the possibility of sharing in God's eternal *life*.[68] On this account, then, the condition of the final new creation is not simply one free of death but one in which there is an eternally expanding, proliferating newness—in short, novelty without loss, a life "in which new occurrences are added but nothing passes away."[69] The New Testament scholar Richard Bauckham gives this eloquent poetic expression in his poem "Four Women and a Tomb":

> After so much slow sorrow,
> emptied of feeling,
> drained dry of hope,
> still their love led them.
>
> At the third cockcrow
> on the third morning
> they gathered,
> heads cloaked and baskets
> weighty with fragrance.
>
> Out of love's fullness
> he poured himself, emptied,
> an offering,
> sweet-scented as April
> in the garden of God.
>
> That spring of all loving
> that never runs dry
> poured a deep draught for them,
> quenching their emptiness
> —an emptied tomb
> and wonder, heart-whelming wonder.[70]

68. "To be raised by and through *God* in the power of *the Holy Spirit* entails a dynamic of being that corresponds with the dynamic of the *living* God who acts purposively in ongoing ways, never 'trapped' in a timeless vacuum from which all experience of succession is excluded. . . . This is more than *imperishability . . . or* immortality" (Thiselton, *Corinthians*, 1272, italics original).

69. Bauckham, *God Will Be All in All*, 186. Gregory of Nyssa spoke of the human journey of worship, moral and epistemological perfection or "straining" (*epektasis*), a ceaseless movement toward union with the infinite God, beautifully described by Khaled Anatolios as "knowing-in-adoration of the transcendence of the glory *perceived, traveled in, but not enclosed*" (Anatolios, *Retrieving Nicaea*, 165, italics added).

70. Bauckham, *Tumbling into Light*, 51. Used by permission. rights@hymnsam.co.uk.

Despite all that we have just said, an obvious caveat is needed: this outpouring of goodness inevitably delivers judgment. The love shown in the events of Good Friday to Easter, on its way to re-creation, exposes and defeats the world's enemies. The "more than" metaphors we have been using—excess, surplus, surfeit, overflow, and so forth—could lead us to believe that the newness of new creation consists merely in the addition of extra qualities to something that itself remains essentially intact. Mammoth questions crowd in at this point concerning the relation between "nature" and "grace," but for our purposes it is enough to note that along with a proper stress on the continuity between the new creation and the "first" creation (the new creation does not bring an obliteration of the already-created world), we need a sense of the discontinuity between the new creation and the old (between the world as renewed and the world as fallen and rebellious). The one vindicated by God on Easter morning is the one who dies on Good Friday as a blasphemer, convict, and rebel; he is the one condemned as guilty, numbered with the worst, bearing the full consequences of humanity's perverse revolt against God. To forget this is to sentimentalize God's uncontainability, to turn divine excess into divine indulgence.[71]

Unmasterable

We turn, fourth, to *the uncontainability of God by the will of another*. The refusal of God to be under the control of another—indeed, the impossibility

71. It is this oppositional, even agonistic dimension of new creation that a number of scholars have been especially eager to recover in recent years. Indeed, in Pauline studies a lively and often intense debate has flared up in the last decade or so concerning the continuity and discontinuity of salvation, much of it centering on the contested term *apocalyptic*. In Paul's worldview, the old order—in which God's good world is held back by sin, decay, and death—has ended through the dying and rising of Christ, and a new order has been inaugurated in the midst of the old, an order in which we can share now, provisionally and partially, through the Spirit. Some vigorously insist we take with full seriousness the *newness* of the new, that what God has done in Christ involves a divine in-breaking that radically disrupts and overturns what has come before. See, e.g., Martyn, *Galatians*; Campbell, *Deliverance of God*; Gaventa, "Singularity of the Gospel Revisited."

In a masterly treatment of this movement, Tom McCall argues quite properly that in the case of human beings, some viable account of the continuity of human identity needs to be maintained if we are to affirm that God is lovingly committed to *this* person both pre- and post-conversion— something that proponents of the "radical apocalyptic" view seem to struggle to do (McCall, *Analytic Christology*, 8–38). At stake here also is the extent to which the body is intrinsic to personal identity, and indeed, whether it is worth saving. The seed analogy Paul uses in speaking of the two types of body (1 Cor. 15:42–44) depends for its effect on at least some degree of continuity. And behind this lies the question of God's commitment to created materiality—something that, again, seems non-negotiable for Paul. Despite *creatio ex nihilo* having a good rhetorical ring to it when applied without qualification to the resurrection of the body, Kathryn Tanner's careful wording is worth quoting in this connection: "The grace that changes us has its *analogue* in the divine acts that created us—from nothing"; this change is "*like* the rebirth from the dead" (Tanner, *Christ the Key*, 64–65, italics added).

of such—is one of Christian theology's pivotal themes. Yet as the history of that theology shows, and as I have noted already, it can become freighted with questionable connotations if divorced from the self-revealing covenantal action of God. It can encourage belief in a deity with minimal tolerance of anything or anyone other than God, making it hard to see how God would have any direct or concrete engagement with the created world at all, or any engagement that could include give-and-take, let alone divine submission to sin's effects in the incarnate life of the Son. It can imply an arbitrariness to God's freedom from the world—and thus to the world's creation—and a view of divine authority that is redolent of domination and exploitative force. And, with all this, it can suggest an intensely negative view of human life in relation to God, one of cowering servility in which the integrity of human agency seems to be all but crushed.

Here it is worth returning to the dynamics of control and mastery evident in our first Johannine interruption, from John 9.[72] In that passage the Pharisees are presented as those anxious to manage and regulate Jesus's healing of the blind beggar according to their own religious strictures. They are met by a person who seems strikingly free of the need to control. And he demonstrates God's power by bringing sight to an anonymous and unwanted street wanderer. The uncontainability of God is manifest here not only in Jesus's lordship over the forces that have led to the beggar's condition but in his refusal to bend to the will of those who are failing to see this extraordinary act as God's love-in-action. The worst kind of bid for mastery is that which hinders God at work for the world's healing (and it can happen as much through thought and speech as anything else, as this story so transparently shows). Modern images of freedom as autonomy will have little place here—and even less when such images are applied thoughtlessly to God. All zero-sum views of divine and human freedom—views that assume the two are inherently competitive—will also be put in question; divine freedom will be reimagined as freedom-in-love *for* the freedom of the other.[73]

The Uncontainability of the World's Meaning

We should attend to one other major implication of our reflections so far on the uncontainability of God's gracious momentum in and toward the world: that

72. See under "Control and Mastery" in chap. 3.
73. Begbie, *Music, Modernity, and God*, chap. 6.

the created order does not contain its own explanation, that its deepest secret lies beyond itself, and that because of its dependence on and openness to the agency of the infinite God, it is possessed of an inexhaustible depth; there is always more that can be discovered, thought, and spoken.[74] There are many ways of expressing this, but one of the most discussed in recent years is that offered by the Roman Catholic philosopher Jacques Maritain (1882–1973). In a key passage, Maritain writes, *"Things are not only what they are. They ceaselessly pass beyond themselves, and give more than they have."*[75] We shall return to Maritain in chapter 9, but for now we can turn to a memorable poetic transposition of Maritain's thought by Malcolm Guite. His poem "Good Measure" condenses much of what has been said so far:

More than good measure, measure of all things,
Pleroma overflowing to our need,
Fullness of glory, all that glory brings,
Unguessed-at blessing, springing from each seed,
Even the things within the world you make
Give more than all they have, for they are more
Than all they are. Gifts given for the sake
Of love keep giving; draw us to the core,
Where love and giving come from: the rich source
That wells within the fullness of the world,
The reservoir, the never spent resource,
Poured out in wounded love, until it spilled
Even from your body on the cross;
The heart's blood of our maker shed for us.[76]

A Brief Case Study

In the next chapter, we will tentatively probe how this uncontainable divine momentum we have been charting might be grounded in the triunity of God

74. "Étienne Gilson wrote that what 'knowledge grasps in the object is something real, but reality is inexhaustible, and even if the intellect had discerned all its details, it would still be confounded by the mystery of its very existence.' . . . This rests not on a lack of intelligibility *but on a surfeit of intelligibility.* Put mundanely, there is always more to know about anything than we can grasp; put more theologically, this is because the deepest truth of anything is its relation to God" (Davison, *Participation in God*, 316, italics added, quoting Gilson, *Methodical Realism*, 102). I am grateful to Austin Stevenson for pointing me to this quotation.
75. Maritain, *Creative Intuition in Art and Poetry*, 127, italics added.
76. Guite, *Parable and Paradox*, 47. Used by permission. rights@hymnsam.co.uk.

in se. But to prepare the way, we should say something briefly about how it plays out corporately, in the life of God's people.

I am going to take it as read that the *telos* of the pressure of divine love for humans is our adoption into the life of God. We are "placed" by the Spirit within the Son's relation to the Father, and in this way become children of God, coheirs with Christ of all that he receives. A little more fully: by the grace of the Spirit we share in the eternal Father's love for the Son and in the Son's eternally grounded, loving response to the Father. In this way the Father's love for the Son comes to be "in" those who love Jesus (John 17:26).

This indwelling, however, moves outward. Commenting on Jesus's prayer in John 17, Francis Watson writes, "The movement of the Spirit towards Jesus' followers includes them within the scope of Jesus' relation to the Father, thereby gathering them together in *koinonia* with one another. But it also has the effect of directing them outwards, turning them towards the world. The comfort that the Spirit brings is not the comfort of communal self-absorption, for it is the role of the Spirit to bear witness to Jesus in the world, and to enable Jesus' followers to do likewise ([John] 1:26–7; 16:7–11)."[77] In a multitude of ways, the New Testament testifies to this ceaseless pressure outward, to a momentum of a love that exceeds the bounds we often assume determine and restrict our lives.

One place this is especially evident is in the eighth and ninth chapters of Paul's Second Letter to the Corinthians.[78] Paul's concern could hardly be more down-to-earth: raising money for poor Christians in Jerusalem. He and his hearers live in a society where goods and resources are relatively limited, where the majority will not be expecting much more than a life of stable subsistence. "It was an economy in which equilibrium, not growth, was the ideal."[79] In this context, the logic of equivalence is hard to avoid: the best one can hope for from anyone, including God, is some kind of balancing of competing interests. "You give me this; I'll give you the equivalent back." But Paul seems to be gripped by a very different economy, one that undercuts any such contractual mentality as it revolves around the "surpassing" grace of God (2 Cor. 9:14). For him, God has done something that vastly outdoes anything it answers, that outstrips anything akin to an evenly squared contract. Moreover, this expansive momentum seems

77. Watson, "Trinity and Community," 182.
78. What follows is a revision of material presented in Begbie, "Word Refreshed." I am deeply indebted in this whole section to the fine study by Frances Young and David Ford, *Meaning and Truth in 2 Corinthians.*
79. Young and Ford, *Meaning and Truth in 2 Corinthians,* 172.

to be potentially unstoppable when let loose in the world. As Frances Young and David Ford write, "'More and More' is the dynamic symbol of this God and of Paul's mission."[80]

We note that Paul promises no exact return for the Corinthians' generosity. Giving money will not generate a calculable payback, yet it will breed more generosity—and still more. Paul writes, "Everything is for your sake, so that grace, when it has extended to more and more people, may increase thanksgiving, to the glory of God" (2 Cor. 4:15). Notice here that grace and thanksgiving both get caught up in this extended expansion of giving: "The rendering of this ministry not only supplies the needs of the saints but also overflows [perisseuousa] with many thanksgivings to God" (9:12). It is this generosity that gives rise to what Paul calls koinōnia—variously translated as "communion," "sharing," "fellowship," "partnership"—a profoundly nonpossessive, noncontractual way of life.

The generative heart of all this is the self-giving enacted by God superlatively and decisively in Christ: "For you know the generous act of our Lord Jesus Christ, that though he was rich, yet for your sakes he became poor, so that by his poverty you might become rich" (2 Cor. 8:9). This is the central exchange that characterizes the divine economy, giving rise to a wealth that far exceeds anything that could be measured or reckoned in advance. And this is surely the core of what Paul has in mind in that jubilant outburst quoted earlier: "Thanks be to God for his indescribable gift!" (9:15).

Clearly, all this is quite foreign to any dynamic of possessive control. For it derives from a God who appears to be effusively, almost recklessly, other-directed—whose power takes the form of giving away: "And God is able to provide you with every blessing in abundance [perisseusai], so that by always having enough of everything, you may share abundantly [perisseuēte] in every good work" (2 Cor. 9:8). Divine power thus becomes especially visible in contexts where people find themselves without those things that encourage them to think they have total control over their lives, as when a hardship comes along that cannot be easily alleviated. Hence Christ's words to Paul: "Power is made perfect in weakness" (12:9). Paul's own suffering, he believes, serves to highlight the nature of divine power as God's capacity to bring life out of death (4:7–14).

The multiple resonances between what we find here in 2 Corinthians and the overall thrust of this chapter scarcely need pointing out. We might add that

80. Young and Ford, *Meaning and Truth in 2 Corinthians*, 173. See the illuminating discussion of the communal expression of "the divine Gift" in Barclay, *Paul and the Gift*, 423–46.

it is hardly surprising that this counter-possessive movement is just what we find in another theme close to Paul's heart, that of *election* (again, a movement of love-in-action). That may seem a decidedly odd connection to make—bizarre, even—but only if we misconstrue divine election as God arbitrarily and inscrutably selecting individuals for a relation that terminates in the privacy of a one-to-one relationship. If election is the outworking of God's desire to create a community that by its nature grows through the overspill of love's momentum (one to another, one for the sake of another, and those for the sake of still others), a community that cannot be anything other than apostolic—*sent*—then not only does election parallel the form of life we have been speaking about; it enacts it in striking form.

8

God's Own "Ex-pressure"

Very truly, I tell you, the hour is coming and is now here when the dead will hear the voice of the Son of God, and those who hear will live. For just as the Father has life in himself, so he has granted the Son also to have life in himself.

John 5:25–26

The Holy Spirit is "that by virtue of which God is an everlasting movement of giving away."

Church of England Doctrine Commission[1]

My leading concern in the previous chapter was to propose that Scripture's witness to the uncontainability of God—the divine "moreness" evident in God's creative and saving engagement with the created world—should be understood as the pressure of the triune God's love-in-action. In this chapter I want to go on to inquire about the extent to which this pressure might be viewed as belonging to God's life *in se*. Can we speak of an unbounded, outwardly directed pressure—an "ex-pressive" momentum—intrinsic to God's own being?

There are, of course, considerable perils even in asking this. When it comes to articulating the trinitarian dynamics of God *ad intra*, the theologian's penchant

1. Church of England Doctrine Commission, *We Believe in the Holy Spirit*, 67.

for speculation has too often landed the church in a welter of unnecessary tangles and predicaments. Nonetheless, in the interests of providing the elements of a theological vision that will best engage the capacity of the arts to resist and undercut the pressures of reductionism, it is, I believe, worth attempting to uncover at least something of how the triune vitality of God might ground God's uncontainability by the world. At every point, however, we need to be alert to a very particular danger: suggesting that God's movement "beyond" God arises through some kind of necessity—put crudely, that God is unable to keep to himself. I shall be taking it for granted that God's action *ad extra*, although wholly appropriate to and consistent with who God is, is nonetheless infinitely free.

Vitality and Love

We can begin by expanding on a theme we encountered in the previous chapter: the theme of God as the eternal and supreme possessor of life.[2] This is a repeated refrain in Scripture. In the Old Testament and first-century Judaism, to confess God as living underscores, among other things, Israel's commitment to monotheism, to the LORD's qualitative uniqueness. In contrast to the idols, which can be multiplied and are miserably inert and impotent (in other words, dead), Israel's God is uniquely and irrepressibly alive and, as such, gives life to all else: "Before the mountains were brought forth or ever you had formed the earth and the world, from everlasting to everlasting you are God" (Ps. 90:2).

However, this divine liveliness is not amorphous or undifferentiated. Among Israel's Scriptures, despite an unwavering monotheistic commitment, there are various texts that hint at, or gesture toward, some degree of divine differentiation. God's Word (Isa. 55:11) and Wisdom (Prov. 8:22–31), for example, seem to hover between being identified with and distinguished from God. In the New Testament this ambiguity is openly drawn upon as the early Christians come to terms with the person of Christ. Hence John's affirmation that, "in the beginning," the Word who "*was* God" was also "*with* God" (John 1:1). The first followers of Jesus find themselves bearing witness (often, it seems, unwittingly) to a divine life that cannot readily be articulated in terms of absolute singularity—and, in due course, to a differentiated life characterized by love given and returned. To develop this, I am again going to have to be selective,

2. E.g., Deut. 5:26; Ps. 18:46; Jer. 10:2–16; Matt. 16:16; Heb. 3:12.

concentrating especially on some key passages from the Fourth Gospel (though many other and earlier writings could be cited).[3]

Significantly, the phrase "living God" does not appear in John's Gospel; instead we find the expression "living Father" (6:57) and an evocation of the Father sharing his own life intimately with his Son. One of the most striking texts to bring this out comes shortly after the second of our Johannine "interruptions": "Very truly, I tell you, the hour is coming and is now here when the dead will hear the voice of the Son of God, and those who hear will live. For just as the Father has life in himself, so he has granted the Son also to have life in himself" (5:25–26). Jesus here tells Jewish authorities that the life the Son has in himself is the life that the Father has given him. We recall the prologue: "In him [the Word] was life" (1:4). Andrew Lincoln glosses "life" here as "God's energizing and life-giving power, sustaining created existence in relation to its Creator."[4] But the life the Father gives the Son is the life the Father has eternally in himself. There is, then, both asymmetry and commonality here: the Son is given life by the Father, but the life that is given is the life that the Father has.[5]

John 5:26 was a key verse in the church's opposition to fourth-century Arianism (the belief that the Son does not partake of the divine nature). Jesus is charged by the Jewish leaders with claiming equality with God (5:18). Jesus rejects the accusation insofar as it might indicate that there are two gods, but he seems to accept it when he says that "whatever the Father does, the Son does likewise" (5:19). The Father's "life in himself" is the life that belongs only to God and is thus the life that is given *eternally* to the Son.[6] More than this, the Father's gift of life to the Son includes the Father's prerogative to give life to others: the Son is able to give his and the Father's life to creatures. Hence, as Marianne Meye Thompson puts it, we have here "neither an ultimate dualism of power tantamount to di-theism nor an arbitrary attribution of living-giving power to the Son as one possible agent through whom the Father might choose

3. For discussion of these and related texts and issues, see, e.g., Bauckham, "Biblical Theology"; Bauckham, *Jesus and the God of Israel*; Hurtado, *How on Earth Did Jesus Become a God?*

4. Lincoln, *Gospel according to Saint John*, 99.

5. I am not convinced that Jesus's words "The Father is greater than I" (John 14:28) imply an oppressive hierarchy or ontological subordination. I take them as intimating the Father as the source of the Son's life, the Son's utter dependence on the loving and life-giving Father for everything, including the Son's very being—not one divine will submitting to another divine will.

6. See Carson, "John 5:26," 83–85. Ian McFarland writes, "Because God's status as Father (that is, the One who gives life to the Son) is eternal, the giving of life is integral to God's being Father" (McFarland, "God, the Father Almighty," 265).

to confer life. *The Father gives life to and through the Son.*[7] God is the life-giving giver, and this is so "prior" to any act of creation or any divine action within the created world. God's life, it seems, is a ceaseless dynamic of giving life.

Moreover, and crucially, this eternal movement of self-bestowal is an enactment of love—and this links up with our previous chapter. When John begins his prologue "In the beginning was the Word" (1:1), he is clearly reworking Genesis, but immediately he tells us that the Word who "was God" was "*with*" God (1:1). Toward the end of the prologue, the Word who is "with" God is identified as the one who "became flesh" and as the "only son" of the Father (1:14), "who is close to the Father's heart" (1:18). In due course, this Son-Father relation will be portrayed as one of love, and it will become a central theological nerve— arguably *the* central nerve—of the whole Gospel.[8] The "withness" within God is the withness of love, a love that includes mutual knowledge (10:15) and mutual glorification (17:1).

Further, there is love given and love returned: the Father's love for the Son is answered by the love of the Son for the Father, played out in Jesus's self-offering throughout his earthly life.[9] Most importantly, this love belongs to God's own being—"God is love" (1 John 4:8, 16)—it is not a potential disposition that God activates in response to something other than God.[10] On the night before he dies, Jesus prays, "Father, I desire that those also, whom you have given me, may be with me where I am, to see my glory, which you have given me because you loved me *before the foundation of the world*" (John 17:24).[11] The love imple-

7. Thompson, *God of the Gospel of John*, 79, italics added. The life humans receive, of course, is given within a finite and contingent world, unlike the life given to the Son. So the parallelism between Father-Son and Son-creatures is by no means exact.

8. See, e.g., John 3:35; 5:20; 10:17; 15:9–10; 17:23–24, 26.

9. John 14:31 is the only place in the Fourth Gospel where Jesus is said to love the Father, "but this reference shows that his whole life of obedience to the Father is grounded in his love for the Father" (Bauckham, "Trinity and the Gospel of John," 101).

10. Speaking of John's Gospel, Marianne Meye Thompson writes, "Love is not one of many possible attitudes or actions that the Father may express towards the Son, the Son towards the Father and believers, and so on. It is the fundamental way of relating among those who find their very life and existence determined by the relationship of 'father' and 'son' to each other" (Thompson, *God of the Gospel of John*, 100).

11. See also John 17:22–23: "The glory that you have given me I have given them, so that they may be one, as we are one, I in them and you in me, that they may become completely one, so that the world may know that you have sent me and have loved them even as you have loved me." Speaking of John 17:3, Andrew Lincoln comments, "For the evangelist, Jesus in his relationship as Son to the Father is intrinsic to this one God's identity. As the second petition will make clear [in v. 5], Jesus was always included in the identity and glory of the one God, even before the foundation of the world" (Lincoln, *Gospel according to Saint John*, 435). This understanding is taken up by numerous figures in the Christian tradition, including Richard

mented and performed for us in the earthly life of Jesus, the enfleshed Son of the Father, belongs to God's own heart, to God the Creator *in se*, "before" any activity *ad extra*.

However fresh and startling this might have been in the world of Second Temple Judaism, the novelty should not be exaggerated. It has long been recognized that whatever non-Jewish elements may be at work in the Fourth Gospel, and despite the relatively few direct verbal allusions to Israel's Scriptures, Jesus is portrayed throughout as deeply immersed in Israel's prior texts and traditions, even if they are dramatically reworked in the light of his coming.[12] There is every reason to suppose that here—and this is more overt in Paul's writings—the commitment of Father to Son portrayed by John in the earthly life of Jesus is the summative enactment of God's faithfulness to Israel, and that Jesus's love of the Father is the enactment of the true, faithful Israelite's love of the LORD. In this sense Jesus is, so to speak, Israel-in-person (God's "beloved"; see Eph. 1:6; Col. 1:13).[13]

The ceaseless giving of life from Father *to* Son, then, is inseparable from the eternal love of Father *for* Son, the love that "predates" the foundation of the world. Indeed, the Father giving everything into the hands of the Son (John 3:35; see also 5:20; 10:17) can be said to *derive* from the Father's love for the Son.[14] It is this love, therefore, that overflows when the Word becomes flesh. "Even as the life of the Father is given to the Son and so through him to others, so too the love of the Father is bestowed on the Son and through him to others."[15] Indeed, the Father's love for the Son is said to be *in* those who love Jesus (17:26). This begins to open up a vista amplified elsewhere in John and implied in numerous New Testament texts: that the Christian life consists in our sharing, by the Spirit, in the eternally "prior" relation of Father and Son.[16]

of St. Victor, Thomas Aquinas, and Duns Scotus. For a helpful overview, see McCall, *Analytic Christology*, 165–69.

12. Hays, *Echoes of Scripture in the Gospels*, chap. 4.

13. Israel is portrayed as God's son in Exod. 4:22–23; Jer. 31:9; and Hosea 11:1 (although in none of these instances is it implied that this son is divine).

14. According to Sean McDonough, the logic of John 3:35 ("The Father loves the Son and has placed all things in his hands") "is that the Father has given all things over to the Son *because* he loves him" (McDonough, *Creation and New Creation*, 233, italics original).

15. Thompson, *God of the Gospel of John*, 99–100.

16. Richard Bauckham writes, "The whole story of salvation that [John's] Gospel tells stems from the love between the Father and the Son and has as its goal the inclusion of humans within this loving relationship" (Bauckham, "Trinity and the Gospel of John," 102).

Arguably, this is the most fitting background for interpreting John's pivotal theme of "eternal life" (sometimes designated simply as "life"), the life granted to those who believe in Jesus. This is much trivialized if it is taken to refer to mere survival after death, or the endless continuation of earthly life. This life (*zōē*), belonging preeminently to God in this Gospel, is the life given by Father to Son. The eternal life that Jesus offers humans is nothing less than a participation as creatures in that life, a life that—in and through Jesus—has overcome death. It is this that grounds the promise that those who follow Jesus will not die (John 11:25–26). Those who truly live are those who live in (and out of) Jesus—Jesus being the one who lives directly in (and out of) God's own life: "Just as the living Father sent me and I live because of the Father, so whoever eats me will live because of me" (6:57). Human life is therefore about far more than merely being biologically alive; it is supremely about living out of the fullness of the God who is the source of all life, and this is made possible by the Father's life-giving action toward and through the Son. Marianne Meye Thompson, commenting on John 17:3, writes, "Eternal life consists of knowing that one, true, life-giving God, who sent the son, Jesus Christ, who embodies and mediates the life of the living Father."[17]

Generativity and Otherness

To speak of God as living, then, is not merely to affirm that God is alive and not dead; it is to say that life-givingness, a life of love-in-action, belongs to who God *is*. This of course pertains to God not only as Redeemer but also as Creator. It is no accident that "the work of creation, the universal sovereignty over creation, and its expected final redemption are all carried on in [John's] Gospel through the Son, and they are all expressed in terms of life."[18] And, we might add, in terms of love. The one through whom all things are made (John 1:3, 10) is the one who is "close to the Father's heart" (1:18), eternally loved by the Father and eternally returning love (14:31). Seen in this light, and in the light of a number of New Testament texts in which the world's creation is linked specifically to the person of Christ,[19] creation out of nothing can be regarded as an outworking or overspill of the love that characterizes God's

17. Thompson, *God of the Gospel of John*, 82.
18. Thompson, *God of the Gospel of John*, 80.
19. E.g., 1 Cor. 8:6; Col. 1:16; Heb. 1:2.

own life.[20] This love reaches its apogee, its most intense "living out," in the crucifixion—where Son and Father give themselves wholly to each other in extremis, to the point of the Son's death—and in the raising of Jesus to new life; even the nothingness of death must yield to God's love-driven giving of life. The creation of all things "in the beginning" is a performance of just *this* love.

The danger here, it hardly needs to be pointed out, is one we flagged above: inadvertently implying that God needs to bring another reality into being in order to be God. We may cautiously speak of an unbounded, eternally outward-moving "pressure of love" belonging to the intra-trinitarian life of God, but this should not be taken as inferring that God must create in order to realize God's own nature (like artists who need to paint in order to be themselves). The created order comes forth freely as irreducibly other than God and is utterly dependent on God—on the plenitude of God's being-as-love. Having said that, free as it may be, creation out of nothing is not arbitrary or lacking rationale, for it is in keeping with who God is as the God of love. As Augustine had it, God's creative love is not "a love that is needy and in want," as if God's love is such "that it is subjected to the things it loves"; rather, God loves "out of the abundance of his generosity."[21]

We may take this a step further. When we speak of God's creative action, we might be tempted to imagine this solely in terms of God's creation of all things out of nothing—perhaps also as God's redeeming and renewing activity in and toward the world. But one of the most intriguing elements of the Christian doctrine of God, appearing relatively early in the church's history, is the belief that there is a loving generativity within God *in se*, a movement of love that takes the form of producing and sustaining, and that issues in God creating the universe and committing to it unconditionally. The Nicene-Constantinopolitan Creed (381 CE) declares that the Son is "begotten of the Father," an affirmation given expression in the church's doctrine of the "eternal generation" of the Son. Although various verses and passages from Scripture have been called on to support this theme,[22] it is in the verse discussed above

20. If we do "appropriate" God's creation of all things to the Father, as is traditionally done, we do so recognizing that the Father is the Father of the Son in the Spirit; the triune God's acts *ad extra* are indivisible (*Opera trinitatis ad extra indivisa sunt*).

21. Augustine, *Literal Meaning of Genesis* 1.13.

22. E.g., Ps. 2:7; Prov. 8; Mic. 5:2; Acts 13:33; Heb. 1:5; 5:5. By no means are all of these regarded in modern scholarship as implying eternal generation. John's prologue is often quoted in this connection, where Jesus is described as *monogenēs* (1:14, 18). But although this has often

(John 5:26) that it is arguably most discernible: "For just as the Father has life in himself, so he has granted the Son also to have life in himself." The Son's eternal generation is one of the two divine "processions" by which the persons of the Trinity are identified and distinguished, the other being the "spiration" of the Spirit.[23]

None of this should be taken to imply that the begetting of the Son happens in time. Nor is begetting equivalent to creating (hence Nicaea's insistence that the Son is "begotten, not made"): the act of creation issues in a finite and wholly contingent reality that is not God, whereas begetting is an eternal mode of God's triune life.[24] Having said that, it nonetheless seems highly appropriate to regard God's *creatio ex nihilo* as reflecting this dynamic of "bringing forth," as a productivity that is redolent of the "ex-pressive," ecstatic love we have been bringing to light in this and the previous chapter. Tentatively, we may spell out what would seem to be the corollary—namely, that if the "productivity" of God's triune being issues in otherness (the Son is distinct from the Father, though of the same essence), the creation of the world is in some manner a reflection of that otherness. Although the parallel is emphatically not exact (again, begetting is not creating), the world's distinctness from its Creator can nonetheless be said to stand in an analogical relation to the otherness belonging to God's own being: both are enactments of the outwardly oriented movement of God's own life. This is hardly a novel idea. It has had numerous

been translated as "only begotten," it is generally agreed that the term is best taken as "one and only" or "unique." See, e.g., Bauckham, "Trinity and the Gospel of John," 88–89. In any case, even if *monogenēs* is rendered "only begotten," this would not establish *eternal* generation, only unique generation. On the other hand, as D. A. Carson points out, if *monogenēs* is to be translated "unique," this cannot be used to *deny* eternal generation. The plausibility of the doctrine has to be decided on other grounds. See Carson, "John 5:26," 89.

23. For a collection of essays on the theme (although with remarkably little said about its implications for the doctrine of creation), see Sanders and Swain, *Retrieving Eternal Generation*. Unfortunately, in some evangelical circles discussion of the Son's eternal generation has been overly entangled in debates about gender subordination, thus eclipsing much of its wider theological significance.

24. Though it may be appropriate to speak of the Father as in some sense the "ground" ("cause") of divine unity, this must not be taken as intimating that the Father alone is productive, which would suggest ontological and passive subordination of the Son and the Spirit to the Father, and thus compromise divine unity. It may be best here, therefore, to follow Ian McFarland (who claims Gregory of Nazianzus for support) in saying that the Son and the Spirit eternally "converge" back on the Father in such a way that their eternal generation is constitutive of the Father's particular identity—for the Father is Father only *as* Father of the Son who eternally receives and gives the Spirit (McFarland, *From Nothing*, 44–46).

(albeit varied) iterations—in Athanasius,[25] Bonaventure,[26] Pannenberg,[27] and von Balthasar,[28] among others.

One further comment seems apt at this point with regard to the grounding of the divine economy in God's "pretemporal" outgoingness. It concerns the internal differentiation and diversity of the created order. The created world is marked not only by plurality but by a diverse plurality. Considerable care is needed here in comparing this with divine, uncreated being. Creation is clearly a composite reality—it is composed of parts—whereas God is decidedly not. Whatever disagreements there may be about the doctrine of divine simplicity, it is generally held that it quite properly preserves the notion that each person of the Trinity reflects God's eternal fullness. Father, Son, and Spirit

25. Athanasius is clear that we cannot make sense of the creation of the contingent order unless we come to recognize that God is intrinsically "productive":

If there be not a Son, how then say you that God is a Creator? Since all things that come to be are through the Word and in Wisdom, and without This nothing can be, whereas you say He has not That in and through which He makes all things. For if the Divine Essence be not fruitful itself, but barren, as they hold, as a light that lightens not, and a dry fountain, are they not ashamed to speak of His possessing framing energy? And whereas they deny what is by nature, do they not blush to place before it what is by will? But if He frames things that are external to Him and before were not, by willing them to be, and becomes their Maker, much more will He first be Father of an Offspring from His proper Essence. (Athanasius, *Discourses against the Arians* 2.14.2)

26. According to Ilia Delio,

The key to Bonaventure's doctrine of creation is in the eternal generation of the Word from the Father. . . . The self-communicative goodness of the Father is literally God giving himself away—but in such a way that fecundity marks the Trinity's dynamic, eternal life. The necessity of God to give God's self away is realised in the Son, while the freedom of God's love is expressed in the Spirit. It is not a necessity imposed from the outside but an inner necessity of the divine being to be always and completely self-sufficient and totally in conformity with itself. . . . Because there is a Word in God, creation can exist as an external word; because there is an Absolute Otherness, there can be a relative otherness. (Delio, "From Metaphysics to Kataphysics," 168)

27. Pannenberg, *Systematic Theology*, 2:34–38.

28. Von Balthasar argues that the Father's eternal self-determination both to generate the Son and to create the world is "proper" to God's very identity (von Balthasar, *Glory of the Lord*, 3:367–68). Brendan McInerny comments,

As Balthasar acknowledges, both Thomas and Bonaventure connect the generation of the Word with the creation of the world. However, by *conceiving the Word as an "outward" expression in the Trinity*, Balthasar sees in Bonaventure a better formulation of the Word's expressive character. . . . By being the Father's perfect expression, the Logos is the "unique expression of someone unique" and expresses this person "in every respect." The Word, therefore, is no mere mental image or lifeless copy but expresses in his own unique person the Father's unique person and the Trinity as a whole. (McInerny, *Trinitarian Theology of Hans Urs von Balthasar*, 25, italics added)

are not components or pieces of a larger reality. To say that they are would be to reduce God to the level of creaturehood, to being one entity among other (composite) entities.

However, even bearing in mind the crucial senses in which creation's diversity is disanalogous to divine threeness,[29] might we not say that the dynamic proliferation of different forms of creaturely being could nonetheless find its analogous root in divine generativity, in the eternal "non-identical repetition" of God's own life? There is little if anything in Scripture to suggest that creation's diversity is an accident or an unhappy consequence of the fall;[30] it is hardly far-fetched to see it as having its deepest ground in the "productive" differentiation of God *in se*.

Filiation and Fulfillment

This eternal sourcing of creation and salvation in the outward-directed character of the triune life may be opened up a little further by considering the "Father-ward" dimension that arises from the Son's eternal generation: the way in which the Son acts out in space and time the divine act of *filiation*—a loving, responsive dependence on the Father.

Here a particularly rich vein of theological metaphysics comes into its own, one receiving much attention in recent theology and drawing especially on the Byzantine theologian Maximus the Confessor (ca. 580–662). It relates to a common theme in patristic theology: that the world is possessed of a pattern of divine rationality by virtue of which all the finite forms of this world are related to their ultimate origin. This vision typically centers on the Word, or *Logos*—the second *hypostasis* of the Trinity, incarnate in Jesus Christ—the one in whom the *logoi* (the finite forms of life that define creatures as the creatures they are) find their primordial coherence and ground.[31] Every finite particular (object, person, discrete entity) reflects in some manner the way in which the eternal *Logos* finds earthly, intelligible manifestation, and every such particular finds its supreme realization insofar as it partakes of the life of the eternal *Logos*. "For the reasons [*logoi*] of all things are set in it [the Word] as finite

29. See extended discussion in McFarland, *From Nothing*, 67–72.
30. See, e.g., Gen. 1:11–12, 21, 24–25; 6:20; 7:14. Paul's discussion of different types of bodies in 1 Cor. 15:39–41 is also relevant here, echoing Genesis.
31. McFarland, *Word Made Flesh*, 203. Torstein Tollefsen, paraphrasing Maximus, describes the *logoi* as "the divine principles of creatures in accordance with which the difference and variety of things are secured" (Tollefsen, "Christocentric Cosmology," 312).

beings, but it is limited [i.e., contained] by none of these beings."[32] We humans, through the agency of the *Logos*, are called not only to be aligned with our own "natural" *logos* but to strive to enable created particulars in the world at large to do the same.

One of the things that makes this tradition distinctive is its foregrounding of the relation between the Word and the Father. The incarnate Word realizes in finite terms—as human and fully embodied in space and time—what eternally characterizes the Word's relation to the Father: "[Christ's] human nature is identified ultimately and decisively by the fact that it actualises divine filiation. . . . [It is] absolutely, uninterruptedly, consciously and thankfully dependent on the self-gift of the Father in such a way that the fullness of that giving life is lived in the one who receives it."[33] Expressed differently: the unique mode of being of the Son (what makes the Son distinct within the triune life) is filiation, the Son's loving dependence on the Father—which is itself integral to the Son's generation *by* the Father. Filiation is the Son's way of being God. In the incarnate Son, the human will of Jesus is in perfect concord with this eternal filiation. Since this filiation is characterized not only by dependence but by radical self-giving (an other-oriented love), our participation in the Son's relation to the Father through the humanity of the incarnate Son involves "playing out" this self-giving in ways appropriate to our nature as finite creatures. We live "divinely" toward God, others, and the world at large, but only through Jesus, the humanly enfleshed Son of the Father. It is in this way that we are—to put it rather clinically—directed to our optimal realization.

The Spirit's Ex-pressure

I have said little about the Holy Spirit so far in this chapter. How might the Spirit's life be appropriately rendered in relation to this intra-divine momentum? Admittedly, this is ground upon which even the most self-assured angels fear to tread. The church has traditionally spoken of the Father's generation of the Son and the spirating of the Spirit as inseparable in God's eternal life, and this has undoubtedly served to offset the common tendency to treat the Spirit as only *just* divine, as an "extra," perhaps, but as functionally extrinsic to what often

32. Maximus the Confessor, *Chapters on Knowledge* 2.10.

33. Paraphrase of Maximus in Williams, *Christ the Heart of Creation*, 105. I am indebted in this section to Williams's discussion on pp. 99–110.

looks like a self-sufficient Father-Son relation.[34] But with respect to the themes we have been addressing, can (or should) anything more be said?

We might begin by noting something uncontroversial: the strong link, evident in many places in the Old Testament,[35] between God's Spirit and life, which is picked up in various places in the New Testament. One commentator on Luke's Gospel speaks of the Holy Spirit simply as "the life of God."[36] I have written above of the Johannine portrayal of God's life as involving an eternal movement of self-sharing in which the Father gives his all to the Son and the Son his all to the Father, the Son's return of love being played out in space and time in Jesus's self-offering to his Father. It is hardly surprising, therefore, if much of the Christian tradition has maintained that when we speak of this divine impulse or momentum of self-giving we are speaking of the activity of the Holy Spirit. A Church of England report ventures that the Spirit can be spoken of as "that by virtue of which God is an everlasting movement of *giving away*"[37]—otherwise put, the bearer of God's inexhaustibility.

There are undoubtedly currents within the New Testament that make fresh sense in this light. In Luke's Gospel in particular, the Spirit as the life-giving power of God is the agent of Jesus's conception (Luke 1:35)—the coming of Jesus is the climactic outgoing act to renew and reestablish the people of God. In turn, the Spirit is presented as witnessing to and enabling Jesus's response to his Father. It is the Spirit (particularly in Luke and Acts) who empowers Jesus at every point to say yes to his Father, to resist temptation, and to heal the sick—in short, to be outwardly directed for the sake of the other. It is this same Spirit who is bestowed *by* the ascended Son; the Spirit of Pentecost generates communion (*koinōnia*), enabling the followers of Jesus to embody the other-oriented life of the new cross-cultural community that God brings to birth (Acts 2:42–47). Paul evokes something of the same when he writes of the Spirit liberating believers to be children of God, through Christ addressing God as "Abba" (Rom. 8:15; see also Gal. 4:4–6), a pattern congruent with

34. I hope, of course, despite the way I structure this chapter, that I am not myself falling into this trap.

35. E.g., Job 33:4; Ps. 104:30.

36. Schweizer, *Good News according to Luke*, 66.

37. Church of England Doctrine Commission, *We Believe in the Holy Spirit*, 67, italics original. The Spirit, the report continues, "is what makes the Father-Son relationship itself possible. . . . The Father gives life to the Son, the Father and the Son give their life to the world, the creation gives itself in praise to the Father through the Son; and what makes this one single act of God's love is the unity of the Holy Spirit, working in both divine and created love" (p. 67).

what we have met already: to come to faith is to participate in the mutual love of Son and Father. We are invited to "abide" by the Spirit in an environment of giving away, whose energy impels us to give ourselves in love to one another.

The Spirit, so conceived, is thus not in the business of closing circles, wrapping things up. Rather the Spirit, so to speak, ensures that the Father-Son relation is not one of inwardly turned self-absorption. "God is no lonely monad or self-absorbed tyrant, but one whose orientation to the other is intrinsic to his eternal being as God. . . . The Spirit, we might say, is the motor of that divine movement outwards."[38] To affirm that the Father loves the Son and the Son loves the Father "in" or "by" the Spirit, or that the eternal generation of the Son by the Father is "in" or "by" the Spirit, or indeed that the Spirit eternally proceeds from the Father and Son, is to throw this momentum into relief. Hence the Spirit radically unsettles the kind of misshapen love that finds its object and attempts to possess it in an exclusive, one-on-one, controllable partnership.[39]

At the same time, the Spirit does not erase particularity, but enables, establishes, and ensures it: in the economy of salvation, the Spirit brings about ever new iterations of what has already been secured in Christ. The Spirit does not collapse (reduce!) the mutual presence of Father and Son into an undifferentiated singularity; likewise, human persons caught up in the life of the Spirit are empowered to be distinctively themselves *as* they are drawn deeper into *koinōnia* with others.[40]

Kenōsis *and Deflected Desire*

The territory I am mapping here with respect to the Holy Spirit has been traversed by many in recent years. It is worth pausing to consider one of the

38. Gunton, *Father, Son, and Holy Spirit*, 86.

39. This is the kind of "closed" pattern that needs avoiding if we affirm (as, with Augustine, I believe we can) that the Spirit is the "bond of love" between Father and Son. Much depends on elucidating *how* the Spirit might exercise this role.

40. This almost inevitably raises the question of how we are to understand the ancient doctrine of *theōsis* (or "divinization") as applied to the reconstitution of humanity in relation to God. To say the least, the term has become "theologically plastic" (Macaskill, *Union with Christ*, 25). Here I can only register the reading I find most consistent with the kind of theological ontology (especially Christology) I am outlining here—namely, that being "participants of the divine nature" (2 Pet. 1:4) is not a matter of the elevation of the creaturely to divine status but of being attuned *as creatures* to the Son's dynamic relation to the Father, an attunement that comes about through the agency of the Holy Spirit. We are analogically patterned by the Spirit, we might say, after the ecstatic love of the incarnate Son for the Father, which is itself a response to the Father's eternal love for the Son. For a helpful and detailed recent treatment of the theme, see Davison, *Participation in God*; or Gorman, *Participating in Christ*.

most striking of these traversals, to be found in the work of Rowan Williams. Like many who are concerned to articulate the notion of divine self-giving, Williams cites the theme of *kenōsis*: Christ Jesus "emptied [*ekenōsen*] himself, taking the form of a slave" (Phil. 2:7). Biblical scholars will be quick to point out that the apostle Paul is less concerned in Philippians 2 with the divine metaphysics of self-giving than with the down-to-earth business of congregational life, with fostering an other-centered humility that comes about as a result of God working within the church (2:13). But we can legitimately ask: What is implied here about the God who works in this way? For Williams—and here he follows many recent writers on the topic—divine *kenōsis* is not a matter of self-evacuation, shrinkage, or withdrawal; applied to God and God-in-Christ, it speaks of a fullness of self-dispossessive life springing from an inexhaustible plenitude. Williams's allusion to John 5:26[41] in the following quotation is telling:

> The self-emptying we speak about in the life of God the Holy Trinity is always life-giving gift. To put it in very simple terms: the Father doesn't "empty himself" in generating the Son because that's what he wants to do in the abstract; he empties *life* into the *life* of the Son, declaring (as it were) to the Son: "I am nothing and have nothing that is not for you." The Son, in eternity and time, says to the Father: "I am nothing and I have nothing that is not for you." The Spirit declares to us, lives out in us: "I am nothing but the witness that gives you, carries you, into the relationship between Father and Son."[42]

The "emptying" enabled in us as we are adopted by the Spirit will thus take the form of being freed from the desire to contain or own the other, to treat the other as the end point of our own desire—from the centripetal urge that makes us want to pull things inward. And it is, of course, in Christ himself— the incarnate Son of the Father, alive in the Spirit—that we see the supreme enactment of such a *kenōsis*.[43]

41. "For just as the Father has life in himself, so he has granted the Son also to have life in himself."

42. Williams, "Conclusion," 231–40, italics original.

43. "Kenosis provides the shape of the self's constructions, just as it provides the shape of ecclesial practice and history, and, indeed human sociality and history, as each of these is, for Williams, an instance of God's life working itself out in the other. Each of these takes a kenotic shape because kenosis is the shape of God's own life" (Green, "Kenosis and Ascent," 169). Bruce McCormack's major study of *kenōsis* in Christology reached me too late to consider it in depth in this book, but some of its trajectories appear to be similar to my own. See McCormack, *Humility of the Eternal Son.*

In his article "The Deflections of Desire: Negative Theology in Trinitarian Disclosure," Williams relates this kenotic theology to the apophatic tradition, with its rigorous disciplines of negation, of un-thinking and un-speaking.[44] He argues that we should not imagine any kind of a hinterland "behind" the trinitarian persons, an inaccessible divine essence or *ousia* more ontologically primordial than the relatedness-in-love of Father, Son, and Spirit.[45] Rather, apophasis is to be understood according to the patterns played out for us in the economy of salvation—and, moreover, as shared in and lived out by the church. (Apophasis is not merely a conceptual or linguistic move for Williams, but also an ethic.) We require therefore a "negative theology of the trinitarian life that derives its negative character not from general and programmatic principles about the ineffability of the divine nature, but from the character of the relations enacted in the story of Jesus and thus also in the lives and life-patterns of believers."[46] In other words, in the last resort, it is only through God's self-presentation as triune that we will discover what it is that needs negating.

What, then, is apophatic about these trinitarian relations, and how might this relate to the work of the Spirit? Citing writings of St. John of the Cross, Williams elaborates on a movement he calls the "deflection of desire." The term *desire* (Gk. *eros*), though obviously open to misunderstanding (in that it could imply lack, or even possessiveness), can nonetheless be appropriately predicated of God, Williams believes, not least because "only such a word . . . can carry the energy of a love that is not simply a static contemplation."[47] And it is the suggestion of stasis or closure that Williams is eager to avoid. "The eros of the created self for God, understood as the longing for communion with the Word, is a desire not for the Word or Son as terminus of prayer and love, but *a desire for the desire of the Word*—i.e. for the Word's own desire for the Father and the relation in which that desire exists, the relation we call 'filial.'"[48]

But we are not to stop there. The Son's desire for the Father is *itself* a desire for the desire of the Father, and thus for the Father's love "beyond" what is directed to the Son: "We, incorporated into [the Son's] relation to the Father, share the 'deflection' of the Son's desire towards the Father's excess of love: we

44. Williams expands on these reflections, especially with respect to Gregory Palamas and Maximus the Confessor, in "Theological World of the Philokalia 1," 102–21.

45. Williams, "Deflections of Desire," 115–17.

46. Williams, "Deflections of Desire," 133.

47. Williams, "Deflections of Desire," 126.

48. Williams, "Deflections of Desire," 119, italics original.

are taken into the movement of the Spirit."[49] That is to say, love never comes to "land" or settle down on a final goal: "The movement that is divine life or essence is not only a self-bestowal in or into the being of an other, but the overflow *beyond* that immediate other."[50] The "other" is always engaged with yet another. The climactic demonstration is Christ's own self-giving to the point of death: "On the cross, Jesus is left without any perceptible consolation or sense of support from the Father; the Father, we might say, has ceased to be in any way a graspable *other* for the subjectivity of Jesus. . . . Divine love is most free in Jesus at the moment when the Father is no longer a determinate other over against him but an absent love that *will not stand still to be consolingly viewed*."[51]

The Holy Spirit, in Williams's account, is the impetus of this deflection, the "extra" of the mutual love of Father and Son, by virtue of which God can never be conceived of as a closed circle.[52] As we are caught up in the propulsion of the Spirit we are opened to the possibility of loving the other—whether the Son, the Father, or the fellow created other—in such a way that we do not treat that other merely as a means to satiate our spiritual thirst, as an instrument of our self-realization. This is profoundly costly, for we become "the 'site' where [the] eternal movement of dispossession is being enacted."[53] This is another way of saying that to follow the Son in the Spirit is to walk in the way of the cross. Our love and desires are not simply redirected but purged and re-formed *as* they are redirected.[54]

The process is in principle ceaseless as it is played out in the world. As we are given to love God through the Spirit we are opened up in such a way that

49. Williams, "Deflections of Desire," 119.

50. Williams, "Deflections of Desire," 120, italics added. Williams invites us to see this at work in Andrei Rublev's famous icon of the hospitality of Abraham (Williams, "Deflections of Desire," 128–29).

51. Williams, "Deflections of Desire," 121. The second set of italics is mine.

52. Williams writes,

The single life of the Godhead is the going-out from self-identity into the other; that cannot be a closed mutuality (for then the other would be only the mirror of the same); the love of one for other must itself open on to a further otherness if it is not to return to the same; and only so is the divine life 'as a whole' constituted as love (rather than mutual reinforcement of identity). If so, the designation of both Spirit and divine essence as love makes sense: it is the Spirit as excess of divine love that secures the character of God-as-such. (Williams, "Deflections of Desire," 118)

See also Milbank, "Second Difference," 213–14.

53. Williams, "Deflections of Desire," 129.

54. Needless to say, this destabilizes at least *some* strongly "hierarchical" models of the Trinity, so that, as Sarah Coakley puts it, "the usual meanings of 'source' or 'foundation' in the Father mysteriously transformed—away from all false hierarchalism and remaining covert subordinationism of the Spirit" (Coakley, "Beyond the Filioque Disputes," 19).

our love is "turned" toward loving others, and in our loving others, their love is turned toward others, and so on. The operative words here are "and so on"— signaling a process that never reaches immobile closure.

Pressures and Counterpressures

It is time to pull together the strands of the last two chapters. In chapter 7, I offered the outline of an account of God's uncontainability by the world. I distinguished four senses of divine uncontainability: God cannot be circumscribed by the world's *finitude*, encompassed by *thought and language*, ruled by the world's *fallenness*, or dominated by *the will of another*. All of these are aspects of the uncontainability of love-in-action—of the covenantal, gracious commitment of the God of Israel, disclosed decisively and supremely in Jesus Christ, crucified and risen. It is *this* that the created world is unable to contain. And it is this that is let loose in the formation of a community, the church, constituted by an abundant self-giving to others, and through these others to yet others, and so on.

In this chapter I have attempted to follow these senses of uncontainability to their ground in an outwardly directed, expansive, "ex-pressing" dynamic that characterizes the vitality of God as triune, an inherently generative (and thus in due course creative) movement into which humans are drawn as they are taken up by the Spirit into the Son's eternal relation to the Father. God is not under any necessity to create, sustain, and redeem a world other than God, but God's life is nonetheless characterized by a love that is constantly on the move beyond static closure, that never operates in such a way as to contain (in the sense of "have" or "possess") the beloved. This is the love of Father for Son in the Spirit, enacted in the Son's generation, and returned in the Son's love for the Father: a love that seeks not to take life into itself but to give life *to* the other in a self-dispossessing *kenōsis* that, paradoxically, entails no loss or diminishment. The Son's generation, I suggested, finds its analogical outworking in the world's creation; the irreducible otherness and inseparability that characterizes the love-relation of Son to Father animated by the Spirit is reflected in the irreducible distinction between God and world. And I suggested that the divine impulse or momentum of self-giving is the life of the Holy Spirit, a momentum that is never to be imagined as the closing of a circle, as the returning of things to a starting point, but always as "exceeding," surpassing any static resolution or terminus.

Standing back, what should be evident now is the way this pressure contrasts sharply with the four pressures of the reductive imagination charted in the

earlier chapters, marked as they were by formidable impulses of containment. We can now expand on this, taking each of those four pressures in turn.

We highlighted first a reductive pressure toward *ontological singularity*— toward considering only one class of being as fully and genuinely real. If someone insists that "reality" is to be limited to the world as accessible to the natural scientist (as in naturalistic reductionism), then the Christian will obviously resist any such drive, for it clearly excludes the possibility of God. Against this, Christian theology affirms the reality of God and all that is not God, the Creator and the created. God has brought into being an "other" that is irreducibly distinct *from* God and yet fully real *to* God—indeed, the object of God's love. And this "making other" is not a purposeless act but one that answers analogically to God's own being. It speaks of the other-directed character of God's own life of love—issuing in and directed "outward" unconditionally to a reality other than God. Any conceptual blurring of the ontological distinction between God and the created world, any weakening of a sense of the utter contingency and dependence of the created world upon God, risks reducing the Creator to the level of creaturehood and thus conceiving of God as in some measure *subject to* the world. The goodness, integrity, and future of the created world depends on God's uncontainability.[55]

Further, recall what was said above about creation's diversity. A Christian ontology of creation resists isolating *one* type of created reality as maximally real in contrast to others, or one "level" as more fully real than others. This clearly presses against the assumption of at least some reductionists that what is irreducible must be utterly undifferentiated, without distinction of any kind. The teeming diversity of creation is not an unfortunate feature of a world whose ideal state would be one of uniform simplicity. Even a cursory reading of the opening chapters of Genesis will quickly put such an idea to rest. The diverse particulars in the created world find both their unity *and* their true relatedness to other particulars as they share through the Spirit in the life of the *Logos*, Jesus Christ. In this outlook, we should note, every created reality is fully real to God in its distinctiveness, for God is fully present in love to each and every particular: "The variety of creation is a mark of God's never-diminishing intimacy with creatures of every type rather than indicative of any variation in divine presence."[56]

55. I note also that to begin with a concept of "the real" and insist that God must be answerable to it is to make essentially the same move: to attempt to subsume God under a logically antecedent category of "the real."

56. McFarland, *From Nothing*, 79.

I spoke of a second reductive pressure, one toward *exclusionary simplicity*: the drive to contain and constrain the scope of what is worthy of attention and explanation. In chapter 4, we found that the "peculiarities" of reductionism were often to a marked degree the peculiarities of omission and absence. I noted that the Ockhamite principle that "entities should not be multiplied beyond necessity" will be of little use unless we address the question of *what drives* our exclusion of this or that entity.

The vision that begins to open up from the findings of the last two chapters is one in which the created order is characterized by an inexhaustible depth. There seems to be more to this world than we will ever be able to account for, more than could ever be fully discovered, thought, or spoken. Moreover, the world's very existence is likely to press the question "Why is there something rather than nothing?" We are not in the realm of philosophical proof here, of course, but a theological reading of this sense of "moreness" is bound to see it as arising from the sustaining presence of the infinitely living God, from the world's being upheld by a limitless plenitude of meaning and significance.

It is important to keep the eschatological thrust of this "moreness" in mind: by virtue of the re-creative activity of God, the *logoi* are on the way to their fulfillment, to a future not yet fully realized. Things are more than they are *at this moment* or *in this place*. This is not simply to claim that although we cannot perceive the fullness of something now, one day we will have a complete grasp of it. It is to say that neither in the present nor in the age to come will this kind of "grasping" perception of things be possible. For, insofar as the created world, free from death, will be given a share in God's infinite abundance, it will be given an uncontainable "expansiveness." This, I suggest, is what is evoked in the stretched, hyperbolic language of Revelation 21 and 22.

Our third reductive drive was the pressure to *permit only one, narrow epistemic stance toward the world*, one that is typically characterized by disengagement, and to insist that reality can be articulated truthfully *only in terms of one very particular type of discourse*. As far as knowledge is concerned, we saw that especially prominent in the reductionisms of late modernity is a kind of "objectivism" according to which epistemic success depends on the extent to which the knower (typically an individual) can attain a third-person, context-free, dispassionate posture toward an object. The "subjectivist" outlook marking sociocultural reductionism might initially strike us as the polar opposite, with its accent on humankind's constructive powers. However, as I suggested, this is in fact the other side of the same coin and no less

reductionist.[57] Both outlooks in their own ways take disengagement or detach-
ment as the quintessential epistemic ideal and tend to assume that any direct,
active engagement with something on our part will necessarily be distorting.
But when the scope of what is to be considered epistemologically significant
has been expanded in the ways we have suggested, we will be open to a more
generous account of knowing, one that could be characterized in terms of an
embodied trust arising from the bodily indwelling of a world we did not make,
a world "there before us."[58]

From this perspective, active faith is logically prior to distrust, and our
embeddedness in communities of tradition prior to suspicion. The sociolo-
gist Hartmut Rosa writes that "the first glimmer of awareness when we open
our eyes in the morning or awake from anesthesia . . . is the perception that
'there is something,' that *something is present.*" He adds, "Subject and world
are not the precondition of, but the result of this presence."[59] From a different
perspective, Rita Felski remarks that "the driving goal of modern thought, it
often seems, is to wrest oneself from a primordial immersion in the given,"
whereas the precondition of meaningful engagement with anything is some
form of attachment: "Even the most abstract and high-flown speculation,
even the most iconoclastic or ironic of postures, pivots on being attached to
something."[60]

All this would seem highly consonant with the christological and trinitarian
perspectives we have explored above. We note the intertwining of knowledge
and love prominent in John's Gospel: Jesus's loving knowledge of the one he
names "Abba" is grounded in the eternal Son's loving knowledge of God the
Father.[61] It is this divine mode of loving awareness and delight in the other in
which we are invited to share—analogically, in a manner appropriate to our

57. See under "Sociocultural Reductionism" in chap. 4.
58. The phrase "there before us" comes from a poem entitled "Lying" by Robert Lowry, in his
New and Collected Poems, and is picked by Roger Lundin in his study *There before Us*.
Jonathan Tran warns, "This is skepticism's threat. It schools us out of mutuality, takes us out of
life, warns us against the local and provincial, provokes the cosmopolitan. The inclination to see
problems in everything will eventually, given enough time, ruin one to everything. The default posi-
tion will become, rather than jumping in, sitting back, where critical distance becomes a point of
pride and the findings of structural analysis, academic entertainment. We will forget what critique
is *for*, an instrument for finding one's way in the world" (Tran, "Lovely Things," italics original).
59. Rosa, *Uncontrollability of the World*, 5, italics original.
60. Felski, *Hooked*, 9, 11, italics original.
61. Recall John's prologue: "No one has ever seen God. It is the only Son, himself God, who is
close to the Father's heart [*loved* by the Father], who has made him *known*" (John 1:18). We might
also consider Paul in Philippians: "And this is my prayer, that your *love* may overflow more and

finitude and creatureliness—as we come to know other persons and created things. The poles of objectivism and subjectivism begin to look less and less relevant. Although always necessarily engaged, self-involving, even passionate, love-shaped knowing is at the same time directed toward the good and integrity of the other: we trust that there is an other that has, so to speak, called us and to which we are responsible. It is not at all surprising to find some describing an account along these lines as "an epistemology of love."[62]

Of course, far more would need to be said to fill out, illustrate, and defend such an epistemology, but its basic contours have been coming into view at many points in this book. Knowing happens *within* a relation or relations, never apart from them. Crucial also is that we are material creatures, already living in and involved with a material world, dependent on communities we have found to be trustworthy.[63] According to the Christian, the practice of "critique" (necessary because of our finitude and the ever-present reality of sin) will be at its most telling and effective when it operates constructively out of a center in Christ, simply because it is only in Christ that the exposure and judgment that critique involves has been enacted for us in a way that carries at its heart forgiveness and dedication to the good of the other.[64] All knowing is partial (we are finite), liable to distortion (we are fallen), and provisional (we are always "on the way")—we "know only in part" in anticipation of the day when we will "know fully" (1 Cor. 13:12).

With this goes a questioning of some of the narrow assumptions about truth-bearing language that reductionisms typically encourage. This is especially true of naturalistic reductionism (NR), where the paradigmatic discourse for bringing any reality to truthful articulation is the third-person declarative assertion, singular in meaning, and stripped as far as possible of the multiple connotations and resonances that come with figurative speech. The theological environment we have been portraying encourages us to acknowledge a far more diverse repertoire of truthful discourse. Language's deepest *telos*, in this light, is the flourishing of relations between us, and between the

more with *knowledge* and full insight" (Phil. 1:9). Or 1 Cor. 8:2–3: "Anyone who claims to know something does not yet have the necessary knowledge, but anyone who *loves* God *is known by him.*"

62. See, e.g., Wright, *History and Eschatology*, 205–14.

63. Felski's comments about art critics are apposite here: "There is a tendency among critics to see ties *only* [as harmful]: as if the condition of being-attached were an inherent weakness or defect, as if ties served only as restraints and limits" (Felski, *Hooked*, 3, italics original).

64. "Christianity's right deployment of critique falls to its confessional mode, less critique in service of criticism and more critique in service of confession" (Tran, "Lovely Things").

world, God, and us. The point is well expressed by Kevin Vanhoozer, against the backdrop of the restrictive philosophy of language enjoined by hard-nosed "scientific" reductionists and the no-less-restrictive protocols of those deeply cynical about the capacity of language to give us trustworthy access to any state of affairs beyond itself. Vanhoozer presses for a close connection between communication and *communion*.[65] "*The design plan for language is to serve as the medium of covenantal relations with God, with others, with the world.*"[66] When the personal ontologically precedes the impersonal, there is no need for the severe linguistic straitjackets of the relentless reductionist; a wide inventory of language becomes feasible. We need only recall the multiply resonant speech of Jesus in our two Johannine passages and the variety of language employed in Scripture (e.g., metaphor, allegory, myth, historical narrative, poetic verse).

The fourth drive we delineated was that toward *control and mastery*. Reductionism's impulse toward a homogenized and homogenizing ontology; a dismissive simplicity; an epistemology bereft of a communal, embodied, and respectful engagement with the integrity of the other; and an excessively narrow view of truthful language—all of these carry heavy overtones of control. Put in theological terms: to imagine that we should do all we can to predict, manage, organize, and colonize any reality we encounter—from deserts and oceans to the person next door—is in effect to reject our creatureliness and "play God."

But with the God of Israel, and supremely in the company of Israel's Messiah, we are invited into a momentum that enables us to delight in our God-given creatureliness, to flourish as creatures through an expansive relation with this God, a momentum that takes the form of dispossession, of giving toward and giving away. To those who insist that such a thing is simply impossible in practice—that at the deepest and most determinative level we are all driven inexorably by a ceaseless, colonizing will-to-power, that James and John who longed for seats of honor at the Messiah's heavenly banquet (Mark 10:37) represent the world as it really is and always will be—the New Testament writers dare to declare that another way of living has indeed been made possible, that because of God's raising of the crucified Jesus from the dead, and us with him through the outpoured Spirit, we need not be hopelessly entrapped and ruled by

65. "Language . . . should be seen as the most important means and medium of communication and communion" (Vanhoozer, *Is There a Meaning in This Text?*, 205).

66. Vanhoozer, *Is There a Meaning in This Text?*, 206, italics original.

ever more oppressive and destructive power plays. Another mode of power has been made available to us (the Father's empowerment of the Son in the Spirit), one that has the capacity to set in motion a form of life that spirals outward, not downward, as we discover "abundantly far more [*hyperekperissou*] than all we can ask or imagine" (Eph. 3:20).

PART 3

Convergences

9

Resonances and Reverberations

Of course that old tree stood
exactly as it had and would

(but why should it seem fuller now?)
and though a man's mind might endow

even a tree with some excess
of life to which a man seems witness,

that life is not the life of men.
And that is where the joy came in.

Christian Wiman[1]

I t is time to turn the spotlight on the striking affinities between our reflec-
tions on the arts in chapter 6 and the contours of the theology opened up
in chapters 7 and 8. This will enable us to draw out some of the implica-
tions of these affinities for the ways in which the arts can be taken up in the life
and witness of the church, as well as for the enterprise of Christian theology.

Doubtless by now the reader will have noticed multiple resonances between
the artistic and theological material we have been navigating, particularly with
respect to the ways in which both display a resistance to reductive, "containing"

1. Wiman, "From a Window," in *Every Riven Thing*, 31–32. I am very grateful to Will Brewbaker
for bringing this poem to my attention.

patterns of thought and action. As far as the arts are concerned, by virtue of the
way they can "re-present" the world to us, they carry intimations of inexhaust-
ibility and overflow, of the world as possessed of an energy that ceaselessly
reaches beyond its limits. On the theological front, we explored something of
Scripture's testimony to the uncontainability of God by the world: God can-
not be circumscribed by the world's finitude, encompassed by human thought
and language, mastered by creation's fallenness, or dominated by the will of
another. Tentatively, we traced this uncontainability to a dynamic of eternal
"ex-pressiveness" within God's own triune life of love.

My use of the word *resonances* here is deliberate. In physics, resonance names
what happens when an object is subjected to regular impulses at a frequency
equal (or very close) to its natural frequency: the object will start vibrating.
As a metaphor, resonance is increasingly employed in a variety of fields,[2] and
it has an obvious fittingness for our purposes through its association with the
art of music. Common to most metaphorical uses of resonance is the notion of
one thing "setting off," or "being set off by," another. This gives rise to a num-
ber of connotations that are especially fruitful for us, not least the idea that a
resonating object is an object coming into its own, becoming more fully itself.

In this chapter I am concerned with more than noting formal parallels be-
tween the arts, on the one hand, and the uncontainable and unbounded char-
acter of God, on the other. I am especially concerned with the ways artistic
practices can resonate with God's own life as they are taken up directly into
it, and thereby come into their own—bearing witness to and mediating in a
creaturely way the counter-reductionist power of that life. I am also keen to
draw out some of the consequences of these resonances—we can call them
"reverberations"—for the practice of Christian theology. The arts, I believe,
have considerable power to help us discover, understand, and articulate the
divine pressure of uncontainable abundance we have been tracing in the previ-
ous chapters. The more we hear resonances, the more we hear reverberations.[3]

A number of clarifications are worth making. First, in what follows I am
especially concerned with giving due weight to the prevenience of divine ac-
tion. This may seem so basic a concern as to be hardly worth mentioning, but

2. The most substantial treatment in recent years is Hartmut Rosa's magisterial *Resonance: A
Sociology of the Relationship to the World*. But see also Erlmann, *Reason and Resonance*; Burdzy,
Resonance; Goldstein, "Resonance"; Felski, "Resonance and Education"; Felski, "Good Vibrations."

3. As this book was going to press, it was pointed out to me by Jonathan Anderson that the
philosopher Gaston Bachelard uses this pair of terms, referring to the "phenomenological doublet"
of *resonance* (*résonance*) and *reverberation* (*retentir*). Bachelard, *Poetics of Space*, esp. xvi, xxii–xxiii.

I have found it remarkably easy to sideline when it comes to speaking about the theological potential of the arts. "How does music reveal God?" is one of the questions I am most often asked. The problem with posing the question that way is that attention to musical phenomena—a written score, perhaps, or the causal powers of sound patterns, or the distinctive modi operandi of making and hearing music—will eclipse, or at least marginalize, God's agency in revelation and reconciliation. Certainly, any theological treatment of music needs to attend to distinctively musical phenomena (I hope that will be clear by now), but if it is to be genuinely *theological*, it can hardly afford to ignore God's prior, active presence in and to the world ("prior" meaning "in advance of any initiative or response of our own") along with the intrinsically purposive nature of that presence. Our leading question, then, is not so much "How does music reveal God?" as "How is music being drawn—or how might it be drawn—into the triune God's re-creative action in the world such that it serves to reveal something of the being and action of this God?" Or, with the particular interest of this book in mind, we might ask, "How are the arts and art-making being drawn—or how might they be drawn—into God's life such that they thereby bear witness to and mediate the uncontainable abundance of God's love-in-action?"

Much the same will apply to the way we think about human agency. So, for example, the question "How might God be involved in our artistic creativity?" gives way to "How might our artistic creativity be involved in God's?" And this shift can be applied as much to our encounter with art as to our making of it. As Murray Rae puts it, "If art is, in some cases, to be understood as a sharing in the redemptive work of Christ and as a medium of divine self-disclosure, then the agency of the Spirit will be required not just in the work's production but also in its reception. Where a work of art becomes an instrument of divine self-disclosure, it will require that the Spirit gives eyes to see and ears to hear, just as is true for the reader of Scripture, that normative instance of inspired human activity."[4] Human agency, then, in the arts (as anywhere else) comes into its own—resonates fully—as it is caught up in the liberating agency of God. And "caught up" is a key phrase here: through the arts, I am suggesting, we are given a distinctive way of participating in the gracious action of God—according to the trinitarian dynamics explored in chapters 7 and 8.

A second clarification: I will not be attempting to demonstrate the veracity of this or that Christian truth claim on the basis of a supposedly theologically

4. Rae, "Divine and Human Agency." Rae is responding to Craft, *Placemaking and the Arts*.

"neutral" inspection of an artistic practice, object, or experience. For reasons I have laid out elsewhere, I believe this kind of enterprise to be dubious at best, without for a moment denying God's active involvement in spheres where God is not explicitly acknowledged.[5] Simply put: if our theological reasoning has not been taken through the disruption and transformation that the cross and resurrection generate, it is more than possible we will have to some degree taken leave of the Christian God.[6]

For similar reasons we should be wary of thinking we can reach robust theological conclusions simply by filling in the gaps left by reductionism. To be sure, we found in chapter 2 that many reductionist schemes are unable to account for large tracts of lived experience, not least artistic experience. These failures may well push us in theological directions—and all to the good if they do. But we drew attention to reductionism's inadequacies not so that we could then simply import Christian beliefs, supplemented with a little art, to pour into the cracks. Even less was it to imply that such beliefs were logically entailed by those inadequacies. It was to make us wonder whether there might be something seriously askew about the reductionist pressures themselves, and this was to pave the way for a recognition of the radically different kind of pressure that propels the Christian gospel.

A third clarification is that what follows is provisional, the beginnings of an attempt to spell out some of the consequences of the argument of the previous chapters. I will need to be highly selective, drawing especially on music (as explained in the introduction). The aim is to stimulate the imagination, not to provide any kind of overview or comprehensive program. It may well be that another volume will follow that will draw out much more fully the material presented here.

With these clarifications in mind, we can turn to the main business of the chapter: to throw into relief and explore some of the resonances between artistic and divine uncontainable abundance, and to spell out a few of the corollaries for the ways the church involves itself both in the arts and in the enterprise of

5. Begbie, *Peculiar Orthodoxy*, chap. 7.

6. I trust it will be evident by now that the format I have adopted in this book—beginning with a scrutiny of reductionist drives, then slowly introducing theological material—is strategic, not methodological. That is to say, this work is emphatically not an attempt to provide theological "solutions" customized according to "problems" conceived and articulated through a supposedly "neutral" cultural analysis. The *ultimate* orientation throughout, and the determinative cues, are intended to be theological—and this is simply because of what I take to be entailed by the material claims of the Christian gospel.

theology. I will use the four pressures of reductionism first set out in chapter 1 to structure the discussion.

Making Other

The first reductive drive, we recall, was toward *ontological singularity*: privileging one single class of being as fully and genuinely real. We argued that the main theological counterpressure to this lies in the affirmation of the ineradicable distinction between God and world. God has freely created a reality that is irreducibly other than God and yet wholly dependent on God—a reality to which God is unconditionally committed and which is fully real *to* God. This divine making can be seen as answering analogically to the generation of otherness, the "ex-pressive" character of God's own life of love. Moreover, insofar as the created world is itself marked by a movement toward the proliferation of diversity (part of God's original and final purpose), it testifies to this momentum of "making other."

Resonant with this, we spoke of artistic making as the bringing into being of something irreducibly distinct. Both the activity and its outcome have their own modi operandi and exceed what is necessary or required, even as they are taken up into a wide range of human purposes and ends. As such, these acts of making can be seen as capable of testifying to and mediating, in a creaturely way, God's own dynamic of "making other," thereby enacting a counterpressure to the reductive drive that seeks to subsume all things under one ontological type.

Generating Otherness

I propose to begin to draw out these resonances and their reverberations by considering a figure whose work might well be heard as a unique and perhaps unsurpassed musical resistance to any aspiration toward ontological singularity: J. S. Bach (1685–1750).[7]

Many scholars have been intrigued by the presence in Bach's music of a proliferating momentum that refuses reduction to a closed or containing logic. Of special import is something that Laurence Dreyfus has argued is central to Bach's art: "invention" (*inventio*).[8] Many pianists' first introduction to Bach will

7. The material that follows in this section has appeared in various forms in other publications. See Begbie, "Created Beauty"; Begbie, *Peculiar Orthodoxy*, chap. 1; Begbie, *Music, Modernity, and God*, chap. 3.

8. Dreyfus, *Bach and the Patterns of Invention*.

be with one of his two-part "inventions."[9] The composer explains that these were designed to serve as models for "good inventions" and for "developing the same satisfactorily."[10] The term *inventio* has its roots in classical rhetoric, and by Bach's time was widely used as a metaphor for the basic musical idea, the unit of music that formed the subject matter of a piece. It could also denote the process of discovering that fundamental idea. The key for Bach, according to Dreyfus, was to find *generative* material, an idea that was capable of being "made other" in a variety of ways: "By crafting a workable idea, one unlocks the door to a complete musical work."[11] So the method of finding an invention was inseparable from thinking about how it might be developed—*elaboratio*, to use the rhetorical term—through being augmented, inverted, switched from major to minor, and so on. Many of Bach's contemporaries viewed *elaboratio* as among the dullest parts of composing, but Bach appears to have delighted in it, seeing it as crucial even when choosing his initial material. He seems to have had an almost superhuman ear for how relatively simple sets of notes would combine, cohere, and behave in different groupings. Speaking of this impulse, Dreyfus writes, "One might even be tempted to say that in Bach's works both invention and elaboration are marked by an almost equally intense mental activity. . . . In no other composer of the period does one find such a fanatical zeal directed so often toward what others considered the least interesting parts of a composition."[12]

We can highlight three interrelated features of this process, and taken together they can be seen as exemplifying the kind of "making other" we have been bringing to light in the preceding chapters. First, there is a striking combination of *radical contingency and stable consistency*. With almost any piece by Bach—although perhaps most of all in his solo instrumental works—the music will sound remarkably free of necessity. Not only does this composer constantly adapt and reshape the forms and styles he inherits from the past, but even within the constraints he sets for himself for any particular piece, we find an astonishing air of contingency. Peter Williams even uses the word "caprice" to describe this aspect of the *Goldberg Variations*.[13] And yet the music has the sound of being profoundly "right": "Each note is an unforced, unnecessary, and

9. Bach, "Inventions and Sinfonias."
10. Bach, quoted in Dreyfus, *Bach and the Patterns of Invention*, 4.
11. Dreyfus, *Bach and the Patterns of Invention*, 2.
12. Dreyfus, *Bach and the Patterns of Invention*, 22, 24.
13. Williams, *Bach*, 46.

yet wholly fitting supplement" to the one before it.[14] Bach's pieces repeatedly defy a closed order, whether mechanistic or organic,[15] and yet they are typically imbued with a deeply satisfying coherence.

Second, Bach gives us an extraordinary demonstration of *diversity as intrinsic to unity*. His celebrated skill in deriving vast amounts of music from tiny musical units enables him to display rich complexity *in* the apparently simple. In the *Goldberg Variations*, for example, one of his most intricate works for keyboard, Bach composes thirty variations on a lyrical and stately aria. After an hour and a quarter of *elaboratio*, he stipulates that the original aria be played at the end, note for note. We now hear the aria with the ineradicable memory of its multiple variations: we hear it *as* varied, full of wit and sorrow, ease and struggle. The variations are not less real than the aria; they are now integral *to* that aria. For Bach, we recall, *elaboratio* was no less substantial than the invention; if Dreyfus and others are right, Bach heard simplicity *as* elaborated simplicity.

Third, as a number of musicologists have noted, the "openness" of Bach's music may well prompt a sense of inexhaustibility and boundlessness. To take the *Goldberg Variations* again, in these there is ample evidence of mathematical sequences and symmetries, yet we find the regularities interlaced with striking and surprising irregularity.[16] Writing of a crucial point in this work, the distinguished Bach scholar John Butt comments, "Rather than coming full circle with the canon at the octave, the canons 'overshoot' with a further canon, now at the ninth. We have a sense of recurrence that could go on *ad infinitum*, but it is one in which things are somehow different at each recurrence."[17] After extensive treatments of arias and choruses from Bach's passions, Butt observes that "Bach's pursuit of the idea that each invention should imply a piece of unified substance brings consequences that could not have been predicted, so that *what seems to be an enclosed world of predetermined connections can in fact imply an infinitude of*

14. Hart, *Beauty of the Infinite*, 283.

15. Tempting as it might be to say that the variations emerge from the inventions like plants from seeds, there is in fact rarely anything organic about Bach's music—in the manner of a quasi-inevitable, smooth, continuous unfolding of an idea or motif. Dreyfus urges that such a model is far too closed and prone to the logic of necessity, suppressing the place of human agency and historical circumstance (Dreyfus, *Bach and the Patterns of Invention*, esp. chap. 6).

16. Williams, *Bach*, 46.

17. Butt, *Bach's Dialogue*, 109. Writing of a chorus in the *St. John Passion*, "Lasset uns den nich zerteilen," Butt remarks, "One could imagine that, had [Bach] chosen, he could have spun the piece out yet further, building more on the implications of the various kinks and paradoxes in the seemingly stable fugal material" (Butt, *Bach's Dialogue*, 262).

possibilities."[18] In another place, he writes, "There is something utterly radical in the way that Bach's uncompromising exploration of musical possibility opens up potentials that seem to multiply as soon as the music begins. By the joining up of the links in a seemingly closed universe of musical mechanism, a sense of infinity seems unwittingly to be evoked."[19]

Of course, none of these observations *prove* the truth of this or any other theology (not even Bach's own Lutheranism). But they do provoke a vision that is highly congruent with the dynamics unfolded in the previous two chapters: God's ways with the world are reliably faithful but not bound to a machine-like or organic necessity immanent to the world. God's own threefoldness is not the elaboration of a more real and primordial oneness; rather, it *is* divine oneness in action. Likewise, we may say, the diverse particulars of creation are not an expansion of some more basic, uniform simplicity. In David Bentley Hart's words, "*The 'theme' of creation is the gift of the whole,* committed to limitless possibilities, open to immeasurable ranges of divergence and convergence, consonance and dissonance (which always allows for the possibility of discord), and unpredictable modulations that at once restore and restate that theme."[20]

Further, insofar as there is an infinity evoked in this music, it is not the infinity of monotonous continuation or sameness but something much more akin to the infinity of proliferating novelty, to the ever new and ever more elaborate richness and bounty generated by the Holy Spirit as creation shares in God's own abundantly differentiated infinity. And this itself might be heard as a glimpse of the uncontainable novelty of the final new creation, "in which new occurrences are added but nothing passes away."[21]

This is not to imply that every church needs to deploy Bach's music regularly in its worship in order to ensure that its services give voice to an authentically Christian worldview. Nor does it mean that all church musicians worth their salt should be composing in a Bachian style; that would be to refuse the kind of "making other" that was so basic to Bach's own method. But it might well suggest that our songwriters and hymnwriters, for example, could learn much from the diverse unity that Bach so consummately achieves (especially given the commercial pressures of the Christian music industry to produce "more of the

18. Butt, *Bach's Dialogue*, 280, italics added.
19. Butt, *Bach's Dialogue*, 292.
20. Hart, *Beauty of the Infinite*, 182, italics added.
21. Bauckham, "Time and Eternity," 186.

same"). The endless fascination with this composer far beyond the boundaries of classical music should give us pause for thought, an interest we find not least among jazz musicians, with their innate interest in generating a dependable yet continually novel momentum in sound. As the legendary jazz pianist Bill Evans once said, "You can never play enough Bach."[22]

Along with these resonances, we should not miss the reverberations they bring to the theologian. There have been several recent attempts to spell out something of the way Bach can provide modes of discovery, thought, and articulation for contemporary theology—especially for imagining a trinitarian theology of the created world as the outpouring of the love of God.[23] The fashioning of an abundant order through the generation of otherness in and through time belongs to the very heart of the way Bach's (and, to some degree, most) music operates. His music does not make an assertion about overflowing abundance in the created order; it plays it out in sound. Put differently, the music *performs possibilities* for the theologian in a way that can render the extraordinary character of God's life at work in the world more conceivable, and for some, perhaps, conceivable for the first time. Indeed, it is his utterly compelling invocation of resurrection life—uncontainable, inexhaustible life—that marks Bach out among so many composers of his time. In the "Et resurrexit" from the *Mass in B Minor*, for example, the composer adds an orchestral postlude that by the conventions of his time was wholly unnecessary, gratuitous, excessive—a fitting testimony to the superabundant character of what happened on Easter Day. In the midst of a society surrounded by the brute physical reality of death, including the deaths of many members of his own family, Bach provides in sound an overspill of energy that pulls against the downward, contracting "running down" of the physical world, evoking a "running up," the life of the resurrection body to come.[24]

Enlarging

We now turn to the second drive, that of *exclusionary simplicity*. Characterized by an eagerness for simple explanations, this is the hurry to screen out or tune out what does not readily resonate with some preestablished worldview. By

22. Harder, "Surprising Influence of J. S. Bach."
23. The most laudatory example can be found in Hart, *Beauty of the Infinite*, 282–85: "Bach is the greatest of Christian theologians, the most inspired witness to the *ordo amoris* in the fabric of being" (p. 282). See also Begbie, *Peculiar Orthodoxy*, chap. 1.
24. See under "Exceeding Goodness" in chap. 7.

contrast, a theologically grounded perception of the created order encourages us to believe that there will always be *more* to be accounted for, an inexhaustibility to things that ultimately derives from the world's inability to provide its own rationale (in other words, from its openness to the living God), and that this should make us wary of over-neat, "closed" and final explanations. Resonant with this, we spoke of the multiple (though not vague or formless) allusivity that so often characterizes artworks and our encounters with them, encouraging us to see the world as an arena that always outperforms our perception of it, exceeding any attempt to grasp it comprehensively.

Among the most important of modern writers to explore and draw out these resonances is the philosopher Jacques Maritain, a figure we met briefly in chapter 7.[25] Maritain's broad Thomist Catholicism nourished a philosophy of art that proved astonishingly adaptable in the twentieth century. His impact on leading writers, painters, and musicians was extensive (among them Flannery O'Connor, Igor Stravinsky, and Georges Rouault). Although his metaphysics of art can take unusual and sometimes obscure turns,[26] many of Maritain's primary concerns converge closely with our own. We find a refusal of any stark subject-object opposition; a resistance to the kind of instrumentalism that is driven by an artist's desire to control or manipulate ("Egoism is the natural enemy of poetical activity"[27]); a stress on the need for art to move with the shape and rhythm of its medium; and the conviction that art-making is able to disclose and generate new forms of what is already "there" in things—relations and dimensions otherwise inaccessible to our off-the-cuff perception ("Creative subjectivity awakens to itself only by simultaneously awakening to Things,

25. The key works are Maritain, *Responsibility of the Artist*; Maritain, *Art and Scholasticism*; Maritain, *Creative Intuition in Art and Poetry*. For a primer, see Trapani, *Poetry, Beauty and Contemplation*.

26. In Trapani's words,

In the depths of its subjectivity, the Self enters into a "mutual entanglement" with that other vast and inexhaustible sea of splendor and intelligibility, the universe of created beings and relations, things that have their own objective, independent existence. It is these that Maritain simply calls "the Self" and "the Things." . . . The "Things" are causally sustained in existence through their participation in an act-of-existing as radiated by the *Ipsum Esse Subsistens* [the self-subsisting act of existing: God]. Through this participation, all created beings receive not only their very existence, but their aspect of mirroring and reflecting the inscrutable, unfathomable, and ineffable ocean of Divine Intelligibility. (Trapani, *Poetry, Beauty and Contemplation*, 66–67, italics original)

While I am sympathetic to Maritain's account of the "excess" characteristic of all finite things, I am not entirely convinced this is best supported by a metaphysics so strongly allied to the classical transcendentals.

27. Maritain, *Creative Intuition in Art and Poetry*, 144.

in a single process which is poetic knowledge"[28]). Especially relevant for us is Maritain's belief that art engenders a sense of the inexhaustible depth of reality, of the uncapturable mystery radiating through contingent, finite forms. I have already quoted his words: "Things are not only what they are. They ceaselessly pass beyond themselves, and give more than they have."[29] But I did not quote the follow-up: ". . . because from all sides they are permeated by the activating influx of the Prime Cause."[30] Maritain was convinced that making and engaging with art calls for nothing less than a theological apprehension of created reality. We recall lines addressed to God in Malcolm Guite's poem "Good Measure":

> Even the things within the world you make
> Give more than all they have, for they are more
> Than all they are.[31]

Along with this, we might set the no less evocative verse of Christian Wiman:

From a Window

> Incurable and unbelieving
> in any truth but the truth of grieving,
>
> I saw a tree inside a tree
> rise kaleidoscopically
>
> as if the leaves had livelier ghosts.
> I pressed my face as close
>
> to the pane as I could get
> to watch that fitful, fluent spirit
>
> that seemed a single being undefined
> or countless beings of one mind
>
> haul its strange cohesion
> beyond the limits of my vision

28. Maritain, *Creative Intuition in Art and Poetry*, 159. Maritain speaks of a "co-naturality" between Self and Things (Maritain, *Creative Intuition in Art and Poetry*, 129), what Brett David Potter calls "the intuitive sense of a connection between one's own consciousness and the mysterious participation of forms in Being itself" (Potter, "Creative Intuition after Beauty," 87).

29. Maritain, *Creative Intuition in Art and Poetry*, 127.

30. Maritain, *Creative Intuition in Art and Poetry*, 127.

31. Guite, *Parable and Paradox*, 47. See the whole poem under "The Uncontainability of the World's Meaning" in chap. 7.

over the house heavenwards.
Of course I knew those leaves were birds.

Of course that old tree stood
exactly as it had and would

(but why should it seem fuller now?)
and though a man's mind might endow

even a tree with some excess
of life to which a man seems witness,

that life is not the life of men.
And that is where the joy came in.[32]

The formal constraints of rhyming couplets[33] and the carefully crafted meta-phors summon a remarkable impression of an "excess of life" we do not and cannot set in motion (for it is "not the life of men"). This is an elevation of our perception beyond what we think of as perception's limits, defying the reductive impulse to conclude that the leaves the poet saw were "really" just birds. Hence the joy of the final line, superseding the aura of death that haunts the opening.

A Future in the Making

To explore a little more fully this sense of theological inexhaustibility af-forded by the arts, I would like to concentrate on their eschatological, or future, orientation—the way they can engender a perception of things being more than they are *at this time and place*. I touched on this in chapter 7: theologically speak-ing, not only entities within the created order but creation as a whole is directed toward a future already secured in the raising of the crucified Jesus from the dead, a future that both takes up the current conditions of the finite world and vastly surpasses them. Particulars (persons, things) here and now can be set in the light of what they will by God's grace *become*. In their own way, they are "on their way."

Unfortunately, much writing about art as a mediator of divine presence (in-cluding my own at times) has tended to lose sight of this dimension, giving the impression that God's interest is confined to a succession of "present moments" of encounter. Without denying for a moment the possibility of such discrete

32. Wiman, "From a Window," in *Every Riven Thing*, 31–32. Reprinted by permission of Far-rar, Straus and Giroux.
33. Linda Gregerson believes the couplets "crack the poem open" (Gregerson, "I Know That This Is Poetry").

epiphanies, we should also reclaim what we have said about the purposive, re-creative presence of God to a time-laden world: God is lovingly and ceaselessly active toward the created order with a view to blessing it with a new future.

It is doubtless one of the distinctive and important capacities of art that it can help us "imagine the world otherwise"[34]—or, more specifically, imagine what will be but is not yet, possible worlds that in some way will reconfigure this one. A recent study by the art historian T. J. Clark, subtitled *Painting and the Life to Come*, opens this theme up in a particularly instructive way.[35] Clark believes that the painted picture "has at its disposal kinds of intensity and disclosure, kinds of persuasiveness and simplicity, that make most feats of language by comparison seem abstract, or anxiously assertive, or a mixture of both."[36] With Christian eschatology in mind, he avers that painting "can make the vision concrete, and therefore spellbinding: persuasive and imminent as never before," providing a "mixture of the wished-for and the matter of fact."[37] With detailed commentary on, among other pieces, Veronese's *Crowning of the Virgin* and Giotto's *Joachim's Dream*, Clark highlights two features of Christian eschatological hope: first, the belief that this earthly world "might open onto another—be interrupted by it, or called to it, or visited by it and make sense at last in the light of the visitation"; and second, the belief that this world as we now know it will be "raised to a higher power, 'deified' by an energy that, though it may ultimately be a gift of God, is manifest here and now in a quickening, an intensifying, an overflowing, a supercharging of altogether human powers."[38] Clark believes that painting has the ability, "perhaps more than any other means of representation, to imagine the world transfigured—have it be entirely familiar and concrete, calling out all our established responses, but with everything in it larger or lighter than life."[39]

Insofar as this is a *theological* vision, Clark makes it clear he is unable to sign up to it.[40] He is far more intent on drawing attention to the "earthboundedness" he discerns in his chosen paintings—"the priority of the here-and-now over the imagined"[41]—even as he recognizes that they are designed to gesture

34. Smith, *Thinking in Tongues*, 84.
35. Clark, *Heaven on Earth*.
36. Clark, *Heaven on Earth*, 12.
37. Clark, *Heaven on Earth*, 12.
38. Clark, *Heaven on Earth*, 17.
39. Clark, *Heaven on Earth*, 22.
40. "Whether this other or higher realm is *true* is the wrong question" (Clark, *Heaven on Earth*, 23, italics original).
41. Clark, *Heaven on Earth*, 15.

toward something more than this world could ever deliver.[42] Clark scores best, in my view, when he highlights the dangers of presenting a vision of the End as something that can be achieved through human force. Unwittingly, he signals toward the kind of power the New Testament ascribes to Good Friday and Easter when he asks, "Could there ever be a thinking and acting directed at changing the world—at truly transforming or revolutionizing it—that did not result in 'paradise for a sect' (meaning hell for everyone else)?"[43]

Might there, then, be an artistic evocation of this world being "opened onto another" and eventually being "raised to a higher power," but not through the violent, hell-bound hubris of humans? Some compelling images come to mind. A lush portrayal of the new creation by Balinese artist Nyoman Darsane takes its cue from Revelation 22, where a perpetual stream flows from God's throne, nourishing the tree of life.[44] Darsane welcomes us into the verdant landscape of his own earthly homeland of Bali but portrays it in a richly augmented, expanded, and abundant form. We are enabled to see his world, *this* world, as blessed with "an intensifying, an overflowing, a supercharging"[45] renewal in which humans are present but by no means dominate. Or again, we might turn to the profusely colored and trinitarian *Tree of Life* by Ojibwa artist Blake Debassige.[46] But an especially potent re-presentation of the same theme—and very obviously set against a misreading of the eschaton as the product of hegemonic utopian dreams—can be seen in yet another *Tree of Life*, a sculpture commissioned by the British Museum in 2005. The tree of the new creation is here composed entirely of decommissioned weapons from the Mozambique civil war.[47] (The inclusion of AK-47s is especially pertinent, since this rifle figures in the Mozambique flag.) Isaiah declares, "They shall beat their swords into plowshares and their spears into pruning hooks" (Isa. 2:4). Indeed, they shall beat their AK-47s into the tree of life. An imprisoning present is broken open to the power of a liberating future.

42. A reviewer comments: "[Clark] wishes earthboundedness on humanity. But humans tend to walk the earth with the head leading the way, and, as a result, for much of the time we are neither on nor of the ground. This airhead species uses language to articulate prayer and dreams of flight" (Bell, "Unseen Eyes"). To my mind, the ordinariness and matter-of-factness of, say, *Joachim's Dream* need not be viewed as especially weighed down by this-worldliness. After all, this is not an eschatologically charged image of the renewal of creation, nor of something akin to the Christ's transfiguration, but of an angel's interruption of Joachim's world with a message of good news.

43. Clark, *Heaven on Earth*, 23.

44. Jones, "Jesus the Dancer, Part 7."

45. Clark, *Heaven on Earth*, 17.

46. "'Tree of Life' by Blake Debassige."

47. "*Tree of Life* (Kester)."

We can turn to music for parallel examples. The professional soprano and theologian Awet Andemicael has written of the act of singing as "a bridge between our created selves and the new creation." She speaks of performing a setting of the Sanctus ("Holy, Holy, Holy"): "It is as if the veil between this in-between place and the fully-new creation were rendered permeable."[48] Numerous studies have shown that corporate singing can, for many, act as an opening up of present conditions to a new future. Some have contended that the slave songs of the American South could well have mediated for many a foretaste of God's promised end. African American novelist Kaitlyn Greenidge writes,

> Right now, there's a lot of talk about the importance of the Black imagination. That our liberation has long rested on our ability to imagine a radically different reality than the one white people insist on. We have been engaged in this since we got here, when we had the audacity to envision a society that was not predicated on slave labor. Black people embodied this daring of imagination as we wrote and talked and sang against slavery, and as those of us who could made the leap into an unknowable future and stole away. We made that leap again, post-Emancipation, when we demanded an understanding of citizenship and worth not based on color or creed. And we have been making it ever since. . . . We are champion imaginers, usually thinking of things ten, twenty, one hundred years beyond what our masters, captors, police and jailers ever could. *When I listen to and read about the old spirituals now, I understand them to be maps of profound imagination.*[49]

This estimation of the power of song is by no means uncommon. Christopher Page notes a "narrow stream" of thought in the early church in which "the use of the [singing] voice is [regarded] as one of the principal continuities between the states of bodily life on either side of the grave."[50] Singing, it seems, could be a kind of advance performance of the final, uncontainable "new song" of the redeemed, a way of enacting a belief that Christians are a people "on their way." Likewise, Erin Lambert has documented the ways in which communal singing during the sixteenth-century European Reformations was intimately intertwined with the church's ancient belief in the resurrection of the body. Indeed, says Lambert, such singing supported a sixteenth-century conception of the embodied nature of belief itself: "Belief engaged, and began with, the body. . . . The flesh bore out one's faith, both within the world and beyond the grave. . . .

48. Andemicael, "Awet I. Andemicael, Musician," 199.
49. Greenidge, "Black Spirituals as Poetry and Resistance," italics added.
50. Page, *Christian West and Its Singers*, 49.

Early modern images focused on the body's continuity through life, death, and resurrection, linking the life one lived on earth with the body's future in the grave and beyond."[51] Integral to this, Lambert points out, was the capacity of singing to convey to the singer an awareness of their own uniqueness: "Sounding within the body that was to rise from the grave, the voice revealed much about that person. Its sound signaled the singer's gender and age; it might be weakened by weariness or illness and strengthened through practice."[52] Moreover, corporate singing could enact powerfully the communal character of faith, uniting earthly believers with one another and with the saints in heaven (something crucial during a period when the medieval church was so painfully fracturing). "The sound of many singing together was an aural representation of community: it brought unity to voices while building on their irreducible individuality."[53] In this connection, we might turn to a closely related medium: dance. Is it far-fetched to think of some forms of dance as advance echoes of the resurrected "spiritual" body of 1 Corinthians 15, as ways that a body can even now begin to "live into" its final, expansive animation by the Spirit?[54]

Examples could be multiplied many times over. But enough has been said, I hope, to show something of how art's evocation of excess—and, not least, of an excess that re-figures the present by carrying intimations of a future—can be drawn into the purposes of a God who will not be reduced or restricted by the limitations of what we can perceive here and now. For artists of faith, this should be another encouragement as to the potential of their craft: they are working with media singularly well equipped to crack open our present-bound imaginations.

And again, there are sizable reverberations for the theologian. For what the visual art, music, and dance highlighted above offer is not only a bodily rooted perception of a present charged with a future, but also a fresh discourse and a panoply of concepts that can greatly enrich our understanding and articulation of the gospel's future "charge." I have tried to develop this much further with respect to music,[55] but others have done so with regard to, for example, film, drama, and fictional literature.[56]

51. Lambert, *Singing the Resurrection*, 14–15.
52. Lambert, *Singing the Resurrection*, 15.
53. Lambert, *Singing the Resurrection*, 17.
54. See Thomas Aquinas's remarkable reflections on the agility of the glorified body: "On the Agility of the Bodies of the Blessed," in *Summa theologiae*, supplement, 84.
55. Begbie, "There Before Us."
56. For film, see Deacy, *Screening the Afterlife*. For drama, see Craigo-Snell, *Empty Church*. For literature, see Fiddes, *Promised End*.

Indwelling

The third reductive drive urged us to accept a narrow *epistemic stance* toward the world and to restrict truth-bearing *language* as far as possible to one particular variety. By contrast, I proposed that an account of our lives as physical and social agents in God's world pushes us in the direction of an "epistemology of love"—in which knowing is seen to be centrally a matter of trust, physically embodied and socially mediated. This makes it possible to acknowledge a far wider range of truth-bearing media than that permitted under typically reductionist protocols. Moreover, I suggested that our capacity for language chiefly answers not the need for description, explanation, or self-expression (vital as such language obviously is in many contexts) but for "communion," for covenantal relations—the leading purpose of God's own direct engagement with the activity of human speaking. Because it mediates realities that it can never fully encompass, truthful language use is ineluctably *open*. Articulation is never over. There is always more that could be said.

The resonances with our reflections on the arts are obviously manifold (especially in the light of our comments on aesthetic cognitivism[57]). Indeed, in some respects artistic practices might even be seen as a sort of acute case of knowledge in action,[58] for they depend intensely on tapping into the pre-reflective, bodily rooted, tacit dimension of experience that supports all our knowing. As we saw, they can set in motion multiple possibilities of meaning that are potentially unlimited (though not thereby confused or wholly indeterminate). Moreover, insofar as the art in question is verbal, our view of what is to be considered permissible and epistemically defensible language will inevitably have to broaden far beyond literal assertions.

Worlds within Worlds

It would take many volumes to begin to do justice to all the ways in which the arts can share in this momentum of knowing when it is oriented explicitly in theological directions. We will focus on just one striking recent instance, from the work of the contemporary artist Steve Prince.[59]

Prince is a native of New Orleans and steeped in that city's history, its celebrations and rituals, its pains and hopes, and—not least—its distinctive expressions

57. See under "Discovery and Understanding" in chap. 6.
58. Williams, *Grace and Necessity*, 58.
59. See "Steve Prince," *Image*, https://imagejournal.org/artist/steve-prince/.

Fig. 9.1. Steve Prince, *Job: Take Me to the Water*, 2015 Linoleum cut, 24 × 36 in.

of Christian faith. Prince's linoleum block print *Job: Take Me to the Water* (fig. 9.1) belongs to a series in which each piece of art is named after one of the thirty-nine books of the Old Testament.

The critic D. Eric Bookhardt notes Prince's "ability to elucidate inexplicable worlds within worlds."[60] The primary world in view here is the devastating aftermath of New Orleans's levees breaking under the force of Hurricane Katrina in 2005, when thousands were driven from their homes by floods and nearly two thousand perished. In the image, a couple sits together on a small stair or stoop.

60. Quoted in Prince, "Conversation with Steve Prince."

The stoop that has been such an integral part of the black migrant experience is a fitting platform for a couple whose grief lies beyond words. . . . The mystery of the home behind the door that invariably awaits is exacerbated by the X-code that marks the moment in place and time. The X-code was the sign that indicated that an official had been there and reported what was found. The sign is both strange and eerily familiar to those surveying homes in the aftermath of Katrina. The search for victims of the flood was documented in florescent spray paint near the front doors of water logged houses.[61]

The X-code thus marks out a home as located in a setting where lives have been devastated on a massive scale.[62] The linocut's title invites us to read Job's grief through this couple's agonized world, and their world through Job's grief.[63]

Other worlds intersect with these. The intimations of threat, of being poised on the edge of life, will be heightened for those who see in the man's posture echoes of Winslow Homer's celebrated painting of 1899, *The Gulf Stream*, where a man stretches across his wrecked boat, surrounded by sharks and awaiting rescue (fig. 9.2).

Further, as Prince himself explains, the premise of his Old Testament series is "that true love is like an old testament [covenant] made new each day."[64] The book of Job witnesses to the reality of restoration by the God of Israel. "Take Me to the Water" is an old and familiar song in Black churches, expressing a yearning for renewal—specifically, the longing to be baptized into the death and resurrection of Jesus.[65] In water baptism—another flood, of course, but leading to a radically different end—we are marked not by death but by a covenantal pledge of new life:

'Cause I'm going back home
I tell you I'm going back home now
Going back home

61. Valerie Sweeney Prince, "Steve Prince's Portrait of a Marriage."
62. It is worth noting that the date of the passing of Prince's mother is etched into the X-code on the wall: 6-15.
63. In this respect, there are doubtless links between this image and the Kollwitz etching we discussed in chap. 6. See fig. 6.1.
64. Prince, "Conversation with Steve Prince."
65. It may well be that it also refers to the way enslaved persons could elude their captors by diving into the water so that tracking dogs could no longer pick up their scent. (I owe this observation to Dan Train.)

Public Domain / Metropolitan Museum of Art, New York

Fig. 9.2. Winslow Homer, *The Gulf Stream*, 1899. 72 cm × 1.25 m.

Within these worlds lies another: that of marital love. This series of images is a "musing on what it has meant to be married for nearly 22 years."[66] It seeks "to explore the emotional terrain of couples carving out a space despite a contesting world, in an attempt to maintain a covenantal love within the complicated context of home."[67] Prince comments on the man holding the string of the woman's shirt: "You'll note that the guy has his fingers and is touching . . . the woman's strap of clothing. That's like he's holding on [to] the fragility of life, which is like that string, you know."[68]

Various techniques make it hard for the viewer to maintain a comfortable distance, to treat this image merely as an aesthetic object (though its aesthetic qualities undoubtedly contribute to its impact). We are being called not to observe the scene but to indwell it. The manner in which the figures fill the space and appear to be only inches away, the larger-than-life hands, the intense rendering of physical detail—all these engender a sense of a reality impinging on, even intruding into, our world. This is a reality that will not let us off the hook. There is a summons to *know* here, one that challenges any merely spectatorial gaze. At the same time, we are directed to much more than the painter's own

66. Valerie Sweeney Prince, "Steve Prince's Portrait of a Marriage."
67. Prince, "Conversation with Steve Prince."
68. Quoted in Barber, "Printmaker Steve Prince."

subjectivity. We are being confronted with concrete realities that call out to us, that compel us, among other things, to face up to the way the devastating effects of disasters like Hurricane Katrina have fallen disproportionately on New Orleans's Black citizens.

Prince also presses us to exercise our bodily "know-how," the indwelling of our flesh. Skin, muscle, and bone are foregrounded, and we note the "strident cuts that give the cloth of [the man's] clothing the feel of sinewy muscle."[69] We are being provoked to sense in bodily terms what it *feels* like to be in desperate straits, hanging on by a thread to each other—and, by implication, to God.

Musical Relating

Music is uniquely equipped to open up our understanding of the kind of bodily indwelling we are considering here, principally because it does not depend on using its notes in a denotative or "picturing" way (as a representational painting would "picture" its subject). The significance of music depends primarily on the patterned relations between its constituent notes and on the significance these patterns come to acquire as we interact through our bodies with the world of persons and things. Consequently, music is especially adept among the arts at activating and shaping that "tacit" or "subsidiary" awareness that I have said much about already.[70] The sociologist Hartmut Rosa takes this up in his massive study, *Resonance*, arguing that "the peculiar quality of music" lies not in its ability to refer to or designate objects beyond itself but "in its ability to produce a highly specific form of relating to the world. . . . Music . . . negotiates the quality of relation *itself*, whereas languages and sign systems can only ever thematize one particular relationship to or segment of the world at a time. . . . Music is the rhythms, sounds, melodies, and tones *between* self and world, even if these of course have their source in the social world and the world of things."[71] He continues, "Music affirms and potentially corrects, moderates, and modifies our relation to the world, repeatedly re-establishing it as the 'ur-relationship' from which subject and object originate."[72] Along lines similar to Rosa's, musicologist Julian Johnson has proposed that music makes possible a kind of being-in-the-world that dramatically contrasts with the "naming" and grasping so characteristic of the modern sensibility (epitomized in the language

69. Valerie Sweeney Prince, "Steve Prince's Portrait of a Marriage."
70. See under "Bodily Indwelling" in chap. 6.
71. Rosa, *Resonance*, 94, italics original.
72. Rosa, *Resonance*, 95.

of instrumentalization, domination, and possession). Music, he believes, has the capacity to free us *from* the kind of alienating relation to our physical environment that an overdependence on instrumental language brings and to free us *for* a far more fruitful indwelling of material reality.[73]

In this connection, it is worth remembering what we said in chapter 6 about the way music "resonates" with features of bodily experience that are emotionally "charged" and with features of the physical world at large (what we called the "sonic order"). We noted also the remarkable powers of music to generate interpersonal empathy, to which we might add its ability to build unity and community through mutual *entrainment*—the interpersonal synchronization of bodily movement with a beat or pulse.[74]

In short, music seems unusually capable of deploying in a particularly concentrated way that tacit form of relatedness to the world (human and nonhuman) that, I have been arguing, supports and suffuses all knowing. One setting in which this becomes especially pertinent is congregational worship. Worship, the church believes, is where God gathers God's people to retune them to God, to each other, and, indeed, to the world God has made. All I have said about music would suggest that it is a remarkably apt vehicle through which these "attunements" can occur—even if we must keep in mind that, when taken up by the Holy Spirit in worship, music's powers will be directed, shaped, and augmented in diverse and often surprising ways.

The powers of corporate song to unite disparate groups, to enable a bodily, emotionally energized awareness of and engagement with each other, are legendary, and understandably so. Recall what was said above about a current in early Christianity that held corporate song to be a bodily foretaste of the life to come, and the way communal singing during the sixteenth-century European Reformations gave expression to the church's belief in the body's final resurrection.[75] Further, as we have noted, the notion that music is in some way capable of attuning us to, and engaging us creatively with, the order of the cosmos at large is a widespread and very ancient one,[76] and it would seem to give voice

73. Johnson, "Music Language Indwelling."
74. Clayton, "What Is Entrainment?"; Tarr, "Social Bonding." For reflections on entrainment in worship, see Myrick, "Embodying the Spirit." Iain McGilchrist writes, "If language began in music, it began in . . . functions which are related to empathy and common life, not competition and division; promoting togetherness, or, as I would prefer, 'betweenness'" (McGilchrist, *Master and His Emissary*, 119).
75. See under "A Future in the Making" in chap. 9.
76. See under "Sociocultural Reductionism" in chap. 4.

to a profoundly theological intuition about our place as physical creatures in a physical cosmos. Doubtless, in worship all these attunements will require other media that do and can refer in quite specific ways (e.g., preaching), but none of that need downplay the singular theological potency of music for mediating the "in-betweenness" of self and world.

A Generous View of Language

What about the other main element of this third reductive pressure, the narrowing down of language? In the case of naturalistic reductionism, the privileged discourse was the "scientific" third-person description believed to deliver bona fide knowledge. But as we saw, reflection on the ways literary art typically operates—in poetry and fictional literature, for example—puts a huge question mark against any such restriction. The potential of literary works, for example, to become media of theological knowledge and understanding, as they are drawn by the Spirit into the movement of God's self-witness, is immense. I quoted Christian Wiman above, but I could just as well have drawn upon Gerard Manley Hopkins, George Herbert, Geoffrey Hill, Abigail Carroll, John Donne, Denise Levertov, Marilynne Robinson, T. S. Eliot—and a host of others. For those at work as artists of language, such a rich legacy should be a source of repeated exploration and reflection, especially when faced with pressures within the church to relegate literary art to the sphere of the solely subjective, ornamental, or didactic.

Resonant Knowing

Just as important as these resonances are the reverberations they can generate for the theologian. As a result of affording particular ways of knowing—especially when this knowing is explicitly theologically directed—the arts can furnish theology with strikingly appropriate language and concepts to advance its work. Here we confine ourselves to just one example, and it turns on a phenomenon we have already been appropriating (albeit in another way): resonance.[77]

Imagine a cellist trying out a new instrument: She pulls the bow across a string, and a rich sound returns. The cello's wood vibrates, ringing on momentarily after the string has stopped vibrating. She begins to play some simple

77. What follows is a revised form of my essay, "Scripture in Sound," in *Hearing and Doing the Word*.

scales, listening for the notes that sound most vivid. Sometimes the entire instrument seems to come alive. The stronger the resonance, the more the wood "calls back," the more its particular character is revealed.

The bearing of such a scenario on epistemology was drawn out many years ago in an intriguing article entitled "Resonance Realism" by mathematician John Puddefoot, expanding on themes in Michael Polanyi.[78] In our example, the player focally attends to the cello in order to find out where it is strong and where it is weak. But to do this she needs to draw on a whole range of tacit experiences: hearing musical sounds, learning how hard she needs to press the bow, playing other cellos, listening to the advice of teachers, and so on. It is *with* and *through* these subsidiaries that she gains a focal awareness of the cello. "The essential point about resonance realism," Puddefoot explains, "is that it places the central criterion of our contact with reality on the boundary between the constructed world of human sense, culture and language and the discovered world 'out there' of which we can have no direct unmediated knowledge. . . . When we 'hit the mark' something comes back to us, an echo, and we tune our theories by searching for resonances with the world that sharpen and increase the volume of that echo. It is this that gives us our sense of reality, of being on the track of the real."[79]

As a model of theologically informed knowing, this has considerable potential—especially when we have the leading themes of this book in mind. Clearly, it avoids the bogeys of a naive realism on the one hand, and of a self-enclosed subjectivism on the other. Against the former, resonance realism holds that the single criterion by which a theory or statement is to be judged is whether it produces better resonances than others. The cellist relies on her senses, her body's signals, and many years of culturally embedded training. She "indwells" these things, never achieving an unmediated "hold" or grasp on the reality of the wood. But—against subjectivism—the very fact that she goes on testing for the strength of resonance betrays her tacit assumption that she is in touch with a reality that is not infinitely malleable, that has its own irreducible integrity. Moreover, this reality has its own *life*: The wood "sounds back" to the player. The reality being disclosed is not a formless "other" being compelled to conform to some interrogation on the player's part. It declares itself according to its nature, and often in surprising ways. The dynamic here is responsive through and through.

78. Puddefoot, "Resonance Realism."
79. Puddefoot, "Resonance Realism," 31.

Further, any notion of the knower as an essentially immaterial, disengaged intellect is abjured: the model is bodily through and through. And the same goes for what might broadly be called correspondence or "naming" theories of truth. Puddefoot comments, "We do not pretend—at least, we should not pretend—that [a] tuning-fork in some sense 'corresponds' with that with which it resonates; on the contrary, we know that it bears no essential resemblance to it, only that it evokes an echo which tells us something about the intrinsic nature of the world."[80] In our example, there is no simple "match" between the sound and the wood of the cello, yet the string evokes a sound that nonetheless discloses something of the wood's own nature: the life of the wood has been "re-represented" in another mode.

Running through all this also is the implication that the activity of knowing is in principle unlimited, never finished (i.e., it is eschatologically oriented); it is not essentially about grasping, holding, containing; rather, it is about "living into" a reality that cannot be fully encompassed or contained. Polanyi writes, "This is, in fact, my definition of external reality: reality is something that *attracts our attention* by clues which harass and beguile our minds into getting ever closer to it, and which, since it owes this attractive power to its independent existence, can always manifest itself in still unexpected ways."[81]

Of course, it may be objected that resonance itself is not an art form, only a sonic phenomenon. Fair enough. But music's very sense and coherence depend on resonance. In the music of virtually every culture, judgments are commonly made regarding the aptness or dissonance of certain tones in relation to others, even though these judgments can take very different forms in different cultural settings. The fact that I have used the model of a cellist drawing a bow across strings is not incidental. As a model of knowing, resonance will likely come into its own in a musical environment.

Gaining and Losing

The pressure to *control and master* was the fourth reductive drive, and it has come to characterize much of our dealings with other persons, with the physical

80. Puddefoot, "Resonance Realism," 31.
81. Polanyi, "Unaccountable Element in Science," 13–14, italics added. Polanyi does not, of course, mean that external reality is *no more* than that which attracts our attention. His point is about externality: extra-human reality confirms its independence by attracting us. The theme of call and response has been developed philosophically by many in the phenomenological tradition, most pointedly by Jean-Louis Chrétien in *The Call and the Response*.

world at large, and indeed, with God. I have argued that, in contrast to moder-
nity's confusion of "reachability" with "controllability"[82] and to what Nora Vaage
calls the "ontology of a controllable life,"[83] to be caught up in God's threefold life
is to discover a momentum of un-grasping, a *giving toward* that challenges any
equation of self-giving with self-shrinking. This is an expansive movement of
free generosity in which the self's "resonance" is maximized, in which loss of
control can be simultaneously joyful gain. "For those who want to save their life
will lose it, and those who lose their life for my sake will find it" (Matt. 16:25;
see also 10:39). This finds its eternal wellspring in the free self-dispossession
of the Son and Father in the Spirit.

Implicit in much of what we have been finding in the arts is a profoundly
analogous momentum. While I do not for a moment want to suggest that the
artistically inclined are less prone to pathologies of control than the rest of us,
there does seem to be an energy that belongs to making and engaging art that
is dispossessive, an "unselfing" that bears more than a passing resemblance
to the humility appropriate to our relation to God—the God who refuses to
be imprisoned by the inward pull of the dominating ego. In this vein, Rowan
Williams muses, "I wonder if the point of art is to spring us from [the] trap of
being proprietorial, to loosen our chokehold on what we think we own and
understand and make us ready to learn and receive again."[84]

Within the church's life, this gain-through-loss can take a huge variety of
forms when enacted in the arts. But I can at least point to one artistic practice
that readily comes to mind, and it bears very directly on the church's worship.
In fact, worship seems an especially fitting context in which to close this section,
given that it is the "site" par excellence where the church is invited to discover
and rediscover the uncontainability of grace and the futility of thinking we are
ultimately in charge of things.

An Unbounded Rush of Gladness

We take our cue from Augustine (354–430), specifically from his exposition
of Psalm 33.[85] He comments on the psalmist's exhortation: "Sing to him a new
song; play skillfully on the strings, with loud shouts" (v. 3). What does it mean
to exult "with loud shouts"?

82. Rosa, *Uncontrollability of the World*, 57.
83. Vaage, "Living Machines," 68.
84. Williams, "Rowan Williams's Diary."
85. This is Ps. 32 in Augustine's Bible, following the Psalm numbering of the Septuagint translation.

It is to realize that words cannot communicate the song of the heart. Just so singers in the harvest, or the vineyard, or at some other arduous toil express their rapture to begin with in songs set to words; then as if bursting with a joy so full that they cannot give vent to it in set syllables, they drop actual words and break into the free melody of jubilation [*et eum in sonum iubilationis*]. The *jubilus* is a melody which conveys that the heart is in travail over something it cannot bring forth in words. And to whom does that jubilation rightly ascend, if not to God the ineffable? Truly is he ineffable whom you cannot tell forth in speech, yet we ought not to remain silent, what else can you do but jubilate? In this way the heart rejoices without words and the boundless expanse of rapture is not circumscribed by syllables.[86]

In another place, Augustine writes,

Consider, beloved ones, how people sing songs when they are making merry. . . . You know how sometimes, in between songs with words, the singers seem to overflow with a joy that the tongue is inadequate to express verbally; you know how then they let out wild whoops to give utterance to a gladness of spirit (*quemadmodum jubilant, ut per illam uocem indictur animi affectus*), since they are unable to put into words what the heart has conceived.[87]

By "jubilation" ("whoops" in this last translation) Augustine seems to have in mind an affectively charged surge of unconstrained wordless praise that overspills the capacities of speech. And this seems especially apt as a mode of praise for a God who, although within the reach of language, cannot be controlled by it.

It could well be objected that Augustine is describing not singing but a cry or shout. Yet as Carol Harrison has argued, we cannot draw a hard and fast line between these two.[88] This jubilation is clearly not everyday speech ("He most definitely has singing in mind"[89]), yet it is not a formally organized or rhythmically patterned melody. Numerous parallels to Augustine's *jubilus* have been suggested—for example, the singing of the Albigensians, the Waldensians, and the nineteenth-century Shakers.[90] As far as we can tell, it is close to

86. Augustine, *Enarrationes in Psalmos* 32(2).8. See also *Enarrationes in Psalmos* 26(2).12; 46.7; 65.2; 80.3. On this topic, see Stewart-Kroeker, "Wordless Cry of Jubilation"; Fogleman, "Becoming the Song of Christ."
87. Augustine, *Enarrationes in Psalmos* 94.3, as translated in Harrison, *On Music, Sense, Affect, and Voice*, 143.
88. Harrison, *On Music, Sense, Affect, and Voice*, 142.
89. Harrison, *On Music, Sense, Affect, and Voice*, 142.
90. Some link Augustine's *jubilus* to "melismatic" singing—the stretching of one syllable over several notes. Whatever the commonalities, we should remember that Augustine has wordless

a phenomenon familiar to charismatic or Pentecostal congregations, the sung equivalent of glossolalia: "singing in tongues" or "singing in the Spirit."[91]

Whatever its precise nature, a number of especially significant features of Augustine's glad "whoops" are worth highlighting, especially in light of our interest in modernity's reductive yearning for control. The first concerns just that: they appear to work against our will to master. The fact that this jubilation is wordless, that it has no terms that directly name specific objects we can "manage," is the essence of its power. It is no accident that Augustine speaks about it in the context of praise, for it is in praise above all—empowered by the Spirit who "gives us away"—that we honor God as uncontrollable, as the one whose love and power are not ours to manipulate.

Indeed, within corporate worship this type of song will likely release worshipers from the illusion that when they address God directly, they are the prime active agents. Those who practice this form of worship frequently speak of it as something *given*; it is not ours to engineer or run. In one place Augustine asks how we can sing the "new song" of the redeemed. "Do not worry," he assures us, for God has *granted* us this "mode of singing" (*modum cantandi*).[92] What Sarah Coakley found in her fieldwork among charismatic worshipers is relevant here: "Above all the theme of 'ceding to the Spirit' was stressed, the way in which tongues averted one's normal and natural tendency to 'set the agenda.'"[93] The same seems to be true of this ecstatic song: through it we might well be delivered from the fantasy that in worship we are in charge.

A second feature to highlight is that ecstatic song is eschatologically energized. The "new song," after all, is the song that all the saints on earth and in heaven share. Augustine's "wordless cry reflects the possibility of a kind of conformity—even if momentary—to the eternal communion with, and contemplation of, the true Word believers anticipate in heaven."[94] Along the same lines, Harrison speaks of it as "proleptic revelation of the life to come. . . . When we do ultimately hear it in the life to come, we will discover that it is the echo of a

song in mind, and that the formalization of the *jubilus* into a melisma on the final syllable of a text first appears far later than Augustine.

91. Hinck, "Heavenly Harmony"; Johansson, "Singing in the Spirit." Appeal is sometimes made in this connection to 1 Cor. 14:15, where Paul writes, "I will pray with the spirit, but I will pray with the mind also; I will sing praise with the spirit, but I will sing praise with the mind also." Rev. 19:6 is also sometimes cited: "Then I heard what seemed to be the voice of a great multitude, like the sound of many waters."

92. Augustine, *Enarrationes in Psalmos* 32(2).8.

93. Coakley, *God, Sexuality and the Self*, 173.

94. Stewart-Kroeker, "Wordless Cry of Jubilation," 81.

never-ending party, one which does not pass away, but is a festival of eternal rejoicing and praise in the eternal and transcendent God, who has always sung, and will always continue to sing, in and through us, uniting us with each other and with Himself, in joy and love."[95] Precisely because it is given, this vocal, festive future is not one we can build or oversee; its character and timing are in the hands of God, whose unconstrained love brings it into being.

Third, singing of this type is an appropriate affective response to a God who is uncontainable by language. Augustine's "jubilation" stands as a vivid and visceral signal that God is unencompassable by speech; the divine always outstrips anything that is (or could be) said. As Harrison puts it, this jubilation "arises from the struggle to articulate what is ineffable—and then, suddenly, we are set free: the *jubilus* escapes, explodes."[96] The implicit political dimensions of this should not be missed, for in contexts where language has become a means of oppressive control, it would not be surprising if forms of utterance and song that exceed conventional language could function as an effective counterforce. In an important (but strangely neglected) book, *Thinking in Tongues*,[97] James K. A. Smith argues that the irreducibility of speaking in tongues—and, by implication, singing in tongues—to philosophical and conceptual articulation is one of its greatest assets: it is ideally suited for "communities of resistance to given cultural norms and institutions."[98] It can serve "faith communities that are marginalized by the powers-that-be" and in this way become "indicative of a kind of eschatological resistance to the powers."[99] Smith's point has been backed up by substantial research, especially in relation to the postcolonial politics of language.[100] Ekaputra Tupamahu, for example, argues that "the disorder and chaotic moments brought by glossolalia potentially lead to a creation of a new space. Glossolalia serves to clear the ground for the flourishing of multiple languages."[101] In the case of

95. Harrison, *On Music, Sense, Affect, and Voice*, 146, 150–51. I will leave aside the question of whether Augustine thought language will disappear in the life to come (see Troutner, "Beyond Silence," 915n15). Earlier, I argued for the continuation of worded language in the eschaton (see under "Beyond Words" in chap. 7). But there is nothing to preclude the possibility that praise will take both worded *and* non-worded forms.

96. Harrison, *On Music, Sense, Affect, and Voice*, 145.

97. Smith, *Thinking in Tongues*, chap. 6.

98. Smith, *Thinking in Tongues*, 123.

99. Smith, *Thinking in Tongues*, 147.

100. See, e.g., Tupamahu, "Tongues as a Site of Subversion." Tupamahu believes "that the practice of speaking in tongues can be viewed as a strategic subversion and disruption of the regime of normalized language" (p. 293).

101. Tupamahu, "Tongues as a Site of Subversion," 310.

singing in tongues, there are the added dimensions of intense affective involve-
ment and empathetic awareness of others that communal singing typically
affords.

And yet, a fourth important feature of this type of singing is that it springs
from language. It is pivotal to note that Augustine never suggests that this ju-
bilation releases us from all responsibility to language (and certainly not from
responsibility to the Psalms as part of Scripture). According to Isaac Harrison
Louth, "Augustine writes that singers in jubilation turn away (*auertunt*) from
the syllables of words (*syllabis uerborum*) towards sound (*sonum jubilationis*) but
notes that the very joy (*laetitia*) which motivates them springs in the first place
from their exulting (*exsultare*) in the words of the songs (*in verbis canticorum*).
. . . There is a way in which jubilant sound burst[s] forth from the text and, at
the same time, works itself free from the text."[102] The *jubilus* in worship, in other
words, arises *from* the joy that comes through reading or hearing the words of
the Psalms. As Louth puts it, "Jubilant sound *burst*[s] *forth from the text*." The
"escape" from language this singing allows does not render the text irrelevant
or expose it as inherently distorting, but it does show that it is insufficient to
convey the enormity of the reality it engages. It is, after all, *through* the appointed
speech of the God of Israel and Jesus Christ that we discover this God to be
ineffable, and thus beyond our linguistic control.

And this of course means that Augustine's jubilant song can, as it were, flip
back on the words of the psalm and help us inhabit those words more fully,
giving us a fresh understanding of them—and, indeed, a new understanding of
the uncontrollability of the God being praised. According to Harrison, when
Augustine says that "the heart's cry of joy is its understanding,"[103] he is most likely
telling us that "it is only when we become aware that God cannot be captured
by words but can only be expressed in spontaneous, involuntary shouts of
joy, that we truly 'understand' Him."[104] Just as speaking or singing the Psalms
"orients [the believer] to the truth and provides correction to false perceptions
and judgments,"[105] so also in this spontaneous bubbling up of praise, the God of
these psalms can now be *re*-understood with the extra emotional and empathetic
intensity that corporate singing makes possible.

102. From an unpublished paper, quoted in Harrison, *On Music, Sense, Affect, and Voice*, 144n89.
103. Augustine, *Enarrationes in Psalmos* 99.3.
104. Harrison, *On Music, Sense, Affect, and Voice*, 139. I would take issue with Harrison's words
"only be expressed" here, for it seems obvious that God can *also* be expressed in language (albeit
not in such a way as to "contain" God).
105. Stewart-Kroeker, "Wordless Cry of Jubilation," 78.

All of this can serve to underline what is no doubt obvious by now: this sort of singing is drawing to a head powers that belong to all corporate singing in worship, of whatever kind, whether employing words or not—capacities that can enlarge our experience and thus our understanding of the uncontrollable grace of the triune God. The stubborn resistance of musical sound to encapsulation in words, its irritating yet wonderful refusal to be tied to determinate expression, the way in which it so often eludes our attempts to control its effects, *along with* the way it nonetheless draws on and generates bodily, affective, and empathetic connections—all this makes music a remarkably potent medium through which God can grant us a share in the abundance of God's life.

This prompts me, finally, to comment on how such singing might in turn nourish theology. In a recent article, Alex Fogleman has explored how both Augustine's musical metaphors in various works and his reflections on the new song of jubilation help him comprehend and articulate "how a human will, encompassed in time, can align with the will of an eternal God whose will is ultimately inexpressible."[106] This concrete practice can both enact theological truth and generate metaphors and concepts by which to articulate it. It is no surprise that the concept of resonance lies just below the surface here, with its connotations of noncompetitive enrichment. For Augustine, our wills are transformed through Christ in such a way that divine and human wills do not vie for the same "space" in some zero-sum game: "In this musical way of framing virtue, the question of God's grace and human effort does not emerge with the kinds of competitive notions with which it is often associated. The human will, as it learns to sing praise, almost surreptitiously aligns with the divine will as it becomes caught up in the jubilant praise of the triune God—self-abandoned, free, and overflowing with joy. . . . We might say that, for Augustine, the human will is nowhere freer than in the praise of jubilation."[107]

◆ ◆ ◆ ◆

I spend much of my time in an educational culture that longs for "programs" that can identify goals and develop clear strategies for achieving them visibly, measurably, and convincingly. Many such programs are designed to address quite specific problems, and their value is assessed entirely by the degree to which they provide solutions to these problems.

106. Fogleman, "Becoming the Song of Christ," 136.
107. Fogleman, "Becoming the Song of Christ," 150.

This book has been concerned with something much more modest. I have indeed attempted to draw attention to what amounts to a problem (indeed, a pathology in late modernity): a reductive imagination that presses toward ends that are not only self-undermining but oppressively narrow, screening out vast areas of our lived experience. And I have outlined four main reductive drives or pressures in which we see this imagination at work. By its very nature, this pathology is a malfunction of the imagination; reductionism has flourished because we have not believed there could be any other way of conceiving the world. This means that reductionism will be most powerfully challenged not, in the first instance, by any particular program but by the offering and living out of an alternative imagination of the world we inhabit—an imagination propelled by drives that move not in a reductive but in an expansive direction. This is what I have argued the arts are especially well positioned to support, by virtue of their distinctive modi operandi. In contrast to the containing pressures of reductionism, they draw on and generate a rich and uncontainable manifold of meaning. They push us toward the multiply allusive, the uncapturable.

Theological concerns, of course, have been running through all this. When viewed in the light of the uncontainability of God by the world and the "ex-pressure" of God's own triune life, the arts hold out enormous theological promise. When taken up by the grace of God's Spirit, they can serve in remarkable ways to bear witness to and mediate something of this divine abundance in and toward the world. In this chapter, I have given just a few examples of what happens when we take the resonance between divine and artistic uncontainability seriously. Not only that, I have suggested that by virtue of their counter-reductionist pressure, the arts can play a key role in the renewal of the church's life and worship, not least in helping the church rediscover the power and joy of theology—which, at root, is a matter of being caught up in the song of Christ, participating in the "moreness" of God, the uncontainable abundance of divine love-in-action.

10

Open Feast

On Michelangelo Merisi da Caravaggio's "Supper at Emmaus" (1601)[1]

I t is evening at Emmaus. Two disciples of Jesus, Cleopas and his friend, have been joined by a stranger they met on their way there. They have told the stranger how they had longed that their rabbi from Nazareth would be the one who would finally liberate Israel, that he might indeed be God's own Messiah, and that all the rumors about him rising from the dead would turn out to be true. But it is obvious now that all such hopes were groundless. As with all the other would-be saviors, this Jesus was eventually contained and overpowered by Jerusalem's religious and political authorities, sent to his death, confined to a tomb.

Caravaggio has us view the dinner table where the dejected disciples sit with their anonymous guest. But only to witness the thinnest slice of time, a fraction of a second as the stranger blesses bread before disappearing altogether from the scene: "Then their eyes were opened, and they recognized him, and he vanished from their sight" (Luke 24:31).

Everything about *Supper at Emmaus* seems to evoke uncontainability, the overspill of God-in-action. The risen Jesus can indeed be recognized, but he cannot be contained by this time and space; he cannot be held or held back.

1. Shown on the front cover of this book.

Here the "ontology of a controllable life" is well and truly ruptured. The all-encompassing drives of the reductive imagination—to identify the *one* kind of reality we can cope with, to tidy things up with neat explanations, to maintain an "objective" distance from the world, to find words that can wholly enclose the truth, and, above all, to control and master—are all met by the shattering-yet-liberating counterpressure of eternity.

An almost overwhelming energy surges out of this painting, multiply resonant and bursting into our world with a theatrical intensity. Rather than organizing each of his characters with their own appropriate space or presenting them as figures to be admired or contemplated at a distance, Caravaggio crowds them together and thrusts them toward us. The picture plane is no longer a barrier or screen between them and our world. They are not "behind" the canvas, but among us. The disciple on the left pushes himself up in thunderstruck astonishment, perhaps even jerking the chair back toward us. His elbow breaks through his worn coat sleeve. The other disciple's arms are thrown wide, and his hand seems to pierce the picture plane, as if touching us directly (the original, in London's National Gallery, has a power here that is almost impossible to reproduce or describe). They are irrepressibly alive in our space. We are treated not as observers but as would-be participants. And the disciples' sudden recognition of Jesus shown here—"then their eyes were opened, and they recognized him" (Luke 24:31)—is, of course, the knowing-in-love that belongs to, and is made possible by, God. It is a far cry from the "knowing" of those who strain to maintain their cool independence; on the contrary, here knowing brings a resonant rush of gladness.

As Christ blesses the bread, he is both close and far. His hand reaches out toward the viewer, but it is hard to quantify or measure the distance between him and the other elements of the painting. The arm of the disciple on the right fails to touch Jesus, despite what must have been a longing to embrace him. The innkeeper's shadow does not intersect in any way with Jesus. "In fact, the closer we try to get to Christ, the farther his image both as an optical and tactile representation flows away."[2] He is indeed concretely present, but he cannot be comfortably incorporated into our space. Moreover, Caravaggio renders Christ in a way that was unconventional for his time: plump, beardless, with a hint of a smile. Just as the "familiar" at first was "unfamiliar" to the disciples ("their eyes were kept from recognizing him," Luke 24:16), so the risen Christ

2. Pericolo, "Visualizing Appearance and Disappearance," 530.

is not straightforwardly identifiable by us, never an object among objects, never containable within our preformed world.

Note the precariously balanced fruit basket at the front. It is only half-held by the table, threatening to tumble over and spill its contents onto the floor—*our* floor. We see here a "virtuoso *Trompe-l'œil* sculpting of substance and shadow that creates the illusion that the object is projecting out of the canvas."[3] Moreover, the basket holds "bursting pomegranates and swollen grapes, rotting russets and radiant quince, which the artist has filled with ripeness to the core."[4] The resonances of Christ's rising from the dead (described as "first fruits" by Paul in 1 Cor. 15:20) and overflow (the basket is more than full) are surely deliberate. By contrast, the rotting apple at the front likely evokes our present human condition: decaying, running down. Jesus cannot be held by our finitude, or by our fallenness.

Note too that the words of Jesus on the road—the retelling of Israel's history around himself—are by no means forgotten. Along with the symbols of resurrection, his strange intimations of suffering are echoed in the right-hand disciple's cruciform pose. Jesus's speech is affirmed, animated, and enacted in color and gesture, and set in the context of an uncontainable pressure that no words could ever enclose.

This meal was to become the meal above all meals, the feast of the new creation in the midst of the old. At all subsequent Suppers held in Jesus's name, the fruit of the earth will never be "nothing but" fruit, the bread Jesus is about to take (partially hidden from view) never "merely" bread. Like the wine (symbolized here by grapes), it will be suffused with a life that it mediates but can never hold, immeasurably exceeding anything we could ever grasp or enclose or manage. Bread and wine will be "more than they are," give more than they have.

Here a familiar narrative is made unfamiliar, pressing against "the lethargy of custom"[5] to convey in our world the freshness of God's threefold life, a life that is eternally giving, eternally and abundantly *more*.

3. Grovier, "Supper at Emmaus."
4. Grovier, "Supper at Emmaus."
5. Coleridge, *Biographia Literaria*, 208.

Bibliography

Abrams, M. H. "From Addison to Kant: Modern Aesthetics and the Exemplary Art." In *Doing Things with Texts: Essays in Criticism and Critical Theory*, edited by Michael Fischer, 159–87. New York: Norton, 1989.

Alexander, Denis. *Genes, Determinism and God.* Cambridge: Cambridge University Press, 2017.

Allen, Brian. "Dawoud Bey Brings Viewers on an Evocative Journey along the Underground Railroad." *Art Newspaper*, January 30, 2019. https://www.theartnewspaper .com/2019/01/30/dawoud-bey-brings-viewers-on-an-evocative-journey-along-the -underground-railroad.

Alter, Robert. *The Art of Biblical Poetry.* New York: Basic Books, 1985.

Anatolios, Khaled. *Retrieving Nicaea: The Development and Meaning of Trinitarian Doctrine.* Grand Rapids: Baker Academic, 2011.

Andemicael, Awet. "Awet I. Andemicael, Musician." Interview in Begbie, Train, and Taylor, *Art of New Creation*, 197–201.

Aquinas, Thomas. *Summa theologiae.* Translated by the Fathers of the English Dominican Province. 2nd rev. ed. London: Burns, Oates, and Washbourne, 1920.

Aristotle. *The Complete Works of Aristotle: The Revised Oxford Translation.* Edited by Jonathan Barnes. 2 vols. Bollingen Series. Princeton: Princeton University Press, 1983.

Athanasius. *Discourses against the Arians.* In *Nicene and Post-Nicene Fathers.* 2nd ser., vol. 4, *St. Athanasius: Select Works and Letters.* Edited by Philip Schaff and Henry Wace. Buffalo, NY: Christian Literature, 1892.

Augustine. *The Literal Meaning of Genesis.* Translated by Edmund Hill. The Works of Saint Augustine: A Translation for the 21st Century I/13. Edited by John E. Rotelle. Hyde Park, NY: New City, 2002.

———. *St. Augustine on the Psalms, or Enarrationes in Psalmos.* 2 vols. Translated by Scholastica Hebgin and Felicitas Corrigan. Westminster, MD: Newman, 1960–61.

———. *Tractates on the Gospel of John*. In *Nicene and Post-Nicene Fathers*. 1st ser., vol. 7., *St. Augustine*. Translated by John Gibb. Edited by Philip Schaff. Buffalo, NY: Christian Literature, 1888. Revised and edited for *New Advent* by Kevin Knight. http://www .newadvent.org/fathers/1701015.htm.

Bach, J. S. "Inventions and Sinfonias." *Aufrichtige Anleitung*. Bach-Werke-Verzeichnis 772–801.

Bachelard, Gaston. *The Poetics of Space*. Translated by Maria Jolas. 1958. Reprint, Boston: Beacon, 1994.

Baker, Lynne Rudder. *Naturalism and the First-Person Perspective*. Oxford: Oxford University Press, 2013.

Ball, Philip. "Neuroaesthetics Is Killing Your Soul." *Nature*, March 22, 2013. https://doi .org/10.1038/nature.2013.12640.

Banks, Joanne. "Life as a Literary Laboratory." *Literature and Medicine* 21 (2002): 98–105.

Barber, Jamaal. "Printmaker Steve Prince: The Power of Expression." *Studio Noize*, March 31, 2021. https://www.studionoizepodcast.com/features/printmaker-steve -prince-the-power-of-expression.

Barclay, John M. G. *Paul and the Gift*. Grand Rapids: Eerdmans, 2015.

Barenboim, Daniel, and Edward W. Said. *Parallels and Paradoxes: Explorations in Music and Society*. New York: Vintage, 2004.

Barnes, Julian. *Levels of Life*. London: Vintage, 2014.

Bartel, Dietrich. *Musica Poetica: Musical-Rhetorical Figures in German Baroque Music*. Lincoln: University of Nebraska Press, 1997.

Bauckham, Richard. "Biblical Theology and the Problems of Monotheism." In *Out of Egypt: Biblical Theology and Biblical Interpretation*, edited by Craig G. Bartholomew, Mary Healy, and Karl Moller, 187–232. Carlisle, UK: Paternoster, 2004.

———, ed. *God Will Be All in All: The Eschatology of Jürgen Moltmann*. Edinburgh: T&T Clark, 1999.

———. *Gospel of Glory: Major Themes in Johannine Theology*. Grand Rapids: Baker Academic, 2015.

———. *Jesus and the God of Israel: God Crucified and Other Studies on the New Testament's Christology of Divine Identity*. Grand Rapids: Eerdmans, 2008.

———. "Time and Eternity." In Bauckham, *God Will Be All in All*, 155–226.

———. "The Trinity and the Gospel of John." In *The Essential Trinity: New Testament Foundations and Practical Relevance*, edited by Brandon Crowe and Carl R. Trueman, 83–106. London: Apollos, 2016.

———. *Tumbling into Light: Collected Poems*. Norwich, UK: Canterbury, 2022.

———. *Who Is God?* Grand Rapids: Baker Academic, 2020.

Baumberger, Christoph. "Art and Understanding: In Defence of Aesthetic Cognitivism." In *Bilder sehen: Perspektiven der Bildwissenschaft*, edited by Marc Greenlee et al., 41–67. Regensburg: Schnell & Steiner, 2013.

Begbie, Jeremy. "Created Beauty: The Witness of J. S. Bach." In *The Beauty of God: Theology and the Arts*, edited by Daniel J. Treier, Mark Husbands, and Roger Lundin, 19–44. Downers Grove, IL: InterVarsity, 2007.

———. *Music, Modernity, and God: Essays in Listening*. Oxford: Oxford University Press, 2013.

———. *A Peculiar Orthodoxy: Reflections on Theology and the Arts*. Grand Rapids: Baker Academic, 2018.

———. *Redeeming Transcendence in the Arts: Bearing Witness to the Triune God*. Grand Rapids: Eerdmans, 2018.

———. "Scripture in Sound." In *Hearing and Doing the Word: The Drama of Evangelical Hermeneutics*, edited by Daniel J. Treier and Douglas A. Sweeney, 287–301. London: Bloomsbury T&T Clark, 2021.

———. "'There Before Us': New Creation in Theology and the Arts." In Begbie, Train, and Taylor, *Art of New Creation*, 1–18.

———. *Voicing Creation's Praise: Towards a Theology of the Arts*. Edinburgh: T&T Clark, 1991.

———. "The Word Refreshed: Music and God-Talk." In *Theology, Music, and Modernity: Struggles for Freedom*, edited by Jeremy Begbie, Daniel K. L. Chua, and Markus Rathey, 358–74. Oxford: Oxford University Press, 2020.

Begbie, Jeremy, Daniel Train, and W. David O. Taylor, eds. *The Art of New Creation: Trajectories in Theology and the Arts*. Downers Grove, IL: IVP Academic, 2022.

Bell, Julian. "Unseen Eyes." Review of *Heaven on Earth: Painting and the Life to Come*, by T. J. Clark. *London Review of Books* 41, no. 3 (2019). https://www.lrb.co.uk/the -paper/v41/n03/julian-bell/unseen-eyes.

Bennema, Cornelis. "Christ, the Spirit and the Knowledge of God: A Study in Johannine Epistemology." In *The Bible and Epistemology*, edited by Mary Healy and Robin Parry, 107–33. Bletchley, UK: Paternoster, 2007.

Berryman, Sylvia. "Ancient Atomism." In *The Stanford Encyclopedia of Philosophy*. Winter 2016 ed. Edited by Edward N. Zalta. Last revised December 15, 2016. https://plato .stanford.edu/archives/win2016/entries/atomism-ancient/.

Bérubé, Michael. "The Utility of the Arts and Humanities." *Arts and Humanities in Higher Education* 2, no. 1 (2003): 23–40.

Bickle, John. *Philosophy and Neuroscience: A Ruthlessly Reductive Account*. Dordrecht: Kluwer Academic, 2003.

Bitbol, Michel. "Ontology, Matter and Emergence." *Phenomenology and the Cognitive Sciences* 6, no. 3 (2007): 293–307.

Black, Max. "Metaphor." *Proceedings of the Aristotelian Society* 55 (1954–55): 273–94.

Blackmore, Susan J. *Conversations on Consciousness: What the Best Minds Think about the Brain, Free Will, and What It Means to Be Human*. Oxford: Oxford University Press, 2006.

Blowers, Paul M. *Drama of the Divine Economy: Creator and Creation in Early Christian Theology and Piety*. Oxford: Oxford University Press, 2012.

Bockmuehl, Markus. "Resurrection." In *The Cambridge Companion to Jesus*, edited by Markus Bockmuehl, 102–18. Cambridge: Cambridge University Press, 2001.

Boden, Margaret A. *Mind as Machine: A History of Cognitive Science*. 2 vols. Oxford: Oxford University Press, 2006.

Bonds, Mark Evan. *Absolute Music: The History of an Idea*. New York: Oxford University Press, 2014.

Born, Bryan. "Literary Features in the Gospel of John: An Analysis of John 3:1–21." *Direction* 17, no. 2 (1988): 3–17.

Born, Georgina. "For a Relational Musicology: Music and Interdisciplinarity, beyond the Practice Turn." *Journal of the Royal Musical Association* 135, no. 2 (2010): 205–43.

Brand, Hilary, and Adrienne D. Chaplin. *Art and Soul: Signposts for Christians in the Arts*. Carlisle, UK: Solway, 2001.

Brooks, Cleanth. *The Second Mountain: The Quest for a Moral Life*. London: Allen Lane, 2019.

———. *The Well Wrought Urn: Studies in the Structure of Poetry*. New York: Reynal & Hitchcock, 1947.

Budwick, Ariella. "Dawoud Bey at the Whitney." *Financial Times*, May 5, 2021. https://www.ft.com/content/eb12b261-bc21-4c39-b076-77b45af1a5db.

Burdzy, Krzysztof. *Resonance: From Probability to Epistemology and Back*. London: Imperial College Press, 2016.

Burnham, Douglas. *An Introduction to Kant's Critique of Judgement*. Edinburgh: Edinburgh University Press, 2000.

Butt, John. *Bach's Dialogue with Modernity: Perspectives on the Passions*. Cambridge: Cambridge University Press, 2010.

Callaway, Kutter. *Scoring Transcendence: Film Music as Contemporary Religious Experience*. Waco: Baylor University Press, 2013.

Calvin, John. *Institutes of the Christian Religion*. Translated by F. Battles. Philadelphia, PA: Westminster Press, 1960.

Campbell, Douglas A. *The Deliverance of God: A Rereading of Justification in Paul*. Grand Rapids: Eerdmans, 2009.

Carlson, Thomas A. "Postmetaphysical Theology." In *The Cambridge Companion to Postmodern Theology*, edited by Kevin J. Vanhoozer, 58–75. Cambridge: Cambridge University Press, 2003.

Carmichael, Calum M. "Marriage and the Samaritan Woman." *New Testament Studies* 26, no. 3 (1980): 332–46.

Carson, D. A. "John 5:26: *Crux Interpretum* for Eternal Generation." In Sanders and Swain, *Retrieving Eternal Generation*, 79–97.

———. "Understanding Misunderstandings in the Fourth Gospel." *Tyndale Bulletin* 33 (1982): 59–91.

Causadias, José M., Eva H. Telzer, and Richard M. Lee. "Culture and Biology Interplay: An Introduction." *Cultural Diversity and Ethnic Minority Psychology* 23, no. 1 (2017): 1–4.

Cavell, Stanley. *Must We Mean What We Say? A Book of Essays.* Cambridge: Cambridge University Press, 1961.

Charlton, Lauretta. "Dawoud Bey." *T Magazine,* October 19, 2020. https://www.nytimes.com/interactive/2020/10/19/t-magazine/dawoud-bey.html.

Chatterjee, Anjan. *The Aesthetic Brain: How We Evolved to Desire Beauty and Enjoy Art.* New York: Oxford University Press, 2014.

———. "What Does Aesthetic Cognitivism Really Mean, Anyway?" *Psychology Today,* January 5, 2021. https://www.psychologytoday.com/gb/blog/brain-behavior-and-beauty/202101/what-does-aesthetic-cognitivism-really-mean-anyway.

Chernavin, Georgy, and Anna Yampolskaya. "'Estrangement' in Aesthetics and Beyond: Russian Formalism and Phenomenological Method." *Continental Philosophy Review* 52, no. 1 (2019): 91–113.

Chrétien, Jean-Louis. *The Ark of Speech.* London: Routledge, 2004.

———. *The Call and the Response.* New York: Fordham University Press, 2004.

Church of England Doctrine Commission. *We Believe in the Holy Spirit.* London: Church House, 1991.

Churchland, Patricia Smith. "Epistemology in the Age of Neuroscience." *The Journal of Philosophy* 84, no. 10 (1987): 544–53.

Churchland, Paul M. *Neurophilosophy at Work.* Cambridge: Cambridge University Press, 2007.

Clark, T. J. *Heaven on Earth: Painting and the Life to Come.* London: Thames and Hudson, 2018.

———. "Interview with T. J. Clark." By Daniel Marcus and Daniel Spaulding. *Selva,* Spring 2019. https://selvajournal.org/interview-with-tj-clark/.

Clayton, Martin. "What Is Entrainment? Definition and Applications in Musical Research." *Empirical Musicology Review* 7, no. 1–2 (2012): 49–56.

Coakley, Sarah. "Beyond the Filioque Disputes: Re-assessing the Radical Equality of the Spirit through the Ascetic and Mystical Tradition." Holy Spirit Lecture, Duquesne University, Pittsburgh, PA, November 11, 2016. https://www.duq.edu/assets/Documents/theology/Holy%20Spirit%20Lecture/362230%20Theology%202016%20Holy%20Spirit%20Lecture%20Booklet%209.19%20Final.pdf.

———. *God, Sexuality and the Self: An Essay 'on the Trinity.'* Cambridge: Cambridge University Press, 2013.

Colburn, T. R., and G. M. Shute. "Metaphor in Computer Science." *Journal of Applied Logic* 6, no. 4 (2008): 526–33.

Coleridge, S. T. *Biographia Literaria.* Edited by Adam Roberts. Edinburgh: Edinburgh University Press, 2014.

Conway, Bevil R., and Alexander Rehding. "Neuroaesthetics and the Trouble with Beauty." *PLoS Biology* 11, no. 3 (2013): 1–5.

Cook, Nicholas. *Beyond the Score: Music as Performance*. Oxford: Oxford University Press, 2013.

Cording, Robert. *Finding the World's Fullness: On Poetry, Metaphor, and Mystery*. Eugene, OR: Slant, 2019.

Corradini, Antonella, and Timothy O'Connor. *Emergence in Science and Philosophy*. New York: Routledge, 2010.

Cowan, Douglas E. *Sacred Space: The Quest for Transcendence in Science Fiction Film and Television*. Waco: Baylor University Press, 2010.

Cox, Christoph. *Sonic Flux: Sound, Art, and Metaphysics*. Chicago: University of Chicago Press, 2018.

———. "Sonic Realism and Auditory Culture: A Reply to Marie Thompson and Annie Goh." *Parallax* 24, no. 2 (2018): 234–42.

Coyne, Andrew. "Behold the Literal-Minded Citizens Who Triumphed in Rewriting Our National Anthem." *National Post*, June 17, 2016. https://nationalpost.com/opinion/andrew-coyne-behold-our-most-literal-minded-citizens-who-triumphed-in-rewriting-the-national-anthem.

Craft, Jennifer Allen. "The Needy in the Gate." *The Visual Commentary on Scripture*. Accessed October 12, 2022. https://thevcs.org/dark-days/needy-gate.

———. *Placemaking and the Arts: Cultivating the Christian Life*. Downers Grove, IL: IVP Academic, 2018.

Craigo-Snell, Shannon Nichole. *The Empty Church: Theater, Theology, and Bodily Hope*. Oxford: Oxford University Press, 2014.

Crane, Tim. "Reduced to Clear." *Times Literary Supplement*, July 27, 2018. https://www.the-tls.co.uk/articles/reduced-to-clear/.

———. "The Significance of Emergence." In *Physicalism and Its Discontents*, edited by Barry Loewer and Grant Gillett, 207–24. Cambridge: Cambridge University Press, 2001.

Crane, Tim, and D. H. Mellor. "There Is No Question of Physicalism." *Mind* 99, no. 394 (1990): 185–206.

Crawford, Lawrence. "Viktor Shklovskij: Différance in Defamiliarization." *Comparative Literature* 36, no. 3 (1984): 209–19.

Crick, Francis. *The Astonishing Hypothesis: The Scientific Search for the Soul*. New York: Scribner, 1994.

Crossick, Geoffrey, and Patrycja Kaszynska, eds. *Understanding the Value of Arts and Culture: The AHRC Cultural Value Project*. Swindon, UK: Arts and Humanities Research Council, 2016.

Culpepper, R. Alan. *Anatomy of the Fourth Gospel: A Study in Literary Design*. Philadelphia: Fortress, 1983.

Cunningham, Conor. *Darwin's Pious Idea: Why the Ultra-Darwinists and Creationists Both Get It Wrong*. Grand Rapids: Eerdmans, 2010.

———. "Who's Afraid of Reductionism's Wolf? The Return of Scientia." In *Our Common Cosmos: Exploring the Future of Theology, Human Culture and Space Sciences*, edited by Zoë Lehmann Imfeld and Andreas Lehmann, 51–81. London: Bloomsbury T&T Clark, 2019.

Dahlhaus, Carl. *The Idea of Absolute Music*. Chicago: University of Chicago Press, 1989.

Davidson, Ivor J. "Christ." In *The Oxford Handbook of Reformed Theology*, edited by Michael Allen and Scott R. Swain, 446–72. Oxford: Oxford University Press, 2020.

Davies, Stephen. "Evolution." In *The Oxford Handbook of Western Music and Philosophy*, edited by Tomás McAuley, Nanette Nielsen, Jerrold Levinson, and Ariana Phillips-Hutton, 677–703. Oxford: Oxford University Press, 2020.

———. *Musical Meaning and Expression*. Ithaca, NY: Cornell University Press, 1994.

Davison, Andrew. *Participation in God: A Study in Christian Doctrine and Metaphysics*. Cambridge: Cambridge University Press, 2019.

Dawkins, Richard. *The Extended Phenotype: The Gene as the Unit of Selection*. Oxford: Freeman, 1999.

———. *River Out of Eden: A Darwinian View of Life*. New York: Basic Books, 1995.

———. *The Selfish Gene*. Oxford: Oxford University Press, 2016.

———. *Unweaving the Rainbow: Science, Delusion, and the Appetite for Wonder*. Boston: Houghton Mifflin, 1998.

Deacy, Christopher. *Screening the Afterlife: Theology, Eschatology, and Film*. London: Routledge, 2012.

Delio, Ilia. "From Metaphysics to Kataphysics: Bonaventure's 'Good' Creation." *Scottish Journal of Theology* 64, no. 2 (2011): 161–79.

Dennett, Daniel C. *Brainstorms: Philosophical Essays on Mind and Psychology*. Montgomery, VT: Bradford Books, 1978.

———. *Consciousness Explained*. Boston: Little, Brown, 1991.

Descartes, René. *Meditations on First Philosophy with Selections from the Objections and Replies*. Translated and edited by John Cottingham. Cambridge Texts in the History of Philosophy. Cambridge: Cambridge University Press, 2017.

Diffey, T. J. "Aesthetic Instrumentalism." *British Journal of Aesthetics* 22, no. 4 (1982): 337–49.

Dijksterhuis, E. J. *The Mechanization of the World Picture: Pythagoras to Newton*. Princeton: Princeton University Press, 1986.

Dissanayake, Ellen. *What Is Art For?* Seattle: University of Washington Press, 1988.

Dixon, Daisy. "The Artistic Metaphor." *Philosophy* 96, no. 1 (2021): 1–25.

Donne, John. *The Collected Poems of John Donne*. Edited by Roy Booth. Ware, UK: Wordsworth, 1994.

Downes, Stephen M. "Evolutionary Psychology." In *The Stanford Encyclopedia of Philosophy*. Fall 2018 ed. Edited by Edward N. Zalta. Last revised September 5, 2018. https://plato.stanford.edu/archives/fall2018/entries/evolutionary-psychology/.

Doyle, Andrew. "An Epidemic of Literal-Mindedness." *Spiked*, July 17, 2019. https://www.spiked-online.com/2019/07/17/an-epidemic-of-literal-mindedness/.

Dretske, Fred I. *Naturalizing the Mind*. Cambridge, MA: MIT Press, 1995.

Dreyfus, Laurence. *Bach and the Patterns of Invention*. Cambridge, MA: Harvard University Press, 2004.

Driscoll, Catherine. "Cultural Evolution and the Social Sciences: A Case of Unification?" *Biology and Philosophy* 33, no. 1–2 (2018): 7.

Dutton, Denis. *The Art Instinct: Beauty, Pleasure, and Human Evolution*. New York: Bloomsbury, 2009.

Edelstein, Dan. *The Enlightenment: A Genealogy*. Chicago: University of Chicago Press, 2010.

Elgin, Catherine Z. "Art in the Advancement of Understanding." *American Philosophical Quarterly* 39, no. 1 (2002): 1–12.

Empson, William. *The Structure of Complex Words*. London: Chatto & Windus, 1964.

Erlmann, Veit. *Reason and Resonance: A History of Modern Aurality*. New York: Zone Books, 2010.

Felski, Rita. "Good Vibrations." *American Literary History* 32, no. 2 (2020): 405–15.

———. *Hooked: Art and Attachment*. Chicago: University of Chicago Press, 2020.

———. *The Limits of Critique*. Chicago: University of Chicago Press, 2015.

———. "Resonance and Education." *On Education: Journal for Research and Debate* 3, no. 9 (2020): 1–5.

Feynman, Richard. *The Feynman Lectures on Physics*. Vol. 1. Reading, MA: Addison-Wesley, 1963.

Fiddes, Paul S. *The Promised End: Eschatology in Theology and Literature*. Oxford: Blackwell, 2000.

Fodor, Jerry A. *In Critical Condition: Polemical Essays on Cognitive Science and the Philosophy of Mind*. Cambridge, MA: MIT Press, 1998.

Fogleman, Alex. "Becoming the Song of Christ: Musical Theology and Transforming Grace in Augustine's Enarratio in Psalmum 32." *Augustinian Studies* 50, no. 2 (2019): 133–50.

Forceville, Charles. "Metaphor in Pictures and Multimodal Representations." In *The Cambridge Handbook of Metaphor and Thought*, edited by Raymond W. Gibbs Jr., 462–82. Cambridge: Cambridge University Press, 2008.

Frankish, Keith. *Illusionism: As a Theory of Consciousness*. Exeter, UK: Imprint Academic, 2017.

Fretheim, Terence E. *Exodus*. Louisville: Westminster John Knox, 2010.

Fried, Michael. "How Modernism Works: A Response to T. J. Clark." *Critical Inquiry* 9, no. 1 (1982): 217–34.

Friskics-Warren, Bill. *I'll Take You There: Pop Music and the Urge for Transcendence*. New York: Continuum, 2005.

Fuller, Michael. "Antireductionism and Theology." *Theology* 97, no. 780 (1994): 433–40.

Gamble, Christopher N., Joshua S. Hanan, and Thomas Nail. "What Is New Materialism?" *Angelaki* 24, no. 6 (2019): 111–34.

Gaut, Berys. "Art and Knowledge." In *The Oxford Handbook of Aesthetics*, edited by Jerrold Levinson. Oxford University Press Online, 2009.

———. *Art, Emotion and Ethics*. New York: Oxford University Press, 2007.

Gaventa, Beverly Roberts. "The Singularity of the Gospel Revisited." In *Galations and Christian Theology: Justification, the Gospel, and Ethics in Paul's Letter*, edited by Mark W. Elliot et al., 147–59. Grand Rapids: Baker Academic, 2014.

Gehring, Stephanie. "Attention to Suffering in the Work of Simone Weil and Käthe Kollwitz." PhD diss., Duke University, 2018.

Gibson, John. "Cognitivism and the Arts." *Philosophy Compass* 3, no. 4 (2008): 573–89.

Gilson, Étienne. *Methodical Realism*. San Francisco: Ignatius, 1990.

Glebkin, Vladimir. "A Socio-cultural History of the Machine Metaphor." *Review of Cognitive Linguistics* 11 (2013): 145–62.

Goatly, Andrew. *Washing the Brain: Metaphor and Hidden Ideology*. Discourse Approaches to Politics, Society, and Culture. Philadelphia: John Benjamins, 2007.

Goetz, Stewart, and Charles Taliaferro. *Naturalism*. Grand Rapids: Eerdmans, 2008.

Goldstein, Jürgen. "Resonance—a Key Concept in the Philosophy of Charles Taylor." *Philosophy and Social Criticism* 44, no. 7 (2018): 781–83.

Goodman, Nelson. *Ways of Worldmaking*. Hassocks, UK: Harvester, 1978.

Goodman, Steve. *Sonic Warfare: Sound, Affect, and the Ecology of Fear*. Cambridge, MA: MIT Press, 2010.

Gorman, Michael J. *Participating in Christ: Explorations in Paul's Theology and Spirituality*. Grand Rapids: Baker Academic, 2019.

Gorski, Philip S., et al. *The Post-secular in Question: Religion in Contemporary Society*. New York: New York University Press, 2016.

Graham, Gordon. "Enchantment and Transcendence: David Brown on Art and Architecture." In *Theology, Aesthetics, and Culture: Responses to the Work of David Brown*, edited by Robert MacSwain and Taylor Worley, 91–102. Oxford: Oxford University Press, 2012.

———. *Philosophy of the Arts: An Introduction to Aesthetics*. 3rd ed. New York: Routledge, 2005.

———. *The Re-enchantment of the World: Art versus Religion*. Oxford: Oxford University Press, 2007.

Grant, Roger Mathew. *Peculiar Attunements: How Affect Theory Turned Musical.* New York: Fordham University Press, 2020.

Green, Ryan. "Kenosis and Ascent: The Trajectory of the Self in the Writings of John Milbank and Rowan Williams." PhD diss., Charles Sturt University, 2017.

Greenberg, Clement. "Avant-Garde and Kitsch." *Partisan Review* 6, no. 4 (1939): 34–49. Reprinted in *Art in Theory, 1900–2000: An Anthology of Changing Ideas,* edited by Charles Harrison and Paul Wood, 539–49. Oxford: Blackwell, 2003.

Greenidge, Kaitlyn. "Black Spirituals as Poetry and Resistance." *New York Times Style Magazine,* March 5, 2021. https://www.nytimes.com/2021/03/05/t-magazine/black -spirituals-poetry-resistance.html.

Gregerson, Linda. "I Know That This Is Poetry." July 15, 2021. YouTube video, 4:39. https://www.youtube.com/watch?v=eDWZTIymjes.

Grovier, Kelly. "The Supper at Emmaus: A Coded Symbol Hidden in a Masterpiece." *BBC,* June 18, 2021. https://www.bbc.com/culture/article/20210617-the-supper-at -emmaus-a-coded-symbol-hidden-in-a-masterpiece.

Gschwandtner, Christina. "Turn to Excess: The Development of Phenomenology in Late Twentieth-Century French Thought." In *The Oxford Handbook of the History of Phenomenology,* edited by Dan Zahavi, 445–66. Oxford: Oxford University Press, 2018.

Guite, Malcolm. *Parable and Paradox: Sonnets on the Sayings of Jesus and Other Poems.* Norwich, UK: Canterbury, 2016.

Gunn, Daniel P. "Making Art Strange: A Commentary on Defamiliarization." *Georgia Review* 38, no. 1 (1984): 25–33.

Gunton, Colin E. *Father, Son, and Holy Spirit: Essays toward a Fully Trinitarian Theology.* London: T&T Clark, 2003.

Haack, Susan. "The Art of Scientific Metaphors." *Revista Portuguesa de Filosofia* 75, no. 4 (2019): 2049–66.

Hainge, Greg. *Noise Matters: Towards an Ontology of Noise.* New York: Bloomsbury Academic, 2013.

Harder, Debra Lew. "The Surprising Influence of J. S. Bach on Jazz Great Bill Evans." *WRTI,* March 18, 2018. https://www.wrti.org/arts-desk/2018-03-18/the-surprising -influence-of-j-s-bach-on-jazz-great-bill-evans.

Harris, Murray J. *The Second Epistle to the Corinthians: A Commentary on the Greek Text.* The New International Greek Testament Commentary. Grand Rapids: Eerdmans, 2005.

Harrison, Carol. *On Music, Sense, Affect, and Voice.* Reading Augustine. New York: Bloomsbury T&T Clark, 2019.

Harrison, Peter. Introduction to Harrison and Roberts, *Science without God?,* 1–18.

Harrison, Peter, and Jon H. Roberts, eds. *Science without God? Rethinking the History of Scientific Naturalism.* Oxford: Oxford University Press, 2019.

Hart, David Bentley. *The Beauty of the Infinite: The Aesthetics of Christian Truth*. Grand Rapids: Eerdmans, 2003.

———. *The Experience of God: Being, Consciousness, Bliss*. New Haven: Yale University Press, 2013.

———. *In the Aftermath: Provocations and Laments*. Grand Rapids: Eerdmans, 2009.

Hart, Trevor. "Creative Imagination and Moral Identity." *Studies in Christian Ethics* 16, no. 1 (2003): 1–13.

Hasker, William. "The Emergence of Persons." In *The Blackwell Companion to Christianity and Science*, edited by James Stump and Alan Padgett, 480–90. London: Blackwell, 2012.

Haslanger, Sally Anne. *Resisting Reality: Social Construction and Social Critique*. New York: Oxford University Press, 2012.

Hausman, Carl R. *Metaphor and Art: Interactionism and Reference in the Verbal and Nonverbal Arts*. Cambridge: Cambridge University Press, 1989.

Hays, Richard B. *Echoes of Scripture in the Gospels*. Waco: Baylor University Press, 2016.

———. *The Moral Vision of the New Testament*. New York: HarperCollins, 2007.

Heidegger, Martin. *Poetry, Language, Thought*. Translated by Albert Hofstadter. New York: Perennial Classics, 2001.

Higton, Mike. "Apophaticism Transformed." *Modern Theology* 31, no. 3 (2015): 511–16.

Hinck, Joel. "Heavenly Harmony: An Audio Analysis of Corporate Singing in Tongues." *Pneuma* 40, no. 1–2 (2018): 167–91.

Hodges, Donald A. "Music through the Lens of Cultural Neuroscience." In *The Oxford Handbook of Music and the Brain*, edited by Michael H. Thaut and Donald A. Hodges, 19–41. Oxford: Oxford University Press, 2018.

Hodgson, Derek, and Jan Verpooten. "The Evolutionary Significance of the Arts: Exploring the By-Product Hypothesis in the Context of Ritual, Precursors, and Cultural Evolution." *Biological Theory* 10, no. 1 (2015): 73–85.

Hodkinson, James, and Silke Horstkotte. "Introducing the Postsecular: From Conceptual Beginnings to Cultural Theory." *Poetics Today* 41, no. 3 (2020): 317–26.

Hopkins, Jasper. *Nicholas of Cusa on God as Not-Other: A Translation and an Appraisal of "De Li Non Aliud."* Translated by Jasper Hopkins. Minneapolis: Banning, 1987.

Horton, Michael S. *Covenant and Salvation: Union with Christ*. Louisville: Westminster John Knox, 2007.

Hoskyns, Edwyn C. *The Fourth Gospel*. London: Faber and Faber, 1940.

Hurtado, Larry W. *How on Earth Did Jesus Become a God? Historical Questions about Earliest Devotion to Jesus*. Grand Rapids: Eerdmans, 2005.

Hüttemann, Andreas, and Alan Love. "Reduction." In *The Oxford Handbook of Philosophy of Science*, edited by Paul Humphreys, 460–84. Oxford: Oxford University Press, 2015.

Hylton, Peter, and Gary Kemp. "Willard Van Orman Quine." In *The Stanford Encyclopedia of Philosophy*. Spring 2020 ed. Edited by Edward N. Zalta. Last revised February 14, 2019. https://plato.stanford.edu/archives/spr2020/entries/quine/.

Hyndman, Roger. "Point of Balance: A Lesson in 'Naming of Parts.'" *English Journal* 50, no. 8 (1961): 570–77.

"'Iron Curtain' Speech." The National Archives. https://www.nationalarchives.gov.uk /education/resources/cold-war-on-file/iron-curtain-speech/.

Irvine, Elizabeth, and Mark Sprevak. "Eliminativism about Consciousness." In *The Oxford Handbook of the Philosophy of Consciousness*, edited by Uriah Kriegel, 348–70. Oxford: Oxford University Press, 2020.

Jackson, T. Ryan. *New Creation in Paul's Letters: A Study of the Historical and Social Setting of a Pauline Concept*. Tübingen: Mohr Siebeck, 2010.

Jacobsen, Douglas, and Rhonda Hustedt Jacobsen, eds. *The American University in a Postsecular Age*. New York: Oxford University Press, 2008.

Jahme, Carole. "Richard Dawkins Wants Evolutionary Science to Be 'the New Classics.'" *The Guardian*, June 12, 2012. https://www.theguardian.com/science/blog/2012/jun /12/richard-dawkins-evolution-new-classics.

Johansson, Calvin M. "Singing in the Spirit: The Music of Pentecostals." *The Hymn* 38, no. 1 (1987): 25–29.

John Chrysostom. "Homily 58 on the Gospel of John." Patristic Bible Commentary. Accessed October 12, 2022. https://sites.google.com/site/aquinasstudybible/home /gospel-of-john-commentary/st-john-chrysostom-on-john/chapter-1/chapter-2 /chapter-3/chapter-4/chapter-5/chapter-6/chapter-7/chapter-8/chapter-9.

Johnson, Julian. "Between Sound and Structure: Music as Self-Critique." Unpublished paper delivered at Music and Philosophy, a study day at King's College, London, on February 20, 2010.

———. "Music Language Indwelling." In *Theology, Music, and Modernity: Struggles for Freedom*, edited by Jeremy Begbie, Daniel K. L. Chua, and Markus Rathey, 295–316. Oxford: Oxford University Press, 2020.

Johnston, Robert K. *God's Wider Presence: Reconsidering General Revelation*. Grand Rapids: Baker Academic, 2014.

Jones, David. *Epoch and Artist: Selected Writings*. London: Faber and Faber, 1959.

Jones, Victoria Emily. "Jesus the Dancer, Part 7: The Art of Nyoman Darsane." *Jesus Question*, March 25, 2012. https://thejesusquestion.org/2012/03/25/jesus-the-dancer -part-7-the-art-of-nyoman-darsane/.

Kane, Brian. "Sound Studies without Auditory Culture: A Critique of the Ontological Turn." *Sound Studies* 1, no. 1 (2015): 2–21.

Kaufman, Gordon D. "Reconstructing the Concept of God: De-reifying the Anthropomorphisms." In *The Making and Remaking of Christian Doctrine*, edited by Sarah Coakley and David A. Pailin, 95–115. Oxford: Clarendon, 1993.

Kessler, Frank. "Ostranenie, Innovation, and Media History." In *Ostrannenie*, edited by Annie van den Oever, 61–80. Amsterdam: Amsterdam University Press, 2010.

Kim, Sung Ho. "Max Weber." In *The Stanford Encyclopedia of Philosophy*. Summer 2021 ed. Edited by Edward N. Zalta. Last revised November 27, 2017. https://plato.stanford .edu/archives/sum2021/entries/weber/.

King, Elaine, and Caroline Waddington, eds. *Music and Empathy*. New York: Routledge, 2017.

King, Linda. "Full of Life: A Cognitive Linguistic Reading of Metaphors of Abundance in the Gospel of John." PhD diss., Brite Divinity School, 2017.

Klotman, Paul, and Mary Klotman. "Opinion: Science, Facts and Collaboration Can Save Us. A Case for Optimism in the Face of Coronavirus." *Houston Chronicle*, May 20, 2020. https://www.houstonchronicle.com/opinion/outlook/article/Opinion -Science-facts-and-collaboration-can-15280861.php.

Koester, Craig R. *Symbolism in the Fourth Gospel: Meaning, Mystery, Community.* 2nd ed. Minneapolis: Fortress, 2003.

Kolodny, Niko, and John Brunero. "Instrumental Rationality." In *The Stanford Encyclopedia of Philosophy*. Spring 2020 ed. Edited by Edward N. Zalta. Last revised November 2, 2018. https://plato.stanford.edu/archives/spr2020/entries/rationality -instrumental/.

Kraft, Quentin G. "Toward a Critical Re-renewal: At the Corner of Camus and Bloom Streets." *College English* 54, no. 1 (1992): 46–63.

Kristeller, Paul O. "The Modern System of the Arts (2)." *Journal of the History of Ideas* 13, no. 1 (1952): 17–46.

Lachapelle, Jean. "Cultural Evolution, Reductionism in the Social Sciences, and Explanatory Pluralism." *Philosophy of the Social Sciences* 30, no. 3 (2000): 331–61.

Lake, Christina Bieber. *Beyond the Story: American Literary Fiction and the Limits of Materialism*. Notre Dame, IN: University of Notre Dame Press, 2019.

Lakoff, George, and Mark Johnson. *Metaphors We Live By*. Chicago: University of Chicago Press, 2003.

Lambert, Erin. *Singing the Resurrection: Body, Community, and Belief in Reformation Europe*. New Cultural History of Music. New York: Oxford University Press, 2018.

Latour, Bruno, and Catherine Porter. *An Inquiry into Modes of Existence: An Anthropology of the Moderns*. Cambridge, MA: Harvard University Press, 2013.

Levenson, Jon D. *The Love of God: Divine Gift, Human Gratitude, and Mutual Faithfulness in Judaism*. Princeton: Princeton University Press, 2016.

Lincoln, Andrew T. *The Gospel according to Saint John*. London: Continuum, 2005.

Locke, John. *An Essay Concerning Human Understanding*. Edited by Peter H. Nidditch. Oxford: Clarendon, 1975.

Lowe, Walter. "Postmodern Theology." In *The Oxford Handbook of Systematic Theology*, edited by J. B. Webster, Kathryn Tanner, and Iain R. Torrance, 617–33. Oxford: Oxford University Press, 2007.

Lowry, Robert. *New and Collected Poems*. New York: Harcourt, 1988.

Lumsden, Charles J., and Edward O. Wilson. *Genes, Mind, and Culture: The Coevolutionary Process*. Cambridge, MA: Harvard University Press, 1981.

Lundin, Roger. *There before Us: Religion, Literature, and Culture from Emerson to Wendell Berry*. Grand Rapids: Eerdmans, 2007.

Macaskill, Grant. *Union with Christ in the New Testament*. Oxford: Oxford University Press, 2013.

MacKay, Donald M. *The Clockwork Image: A Christian Perspective on Science*. Leicester, UK: Inter-Varsity, 1997.

Malina, Bruce J. *The Gospel of John in Sociolinguistic Perspective*. Colloquy. Berkeley: Center for Hermeneutical Studies in Hellenistic and Modern Culture, 1985.

Mallon, Ron. "Naturalistic Approaches to Social Construction." In *The Stanford Encyclopedia of Philosophy*. Spring 2019 ed. Edited by Edward N. Zalta. Last revised January 11, 2019. https://plato.stanford.edu/archives/spr2019/entries/social-construction-naturalistic/.

Marion, Jean-Luc. "The Saturated Phenomenon." In *Phenomenology and the "Theological Turn": The French Debate*, edited by Dominique Janicaud and Jean Francois Coutine, 176–216. New York: Fordham University Press, 2000.

Maritain, Jacques. *Art and Scholasticism, with Other Essays*. London: Sheed & Ward, 1932.

———. *Creative Intuition in Art and Poetry*. Princeton: Princeton University Press, 1977.

———. *The Responsibility of the Artist*. New York: Scribner, 1960.

Marsden, George M. *The Soul of the American University Revisited: From Protestant to Postsecular*. New York: Oxford University Press, 2021.

Martyn, J. Louis. *Galatians: A New Translation with Introduction and Commentary*. New York: Doubleday, 1997.

Maximus the Confessor. *Chapters on Knowledge*. In *Maximus Confessor: Selected Writings*. Translated by George C. Berthold. New York: Paulist Press, 1985.

McCall, Thomas H. *Analytic Christology and the Theological Interpretation of the New Testament*. New York: Oxford University Press, 2021.

McCormack, Bruce L. *The Humility of the Eternal Son: "Reformed" Kenoticism and the Repair of Chalcedon*. Cambridge: Cambridge University Press, 2021.

McCrae, Shane. *In the Language of My Captor*. Wesleyan Poetry. Middletown, CT: Wesleyan University Press, 2017.

McCullough, James. "Spirituality and the Visual Arts." In *The Routledge International Handbook of Spirituality in Society and the Professions*, edited by Laszlo Zsolnai and Bernadette Flanagan, 372–79. New York: Routledge, 2019.

McDonough, Sean M. *Creation and New Creation: Understanding God's Project*. Peabody, MA: Hendrickson, 2016.

McFarland, Ian. *From Nothing: A Theology of Creation*. Louisville: Westminster John Knox, 2014.

———. "The Gift of the *Non Aliud*: Creation from Nothing as a Metaphysics of Abundance." *International Journal of Systematic Theology* 21, no. 1 (2019): 45–58.

———. "'God, the Father Almighty': A Theological Excursus." *International Journal of Systematic Theology* 18, no. 3 (2016): 259–73.

———. *The Word Made Flesh: A Theology of the Incarnation*. Louisville: Westminster John Knox, 2019.

McGilchrist, Iain. *The Master and His Emissary: The Divided Brain and the Making of the Western World*. New Haven: Yale University Press, 2012.

McGivern, Patrick, and Alexander Rueger. "Hierarchies and Levels of Reality." *Synthese* 176, no. 3 (2010): 379–97.

McInerny, Brendan Michael. *The Trinitarian Theology of Hans Urs von Balthasar: An Introduction*. Notre Dame, IN: University of Notre Dame Press, 2020.

McKerrell, Simon. "Social Constructionism in Music Studies." *Popular Music* 35, no. 3 (2016): 425–28.

McLeish, Tom. "Strong Emergence and Downward Causation in Biological Physics." *Philosophica* 92, no. 5 (2017): 113–38.

Menand, Louis. "What Comes Naturally: Does Evolution Explain Who We Are?" *New Yorker*, November 25, 2002. http://www.newyorker.com/magazine/2002/11/25/what-comes-naturally-2.

Merleau-Ponty, Maurice. *Phenomenology of Perception*. New York: Humanities, 1962.

Merton, Thomas. *No Man Is an Island*. London: Hollis & Carter, 1955.

Mesoudi, Alex. *Cultural Evolution: How Darwinian Theory Can Explain Human Culture and Synthesize the Social Sciences*. Chicago: University of Chicago Press, 2011.

Midgley, Mary. *Are You an Illusion?* Durham: Acumen, 2014.

———. *What Is Philosophy For?* London: Bloomsbury Academic, 2018.

Milbank, John. "The Second Difference: For a Trinitarianism without Reserve." *Modern Theology* 2, no. 3 (1986): 213–34.

Milliner, Matt. "Art and the Apophatic Horizon." *Psychology Today*, January 25, 2021. https://www.psychologytoday.com/gb/blog/brain-behavior-and-beauty/202101/art-and-the-apophatic-horizon.

Miłosz, Czesław. *New and Collected Poems, 1931–2001*. New York: Ecco, 2001.

Milton, John. *John Milton: The English Poems*. Edited by Laurence Lerner. Ware, UK: Wordsworth, 2004.

Moberly, R. W. L. *The God of the Old Testament: Encountering the Divine in Christian Scripture*. Grand Rapids: Baker Academic, 2020.

Molnar, Paul D. *Incarnation and Resurrection: Toward a Contemporary Understanding.* Grand Rapids: Eerdmans, 2007.

———. *Thomas F. Torrance: Theologian of the Trinity.* Farnham, UK: Ashgate, 2009.

Morley, Iain. *The Prehistory of Music: Human Evolution, Archaeology, and the Origins of Musicality.* Oxford: Oxford University Press, 2013.

Morris, S. Conway. *Life's Solution: Inevitable Humans in a Lonely Universe.* Cambridge: Cambridge University Press, 2003.

Mosès, Stéphane. *System and Revelation: The Philosophy of Franz Rosenzweig.* Detroit: Wayne State University Press, 1992.

Myrick, Nathan. "Embodying the Spirit: Toward a Theology of Entrainment." *Liturgy* 33, no. 3 (2018): 29–36.

Newbigin, Lesslie. *The Light Has Come: An Exposition of the Fourth Gospel.* Grand Rapids: Eerdmans, 1982.

Noë, Alva. *Strange Tools: Art and Human Nature.* New York: Hill and Wang, 2015.

O'Connor, Timothy, and Hong Yu Wong. "Emergent Properties." In *The Stanford Encyclopedia of Philosophy.* August 10, 2020. https://plato.stanford.edu/entries/properties-emergent/.

O'Hear, Anthony. *The Element of Fire: Science, Art and the Human World.* London: Routledge, 1988.

Oldfield, Christopher. "Who's Afraid of Naturalism?" *Pulse* 22 (2016): 22–24.

Oppenheim, Paul, and Hilary Putnam. "Unity of Science as a Working Hypothesis." *Minnesota Studies in the Philosophy of Science* 2 (1958): 3–36.

Otis, Laura. "The Metaphoric Circuit: Organic and Technological Communication in the Nineteenth Century." *Journal of the History of Ideas* 63, no. 1 (2002): 105–28.

Page, Christopher. *The Christian West and Its Singers: The First Thousand Years.* New Haven: Yale University Press, 2010.

Pannenberg, Wolfhart. *Systematic Theology.* Vol. 2. Translated by Geoffrey W. Bromiley. Edinburgh: T&T Clark, 1991.

Parsons, Craig. "Constructivism and Interpetive Theory." In *Theory and Methods in Political Science,* edited by David Marsh, Gerry Stoker, and Vivian Lowndes, 80–98. Basingstoke, UK: Palgrave Macmillan, 2010.

Peacocke, Arthur. "Reductionism: A Review of the Epistemological Issues and Their Relevance to Biology and the Problem of Consciousness." *Zygon* 11, no. 4 (1976): 307–34.

Pericolo, Lorenzo. "Visualizing Appearance and Disappearance: On Caravaggio's London 'Supper at Emmaus.'" *Art Bulletin* 89, no. 3 (2007): 519–39.

Pfau, Thomas. *Minding the Modern: Human Agency, Intellectual Traditions, and Responsible Knowledge.* Notre Dame, IN: Notre Dame University Press, 2013.

Piekut, Benjamin. "Actor-Networks in Music History: Clarifications and Critiques." *Twentieth-Century Music* 11, no. 2 (2014): 191–215.

Pigliucci, Massimo. "Between Holism and Reductionism: A Philosophical Primer on Emergence." *Biological Journal of the Linnean Society* 112 (2014): 261–67.

Pinker, Steven. *How the Mind Works.* New York: Norton, 2009.

Placher, William C. *The Domestication of Transcendence: How Modern Thinking about God Went Wrong.* Louisville: Westminster John Knox, 1996.

Plantinga, Alvin. *Where the Conflict Really Lies: Science, Religion, and Naturalism.* Oxford: Oxford University Press, 2011.

Plato. *Plato: Complete Works.* Edited by John M. Cooper. Cambridge: Hackett, 1997.

Platter, Jonathan M. "Divine Simplicity and Scripture: A Theological Reading of Exodus 3:14." *Scottish Journal of Theology* 73, no. 4 (2020): 295–306.

Polanyi, Michael. *Personal Knowledge: Towards a Post-critical Philosophy.* New York: Harper & Row, 1964.

———. *The Tacit Dimension.* New York: Doubleday, 1966.

———. "The Unaccountable Element in Science." *Philosophy* 37, no. 139 (1962): 1–14.

Polanyi, Michael, and Harry Prosch. *Meaning.* Chicago: University of Chicago Press, 1975.

Polkinghorne, John. "Reductionism." In *Interdisciplinary Encyclopedia of Religion and Science,* edited by G. Tanzella-Nitti, I. Colagé, and A. Strumia. 2002. https://inters.org/reductionism.

Potter, Brett David. "Creative Intuition after Beauty: Jacques Maritain's Philosophy of Art in the Contemporary Context." *Logos: A Journal of Catholic Thought and Culture* 21 (2018): 81–108.

Prince, Steve. "A Conversation with Steve Prince." Interview by Beth McCoy. *Image,* no. 78. https://imagejournal.org/article/web-exclusive-interview-steve-prince/.

Prince, Valerie Sweeney. "Steve Prince's Portrait of a Marriage: An Old Love Made New Every Day." *International Review of African American Art Plus.* Accessed October 10, 2022. http://iraaa.museum.hamptonu.edu/page/Steve-Prince%27s-Portrait-of-a-Marriage.

Puddefoot, John C. "Resonance Realism." *Tradition and Discovery* 20, no. 3 (1993): 29–38.

Rae, Murray. "Divine and Human Agency." *Syndicate Network,* May 19, 2020. https://syndicate.network/symposia/theology/placemaking-and-the-arts/.

Ramachandran, V. S., and William Hirstein. "The Science of Art: A Neurological Theory of Aesthetic Experience." *Journal of Consciousness Studies* 6, no. 6–7 (1999): 15–41.

Reed, Henry. *Henry Reed: Collected Poems.* Edited by Jon Stallworthy. Manchester, UK: Carcanet, 2007.

Reisenzein, Rainer. "Cognitive Theory of Emotion." In *Encyclopedia of Personality and Individual Differences,* edited by Virgil Zeigler-Hill and Todd K. Shackelford, 723–33. Cham: Springer International, 2020.

Richards, I. A. *The Philosophy of Rhetoric.* The Mary Flexner Lectures on the Humanities. London: Oxford University Press, 1936.

Ricœur, Paul. *The Rule of Metaphor: Multi-disciplinary Studies of the Creation of Meaning in Language.* Translated by Robert Czerny. Toronto: University of Toronto Press, 1977.

Robinson, Marilynne. *Absence of Mind: The Dispelling of Inwardness from the Modern Myth of the Self.* New Haven: Yale University Press, 2010.

Rookmaaker, H. R. *Modern Art and the Death of a Culture.* Carlisle, UK: Piquant, 2003.

Rosa, Hartmut. *Resonance: A Sociology of the Relationship to the World.* Medford, MA: Polity, 2019.

———. *The Uncontrollability of the World.* Translated by James C. Wagner. Cambridge: Polity, 2020.

Rosenberg, Alex. "The Disenchanted Naturalist's Guide to Reality." *National Humanities Center,* November 9, 2009. https://nationalhumanitiescenter.org/on-the-human /2009/11/the-disenchanted-naturalists-guide-to-reality/.

———. *Reduction and Mechanism.* Cambridge: Cambridge University Press, 2020.

———. *Sociobiology and the Preemption of Social Science.* Baltimore: Johns Hopkins University Press, 1980.

Rough, Robert H. "Metaphor in the Art of Vincent van Gogh." *Centennial Review* 19, no. 1 (1975): 362–79.

Ruden, Sarah. *The Face of Water: A Translator on Beauty and Meaning in the Bible.* New York: Pantheon Books, 2017.

Sanders, Fred, and Scott R. Swain, eds. *Retrieving Eternal Generation.* Grand Rapids: Zondervan, 2017.

Saner, Andrea D. *"Too Much to Grasp": Exodus 3:13–15 and the Reality of God.* Winona Lake, IN: Eisenbrauns, 2015.

Sayer, Andrew. "Reductionism in Social Science." Department of Sociology, Lancaster University. https://www.lancaster.ac.uk/fass/resources/sociology-online-papers /papers/sayer-paris1.pdf.

Schaffer, Jonathan. "Is There a Fundamental Level?" *Noûs* 37, no. 3 (2003): 498–517.

Schmalzbauer, John, and Kathleen A. Mahoney. *The Resilience of Religion in American Higher Education.* Waco: Baylor University Press, 2018.

Schweizer, Eduard. *The Good News according to Luke.* London: SPCK, 1984.

Seerveld, Calvin. *Rainbows for the Fallen World: Aesthetic Life and Artistic Task.* Toronto: Tuppence, 1980.

Shiner, Larry E. *The Invention of Art: Cultural History.* Chicago: University of Chicago Press, 2001.

Shklovsky, Victor. "Art, as Device." Translated by Aleandra Berlina. *Poetics Today* 36, no. 3 (2015): 151–74.

Shortt, Rupert. *God Is No Thing: Coherent Christianity.* London: Hirst, 2016.

Small, Christopher. *Musicking: The Meanings of Performing and Listening.* Hanover, NH: University Press of New England, 1998.

Smith, James K. A. *Thinking in Tongues: Pentecostal Contributions to Christian Philosophy.* Grand Rapids: Eerdmans, 2010.

Snævarr, Stéfan. "The Heresy of Paraphrase Revisited." *Contemporary Aesthetics* 2 (2004). http://hdl.handle.net/2027/spo.7523862.0002.008.

Sonderegger, Katherine. *Systematic Theology.* Vol. 1. Minneapolis: Fortress, 2015.

Soskice, Janet Martin. "The Gift of the Name: Moses and the Burning Bush." In *Silence and the Word: Negative Theology and Incarnation,* edited by Oliver Davies and Denys Turner, 61–75. Cambridge: Cambridge University Press, 2002.

———. *Metaphor and Religious Language.* Oxford: Clarendon, 1985.

Spade, Paul Vincent, and Claude Panaccio. "William of Ockham." In *The Stanford Encyclopedia of Philosophy.* Spring 2019 ed. Edited by Edward N. Zalta. Last revised March 5, 2019. https://plato.stanford.edu/archives/spr2019/entries/ockham/.

Spitzer, Michael. *A History of Emotion in Western Music: A Thousand Years from Chant to Pop.* New York: Oxford University Press, 2020.

Stacy, R. H. *Defamiliarization in Language and Literature.* Syracuse: Syracuse University Press, 1977.

Stewart-Kroeker, Sarah. "A Wordless Cry of Jubilation." *Augustinian Studies* 50, no. 1 (2019): 65–86.

Tallis, Raymond. *Reflections of a Metaphysical Flâneur and Other Essays.* Durham: Acumen, 2013.

Tanner, Kathryn. *Christ the Key.* Cambridge: Cambridge University Press, 2010.

———. *Christianity and the New Spirit of Capitalism.* New Haven: Yale University Press, 2019.

Tarr, Bronwyn. "Social Bonding through Dance and 'Musiking.'" In *Distributed Agency,* edited by N. J. Enfield and Paul Kockelman, 151–58. Oxford: Oxford University Press, 2017.

Taylor, Charles. *The Language Animal: The Full Shape of the Human Linguistic Capacity.* Cambridge, MA: Belknap, 2016.

———. *A Secular Age.* Cambridge, MA: Belknap, 2007.

Thalos, Mariam. *Without Hierarchy: The Scale Freedom of the Universe.* New York: Oxford University Press, 2013.

Thiselton, Anthony C. *The First Epistle to the Corinthians: A Commentary on the Greek Text.* Grand Rapids: Eerdmans, 2000.

Thompson, Andrew. Foreword to Crossick and Kaszynska, *Understanding the Value of Arts and Culture,* 4–5.

Thompson, Marianne Meye. *The God of the Gospel of John.* Grand Rapids: Eerdmans, 2001.

———. *John: A Commentary*. New Testament Library. Louisville: Westminster John Knox, 2015.

Thomson, Iain. "Heidegger's Aesthetics." In *The Stanford Encyclopedia of Philosophy*. Fall 2019 ed. Edited by Edward N. Zalta. Last revised August 6, 2019. https://plato .stanford.edu/archives/fall2019/entries/heidegger-aesthetics/.

Tihanov, G. "Russian Formalism." In *The Princeton Encyclopedia of Poetry and Poetics*, edited by Roland Greene, 1239–42. Princeton: Princeton University Press, 2012.

"To Be in a Rage, Almost All the Time." *1A*. NPR. June 1, 2020. https://www.npr.org /2020/06/01/867153918/-to-be-in-a-rage-almost-all-the-time.

Tollefsen, Torstein. "Christocentric Cosmology." In *The Oxford Handbook of Maximus the Confessor*, edited by Pauline Allen and Bronwen Neil, 307–21. Oxford, Oxford University Press, 2015.

———. *St. Theodore the Studite's Defence of the Icons: Theology and Philosophy in Ninth-Century Byzantium*. Oxford: Oxford University Press, 2018.

Tolstoy, Leo. *What Is Art?* Translated by Richard Pevear and Larissa Volokhonsky. London: Penguin Books, 1995.

Tomlinson, Gary. *Culture and the Course of Human Evolution*. Chicago: University of Chicago Press, 2018.

Torrance, Alan J. *Persons in Communion: An Essay on Trinitarian Description and Human Participation*. Edinburgh: T&T Clark, 1996.

Torrance, Andrew B. "Should a Christian Adopt Methodological Naturalism?" *Zygon* 52, no. 3 (2017): 691–725.

Torrance, Thomas F. *Space, Time and Incarnation*. London: Oxford University Press, 1969.

Tran, Jonathan. "Lovely Things: The Confessional Ends of Critique." *Syndicate*, February 4, 2020. https://syndicate.network/symposia/theology/syndicate-project-on -the-state-of-theology/#lovely-things.

Trapani, John G., Jr. *Poetry, Beauty and Contemplation: The Complete Aesthetics of Jacques Maritain*. Washington, DC: Catholic University of America Press, 2011.

"'Tree of Life' by Blake Debassige." *Norval Morrisseau Blog*, December 24, 2009. https:// norvalmorrisseau.blogspot.co.uk/2009/12/tree-of-life-by-blake-debassige.html.

"*Tree of Life* (Kester)." Wikipedia. Last modified August 6, 2022, 16:06 (UTC). https:// en.wikipedia.org/wiki/Tree_of_Life_(Kester).

Trehub, Sandra E., Judith Becker, and Iain Morley. "Cross-Cultural Perspectives on Music and Musicality." *Philosophical Transactions of the Royal Society of London: Series B, Biological Sciences* 370, no. 1664 (2015). https://doi.org/10.1098/rstb.2014.0096.

Troutner, Timothy. "Beyond Silence: Toward an Eschatology of Praise." *Modern Theology* 37, no. 4 (2021): 913–33.

Tupamahu, Ekaputra. "Tongues as a Site of Subversion: An Analysis from the Perspective of Postcolonial Politics of Language." *Pneuma* 38 (2016): 293–311.

Tyson, Paul G. *Seven Brief Lessons on Magic*. Eugene, OR: Cascade Books, 2019.

Vaage, Nora S. "Living Machines: Metaphors We Live By." *NanoEthics* 14 (2020): 57–70.

van den Heever, G. A. "Theological Metaphorics and the Metaphors of John's Gospel." *Neotestamentica* 26, no. 1 (1992): 89–100.

Vanhoozer, Kevin J. *Is There a Meaning in This Text? The Bible, the Reader, and the Morality of Literary Knowledge*. Leicester, UK: Apollos, 1998.

Viega, Michael. "Exploring the Discourse in Hip Hop and Implications for Music Therapy Practice." *Music Therapy Perspectives* 34, no. 2 (2015): 138–46.

von Balthasar, Hans Urs. *The Glory of the Lord: A Theological Aesthetics*. Vol. 1, *Seeing the Form*. Translated by Erasmo Leivà-Merikakis. Edinburgh: T&T Clark, 1982.

———. *The Glory of the Lord: A Theological Aesthetics*. Vol. 3, *Studies in Theological Style: Lay Styles*. Translated by Andrew Louth, John Saward, Martin Simon, and Rowan Williams. Edited by John Riches. Edinburgh: T&T Clark, 1989.

———. *Prayer*. San Francisco: Ignatius, 1986.

Warburton, Edward C. "Of Meanings and Movements: Re-languaging Embodiment in Dance Phenomenology and Cognition." *Dance Research Journal* 43, no. 2 (2011): 65–83.

Wasserman, Earl R. *The Subtler Language: Critical Readings of Neoclassic and Romantic Poems*. Westport, CT: Greenwood, 1979.

Watson, Francis. "Trinity and Community: A Reading of John 17." *International Journal of Systematic Theology* 1, no. 2 (1999): 168–84.

Weber, Max. *Economy and Society: A New Translation*. Edited and translated by Keith Tribe. Cambridge, MA: Harvard University Press, 2019.

Webster, John. *Confessing God: Essays in Christian Dogmatics II*. London: T&T Clark, 2005.

Westerhoff, Jan. "What Are You?" *New Scientist* 217, no. 2905 (2013): 34–37.

Wijnia, Lieke. *Beyond the Return of Religion: Art and the Postsecular*. Leiden: Brill, 2019.

Williams, Peter F. *Bach: The Goldberg Variations*. Cambridge: Cambridge University Press, 2001.

Williams, Richard N., and Daniel N. Robinson, eds. *Scientism: The New Orthodoxy*. London: Bloomsbury, 2016.

Williams, Rowan. *Christ the Heart of Creation*. London: Bloomsbury, 2018.

———. "Conclusion: Knowing and Loving the Triune God." In *A Transforming Vision: Knowing and Loving the Triune God*, edited by George Westhaver, 231–40. London: SCM, 2018.

———. "Confronting Our Own Mortality." *New Statesman*, August 19, 2020. https://www.newstatesman.com/uncategorized/2020/08/covid-and-confronting-our-own-mortality.

———. "The Deflections of Desire: Negative Theology in Trinitarian Disclosure." In *Silence and the Word: Negative Theology and Incarnation,* edited by Denys Turner and Oliver Davies, 115–35. Cambridge: Cambridge University Press, 2002.

———. *The Edge of Words: God and the Habits of Language.* London: Bloomsbury Continuum, 2014.

———. *Grace and Necessity: Reflections on Art and Love.* London: Continuum, 2005.

———. "Rowan Williams's Diary: Judging the Booker Prize, the Ethics of Climate Change, and the Birth of Our First Grandchild." *New Statesman: UK Edition,* November 10, 2021. https://www.newstatesman.com/diary/2021/11/rowan-williamss-diary -judging-the-booker-prize-the-ethics-of-climate-change-and-the-birth-of-our-first -grandchild.

———. "The Theological World of the Philokalia 1." In *The Philokalia: A Classic Text of Orthodox Spirituality,* edited by Brock Bingaman and Bradley Nassif, 102–21. Oxford: Oxford University Press, 2012.

Wiman, Christian. *Every Riven Thing.* New York: Farrar, Straus & Giroux, 2010.

Winterson, Jeanette. "What Is Art For?" In *The World Split Open: Great Authors on How and Why We Write,* edited by Chimamanda Ngozi Adichie et al., 173–88. Portland, OR: Tin House Books, 2014.

Wolfe, Gregory, ed. *Bearing the Mystery: Twenty Years of Image.* Grand Rapids: Eerdmans, 2009.

Wolpert, Lewis. *The Unnatural Nature of Science.* Cambridge, MA: Harvard University Press, 1994.

Wolterstorff, Nicholas. *Art Re-thought: The Social Practices of Art.* Oxford University Press, 2015.

Wright, N. T. *History and Eschatology: Jesus and the Promise of Natural Theology.* Waco: Baylor University Press, 2019.

———. *The Resurrection of the Son of God.* London: SPCK, 2003.

Young, Frances, and David Ford. *Meaning and Truth in 2 Corinthians.* Grand Rapids: Eerdmans, 1987.

Index